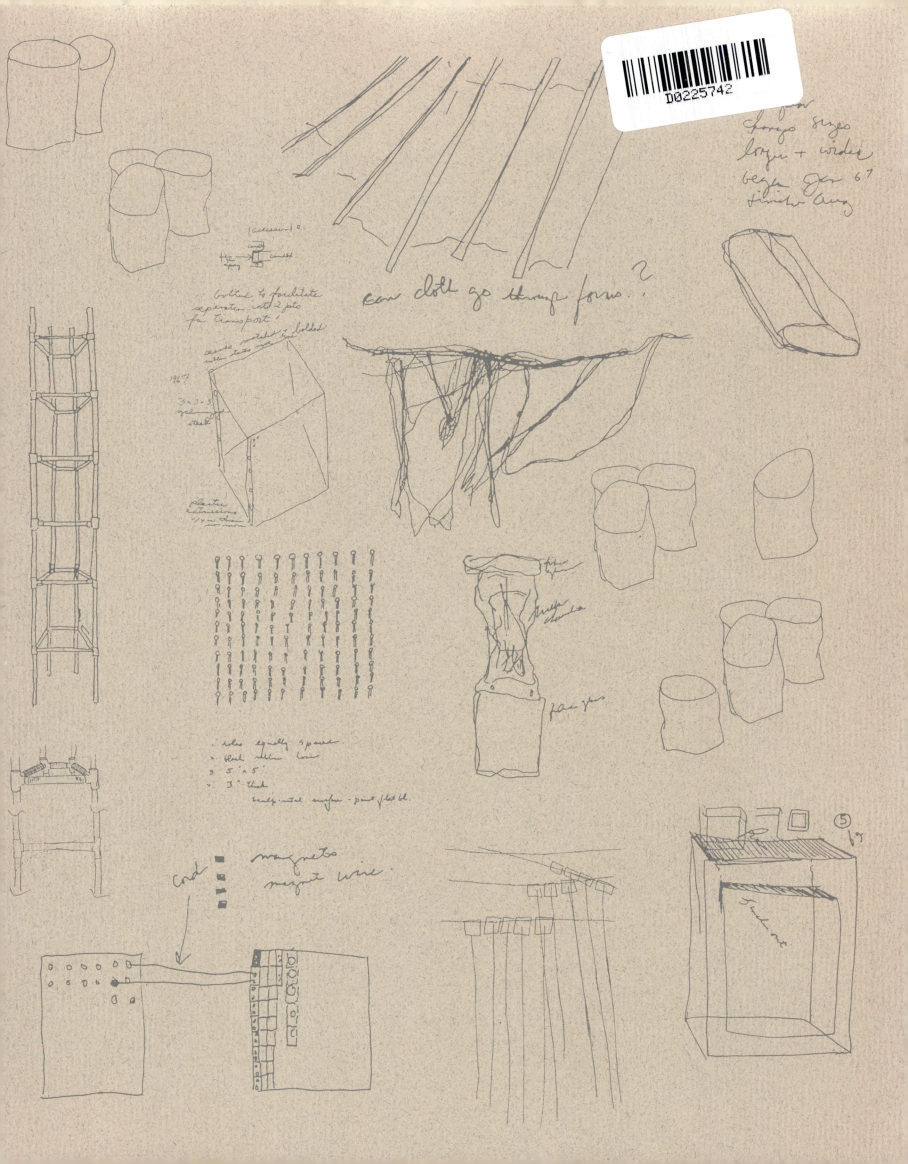

can cloth go through forms?

EVA HESSE: *A Retrospective*

I want to be surprised, to find something new.
I don't want to know the answer before but want
an answer that can surprise.

Eva Hesse, 10 December 1964

EVA HESSE: *A Retrospective*

Exhibition and catalogue organized by Helen A. Cooper

Essays by Maurice Berger
Anna C. Chave
Maria Kreutzer
Linda Norden
Robert Storr

Yale University Art Gallery · New Haven

Yale University Press · New Haven and London

Published in conjunction with the exhibition
Eva Hesse: A Retrospective
Organized by the Yale University Art Gallery

Yale University Art Gallery, New Haven
15 April–31 July 1992

Hirshhorn Museum and Sculpture Garden,
Smithsonian Institution, Washington, DC
15 October 1992–10 January 1993

Exhibition and publication made possible by grants from
The Henry Luce Foundation, Inc.
The National Endowment for the Arts
The Andy Warhol Foundation for the Visual Arts, Inc.
The Joseph Albers Foundation, Inc.
Susan Morse Hilles
The Estate of Eva Hesse

Edited by Lesley K. Baier

Library of Congress
Cataloging-in-Publication Data

Eva Hesse : a retrospective / exhibition and
catalogue organized by Helen A. Cooper ;
essays by Maurice Berger . . . [et al.].
 p. cm.
 Includes index.
ISBN 0-300-05489-0 (hard : alk. paper)—
ISBN 0-89467-059-x (pbk. : alk. paper)
1. Hesse, Eva, 1936–1970—Exhibitions.
I. Cooper, Helen A. II. Berger, Maurice.
III. Yale University. Art Gallery.
N6537.H4A4 1992
709'.2—dc20 92-5605
 CIP

Cover, Jacket, Endleaves:
Details from Eva Hesse's working drawings, 1967, The
Museum of Modern Art, New York, gift of the Eva Hesse
Estate; and notebook sketches, 1965–70, Allen Memorial Art
Museum, Oberlin College, gift of Helen Hesse Charash

CONTENTS

DIRECTOR'S FOREWORD

This retrospective of Eva Hesse's paintings, drawings, and sculpture allows the viewer an unprecedented opportunity to witness firsthand the full magnitude of her achievement. One of the first women artists to gain international recognition in the 1960s, Hesse has assumed a near-mythic status in the history of contemporary American art. Yet no comprehensive exhibition of her work has ever before been organized. The physical condition of the sculpture—its ever-increasing fragility and the difficulties inherent in its installation—as well as the work's dispersal in private and public collections throughout North America, Europe, and Asia, are daunting realities facing anyone eager to undertake so major an enterprise.

It is most fitting that this Hesse retrospective is part of the Yale University Art Gallery's ongoing celebration of the distinguished work of graduates of the Yale School of Art. Hesse's years there—she entered in 1957 and received her B.F.A. in 1959—coincided with the uncertainty engendered by the imminent retirement of Josef Albers. As Dean of the Art School from 1950, Albers was not only the dominant force in the formation of one of America's most prestigious cultural institutions, but also an essential presence for a generation of American artists who would redefine the parameters of artistic expression. Certainly Hesse's experiences at Yale strengthened her commitment to her work and played a key role in her development. Although at the time she expressed mixed feelings about her years there, she would later write that they were among the most productive of her life.

Helen A. Cooper, Curator of American Paintings and Sculpture, pursued the idea of an Eva Hesse exhibition and catalogue tirelessly and coordinated both with skill and intelligence. Her persistence and determination in obtaining many of Hesse's most significant works were exemplary, providing us with a striking exhibition as well as a publication whose authors offer new critical insights into the profound ties between Hesse's life and work.

In this time of diminished resources for the arts, it is especially gratifying to acknowledge the generous support of The Henry Luce Foundation, Inc.; the National Endowment for the Arts; The Andy Warhol Foundation for the Visual Arts, Inc.; The Josef Albers Foundation, Inc.; Susan Morse Hilles; and The Estate of Eva Hesse. Their enthusiastic response insured that the exhibition and catalogue could go forward without compromise.

We are proud to share the Hesse retrospective with the Hirshhorn Museum. As the only other venue, it is appropriate that the exhibition be seen in the nation's capital within the walls of an institution committed to contemporary art and renowned for its own sculpture collection.

In her acknowledgments, Helen Cooper thanks the many colleagues and friends who have been instrumental in the organization of the exhibition, and I can only underscore our appreciation for their contributions. Particular thanks go to our colleagues David Pease, Jules Prown, and Ann Gibson in the School of Art and the Department of the History of Art for their vigorous and sustaining enthusiasm. Above all, we are most profoundly grateful to our lenders, who have entrusted us with their rare and fragile objects. Through their generosity, Eva Hesse's paintings, works on paper, and sculpture have been brought together in an exhibition that will surely surprise and move even those long familiar with her achievement.

Mary Gardner Neill
The Henry J. Heinz II Director

PREFACE AND ACKNOWLEDGMENTS

Eva Hesse began to receive serious recognition as an artist in 1966 when her work was included in Lucy Lippard's important exhibition "Eccentric Abstraction." Following the critical success of Hesse's one-woman show at the Fischbach Gallery in the fall of 1968, her career rapidly accelerated. Sadly, the period of her triumph was brief. In May 1970 she died from a brain tumor at the age of thirty-four. Only posthumously were her extraordinary talent and influence fully realized. Acknowledged today as a pivotal figure in offering American art an alternative to the constraints of minimalism, she opened up new frontiers in sculptural form, content, and material. In the present-day climate of a renewed interest in expressionism and gesture, Hesse's work continues to exert a powerful presence.

Drawing together in a subtle and complex way many of the artistic concerns that occupied such contemporaries as Carl Andre, Mel Bochner, Donald Judd, Sol LeWitt, and Robert Morris, Hesse explored the central issues that much of the best work of the sixties sought to redefine: the essential nature of the art object, the increasingly important role of the viewer, and the artist as conceptualizer and fabricator. Unlike the work of her contemporaries, however, Hesse's art is remarkable for its emphasis on light, its expressive use of materials, its non-unitary repeating forms, and its spatial variety. She built on the internal oppositions within each work: the geometric and the organic, order and chaos, repetition and difference, hard and soft, permanence and change. The tension between these various positions, once considered absolutes, animates her work and gives it its intellectual, psychological, and sensory edge.

Painting and particularly drawing played an integral part in Hesse's artistic development. Indeed, she first achieved a personal style in her drawings. By the mid-1960s, when traditional oil painting no longer offered her enough expressive possibilities, it was through the use of line and collage that she moved into sculpture. And even as she devoted herself to establishing a reputation as a sculptor, she continued to be actively involved with works on paper, describing sheets built up from layer upon layer of subtle washes as "really paintings on paper . . . but I call them drawings. But they are really not. There is no difference between [drawing and] painting except that it is smaller and it is on paper." Similarly, Hesse blurred the boundaries between painting and sculpture, asserting that *Contingent* of 1969 (fig. 65) was "really hung paintings . . . hung from the ceiling and hung against the wall . . . more than it is

sculpture." As in her testing of the limits set by the Abstract Expressionists and the minimalists, she approached all boundaries obliquely, even playfully.

Hesse shared with many of her contemporaries an enthuasiasm for the exploration of non-traditional and industrial materials. The characteristics of latex and fiberglass, her signature materials, affected her work in a number of ways. Latex produced objects that were prone to deterioration and hence ephemeral, qualities Hesse came to regard as attributes; fiberglass, on the contrary, offered permanence. Hesse extended her interest in opposites by combining these two materials in a number of late pieces. The translucency of fiberglass alone or in combination with latex gave a central role to light, thereby emphasizing the viewer's perception of the piece and providing an experience of light and color that may be unique in the art of the period. Finally, in Hesse's hands, these materials retain the traces of their making, resulting in objects that are ultimately private utterances, instinctual and personally expressive.

At a time when the status quo was being questioned on many fronts, Hesse thought of herself as an individual, unattached to any movement. Included in a number of groundbreaking and critically acclaimed exhibitions, her sculpture baffled viewers and critics, who found it difficult to categorize. The titles of some of the exhibitions in which she participated suggest the dilemma contemporaries faced when trying to situate her work: "Abstract Inflationism and Stuffed Expressionism" (1966), "Eccentric Abstraction" (1966), "Art in Series" (1967–68), "Soft and Apparently Soft Sculpture" (1968–69), "When Attitudes Become Form" (1969), "Anti-Illusion: Procedures/ Materials" (1969), and "A Plastic Presence" (1969–70). Her work was variously described as soft sculpture, serial work, "anti-form," and process art. Ultimately, of course, it is the multi-dimensional character of Hesse's art, its stubborn refusal to be neatly categorized, that gives her work its impressive power.

In organizing this exhibition, my primary goal was to show the full range of Hesse's artistic achievement. "Eva Hesse: A Retrospective" brings together major pieces in every medium, not only her well-known sculpture but rarely seen paintings and drawings from every phase of her professional career: the early abstract expressionist works; the brightly colored drawings and paintings of the mid-sixties, which show a lineage from Gorky and de Kooning; the witty organic-machine pieces from her German sojourn; the circle and grid drawings of 1966–67; and finally the late, light-enclosing "window" series, which coincides with the monumental sculpture of the last year of her life. Moreóver, the exhibition reunites the five sections of *Sans II,* which have not been seen together since the sculpture was first exhibited in 1968. The works are installed chronologically, and viewers may feel compelled to seek clues in the earlier work for the accomplishments of the later.

In Hesse's journey from the Yale School of Art to her studio in the Bowery, her career can be seen as a model within the New York art world. From her self-conscious reworking of the expressionist style, to her uneasiness with Pop art, to her struggles with the confinement of minimalism, she illuminates the problem of a generation of artists who came to maturity in the waning shadows of Abstract Expressionism. To engage in a fresh discussion of Hesse's achievements, I invited a group of schol-

ars—none of whom had known her personally but all of whom were deeply drawn to her work—to reexamine her career. As the reader will quickly see, they offer a provocative range of approaches and interpretations—often of the same work—that are testimony to the profound richness of Hesse's art.

The catalogue begins with a chronology of Hesse's life, told as much as possible in her own words to honor her embrace of writing as integral to her sense of self. It is followed by Linda Norden's discussion of Hesse's gradual move away from Abstract Expressionism and painting, a move she shared with many of her minimalist and conceptualist contemporaries without ever participating in their denial of self in their art. Maria Kreutzer considers Hesse's work in Germany in 1964–65 as a kind of search for a personal language or semiological praxis when, stimulated by the avant-garde art world of Düsseldorf, she abandoned painting and sought a new expression in sculpture. Robert Storr focuses on Hesse's evaluation of her "weird humor" as the crucial, catalytic element in her aesthetic, thereby making the surreal physicality and submerged sexuality of her art more readily understandable. Anna Chave differentiates Hesse's practice from the predominantly impersonal visual modes of the sixties in light of contemporary feminist theory on sexual subjectivity and the relation of femininity to pathology. And in the final essay, Maurice Berger analyzes the complex phenomenological relationship between Hesse's mature sculpture and the viewer's body, arguing that in breaking the rules, she allowed humor, eroticism, and pleasure into a primarily abstract terrain.

I am profoundly grateful to these five scholars, whose provocative and rigorous texts both celebrate Hesse's legacy and cast new light on her achievement. As their contributions so clearly reveal, no major exhibition and catalogue are ever the result of a single individual's efforts. Even more than most projects, "Eva Hesse: A Retrospective"—the most comprehensive exhibition of her art ever mounted—has been a collaborative effort. From original concept to final installation, it reflects the scholarship, extraordinary commitment, and generosity of a great many people.

This book and exhibition build on the pioneering efforts of three publications: Lucy Lippard's seminal biography of the artist, published in 1976, provided the broad foundation; Ellen Johnson's catalogue of the 1982 Allen Memorial Art Museum exhibition of Hesse's drawings helped us focus on that aspect of her oeuvre; and Bill Barrette's superb catalogue of Hesse's sculpture gave us essential information on materials and techniques. It is fair to say that without the benefit of these earlier scholarly contributions, our own efforts would have been greatly diminished.

My initial thanks must go the enlightened and generous financial support of The Henry Luce Foundation, Inc.; the National Endowment for the Arts; The Andy Warhol Foundation for the Visual Arts, Inc.; The Joseph Albers Foundation, Inc.; Susan Morse Hilles; and The Estate of Eva Hesse. Mary Jane Crook, Emily Todd, and Nicholas Weber at the Luce, Warhol, and Albers foundations respectively, offered important guidance, and I thank them for their help. I am also indebted to Christopher Reaske, Director, and Johanna Kelly, Associate Director, Corporate and Foundation Relations, Yale University, who worked closely with me to secure the funding critical to producing the exhibition and catalogue.

The support and encouragement of many individuals allowed the project to go forward as well. Helen Charash, Eva Hesse's sister, shared family information, and her enthusiasm for the exhibition inspired all of us. I owe warm and very special thanks to Barry Rosen, whose assistance and support were critical to the project's realization. Bill Barrette generously shared his intimate knowledge of Hesse's sculpture and was a most patient and wise guide, responding graciously to every request. The Robert Miller Gallery, representatives for the Eva Hesse Estate, especially Nathan Kernan, Diana Bulman, and Wendy Williams, offered every possible practical assistance, from reframing drawings to tracking down unlocated works, and responded to a seemingly unending stream of requests for photographs with unflagging courtesy. The staff of the Allen Memorial Art Museum at Oberlin College made access to the Eva Hesse Archives as easy as possible. In particular, I wish to acknowledge Joan-Elisabeth Reid, Registrar, who went beyond the call of duty; without her help, our research efforts would have been significantly hampered.

Many of Hesse's friends and collectors challenged my thinking, shared their knowledge of the artist, helped me better understand her work, showed me through their collections, or led me to previously unlocated works. In particular I thank Mel Bochner, Katherine Cline, Tom Doyle, Dr. and Mrs. Samuel Dunkell, Mrs. Victor Ganz, Dr. Susanne Henle, Ethelyn Honig, Ellen Johnson, Sol LeWitt, Lucy Lippard, Mr. and Mrs. F. Arnhard Scheidt, Naomi Spector, Gioia Timpanelli, Manfred Tischer, and Grace Wapner. Thanks also go to John Caldwell, Ann Gibson, Craig Newick, David Pease, Dennis Piechota, Jules D. Prown, Ned Rifkin, Kenneth Silver, and Ursula von Rydingsvard for rewarding conversations.

At the Hirshhorn Museum, James T. Demetrion, Director, offered every assistance. I had the pleasure of working first with the former Chief Curator, Ned Rifkin (now director of the High Museum, Atlanta), who was instrumental in bringing the exhibition to Washington, and more recently with Phyllis Rosenzweig, Associate Curator. Exhibits Designer Edward Scheisser and his staff planned the beautiful installation; Barbara Freund ably handled the arrangements in the Registrar's office. The enthusiastic response of the Hirshhorn staff to hosting the exhibition has been immensely gratifying.

I am deeply indebted to my colleagues in the Yale University Art Gallery, in particular to Mary Gardner Neill, Henry J. Heinz II Director, for her enthusiasm and confidence; and Louisa Cunningham, Business Manager, for her superb administrative skills. Registrar Susan Frankenbach and Associate Registrar Diane Hart handled with deceptive ease the tremendously complicated packing and travel arrangements. Kristin F. Hoermann, Mark Aronson, Theresa Fairbanks, and Christopher Foster oversaw all conservation needs from the smallest frame adjustment to the most complicated paper treatment. Richard S. Field, Curator of Prints, Drawings, and Photographs, generously made available the assistance of his department. Janet Dickson and Janet Gordon, Curator and Associate Curator of Education, organized a rich program of public events. Beverly Rogers, Administrative Assistant, attended to the myriad details associated with loan arrangements, permission requests, and acquisition of photographs with amazing efficiency; Miles Finley cheerfully ran

errands, typed labels, and catalogued photographs; Anne Campbell and Tim Maher typed innumerable drafts of the manuscript. Joe Szaszfai and Michael Agee graciously responded to every request for photo reproduction despite their own overburdened schedules. Richard Moore and his expert crew of art handlers, Burrus Harlow, Maishe Dickman, Richard Johnson, and Robert Soule, installed the works with exemplary care. Marie Weltzien coordinated press coverage and public relations with her usual intelligence and flair. Thanks go also to Sasha Newman, Seymour H. Knox, Jr. Associate Curator of European and Contemporary Art, for her efforts on our behalf.

During the course of this project I had the good fortune to have the able research assistance of several graduate students, and I thank them warmly for their important contributions: Jane Desmond, Diane Dillon, Sheryl Freedland, Alison Tilghman, and Amy S. Weisser. I owe a special debt of gratitude and appreciation to Robin Jaffee Frank, Assistant Curator of American Paintings and Sculpture, for her exceptional dedication throughout the project but especially during the critical last phases of catalogue preparation; daily, with characteristic grace and good humor, she accomplished the impossible. Lesley K. Baier was an exemplary editor; her sensitivity to the material, clarity of judgment, and meticulous respect for language as well as for each essayist's own voice are evident throughout. This book has benefitted immeasurably from her involvement. I am grateful to David Britt for his seamless and elegant translation of Maria Kreutzer's essay. I also owe sincere thanks to Jill Lloyd for insightful comments and suggestions that significantly improved parts of the manuscript. It has been a pleasure as well to work with the Yale University Press, copublishers of this book; in particular I thank Judy Metro for her enthusiastic support.

For allowing Hesse's art to speak for itself, I am indebted to Sarah Buie's sensitive exhibition design at Yale. Special thanks must go to Catherine Waters, whose responsiveness to and respect for Hesse's art illuminate the design of these pages; that she created this beautiful and expressive book under extreme deadline pressures is proof that exceptionally talented individuals indeed have magical powers. And finally, I thank Jack R. Cooper for enduring countless inconveniences to give me the gift of time.

Organizing this exhibition has been a privilege. My only regret is that I never knew Eva Hesse personally. I can only hope that this catalogue and exhibition honor her memory as well as do justice to her art.

Helen A. Cooper
Curator of American Paintings and Sculpture

Allen Memorial Art Museum, Oberlin College, Ohio

Thomas Ammann Fine Art, Zurich

The Art Institute of Chicago

The Baltimore Museum of Art

Martin Bernstein

Ellen S. Cantrowitz

Centre Georges Pompidou, Musée National d'Art Moderne, Paris

Mr. and Mrs. Murray Charash

John Eric Cheim, New York

Des Moines Art Center

Detroit Institute of Arts

Ruth and Samuel Dunkell

The Estate of Eva Hesse. Courtesy Robert Miller Gallery, New York

Marilyn Cole Fischbach

Mr. and Mrs. Tony Ganz

Mrs. Victor W. Ganz

Sondra and Charles Gilman, Jr.

Bette Greenblatt

Barbara Gross Galerie, Munich

Hirshhorn Museum and Sculpture Garden, Smithsonian Institution, Washington, DC

Rhona Hoffman Gallery

I.B.J. Schroder Bank & Trust Co.

Audrey and Sidney Irmas, Los Angeles

J.J.N. Collection

Ellen H. Johnson

Yoshio Kojima, Japan

Werner H. and Sarah-Ann Kramarsky

Kunstmuseum Winterthur, on permanent loan from Volkart Foundation

Lannan Foundation, Los Angeles

The LeWitt Collection. Courtesy of the Wadsworth Atheneum, Hartford, Connecticut

Lucy R. Lippard

Dr. and Mrs. Norman R. Messite, New York

Milwaukee Art Museum

Moderna Museet, Stockholm

The Museum of Modern Art, New York

Museum Wiesbaden, Germany

Neuberger Museum, State University of New York at Purchase

Louise R. Noun

Philadelphia Museum of Art

Private Collections

Anthony Ralph Gallery

Refco Group, Ltd.

Barry Rosen

The Saint Louis Art Museum

F. A. Scheidt, Kettwig, Germany

Anna Marie and Robert F. Shapiro

Naomi Spector and Stephen Antonakos

State Museum Kröller-Müller, Otterlo, The Netherlands

Tate Gallery, London

Gioia Timpanelli

Galerie Sophia Ungers, Cologne

Paul F. Walter

Grace and Gerald Wapner

Weatherspoon Art Gallery, The University of North Carolina at Greensboro

Whitney Museum of American Art, New York

Wiesbaden Museum, Germany

Reader's Note

All works in the exhibition are illustrated in the plate section, ordered chronologically by medium. Figure references are to works illustrated in the chronology and essays. Dimensions are provided in inches and centimeters, height preceding width for paintings and works on paper, followed by depth for sculpture. The often variable dimensions and various media of the latter are detailed as precisely as possible.

With the exception of minor orthographic corrections, all quotations from Eva Hesse's diaries and notebooks—in the Eva Hesse Archives at the Allen Memorial Art Museum, Oberlin College, Oberlin, Ohio—are published as written. When the dates of undated entries have been determined from context, they are indicated in brackets.

All quotations from Cindy Nemser's 1970 interviews with Hesse are from the original transcript, also in the Eva Hesse Archives at Oberlin; it is cited in the Notes as Hesse/Nemser transcript. The following abbreviated references for two frequently cited publications are used throughout the Notes as well:

Barrette: Bill Barrette, *Eva Hesse: Sculpture* (New York: Timken Publishers, Inc., 1989).
Lippard: Lucy R. Lippard, *Eva Hesse* (New York: New York University Press, 1976).

EVA HESSE: *Diaries and Notebooks*

Helen A. Cooper

I thought one must know oneself to write and that always intrigued me most of all. The idea of honesty is so challenging, much more so in words than pictures.

Eva Hesse, 1964[1]

Fig. 1
Sketches of finished sculptures, 1965–66
Inside back cover of bound notebook begun
26 March 1965
Pen and ink on lined paper
8¼ x 5¹³/₁₆ in. (21 x 14.8 cm)
Allen Memorial Art Museum, Oberlin College,
Gift of Helen Hesse Charash, 1977

No chronology of Eva Hesse's life would be complete without reference to her writings—the private diaries, datebooks, and letters to friends—which reveal a "near-obsession with autobiography" and allow a remarkably candid glimpse into the complex connections between her life and art.[2] In these intensely personal and often pain-filled pages, at times written with scrupulous control, at others hastily scrawled, Hesse gave voice to her deepest anxieties and ambitions. And while she focused on the present, the events of her past were a frequent refrain. Her diary-writing may even have drawn its initial impetus from the journals and scrapbooks her father kept for his two children, documenting every phase of their early lives.[3] From young adulthood until her death, Hesse's diaries were an expression of her search for her own identity. It was a search that found its ultimate expression in her art.

Hesse's most active diary-writing occurred in two periods: 1957 to 1961, through her years at Yale to her marriage to Tom Doyle; and 1964 to 1967, when her marriage was disintegrating and she felt overwhelmed by feelings of loss. In both periods she turned to her diary as to a trusted friend, pouring out her often troubled feelings. Significantly when she was the happiest, as in the first years of her marriage, she wrote very little. And by mid-1967, when she felt more secure in her career and in her personal life, the diaries changed in tone, becoming largely appointment books with notes on materials, chemicals, and fabrication techniques.[4] Even the detailed accounts of dreams and feelings that she had long prepared for her therapist became more fragmented. As Hesse's professional stature among fellow artists increased and her self-confidence as a sculptor grew, she was able to express more of herself in and through her work. Yet she never gave up the need for words. No longer the signifiers of a troubled personal life, they took on a more subtle role, often as notes on titles or possible works, or as statements to accompany specific sculptures.

Hesse loved words. A voracious and eclectic reader, she carefully noted in her diary whatever book she was currently reading. Mel Bochner gave her a thesaurus whose contents she mined for possible titles, sometimes annotating lists of words with definitions. Although she wrote in 1967 that "a title is after the fact," in 1969 she underscored their importance by noting in her diary that "titles vivify all to me."[5] Hesse's sense of humor and playfulness, her fondness for verbal rhythms, puns, and obscure references, is not surprisingly often revealed in the titles she gave her works: *Oomamaboomba* (plate 81), *Eighter from Decatur* (fig. 77), and *Metronomic Irregularity*

(plate 96). Several titles emphasize her interest in repetition and seriality: *Accession* (plates 107 and 108), *Addendum* (plate 101), *Repetition Nineteen III* (plate 104); others, her preoccupation with change and the passage of time: *Sequel* (plate 103), *Right After* (plate 111). Such titles as *Ishtar* (plate 90) and *Ennead* (see fig. 13) draw on the richness of ancient art and mythology to suggestively expand the realm of possible meanings. A few refer strictly to personal matters: *Hang Up* (plate 91) was the phrase Hesse evoked most frequently in her diaries to describe her failing relationship with Doyle.

The interwoven relationships between the visual and the verbal in Hesse's life and art reveal themselves in the numerous drawings that animate her diary pages. Particularly after 1967 she freely interspersed sketches within written texts. Conversely, in the early 1960s she incorporated words and phrases into many of her finished drawings (plate 28). Perhaps the most subtle conflation between the verbal and the visual exists in the way Hesse often placed words themselves on the diary page—sentences broken down into phrases on separate lines, with little punctuation, and lines spaced so that the untouched areas resonate as verse breaks—thereby endowing the black-inked words on white paper with a further visually expressive, even poetic presence.

Hesse's diaries and notebooks served not only as a testimony to her emotional and intellectual life but also as a medium through which she originated the personal dimension of her creative process. Thoughts and feelings which were first expressed on paper often later became the raw material for her work. The process can be seen to come full circle on those pages where she drew tiny sketches of her finished sculptures next to the appropriate titles and definitions (fig. 1). Here the diary became an inventory as well, keeping track of her artistic production as previously it had her emotions, and thus reinforcing the connections between the two.

Only a fraction of Hesse's writings appears in the following chronology and essays. The selection in the chronology aims to follow the line of her inner life as she presented it, and to reflect, in proportion, the conflicts and satisfactions she expressed. At times the voice is that of an immature, narcissistic young woman, at others that of a complex individual struggling to define herself as an artist. Yet language alone, no matter how intimate, never completely reveals the self. The fabric of Hesse's identity is a tight weave of intertwined threads of words and art.

Notes

1 Diary entry of 7 May 1964.
2 Lippard, 6. Diane Dillon is currently engaged in a study of the relationship between Hesse's diary writing and her art. Many of the ideas expressed in this note are drawn from a report Ms. Dillon originally prepared for the American Arts Office.
3 These journals and scrapbooks are in the collection of Helen Charash.
4 Lippard, 85.
5 Datebook, Tues., 11 Nov. 1969.

CHRONOLOGY

1936 Born 11 January, Hamburg, Germany, the second and youngest child of Wilhelm Hesse, a criminal lawyer, and Ruth Marcus Hesse.

1938 November: to escape Nazi persecution, is sent with sister Helen on a children's train to Amsterdam and placed in a Catholic children's home. They are reunited three months later with their parents, who had fled into hiding in the German countryside.

1939 June: family emigrates to New York City and settles in Washington Heights, where her father becomes an insurance broker. Her mother, already severely depressed by the war and the family's displacement, is eventually hospitalized.

1945 Parents divorce and soon afterward her father marries Eva Nathansohn. Both children live with him and their stepmother.

1946 January: mother commits suicide. Hesse never really gets over the shock, worrying throughout her life that she may have inherited her mother's instability.

1949 June: graduates with honors from Humboldt Junior High School, where one of her lowest grades is in art. She nonetheless has decided to become an artist.

1952 June: graduates from the High School of Industrial Arts, New York. For the yearbook *The Palette,* she writes a commentary on the window display class, describing the stages of working through a project: determining the scale and building a miniature model with balsa wood, razor blades, pins, and rulers. The description reveals an early penchant for using ordinary, hardware store materials and for working in three dimensions.[1]

September: enters Pratt Institute of Design to study advertising design. Unhappy there, she leaves in the middle of her second year.

The only painting I knew, and that was very little, was Abstract Expressionism. And at Pratt they didn't stress painting at all, and when you started painting class you had to do a lemon still life, then you graduated to a lemon, bread still life, and this was not my idea of painting . . . I waited until I was getting A's instead of C's and declared I was quitting.[2]

1954 February: gets a part-time job as an intern at *Seventeen Magazine* and takes life drawing classes three evenings a week at the Art Students League.

Summer: insecure and anxious much of the time, she begins therapy with Dr. Helene Papanek. Meets Rosalyn Goldman, who would become a lifelong friend.

September: Hesse's name appears in print for the first time, in *Seventeen*'s continuing series "It's All Yours," dedicated to the work of writers and artists under twenty. Hesse is eighteen. The article reproduces in color three watercolors, one drawing, and one lithograph, all executed in a Cézannesque-cubist style. In the accompanying text, Hesse attributes her interest in what lies beneath the surface of things to being raised in a Jewish family that had survived the Holocaust.

For me, being an artist means to see, to observe, to investigate . . . I paint what I see and feel to express life in all its reality and movement.[3]

1954–57 September 1954: enters Cooper Union, where her teachers are Nicholas Marsicano, Neil Welliver, Will Barnet, Robert Gwathmey, and Victor Candell. Although she would later recall "loving Cooper from the start," her contemporaneous diaries express dissatisfactions with the program by the end of the first year.

March 1955: I discovered we don't really learn here . . . Just to paint and discuss the painting is not enough.[4]

March 21: The more I see of life, day to day experiences, the more dissatisfied I am with conditions and with myself. I know so little how can I really paint or just paint? What do I have to say that's worthwhile, and if I spend all my time saying and feeling when will I learn more which in turn will be told? It's like writing memoirs, without a previous life.[5]

June 1957: graduates from Cooper Union; accepts a scholarship to the Yale Summer School of Music and Art, Norfolk, Connecticut.

1957–59 September 1957: enters Yale School of Art and Architecture, where her teachers are Josef Albers (fig. 2), Rico Lebrun, and Bernard Chaet.

I went two weeks. I really didn't like it but I stayed, a combination of being afraid to get out of school because that was frightening, and of being defeated . . . I loved Albers' color course but I had it at Cooper. I did very well with Albers. I was Albers' little color studyist . . . I didn't do it out of need or necessity. I loved those problems [fig. 3]. But he couldn't stand my painting, and of course I was much more serious about the painting. But I had the Abstract Expressionist student approach, not Albers', Lebrun's, Chaet's idea. And if you didn't follow their idea it wasn't an idea and in color I mean you had to . . . that struggle between student and finding one's self . . . I don't think [it] can be avoided, and mine was very difficult and very frustrating.[6]

September 1958: returns to Yale on a scholarship, but continues to find painting difficult in an academic environment, and social pressures distracting.

Sept. 9: People are returning constantly and show up in the apt. and I meet them in the streets and school. There is eagerness and apprehension . . . I can't seem to feel comfortable enough at the studio to paint . . . I hope I will be able to refrain from the competitive involvements, the exhibitions, prizes and so forth. The less pressures and strains that personally effect me the more relaxed and thoughtful can my powers be directed to constructive meaningful work. Too bad I need any of this type [of] attention to sustain ego. I will try hard to abstain from these needs.

Sept. 21: School will be rough and I will have to come to grips with problems in my work, regarding a more definite direction and objective. Is the problem with large or small canvases one

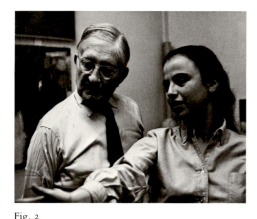

Fig. 2
Eva Hesse with Josef Albers at the Yale School of Art and Architecture, ca. 1958
© The Estate of Eva Hesse. All rights reserved.
Courtesy Robert Miller Gallery, New York

of scale? A concept, would this determine size? . . . [I] must concentrate on my painting and my own development therein. Outside influences should by now have little effect on my own efforts.

Spring 1959: torn between the Abstract Expressionist approach and Albers' theories, Hesse continually questions the instruction she is receiving. Her anxieties and ambivalences are furthermore exacerbated by the general tension in the school caused by friction between Chaet and Lebrun, and by the fact that Albers had postponed his retirement and was staying on until a successor could be named.

April 14: *The hell with them all. Paint yourself out, through and through, it will come by you alone. You must come to terms with your own work not with any other being.*

April 15: *Albers' lecture was a summary of all that he believes. It is a doctrine of thought, all inclusive based on one idea. That old past is said and done, this is new and from this only should new ideas and vision come forth. However how much more can be done with this notion. If every new work is based on this conception it is not new but variations on a theme. He is terribly limited but really maintains one point of view throughout. This is a paradoxically strong and weak attribute and shortcoming.*

Sells her first painting, to Leif Sjöberg, a visiting professor from Columbia.

June 1959: graduates from Yale with a B.F.A. and moves back to New York; lives at 82 Jane Street and shares a studio on Ninth Avenue with Phyllis Yampolsky. Takes a part-time job in a jewelry store on West 4th Street. Meets Claes and Patty Oldenburg through Yale classmate Irving Petlin.

Fall 1959: on the advice of Dr. Papanek, who thought she would make better progress with a male psychiatrist, Hesse becomes a patient of Dr. Samuel Dunkell, with whom she would remain in therapy until her death.

1960 January: takes a part-time job as a textile designer at the Boris Kroll company.[7] Finds the work situation dispiriting and quits sometime in the spring. Yet her therapy is going well, and she is full of energy for her own work.

Jan. 21: *I have so much stored inside me recently, I need to paint . . . I am overflowing also with an energy of kind needed in investigating ideas, and things I think about. This is a positive creative notion very likely I wanted also to encourage, develop, bring out, search into this thing of maturity—to be a big person—mainly as a person, then as a painter, finally as a whole being.*

[Jan. 27]: *Sacredness of art objects—I don't put that much value on any one object d'art!*

[Feb., n.d.]: *I am getting well—strong—and might yet really become what I so want.*

[Feb., n.d.]: *The satisfaction [at Kroll] is so small. It is so much easier than my own work . . . The individual [is] just part of the whole mechanism . . . The few creative decisions I fear thus go to superior. [I] thus feel inferior and cheated . . . I strongly feel I will yet get fired, and presently I cannot afford this to happen.*

Enthusiastic about a series of gestural drawings in black and brown ink washes on small sheets of paper (see plates 12, 13, 18–20). In their configurations of circular forms and tangled lines they are prophetic of much of her later sculpture. Despite her obvious pleasure in drawing, however, she frequently reminds herself that painting must be her goal.

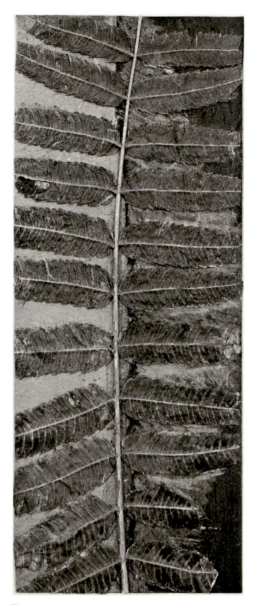

Fig. 3
Leaf study, 1958
Torn paper, leaves, and gouache on construction
paper mounted on board
10¼ x 4⅛ in. (26 x 10.5 cm)
Collection of Katherine D. Cline

Feb. 22: *I have begun to work on my own work as actively as time allows . . . I have managed to do much drawing, actually small scale painting in ink and tempera; the problems of content being the same. Some are really good and "painterly." What pleases me most is that the forms that I have been playing with all along are blossoming into something personal and afford me a central core from which to build. I see a continuity among the series with a relationship between them and my painting of the last years and the bigger possibilities for further development in painting.*

[Feb., n.d.]: *Terribly excited! . . . Have been working hard! Feel good about work (my own). Stronger than ever before. Sold another painting . . . Received $1,300.00 from grandparents' stay in concentration camp. I will make use of the money wisely. I will go on my own soon, paint and get a show and be in a gallery. It all is going so much quicker than I anticipated. God I feel strong.*

[Feb., n.d.]: *I am progressing at a rate I had not anticipated so much may come to a climax rather shortly. I intend to really begin working on my own and hope shortly to attempt a few months trial of directing myself to painting alone . . . Regarding my present work I have and still continue with a series of drawings in ink with my main tool a crudely shaped wrong side of small brush. The drawings can at best be described as imagined organic and natural forms of "growth." They are essentially quite free in feeling and handling of medium. "Ultra alive!"*

[Feb., n.d.]: *Must paint soon, drawing not enough. I want to really work . . . By next year I must be ready. Only if I act now will I break through this stage to one of being a painter.*

[March, n.d.]: *Last eve. I draw, intended to paint a picture—homage to F[rank] Roth, 1st good young painter to be totally recognized. Turned out lousy. Tore it up and after approx. 3½ hours of work I tore it and within 30 minutes made a lovely little collage. A very good one. Looks like a little Klee. Red and black.*

Suffers recurring nightmares about abandonment and early death, which she records in her diaries for use in therapy, a practice she will continue almost to the end of her life. Equates her struggle to be healthy with her struggle to be an artist.

April 24: *Fight to be a painter. Fight to be healthy. Fight to be strong.*

May 1: *My aspirations must either lessen and then failure will not be so great, or something must come forth to lessen the burden . . . Something is also quite wrong in my work—it's a fear to really work it . . . with certain abandonment and discoveries. I'm almost making it too much, moulding it, rather I should also let it speak back to me, letting it move and grow. I am enforcing a notion on it—not letting it evolve from itself. There is yet too much need for immediate gratification. I cannot accept the slow process of development. Fear of my own potential, to live it, to explore its possibilities.*

[June, n.d.]: *Yrs. of therapy, and what have I achieved! I like myself better but trust myself not yet at all.*

Summer: meets Sol LeWitt, who becomes one of her closest friends and will later be extremely influential in her life. She is working hard and enjoys some feelings of success as a painter.

[July 7]: *My paintings (last 2) look good to me, for how long this sentiment lasts is questionable. I just completed 2 in 2 days. They were in progress one month. They are painterly. They are developed images, they were really built, made, and came into being. Both of them spoke back.*

Aug. 8: *They [the last years] have probably been the 2 most eventful years, with their ups and downs, the most traumatic for me—with the greatest of changes—deep inside of myself . . . My own development has progressed rapidly this last year. I have grown quite independent, psychologically as well, and have settled much of the unnecessary turmoil so persistently afire within . . . I have become a painter, working in isolation, constructively even productively.*

An avid reader, she lists the authors read in the past year, among them Camus, Nabokov, Gide, Austen, Dostoyevsky, Joyce, Ortega, Brecht, Orwell, Theodore Reich, Mary McCarthy, Carson McCullers, Clive Bell, and Roger Fry. Her painting is slowly becoming freer and she is determined to find her own artistic voice. Mood swings between elation and discouragement are usually a result of how her painting is going.

Aug. 24: *I have become a reader. The thing I've always wanted most, but was in too great a conflict with myself to do.*

Oct. 28: *I will strip me of superficial dishonesties. I will paint against every rule I or others have invisibly placed. Oh, how they penetrate throughout and all over . . . I should like to achieve free, spontaneous painting delineating a powerful, strong, structured image. One must be possible with the other. A difficult problem in itself but one which I shall achieve.*

[Oct., n.d.]: *Materials*
2 points of view—
a) materials lifeless til given shape by creator
b) materials by their own potential created the end

Nov. 2: *I have moved so rapidly. I feel so alive, I am almost too anxious for every moment, and every future moment. Optimism and hope—even confidence. It cannot be defined as happiness, very rarely am I actually happy. But that bugs me less, maybe I care not whether or not I am happy.*

[Nov. 7]: *I cannot achieve what I want and I feel real frustration. I want to plunge further into all the paintings, achieve a depth I might yet be incapable of handling.*

Nov. 9: *Kennedy won! Stayed up til 5:30 . . . Saw Rouault [at Perls], Bontecou (very fine!) [at Castelli], Dubuffet [at Cordier-Warren], Chagall [at Contemporaries], Diebenkorn, Bishoff, Park [at Staempfli], Appel [at Martha Jackson], Rivera.*

[Nov. 16]: *I must be totally engrossed in my own work, it is only thing that is permanent, matures and is lasting.*

[Nov. 19]: *One thing has changed of late, or developed—I want to and feel I can and should sell paintings. What I am doing now might not be a peak of matured painting, but they are good, follow an idea—and they are works of a young, active developing painter. Maybe the change lies in that I feel myself to be a painter, which evidently is recent.*

The marriage of painter Victor Moscoso, probably her closest friend from Cooper Union and Yale, and with whom she had had an intimate relationship, sets off a host of painful feelings. Beset with insecurity, she finds solace only in her art.

Dec. 12: *I am in a bad way. Things have come to pass, so disturbing that the shell made of iron which has refused to be set ajar—will—must—at last open . . . Problems of my past, of my past sickness, of the scars of my early beginnings. The deeprooted insecurity which has made any relationship, meaningful one, impossible.*

[Dec. 27]: *Only painting can now see me through and I must see it through. It is totally interdependent with my entire being. It is [the] source of my goals, ambitions, satisfactions and frustrations. It is what I have found through which I can express myself, my growth—and channel my development. It affords the problems which I can think through, form ideas which I can work with and arrive at a statement. Within its scope, I can develop strength and conviction.*

1961 Tired, unable to shake a lingering cold, she spends New Year's week in the hospital.

[Jan. 6]: *Felt constant guilt in hospital, not really sick, no right to be taken care of. Unconsciously I feel I needed to be child again, taken care of; totally dependent.*

[Jan. 19]: *I truly am losing faith in all but [art], the only genuine strength and love I at present am capable of . . . [is] belief in my ability, my person, as a painter.*

[Jan. 23]: *Bob Slutzky's work is to my eyes really fine! He says if I have opportunity to show I should regardless of others in gallery. Work must be seen . . . Psychologically for me, it would greatly aid if I had a show. Furthermore other galleries would see, and know name and more readily respond . . . I want though to stop working. [The job] is getting greatly on my nerves and is too much.*

Hesse worked hard at becoming more professional and entering the art world. Even while at Yale she took her work to museums and galleries to be viewed (she was bitterly disappointed when she was turned down for the "Sixteen Americans" exhibition at the Museum of Modern Art, 16 Dec. 1959–14 Feb. 1960). She is invited to participate in a spring show at the John Heller Gallery, which showed both new and established artists. Hesse may have been recommended to Heller by Nicholas Marsicano, one of her teachers at Cooper Union. Moves in February to a loft at Park Avenue South and 19th Street, which she shares with Eila Kokkinen.

Jan. 24: *Will be in a 3 group drawing show opening April 11 . . . I feel a peculiar peace. I know I feel more an individual, confident of my own person, accepting of my own decisions, aware of myself still entangled in what seems my most difficult problem. I am much more easy going. How fine! I am beginning to sell and show my work, in that order. One gave me the confidence to proceed to the other.*

Feb. 17: *I am sick again! . . . Sulphur pills and penicillin shot. Will move Wed. Feb. 22 [to Park Avenue South]. Great loft—to be shared. This is it. I will make it work. I will really paint. The next 6 months will be my first one man show. [In fact her first one-person show did not occur until March 1963.] I will come forth—bear the fruits of 7 years and in other ways also. The money [from show] if I get it will add to security and give me food for thought regarding trip or possibly to stop work—I will see.*

Feb. 24: *Period of adjustment. It is so hard . . . living with another, there is a constant stream of actions and reactions, conversation, and ever another present. I am edgy—tired of being physically sick, eager to start my work—tired of over-sociability and in need of once again spending more time alone.*

[Feb. 26]: *Painting. Why do I write so little regarding painting?*

[Feb. 28]: *I will get really started now, must schedule myself. Unorthodox working habits are useless, even if I desire to work. There must be an order . . . If there will be a show next year. I must really show and work.*

[March 3]: *Cannot work! Am too excited about everything and have early spring fever. I walk*

and really enjoy weather—and life—everything . . . New home, new studio, first show . . . Just saw another teenage friend from the old neighborhood with 1 yr. old child. She envies me; I her. I am now not only the talented, different one—but the one who made it. How little people know people . . . And I am only successful to myself in that now I have achieved an inner peace and the knowledge that I am. That is the quality that for me is so important. I am equipped now to achieve as much as I want and whatever I set myself to do.

[March 11]: *My work . . . is my strength, my energy and only thing I have proven real dedication to. It draws upon all my faculties; I reach towards, touch it, and it is another step ahead or further or away and I reach farther. So it goes, and the thrill and fascination and frustration lessens not.*

Conflicted and lonely because a romantic relationship is not going well, she is ambivalent about her ability to commit to art and to a person at the same time.

[March 13]: *My work is impossible! Bad—nothing—which is O.K. since I just must force myself regardless and I am at least in some form—drawing. Keep light—build slowly.*

[March 19]: *I am awaiting less conflicts and frustrations, less lonely times and more joy, love, warmth, understanding and happiness.*

[March 22]: *Involvement in my own work, reading and again going out with others.*

[March 23]: *Eva, from what I know of myself my only way out of temporary standstill [in personal relationship] is to immediately pursue my work.*

[March 25]: *Reading [Susanne] Langer's "Problems of Art." Enjoying it. My—what pressure I was under when I formerly read her other 2 books [at Yale] "Philosophy in a New Key" and "Feeling and Form."*[8] *. . . Now really might be the time to paint. I don't feel painting as a substitute for anything—and this is different and needs a different channel for expression—a human object to communicate with—to humanly respond to my human feelings.*

[March 29]: *When I get back to painting, my problems and plenty of them will arise from my work—keep me busy enough to forget this trivia.*

[March 30]: *Started painting. Do not feel well, low in spirit. Want to be alone and/or only with one person I can love.*

April: meets the sculptor Tom Doyle, eight years her senior and already established as an artist. Participates in "21st International Watercolor Biennial" at the Brooklyn Museum, and in "Drawings" at the Wadsworth Atheneum. "Drawings, Three Young Americans" opens at the John Heller Gallery on April 11, including works by Hesse's former Cooper Union classmates Donald Berry and Harold Jacobs. She is singled out in a review by Donald Judd as "the most contemporary and proficient. Her small and capersome ink-and-wash drawings are a combination of the stroke (used as both sign and association) and of encompassing rectangles."[9]

April 12: *Brooklyn Mus. opening . . . and 3 Young Americans—my show—last eve. I have been with Tom Doyle the last 3 days. Last eve we also went to Elaine de Kooning's opening party. Eva has seen all the knowns except her childhood idol Bill de Kooning himself. So what to it all—yet it is the beginning of being fully in the midst of the art world—not only in and within myself—but in my work, my relation to the outside world—and in this alone it makes it rightfully important. It will not be easy with Tom—maybe this too is good. Maybe love—or love between complex people can never be easy. Am I capable of even trying?*

[April 19]: *All is well; it's been a beautiful week. The only thing I missed in a certain sense is not being able to paint . . . How to combine all aspects of my life momentarily is rather difficult. Tom is a beautiful human being—and I enjoy all aspects of him. It is a real, live and beautiful romance.*

[April 25]: *Problem . . . which I discussed only with Rosie [Goldman] . . . Show [at Heller] gallery disappointment. [The problem of] woman's role—feminine [when] both artists. I am really so happy . . . no relationship was ever based on this much—on everything that we are—and we are both strong individual people.*

[April 26]: *In painting I get so close then change, destroy, alter—whether it is just a particular painting—or a whole idea. It is never quite seen through to the end. I get distrustful of myself and reneg, cancel out. To be able to finish one, a serious one, stand ground—this is me, this is what I want to say.*

[May 2]: *Time concepts must go! Actually action time, time of physically working need not be of any long duration. It is the power of the idea, the execution could be momentary or year, trailing from canvases long since worked through. One is actually living with the work—this is as much work time as the application of paint to canvas. Yet the experience of doing can in no way be minimized and cannot be translatable into ideas alone. The working out of vision must be there, be seen outside of oneself. The ideas are never new. The handling and relationship of ideas transformed into art can be new. When the two are in harmony, in working order, the struggle is in operation.*

. . . Tom is reluctant about my wanting to paint.

Spends a happy summer with Doyle in Woodstock, New York; meets the artist Grace Bakst Wapner, who would become a close friend.

Aug. 20: *I love Tom more every day. It is all so beautiful and complete. My journal has not been written in, I cannot write as in the past, since then it was a person writing seeking love. That was the main topic, the underlying theme. A young girl in search of herself, in search of living, in search of sharing, in search of becoming a person. I have so much now of all that I ever could dream of, wish for.*

November: Hesse and Doyle marry on the 21st and move to a loft at Fifth Avenue and 15th Street, subletting space to Wapner and the artist Ethelyn Honig. Hesse works sporadically. She makes no entries in her diary for almost a year and will not resume extensive diary-writing until January 1964.

1962 Spends summer in Woodstock. Makes first three-dimensional object there, a floppy costume of chicken wire and soft jersey for the "Sculpture Dance" in the Ergo Suits Travelling Carnival, a series of Happenings organized by Allan Kaprow, Walter de Maria, David Weinrib, and Peter Forakis. Hesse herself did not wear the construction.

Aug. 3: *I am working; even though I so often contest the fact, when I work all else seems to hold together much better.* [10]

Aug. 8: *My feelings of inadequacy persist and I am constantly torn in a million directions. I cannot believe in myself to make any statement mine.* [11]

Aug. 21: *The carnival is over—and for that I am grateful . . . Now I went back to my work. It is farcical—because again it is the huge question of direction. Where? What do I stand on. But it*

is equally so just with my person. My own convictions and ideas are as easily shattered as my work . . . I must try harder . . . Funny—now I have too much time; it is so threatening—rising every day—with all day to face and to do with.

Her paintings and drawings become more linear, harsher in color and less ordered, and incorporate repeated box shapes, signs, and words. Drawings combine elements of collage with ink, pencil, watercolor, and gouache (fig. 4).

1963 March: first one-person exhibition, "Eva Hesse, Recent Drawings," opens on the 12th at the Allan Stone Gallery, New York. Includes brightly colored works in pen and ink and collage. Identifying her as a student of Marsicano and Albers, one reviewer praises new relationships she establishes: "She smashes down on little cut-out shapes, half-erased ideas, repetitive linear strikings . . . [and] invents dimension and position with changes of kinds of stroke, levels of intensity, starting and breaking momentum, and by redefining a sense of place from forces which are visible coefficients of energy."[12]

May 8: *I guess I am doing well but I am not happy in how I feel. What am I? There is always a tenseness and anxiousness that never leave me . . . I always have work to do. I never allow myself to do nothing. Probably when there is nothing to do I fear anxiousness . . . I am constantly dissatisfied with myself and testing myself . . . I have so much anger and resentment within me. Why still now? . . . Can I not believe I have a right to be happy and have a right to believe I am doing well as a human being, wife and artist?*

December: Hesse and Doyle move to the Bowery; her studio is the loft above their apartment, his a loft directly across the street. Neighbors include Robert Ryman, Lucy Lippard, Frank Viner, Robert and Sylvia Mangold. Hesse increasingly resents Doyle's lack of participation in domestic chores.

1964 Jan. 4: *I cannot be so many things . . . Woman, beautiful, artist, wife, housekeeper, cook, saleslady all these things. I cannot even be myself, nor know what I am. I must find something clear, stable and peaceful within myself . . .*

[Jan., n.d.]: *Our marriage is over, a farce now. I crave to be different from the way I am. To feel and think differently. I want to be free of fear and guilt. I want to be happy or at least do something with my unhappiness. Make something good out of the misery I always feel. Cannot my anger and hate find its expression in my work.*

April 21: *It is as difficult as it is said to be to be an artist's wife and an artist also. Not always for the reasons one thinks however it is not all "The Free Life."*

F. Arnhard Scheidt, a German textile manufacturer and art collector interested in Doyle's sculpture, invites Doyle and Hesse to work for a year in one of his abandoned factories in Kettwig-am-Ruhr, near Düsseldorf, promising support and materials in exchange for sculpture. Hesse's feelings about returning to her native country—whose language she speaks fluently—are, not surprisingly, ambivalent. Unhappy with the state of her marriage, she nonetheless agrees to go.

May 18: *I sit here now, panicked and crying. The pressure of leaving lies heavy on me . . . I cannot work because I have not the peace of mind to take up my own private work, both artistic and other.*

[N.d.]: *[It will be] a weird search, like a secretive mission . . . a new generation seeking a past.*

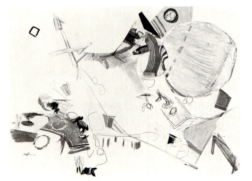

Fig. 4
Untitled, 1962
Collage, gouache, chalk, pencil, and ink on paper
21¾ x 30 in. (55.2 x 76.2 cm)
The Estate of Eva Hesse. Courtesy Robert Miller Gallery, New York

I know nothing of my family—my grandparents. Seeking out statistics, establishing losses encountered by the H[esses] . . . never knowing their lives, their never knowing me or mine . . . never having a grandma, grandpa [Moritz and Erna Marcus], life at all the gatherings, house, encouragements, proudnesses . . .[13]

Hesse and Doyle arrive in Kettwig in early June. Scheidt gives them an enormous floor in one of his factories and puts at their disposal any materials they might need as well as the services of the welders, carpenters, electricians, and plasterers who are working on the other floors. Hesse begins painting and drawing.

June 13: *Our studio, top floor with skylight and windows every 2 feet, is very hot [fig. 5]. I sit and hope I will work some. I might just have to believe in me more before working will mean something to me. Tom and I are together constantly and are quite in love and happy this way. It is like our first summer together in Woodstock.*

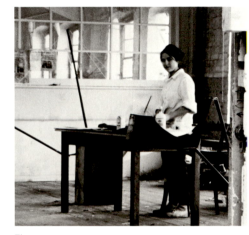

Fig. 5
Eva Hesse in her Kettwig studio, 1964–65
© The Estate of Eva Hesse. All rights reserved.
Courtesy Robert Miller Gallery, New York

June 19: *Started work in oil paint today. That is new since last 1½ years I used magna paints. Did 2 tiny very expressionistic paintings. Feel rather enthused since I enjoyed them and they seemed real for me. Somehow I think that counts. What counts most is involvement and for that to happen one must be able to give lots. Just like with a person. The giving must be very constant and thorough and one must be in constant check with it. It just seems to me that the "personal" in art if really pushed is the most valued quality and what I want so much to find in and for myself. "Idea" painting is great if it truly belongs to a person. However [it] fails when it is externally acquired. I must drop that from my mind, leave it behind. That shadow is superfluous. I am afraid to commit myself. I must really learn to forget anything and everyone and let it just take its course on the canvas.*

June 21: *To date have again done mainly drawings. Coming along. Sometimes I feel these [are] good often I get discouraged. Staying at studio gets a little easier and more pleasant.*

With Mr. and Mrs. Scheidt and the Mulheim painter Bernard Volke, Hesse and Doyle spend three days visiting "Documenta 3," the international exhibition at Kassel.

June 27: *Very hot, speeches and sculpture at Orangerie. Calder, Moore, Lipshitz, Chilida, Rickey, Noguchi—evening garden party.*

June 28: *Kassel . . . [is] an ugly city destroyed in the war and rebuilt in the worst of 20th century architecture. It is like a mid-western ghost town. No fantasy and most provincial. We had a jolly time, much laughter, drinking, eating and no sleep. We spent many hours each day at exhibitions which were beautifully installed. Much of work was good to see, some bad some worse but in such a large show bad as well as good is inevitable. I had a great time . . . but strongly felt if I were freer and more confident I could enjoy so much more fully. The same old fears existed even there.*

June 29: *Went through both painting shows again. Looked more carefully than I ever have before. Somehow I felt everyone's involvement in art more genuine. The interest of those I spoke with was very real. I liked Alechinsky and Jorn particularly, also Alan Davies.*

Bothered by severe pains in legs and nightmares (the latter haunt her throughout her German stay), she finds it difficult to work. Reads a great deal (Carson McCullers, Gertrude Stein, Mark Twain, Katherine A. Porter, Shirley Jackson, Kingsley Amis, Colin Wilson).

July 1: *I still am agonized about my painting but at least now the agony is in and about work. And if I work that will most probably change into another kind of feeling. And if it remains it is better placed there, than back into myself.*

I cannot stand the color I use and yet it mostly develops in this same way. This I should change since I decided I like it not. It is amazing how this happens again and again. The Picasso at Documenta had an interesting use of color. I end up with red, yellow, blue, green, and I hate it. It is dumb, uninteresting and I know better. I guess I am so involved in creating my own forms that I can't at [the same] time be concerned that much. But ironically they scream in color and then I am defeated by my own lack of concern.

July 3: *I'm still not working right, as I know in my mind one should, but I have been more consistently at work than ever before. Time will never be more adequate or a situation more created for work than now . . . I have one stumbling block that I only hope I created and is not permanent physical handicap. I have developed awful pains in my legs. It is difficult to stand and walk . . . I still find working very difficult. Could that be because of pain. "Yes." Like I might just set up one last block. At any rate this time I will fight it through*

. . . Very basic conceptual aims are still unclear for me. I must work them out. I have actually painted very few paintings. It is hardly any wonder that such difficulties arise.

July 7: *At night could not get to studio as legs would not make it there.*

July 8: *Did a good drawing.*

July 13: *Got to studio late and just could do nothing . . . I am torn with feelings of inadequacy. Also received more oil paints, that makes it worse since I feel I can't use them.*

July 14: *Am wondering if not my reasons for working are all wrong. The need for recognition, praise, acceptance is so excessive a need it causes an impossible pressure to live with. My feelings of inadequacy are so great that I oppose this with equally extreme need for outside recognition to find some equilibrium. I think it is in everything but greatest in art. Tom can achieve both in the right way, that is he can find himself in his work and then and therefore achieve recognition. With this I then compete, and find no success. No wonder I get anxious. I keep going downhill then, finding failure with myself in my appearance, mentality, abilities, and finally there is nothing at all left of myself.*

July: trip to Brussels (which she loves) and Basel.

August: visits the German artist Hans Haacke and his wife Linda in Cologne on the 1st. Gets German measles on the 12th.

Hesse's first paintings and drawings in Germany are characterized by bright colors and biomorphic shapes. She cuts some into pieces which she reworks into collages.

Aug. 16: *Finished 1st painting* [plate 10]. *Had cut 1st 2 up and on 2nd attempt second round I completed one.*

August–September: travels to Mallorca, Paris, Rome, Florence, and Zurich, visiting museums and sightseeing. Makes particular mention of Fernand Léger, whose work impressed her in Basel and Paris.

October: returns to Kettwig on the 4th. Late in the month travels to Bern for the opening of Doyle's exhibition at the Kunsthalle, then to Basel to see Jean Tinguely, and to Düsseldorf for the opening of Robert Morris exhibition.

Nov. 3: *Stayed up all night and listened to [U.S.A.] election returns. Day again in Düsseldorf. Brought 3 drawings to be juried for large Xmas exhibition [at the Kunsthalle, Düsseldorf] under guidance of [the photographer] M[anfred] Tischer who even had them framed at Kunstverein.*

Nov. 4: *Democratic Victory!*

Nov. 5: *Did painting from another drawing. Smaller in size than 1st 2. Spent the day on it in contrast to 1 month on 1st two.*

Nov. 8: *Tom and I went to Folkwang Museum in Essen. Photography show and Arshile Gorky drawings—great.*

Nov. 10: *Received acceptance for all 3 of my drawings. Am also reading . . . "Second Sex" by Simone de Beauvoir.*

The Scheidt children often visit Hesse in the studio. Stimulated by their drawings, she does a series of "adult children's drawings." Influence of de Beauvoir is evident in several diary entries.

Nov. 16: *Made drawings for children on Saturday. They were colorful. Red Blue Yellow Green in squares each one a letter of alphabet. Today made one with numbers 1–10. They are clear, direct powerful. It set me off again because they are different just enough to make me wonder where I am going. Why and is there an idea! or too many different ones? Do I know what my vision is. Am I working toward something or the best of all possible worlds. Hard, too hard on myself again.*

Why is it that I cannot see objectively what I am about? My vision of myself and of my work is unclear, clouded. It is covered with many layers of misty images. Inconsistent. I do want to simplify my turmoil. I do want to know where I stand in relation to myself so I'm not in for constant shocks.

Nov. 19: *I refuse to fear any longer . . . When [there is] a problem, just do it then and there, say it, write it, get rid of it. Face all that I fear to fear it no longer . . . In my work too. If crazy forms do them outright. Strong, clear. No more haze . . . I'll show myself another form. If playacting eventually I'll feel it. Without trying I'll never know. Simone D.B. writes woman is object—has been made to feel this from first experiences of awareness . . . It must be a conscious determined act to change this. Mine is not as much the acceptance of object role as it was insecurities from a broken, sick, unsupportive home. I survived, not happily but with determination, goals, and an idea of a better way. Now cope with it, no longer hide from the consequences but face them. To face them, give more in all aspects of living and working. Risk nothing <—> nothing gained.*

Nov. 21: *Our 3rd wedding anniversary . . . One must take pride in what one is and achieves. I still doubt myself in both, myself and my work. In competing with Tom I must unconsciously be competing with my alter ego. In his achievements I see my failures . . . Resentments enter most precisely if I need to be cooking, washing or doing dishes while he sits King of the Roost reading.*

Nov. 22: *I really need to take a firm, strong step in my work. I do feel a need to say something in my way.*
[Quotes de Beauvoir]: *In boldly setting out towards ends, one risks disappointments; but one also obtains unhoped for results; caution condemns to mediocrity. What woman essentially lacks*

today for doing great things is forgetfulness of herself; but to forget oneself it is first of all necessary to be firmly assured that now *and for the* future *one has found oneself.*

November: to Amsterdam with Doyle on the 24th and 25th. Opening of "Winterausstellung" at the Kunsthalle, Düsseldorf on the 29th; show includes three of her drawings.

December: still frustrated by the limitations of painting. Doyle suggests she try working with the string and other discarded weaving materials in the factory and studio. By mid-month, she is working with plaster and cord and has begun to experiment with the grid and the threading/knotting process to which she would return in her mature work.

Dec. 4: *Started sculpture. Lead wire through a huge screen. Shortage of wire forced a change to plaster.*

Dec. 5: *Went to Köln opening of Zwerner's Gallery. Stayed at Hans Haacke's house, saw his new work.*

Dec. 10: *Plaster! I have always loved the material. It is flexible, pliable, easy to handle in that it is light, fast working. Its whiteness is right. I will take those screens. Finish one I began in lead. Then get cloth cut in strips and dip in plaster and bring through screen. I needed a structure that is perfect.*

. . . For me painting has become . . . [anti-climactic]. "Making art, painting a painting." The Art, the history, the tradition is too much there. I want to be surprised, to find something new. I don't want to know the answer before but want an answer that can surprise.

Dec. 11: *Finished scarf [for Tom] and learned to crochet.*

Dec. 12: *Continued with cord and plaster.*

Dec. 14, from a letter to Rosalyn Goldman: *I want to explain what I have been doing. And* although I already question validity, worth, meaning, antecedent etc. I have been enjoying the newness and the work. In the abandoned factory where we work there is lots of junk around. *Tom has used much steel and odds and ends for his sculpture. I have all these months looked over and at much of the junk.* I finally took a screen, heavy mesh which is stretched on a frame . . . and taken cord which I cut into smaller pieces. I soak them in plaster and knot each piece through a hole and around wire. It is compulsive work which I enjoy. *If it were really a new idea it would be terrific. But it is not. However I have plans with other structures and working more with plaster. It might work its way to something special.*[14]

Trip to Berlin for Christmas; in East Berlin visits Staatliche Museum (Pergamon Museum), where she sees the Laocoön and the Ishtar Gate, works whose titles (and, less explicitly, forms) she will later adopt.

Hesse is liked by Scheidt's factory workers, who often bring her interesting materials. As she is uncomfortable using tools, they help her as well, later fabricating the wood-and-masonite panels for her reliefs.

1965 Jan. 11: *My birthday all the workers celebrated with us.*

Jan. 26: *I feel and am terrified that my family, my life is cursed. I received today a letter . . . that my father is hospitalized in Fla. with pneumonia and heart attack and I know nothing. I cabled U.S. Await an answer. How does one wait patiently for such an answer?*

February 2: attends opening of "Vier Schweizer Bildhauer," showing the work of Swiss sculptors Hans Aeschbacher, Walter Bodmer, Walter Linck, and Bernhard Luginbühl, at the Kunsthalle, Düsseldorf. Hesse is increasingly interested in drawings, which are now dominated by organic machine images, rendered in a flat linear style, many in pen and black ink.

Feb. 5: *If painting is too much for you now, fuck it—quit. If drawing gives some pleasure —some satisfaction, do it—go ahead. It also might lead to a way other than painting, or at least painting in oil. First feel sure of idea, then the execution will be easier . . . I will continue drawing. Push the individuality of them even though they go against every "major trend."*

[N.d.], from a letter to Goldman: *My drawings are very* HARD. *That is they are forms I have always used but enlarged and very clearly defined. Thus they look like* machines, *however they are not functional and are nonsense.*[15]

Feb. 17: *Went to studio to paint board white. On this board I will "display" my drawings. Tischers came last eve. and chose one of my drawings for their collection. I am so discouraged again regarding work. I think I should just stop until when something jells for me and I can go on.*

Feb. 19: [Quotes Mark Twain, *Innocents Abroad*]: *To give birth to an idea—to discover a great thought— . . . to be the* first—*that is the idea. To do something, say something, see something before anybody else—these are the things that confer a pleasure compared with which other pleasures are tame and commonplace, other ecstasies cheap and trivial.*

[Quotes *Cinema Magazine* 2, no. 1 (Feb.–March)]: *The study of art is the study of individual authors. If a piece of art work hasn't the definite stamp of a single personality, it is not honored with the title of art.*

February 21: Scheidt invites a group of friends to see Doyle's sculpture and Hesse's drawings.

Feb. 22: *A gross failure . . . Tom and I both anticipated great happenings. That was first mistake . . . I got from sober to ridiculously sober and alert and unnerved, Tom exceedingly drunk but not misbehaving . . . Tom and I feel very let down . . . I am ultimately convinced that people must first be told that so and so is great and then after a period of given time they come to believe this for themselves.*

March 1: completes first relief, *Ringaround Arosie* (plate 79), named for Rosalyn Goldman who is pregnant. Hesse is increasingly depressed by the growing estrangement from Doyle and insecure about the recent developments in her art.

March 5: *I just feel we are no longer one as we were for that short period of time so long ago. I wonder can we be—in love.*

March 7: *I am a terror. But it is fear that brings this about . . . Fears of desertion, death, sickness, poverty. But these are universal. It is more personal like the daily fears of being a lost, small nothing without abilities, without courage, without distinction, without . . . It caused me anxiety dawn to dusk, created the gulf between myself and the man I loved and loved me . . . I can remove myself from these hang-ups to complete an idea, a removal from myself must exist in order to create something else.*

. . . Do I have a right to womanliness. Can I achieve an artistic endeavor and can they coincide.

March 18, from a letter to Sol LeWitt: *It is to you I want to talk to about what is on my*

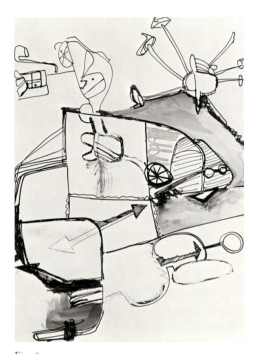

Fig. 6
Untitled, 1965
Ink and gouache on paper
11⅝ x 8¼ in. (29.5 x 21 cm)
The Estate of Eva Hesse. Courtesy Robert Miller
Gallery, New York

mind. It is because I respect and trust you and also in this case you are one who understands somewhat me personally and my art existent or non-existent . . . I want to explain (try to) what I am going through in my work non-work. I trust myself not enough to come through with any one idea, or maybe a singular good idea does not exist. And if there would be one among the many I don't think I could recognize it. So I fluctuate between working at the confusion or non-working at the confusion . . . grasping everything and nothing in the hope of finding self . . . But I cannot sustain the desire to work long enough to solve anything. And maybe I don't love it enough to try. But then what else shall I do. I read and worry and it goes in circles . . . I don't want sympathy but I don't want you to laugh at me. I would only like to be able to show you what I have done here and ask you what you think. That is impossible so I am talking with you.

What drives us to work. It seems to me some kind of recognition which maybe we cannot give ourselves. Mine seems to be disproportionate like I respect myself too little so too much must come from the outside . . . One should be content with the process as well as the result. I'm not! I find nothing I do gives me the feeling that this is right . . . I am constantly at ends with the idea, myself and or what I am about.

I mean to tell you of what sits in front of me. Work.

I have done drawings. Seems like hundreds although much less in numbers. There have been a few stages. First kind of like what was in past, free crazy forms—well done and so on. They had wild space, not constant, fluctuating and variety of forms etc. [fig. 6] Paintings were enlarged versions, attempts at similar space—etc.

2nd Stage. Contained forms somewhat harder often in boxes and forms become machine like, real like, and as if to tell a story in that they are contained [see plates 29 and 31]. Paintings follow similarly.

3rd Stage. Drawings—clean, clear—but crazy like machines, forms larger and bolder, articulately described. So it is weird. They become real nonsense [see plates 33–52].

So I sit now after 2 days of working on a dumb thing which is 3 dimensional—supposed to be continuity with last drawings. All borders on pop, at least to the European eye. That is anything not pure or abstract exp. is pop-like. The 3d. one now actually looks like breast and penis—but that's O.K. and I should go on with it maybe it or they would make it in another way, but I don't know where I belong and so I give up again. All the time it is like that.

. . . Have really been discovering my weird humor and maybe sick or maybe cool but I can only see things that way—experience them also but I can't feel cool—that is my hopelessness, like it all is based on fear and one cannot be cool when one constantly feels fear. That is what is sad. Everything for me personally is glossed with anxiety. How do you believe in something deeply? How is it one can pinpoint beliefs into a singular purpose?

LeWitt responds to Hesse's letter at length, urging her to stop trying so hard to do the "right" thing and just work.[16]

March 23: *I produced 4 drawings, which I like—at this moment.*

March 27: *Went to Köln. Stayed with Linda and Hans [Haacke]. Talked much.*

April: Hesse and Doyle are leading almost separate lives, their relationship at its lowest point. While the state of their marriage causes her great pain, she is less anxious about her work, and is enthusiastic about her relief pieces. Doyle has shown her how to build up forms with plaster, which she then paints, combining them with cord and discarded machine parts.

April 1, from a letter to Goldman: *[Working on a] three-dimensional contraption. Not finished yet but it is weird, not machine-like but weird.*[17]

April 2: completes *Two Handled Orangekeyed Utensil* (see fig. 7).

April 20, from a letter to LeWitt: *I finished the "Breast" job [Ringaround Arosie]—and another. They are good—or I like them now so that is good—am working the 3rd one—much difficulties—but I am pushing.*

April 27: *Finished* An Ear in a Pond [plate 80].[18]

April 28: *Started the 4th.*

May 4: completes *Legs of a Walking Ball* (see fig. 35).

May 4, from a letter to Goldman: *I am working like crazy. First we cannot take home our work I don't think. Transporting would be very expensive . . . My things might be transported but also will see. If really good can have gallery take them here—will see. Have one completed. I will describe. Am working on masonite which is pressed wood fibers. On this I build forms (glue and paper) on some forms I have glued cord. On one I have a heavy twisted cord which comes out of a form and hangs loose. On another there are two metal forms which can be moved.*[19]

May 5: completes another relief, later named *Oomamaboomba* (plate 81).

May 11: *I have been working harder than ever in my life, and under a lot of pressure.*

May 15: informal exhibition of Doyle's and Hesse's work at Scheidt home. Hesse's reliefs and drawings shown in an old greenhouse, hung from the rafters (fig. 7).

Show went well. I sold 2 Tom also maybe 2. I will also show Aug. 6 in graphics room in Kunsthalle, Düsseldorf. Nolde and Volke came.

May, n.d., from a letter to LeWitt: *Show in Düsseldorf . . . I [will] show my work in one room same time the graphic supplement. New reliefs also. Have 6 finished and 2 almost—grand total 8 to date. Working all the time—you would not recognize me . . . One has been spoken for—of course the best one . . . Tom sold his 2nd piece this week. I sold 4 drawings.*

May 19: Hesse and Doyle visit Hameln, her mother's hometown, and Hamburg, to see the apartment where Hesse was born and had lived as a child. The present occupants do not let them inside. She finds the experience very unsettling, and for nights afterward has difficulty sleeping. She has also begun to worry about returning to America.

June 4: *Here [is] not so bad. I fear the N.Y. scene.*

June 6–10: completes *Tomorrow's Apples* (plate 82), *2 in 1* (plate 83), *H + H* (fig. 8).

June 24–28: Hesse and Doyle visit Basel to see Al Held's show, which Hesse describes as terrific. Meet Meret Oppenheim. Visit Colmar to see Grunewald altarpiece (June 27). Spend the following evening at an opening at the Stedelijk Museum in Amsterdam, where Hesse is thrilled to be seated at dinner next to James Baldwin, whose *Giovanni's Room* she has just read.

July: completes *Cool Zone* (plate 84) on the 9th and *Pink* (plate 85) on the 10th. By the

Fig. 7
Eva Hesse at the opening of the informal exhibition in F. A. Scheidt's greenhouse, May 1965
Two Handled Orangekeyed Utensil appears in foreground; Hesse points to a related collage.
Collection of F. A. Scheidt, Kettwig

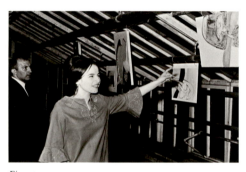

Fig. 8
H + H, June 1965
Enamel, gouache, alcohol varnish, ink, papier-mâché, wood, cord, and metal conduit on particle board
27 x 27½ x 4⅞ in. (68.6 x 69.8 x 12.4 cm)
Private Collection, New York

end of the month completes *C-Clamp Blues* (plate 86), *Eighter from Decatur* (fig. 77), *Up the Down Road* (fig. 39), and *Top Spot*.[20]

July 31: *Have 14 objects and 14 new terrific drawings.*

Aug. 2: *Moved all work to Düsseldorf.*

Aug. 3: *Hung show.*

Aug. 4: *Worked like crazy, did 5 more groovy drawings.*

August 6: opening of "Eva Hesse: Materialbilder und Zeichnungen" at the Kunsthalle, Düsseldorf, with fourteen mixed media reliefs and fifty drawings (fig. 9).[21] She does not write about the opening or the show's reception. The exhibition is not reviewed in any major German or English publications.

August: Hesse and Doyle fly to London on the 10th; on the 16th they take a boat to Dublin and travel in Ireland. Return to New York at end of the month.

September: completes *Untitled* (see fig. 13), a free-standing six-foot pole rising from a rimless spoked wheel graded from black to gray.

October: completes *Untitled* (fig. 10) from materials found in the studio, and paints it in graded shades of purple; it is the last work in color until 1967, when she reintroduces it through use of latex. Gets a job teaching art one day a week to children in Scarsdale. Her marriage virtually over, she is torn between feelings of anger, hatred, and abandonment. Begins a series of dark, disturbing sculptures—using flexible materials such as surgical tubing, rubber cord, inflatable beach balls, latex balloons, polyethylene sheeting, inner tubes, and nets—that seem to express the intense emotions she is experiencing.

November: completes *Long Life* (see fig. 13), a black cord-wrapped beach ball and long tube, graded from dark to light gray; *Several* (plate 88), *Ingeminate* (plate 87), and *Untitled* (plate 89).

Dec. 12: *I feel I have nowhere to turn. All my stakes are in my work. I have given up in all else. Like my whole reality is there. I am all there. When then, I am rejected, it is an entire loss—like all of me . . . I do feel I am an artist—and one of the best. I do deeply . . . With my work I have one person here and one there, artists who know me and think I am good, most others don't know me as an artist and give me no credit at all and I can't take this.*

December: completes *Ishtar* (plate 90). With its ten double rows of domes, it recalls the many-breasted Babylonian fertility goddess, Ishtar. Hesse saw the Ishtar Gate at the Pergamon Museum in Berlin in December 1964.

1966 Through LeWitt Hesse meets Robert Smithson, Nancy Holt, and Dan Graham; her circle of friends includes Mel Bochner, Don and Julie Judd, Dan and Sonja Flavin, Robert and Sylvia Mangold, Robert Ryman, Lucy Lippard, Al Held, Grace Wapner.

January: completes *Hang Up* (plate 91), which she later considered her first important work. Doyle moves into his studio across the street. The break is final, and Hesse is in despair.

[Feb., n.d.]: *Where do I go from here.*
1. By means of work and also through the fruits of acceptance and approval.
2. Friendship and social life.
3. Unveiling past—and thus overcoming shit—purging it from entering future life—altogether, forever!!!

February: completes *Total Zero* (see fig. 13). Meets Carl Andre and Rosemary Castoro. Her diaries and notebooks of this period are filled with jottings for materials and ideas for works.

[Spring, n.d.]: *Possibilities*
large balloon—papier mâché. Off of wall . . . another smaller attached and on floor.
Stove pipe.
rope irregular (like snake hung while working on Laocoon, *hang from ceiling to floor ad infinitum (room).*
cord room like new piece going and coming every which way.
"not yet" possibilities inside. more mysterious—epoxy a surface. Try paper wrapping from Sol. (tried something, so far too like Christo).
relief pieces. like Vietnam board collage and glue with wood chips[22] (can even attach papier mâché balloons on to board and incorporate).

March: completes two untitled works incorporating cord-wrapped balloons (plates 92 and 93), *Metronomic Irregularity I* (plate 96), *Not Yet* (plate 95), *Vertiginous Detour* (plate 94), and *Untitled*.[23] About this time, Bochner gives her a thesaurus, which she uses together with a dictionary to title selected works, choosing a word as much for its sound as for its associative qualities.

March 1: opening of "Abstract Inflationism and Stuffed Expressionism," organized by Joan Washburn at the Graham Gallery (fig. 11). Hesse is represented by *Hang Up, Ishtar,* and *Long Life.* The other artists—Paul Harris, Jean Linder, Marc Morrel, Philip Orenstein, and Viner—are also relatively unknown. Hesse's work is generally misperceived by the critics: some see the formal statement as potentially diminished by attempts at humor, others view the experimentation as without redeeming esthetic values.[24] Only Lippard introduces the often opposing themes with which Hesse's

Fig. 10
Untitled, October 1965
Acrylic paint on wood
45 x 8–21½ x 2½ in. (114.3 x 20.3–54.6 x 6.3 cm)
The Estate of Eva Hesse. Courtesy Robert Miller Gallery, New York

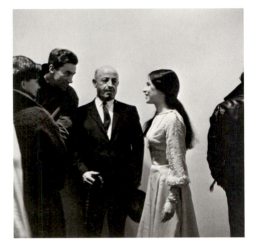

Fig. 11
Eva Hesse with her father, Wilhelm Hesse, at the opening of "Abstract Inflationism and Stuffed Expressionism" at the Graham Gallery, New York, March 1966
Eva Hesse Archive, Gift of Helen Hesse Charash
© Allen Memorial Art Museum, Oberlin College

work will later be associated: freedom/confinement, suppression/release, pathos/ humor, sexual and anthropomorphic intertwined with the geometric.[25]

Spring: despite her productivity, Hesse is in an almost constant state of anxiety and sadness. Completes *Ennead* (see fig. 13), one of the last sculptures in which she uses graduated tones. She will continue to use the technique in a group of concentric circle drawings executed during the summer.

[April 20]: *I went to help Sol wrap his work . . . Helping Sol also was Ethelyn [Honig]. Even in wrapping I am competitive, saw this so clearly. To see the extent I have this awful trait in competing with "male" artists, which is to say almost everyone. Then that's not bad enough I compete then as a "woman" with women in "female" area.*

[April 29]: *Spent afternoon dyeing cord.*

[April 30]: *Finished my 2 last pieces—one today, one the other day. Laocoon [fig. 70] and titleless so far. Cords everywhere. Will do one that does not come from a form, that is endless, totally encroaching and irrational. With its own rationale even if it looks chaotic.*

[May 6]: *Mike Steiner brought Claus Keurtiss [sic; Klaus Kertess, the dealer] here . . . He looked hard at [my] work, although I could not sense his reaction . . . He said . . . he would like to come back. I felt good.*

[May, n.d.]: *Met Sol at Whitney. Saw recent acquisitions (Held, Johns, Kelly) and Lipman collection. Lot of mediocrity, along with a few fine pieces. One beautiful Samaras (two inferior ones) and a fine Morris and Judd. The Samaras I loved was a box covered with pins, cover slightly ajar with bird's head forcing its way out from under cover. Old cords and rope dropping out from front. The piece sits in a plexiglass case. Sol went to Dwan. I on to Modern . . . Saw Kahn architecture, beautiful forms, very related to "primary structures." Turner was crowded and boring after Kahn. Although interesting to note how much abstract expressionism is indebted to 1830 Turners . . . Also slide talk on Kahn by Vincent Scully (Yale). Met Diana McGowan, who still lives with Louise Nevelson. We went to Pace to see show. Then to Dwan with Smithson and Mel Bochner. Mel and I went for cokes and then to my studio.*

May 18: *I can trust Rosie and Sol. My real true friends and the only ones who really know and trust me. Mutual respect. They would never let me down.*

[May 21]: *Saw 2 Whitney Happenings. There were a few exciting images but I was not with it.*

[May 23]: *Spent afternoon with Mel. Went to Met and park. Talked, communicated. Stupid of me to feel age difference.*

. . . It's wild. I have many critics (writers) believing in me and my work before I have really shown. Lucy, Mel, Gene [Swenson], Smithson, all want to write about it. Wild. Mel said he has heard much talk about my work.

. . . Maybe I will be able to live alone—with work, reading and friends—I'll make it . . . I must go to Dr. to become a woman, to allow myself to be womanly when I want to. Shit, I am 30 and I do have a right to have sex if I want. Amazing to be put in this position at this time.

Lippard invites Hesse to participate in the forthcoming exhibition "Eccentric Abstraction" (Fischbach Gallery, 20 Sept.–8 Oct.), offering her the opportunity to do anything she wants in the space.

[May 25]: *Lucy wants me to do a big piece for show. It scares me to have it put that way. A finality, also like an examination.*

June 4–5: weekend at Fire Island with artists Paul Thek and Mike Todd.

June 5: *Read Saul Bellow's* Dangling Man. *Inner struggle of an individual to find himself, his own freedom, confrontation of self.*

[June 8]: *Spent all day with Mel . . . We went to Fischbach, looked at space. Lousy ceilings. Bad for all art. My big piece* Laocoon *will not be right with all the gadgetry above . . . Worked some, finished another snake [for* Laocoon*].*

[June 9]: *Excited! could not sleep. Last eve. with Mel, Smithson, Nancy, Brian O'Doherty and Barbara Novak and Will Insley and Ruth Vollmer. Beautiful communication, basically positive feelings, intuitive liking all around, warm things said also, heated undertones but with mutual respect . . . Ruth Vollmer asked to see me and work. O'Doherty also work. Smithson and Mel described and highly praised my work. Necessary because 1. am relatively unknown, 2. am woman. Am sure that exists for all, however. I must drop that thought as totally meaningless.*

June 11–19: in East Hampton for a week at Don and Franca Vlack's.

[June 12]: *Funny regarding work—Now I am so respected by those who know my work and yet I still feel with those who don't understand, the rejection or rather not acceptance of me as an important artist. How can I do work here . . . too much distraction and obligation . . . I don't want to accept summer at a loss of 3 months work. However I did have to go away, "necessary emotionally." I must think, plan next moves, draw out ideas. I must have time by myself.*

[June 14]: *Finished Robbe-Grillet [The Erasers] and reading Miller's* Focus. *Rode bike to beach . . . Give up on plans for work.*

[June 16]: *Must develop realistic approaches to ways and events . . . I can't live other lives. I want to go home but am afraid. Of what?*

[July 2]: *. . . only work can now give satisfaction and decrease or eliminate frustration.*

July 5: *Survived weekend . . . Sol and I went to Modern and movies. Read* In Cold Blood, *saw "Shop on the Main Street"—lousy. "8½," "Breathless," "Unholy Three" circa 1930, "La Notte" . . . Thursday will go (against my desire) for job interview which I know I will get. Teaching children in Riverdale. Spent morning shopping on Canal St. Sol joined me. Must of spent approx. 25 to 30.00 dollars. I think I reconsidered job because of that total spent on relatively little supplies . . . If I get more private students I can quit in Jan . . . I bought a lot of small extras for small work. I really should do them as in between main work. Sol will help build sub-armatures (structures). Am still thinking about main summer piece.*

[July 8]: *Mel said this: all circles grasping holding nothing, "a great gesture around nothing."*

July–August: visits Ethelyn and Lester Honig at Loveladies Harbor, New Jersey (July 15–20). Begins the wash and ink drawings of circles, a combination of medium and motif that she will pursue through 1968. Death of father in mid-August is a devastating shock, compounding the feelings of loneliness and anxiety with which she has struggled since the break-up of her marriage.

[July, n.d.]: *I go in O circles. maybe therefore my drawings.*

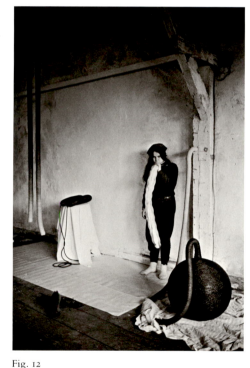

Fig. 12
Eva Hesse preparing her Bowery studio for photographer Gretchen Lambert, 1966
© The Estate of Eva Hesse. All rights reserved.
Courtesy Robert Miller Gallery, New York

Fig. 13
Eva Hesse's Bowery studio, 1966
Photograph by Gretchen Lambert
Left to right: *Untitled*, 1965; *Ennead*, 1966; *Ingeminate*,
1965; *Several*, 1965; *Vertiginous Detour*, 1966; *Total
Zero*, 1966; *Untitled*, 1966; *Long Life*, 1965; *Untitled*,
1966; *Untitled*, 1965; *Untitled or Not Yet*, 1966

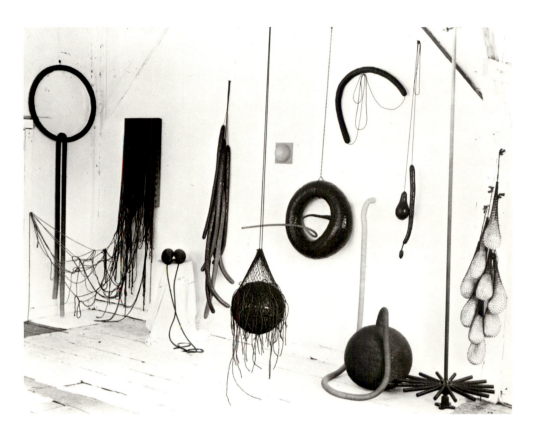

Aug. 4: I am awaiting Gretchen Lambert . . . She will photograph my work. Almost one year's work. There is lots. It is good! Very good. A most strange year. Lonely, strange, but a lot of growth and awkward search . . . It scares me to have my work photographed. I find it impossible to either dust, arrange a plan on the wall, even paint a wall for photographing . . . The work is there, the love, the pain, the concrete manifestations. I cannot touch them now [fig. 12].

Aug. 8: I had my work photographed [fig. 13]. The ceiling in living room (summer studio) collapsed. Took all wallpaper off. Workmen fixed ceiling. Ordered wire for exhibition piece . . . The pressures are just beginning. Entire house and studio have to be fixed and painted. My piece has to be built. I won't know what it really is til installation.

[Aug. 14]: I realize how hung up I am about always feeling what I do is wrong, not good enough. In art, my work. Always that it will break, wear badly, not last, that technically I failed. It does parallel my life for certain.

Aug. 16: Daddy is dead. He is in Switzerland.

Aug. 17: I am numb. Lucy and Mel stayed with me last eve . . . Sol and Mel and I walked N.Y.C. today. There is not a thing I can do . . . I must now work even harder to be strong, get well, yes Be Happy.

Aug. 24: I have grown so this year. Last Aug. 28 we came back to America. Since then in fact I have lost my husband (through separation) and my father through death . . . My only weapon is art, my friends . . . I must go on from here . . . It is a crucial year for me. My work. 30 yrs. old.

[Sept. 4]: Some of my work is falling apart. 2 pieces. 2 other pieces are discolored from the varnish. If and when I can repair. If not, so what. They are not wasted. I went further in the work that followed. I take more care technically. I plan and figure out more wisely.

Fig. 14
Notebook pages: *Study for "Untitled,"* April 1966;
Study for "Magnet Boards," Fall 1966
Pencil on lined notebook paper; ink on paper
Each 7¾ x 5 in. (19.7 x 12.7 cm)
Allen Memorial Art Museum, Oberlin College,
Gift of Helen Hesse Charash

[Sept. 9]: *Sol's birthday. Doctor. Dan Graham, Sol and Mel met me at 91 St. and Park . . . Went to Avant Garde festival. There we met N.Y. Art Scene 66–67, Smithson and Steiner and Virginia. Smithson hardly knew us. He is solo in Dwan. My whole world is in Dwan. She does not even accept me as an artist . . .*

I must also learn to have work sent out. Not for non-work theory, but for permanency. Tonight again, same crew. Dinner at Smithsons. I am again non-artist, amongst Virginia. Same position. They all forget me when it comes down to tally . . . I want to be accepted.

[Sept. 15–16]: *Almost finished piece, beautiful* [Metronomic Irregularity II *for "Eccentric Abstraction" show*]. *Crash. fell off the wall. Now midnight again, I can't believe it. So I am drunk on librium and stuck. I must pull through . . . 1:30 a.m. I am tired, scared. It's up but might not be long. I am running bad luck streak . . . Where it is my own fault, my making it this way, I must learn and change . . . That I let Sol and Mel help me when neither are technicians is wrong.*

September 20: "Eccentric Abstraction" opens at Fischbach Gallery. Other artists are Alice Adams, Louise Bourgeois, Lindsey Decker, Gary Kuehn, Jean Linder, Bruce Nauman, Don Potts, Kenneth Price, Keith Sonnier, Frank Lincoln Viner, and H. C. Westermann. Hesse, who shows *Metronomic Irregularity II* (fig. 33), *Several* (plate 88), and *Ingeminate* (plate 87), is named as among the most successful of the young artists. Bochner writes that "Hesse's work is the best in the exhibition. Her work and sensibility is far in advance of the various categories it has been placed in."[26] Hilton Kramer suggests that in *Metronomic Irregularity,* she is adapting the imagery of Jackson Pollock's drip painting to a three-dimensional medium.[27]

[Sept. 21]: *Sold piece, big one to Texas collectors* [Metronomic Irregularity II; *sale later fell through*]. *Dependent now on making piece permanent, packing wise, and shipment. Good coming from bad.*

Fig. 15
Notebook page: *Study for "Metronomic Irregularity III,"* Fall 1966
Pen and ink on lined notebook paper
7¾ x 5 in. (19.7 x 12.7 cm)
Allen Memorial Art Museum, Oberlin College,
Gift of Helen Hesse Charash

Fig. 16
Metronomic Irregularity III, 1966
Painted wood, Sculp-Metal, and cotton-covered wire
10 x 50 x 2½ in. (25.4 x 127 x 6.3 cm)
Collection Mrs. Victor W. Ganz

[Sept., n.d.]: *[I need] to get settled, clear things away and get started again. I need to be moving. I can't stand. Standing implies satisfaction with status quo. I am not, and am very lonely . . . I am now my art.*

[Oct., n.d.]: *Robert Doty [curator] of Whitney wants to see my work. Aldrich Museum took my photos. Nothing helps though. Nothing seems to get better.*

Diaries of this period are full of small sketches, word-plays, and notations on materials for possible pieces (fig. 14); some similar ones will later be realized.

Oct. 28: *D[onald] Droll [director of Fischbach Gallery] . . . asked to buy Several. Earlier this week Florette Lynn asked to buy Ishtar. Still earlier this week or late last week I promised Metronomic Irregularity I to Smithsons as a trade.*

November 21: Doyle asks for a divorce, but Hesse does not agree to it.

December: "Working Drawings and Other Visible Things on Paper Not Necessarily Meant to be Viewed as Art," organized by Bochner, opens on the 2nd at the School of Visual Arts' Visual Arts Gallery. By the end of the year, Hesse has gained new confidence in herself and a renewed sense of enthusiasm for and commitment to her work.

Dec. 2: *Tonight Visual Arts show opened. Working drawings. I have 5 drawings, along with Sol, Mel, Smithson, Judd, Andre.*

[Dec. 4]: *Drawing some, nothing else. Dispel romantic ideas from art.*

[Dec. 14]: *Strange how much I have changed. That people like Don [Judd] have become so important to me . . . Started to work. Difficult, but I know how important it is now for me, and that it almost alone can again make me stand tall . . . That in 1967 I will be in Jewish Museum and probably have 1st one man sculpture show. "Things Show" "objects." I would call them "objects." What's the difference, makes none at all. Little like "Eccentric Art," little like "Abstract inflationism," nor stuffed expressionism.*

[Dec., n.d.]: *Last eve. met Rosie. She and I returned to 134 [Broadway] to see my new work. I saw immediately that version 3 [of Metronomic Irregularity (figs. 15 and 16)] was wrong and that the new small model for next piece was very good. So I 1. must lessen amount. 2. try clear wire or some of other slightly mottled kind I saw on Canal St.*

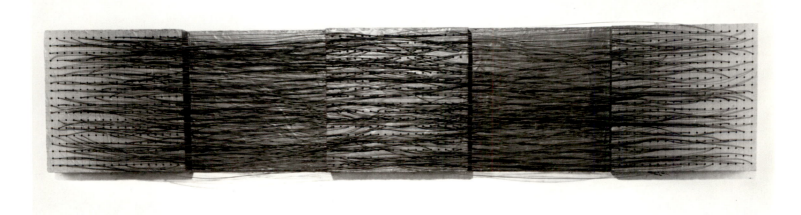

Dec. 24: Sol gave me this book Dec. 23, 1966. Lots of books, lots of surprises . . . Sol dated the book. One book will be "guest" book. Drawings of my friends. One rule. Signatures, side by rule, no tearing out pages. Another is for my work drawing. It is a fitting ending for another strange, bewildering, sad and yet strangely productive year. A final abandonment. And Daddy's death. And now on to work, and other changes, changes for another start.

Dec. 28: Took off wedding ring . . . My progress. I did not want to. Left no longer any alternative. I have been alone one year. I have been working.

By the end of the year there is a marked decrease in the number of diary entries, and their content gradually shifts from descriptions of her inner life to notes on sculpture and pieces she is working on.

1967 *Jan. 1: I am working well and eager to go on. Might even be ready for 1st one-man [sculpture show] by next fall . . . I am finishing 2nd version of piece from this past summer [plate 97]. Painted it simply light grey, very slight gradation.*

Jan. 2: I worked this morning. Reversed decisions on graduated piece. It will remain as 3 boards or possibly even 2 or just separate sections. It is on the wall now for me to look at for awhile as is. I always know after some time and feel free to decide

. . . went to Whitney Annual. As crowded as Macys 2 weeks before Xmas. Pieces themselves without people hardly had the room they needed. It was depressing, people knowing nothing, just there as a place to go, or the right thing to have seen . . . I wanted to get away.

Jan. 7: I am working relatively well. The eagerness and enthusiasm at its highest point. I have many small new pieces.

Feb. 28: a bag is a bag
a semi-sphere—a semi-sphere
a tube a tube
1 art is what is
2 tension and freedom
3 opposition contradictions
4 abstract objects
5 not symbols for something else
6 detached but intimate personal

March: joins Fischbach Gallery, which represents among others Jo Baer, Alex Katz, Mangold, and Ryman. On the 25th, participates on "Erotic Symbolist" panel at the School of Visual Arts, with Louise Bourgeois, Paul Thek, James Wines, and Lindsey Decker.

May 7: I still can't be what I want but get closer, although I get lonelier too—and nihilistic. All work now seems superfluous . . . I feel old and worn—no energy—little hope.

May 26: [Quotes Carl Andre]: anything worth doing is worth doing again and again.

June: moves away from wall pieces in favor of open box and vessel forms. Makes *Accession I,* in aluminum and rubber tubing.[28]

Summer: visits Lucy Lippard, Donald Droll, and Roy Leaf in Georgetown, Maine, and Ruth Vollmer in Southhold, Long Island. In New York studio she works on graph paper drawings and Sculp-Metal pieces (plate 99).[29]

Fig. 17
Repetition Nineteen I, 1967
Papier-mâché, Elmer's glue, polyester resin, and
Dutch Boy Diamond Gloss paint over aluminum
screening
Each of nineteen units, 9⅛–10½ x 6½–9⅛ in.
(23.2–26.7 x 16.5–23.2 cm)
The Museum of Modern Art, New York, Gift of
Mr. and Mrs. Murray Charash

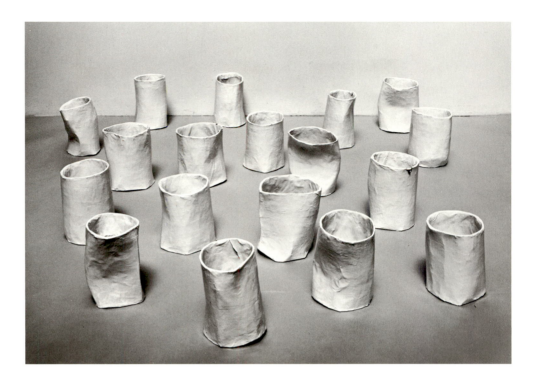

Fall: is persuaded by friends to use outside or factory fabrication (something to which she is not initially sympathetic); commissions a 36-inch galvanized perforated steel cube from Arco Metals, Manhattan. Threads over 50,000 lengths of vinyl extrusion through the perforations.[30] Begins experiments with latex, attracted to its subtly modulated coloring and flexibility, which allows for distortion in an effortless way. She uses it like paint, building up layer over layer. She will eventually create sixteen full-scale works in latex.

[Sept., n.d.]: *Am in the process of casting a sheet of rubber (on Sol's table) 3'6". On top of which sit semi-spheres 2⅛" in diameter [plate 102]. It is all transparent to translucent, clear rubber. Looks like that vinyl type hose. It's a long process, painted on with brush and having to wait ½ hr. to one hr. between coats. Although this varies depending on size of what I cast, thickness etc. The sheet will need 10 coats.*[31]

September: completes *Repetition Nineteen I* (fig. 17), the first of two realized versions; it is the last piece in which she uses papier-mâché.

December: *Addendum* (plate 101) included in "Art in Series," organized by Bochner at the Finch College Museum of Art, New York. Hesse called the only artist who "sees, questions, and in a way relishes the absurd implications of this new cliché [of seriality]."[32]

1968 January: anniversary each year of her mother's death is very painful. To lift her spirits Ruth Vollmer takes her to Mexico City for ten days. On her return, Hesse goes to Oberlin College for two days (17–18) as visiting artist. Is included in the exhibition "American Drawings, 1968" at the Moore College of Art, Philadelphia, selected by Richard Anuskiewicz, Brian O'Doherty, and Stephen Prokopoff. Hesse and Marisol are the only female artists among the twenty participants.[33]

March: exchanges studio visits with Keith Sonnier and Richard Serra. Dorothy

Beskind makes a film of Hesse working in her studio. For the next several months Hesse focuses on planning and executing pieces for her forthcoming one-woman show at Fischbach.

[April, n.d.]: *If I can forever lose panic I know I am then capable of being great artist, great person. That terror stands so in my way. It is a haunting paralyzing experience, one of which I stand in dread of occurring, and when it happens it is even worse than I anticipated . . . It is easy in my work now. I know the important things there, but in life, yet a way to go.*[34]

June: Hesse participates in "Directions I: Options" at the Milwaukee Arts Center. Begins experimenting with fiberglass and polyester resin at Aegis Reinforced Plastics, Staten Island, with the help of Doug Johns, who becomes her friend, technical advisor, and assistant on all subsequent major pieces. Attracted to fiberglass's translucence, which allows her to make light an element in her work, she would later combine it with latex in a number of works.

Color is whatever comes out of a material and keeps it what it is . . . if you use fiberglass clear and thin, light does beautiful things to it . . . it is there—part of its anatomy . . . The materials I use [fiberglass and latex] are really casting materials, but I don't want to use them as casting materials. I want to use them directly, eliminating making molds and casts . . . I am interested in the process, a very direct kind of connection.[35]

July 23: completes *Repetition Nineteen III* (plate 104), first piece that she has fabricated in fiberglass at Aegis. The second will be *Accretion* (plate 105), also completed that summer.

September: begins teaching at the School of Visual Arts. First symptoms of serious illness appear (extreme fatigue, headaches, nausea), but she continues to work and teach. Meets the artist Gioia Timpanelli, who becomes a devoted friend.

Oct. 27: *Finish coat here, studio. SANS COMPLETE! FINI! Turned out great!* [plate 106; the last of the four pieces fabricated at Aegis for exhibition at Fischbach].

Fig. 18
Area, 1968
Latex on wire mesh and metal wire
240 x 36 in. (609.6 x 91.4 cm)
Collection Wexner Center for the Arts, Ohio State University; Purchased in part with designated funds from Helen Hesse Charash, 1977

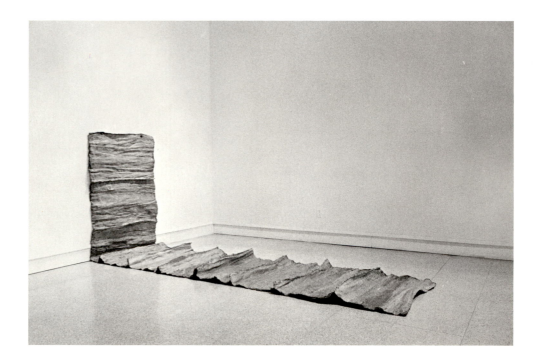

October: makes *Area* (fig. 18) for "Soft and Apparently Soft Sculpture," a touring exhibition organized by Lippard; also included are works by Bourgeois, Linder, Sonnier, Viner, and Harold Paris. *Repetition Nineteen III* is featured in "Made of Plastic," at Flint Institute of Arts, which includes work by Tony DeLap, Frank Gallo, Judd, Roy Lichtenstein, Morris, Nevelson, and Claes Oldenburg.

November 16: first one-person show of sculpture, "Eva Hesse: Chain Polymers," opens at Fischbach Gallery. Included are *Schema, Sequel, Repetition Nineteen III, Accretion, Sans II* (plates 102–106), *Accession III,* and *Stratum,*[36] as well as some test pieces and drawings. The exhibition is well received, several works sell, and Hesse is hailed as an important new artist. Overall, the work is identified by the critics as conceptual art mediated by materials and processes.[37] Hesse's own statement for the exhibition, written in June, underscores her exceptional ability to communicate with words as well as with materials:

I would like the work to be non-work. This means it would find its way beyond my preconceptions.
What I want of my art I can eventually find. The work must go beyond this.
It is my main concern to go beyond what I know and what I can know.
The formal principles are understandable and understood.
It is the unknown quantity from which and where I want to go.
As a thing, an object, it accedes to its non-logical self.
It is something, it is nothing.[38]

December: *Aught* and *Augment*[39] are included in "9 at Leo Castelli," a warehouse exhibition organized by Robert Morris as an international "Process" or "anti-form" exhibition (4–28 Dec.). Show includes works by Morris, Nauman, Serra, Saret, Sonnier, Steve Kaltenbach, Bill Bollinger; Hesse is the only woman. Her work receives mixed reviews: Kozloff describes it as "slightly more picturesque versions of minimal sculpture"; Perreault calls it "cruel and bland."[40] Hesse invited to show *Sans II* in the Whitney Museum's "Annual Exhibition" (Dec. 1968–Feb. 1969); other artists are Saret, Viner, Serra, Bourgeois, DeLap, Doyle, Gallo, Vollmer, and Smithson; the Whitney will later (1969) purchase two sections of *Sans II*. TIME magazine singles Hesse out for praise.[41]

Spends Christmas with Wapners in Woodstock.

1969 January: completes *Sans III* and *Vinculum II*[42] for inclusion in "When Attitudes Become Form," opening at the Kunsthalle Bern in March. Participates in the traveling exhibition "Plastics and New Art," organized by the Institute of Contemporary Art at the University of Pennsylvania. Is identified as one of the artists who freely combine minimal art with organic fluidity, and who cultivate the variable surface properties of materials such as fiberglass.[43]

January 26: lectures at Boston Museum School.

March: serious illness begins to be factor in her ability to work alone. With the help of Doug Johns and Martha Schieve, completes *Vinculum I* (plate 109). She nevertheless participates in her largest number of exhibitions this year, including several at small regional and university museums.[44]

Prior to that time the process of my work used to take a long time. First because I did most of it

myself, and then when I planned the larger pieces and worked with someone, they were more formalistic. Then when we started working less formalistically or with greater chance, the whole process became speeded up.[45]

April: begins *Tori* (plate 112). Collapses on the 6th after finishing *Accession II* (plate 108).[46] Twelve days later has operation for brain tumor at New York Hospital.

One of my first visions when I woke up from my operation is that I didn't have to be an artist to justify my existence. And one of my second thoughts or third was that if I couldn't be an artist, I would make films.[47]

May: convalesces at her sister's home in Fair Lawn, New Jersey. Although weak and confined to a wheelchair, attends opening of "Anti-Illusion" at the Whitney, the most important show of the season, organized by Marcia Tucker and James Monte. *Vinculum I, Expanded Expansion* (fig. 19), and *Untitled* (plate 110) appear with work by Andre, Lynda Benglis, Bollinger, Morris, Nauman, Ryman, Serra, and Sonnier.

August: completes *Right After* (plate 111), which she had begun before her surgery. Is unhappy with the way it turns out.[48] Completes *Tori;* goes to Woodstock with the Wapners and Timpanelli. Works on drawings, using a variety of materials: gouache, pencil, crayon, gold and silver paint, chinese ink sticks, colored inks (plates 73–77).

Aug. 10: *My . . . drawings now are . . . really paintings on paper . . . but I call them drawings. But they are really not. There is no difference between [drawing and] painting except that it is smaller and it is on paper.*

August 18: second operation for brain tumor; begins radiation and chemotherapy.

September: *Accretion* included in "557,087," organized by Lippard for the Seattle Art Museum; show traveled to Vancouver Art Gallery as "995,000" (the titles referring to the respective populations). Other artists are Bochner, Morris, Ed Ruscha, Ryman, Fred Sandback, Smithson, and Sonnier.[49]

Nov. 11: *Titles vivify all to me. Right After, Tori, Contingent.*

November: *Right After* included in the traveling exhibition "A Plastic Presence" at the Jewish Museum, New York. Pincus-Witten wrote: "Anyone who has watched the evolution of newer American sculpture is aware of Eva Hesse's central contribution to this development. Her work, whose forms are strong, suggestive and intellectually focused, surpasses any piece in the show."[50] Hesse completes *Contingent* (fig. 65; see also plate 113) on the 16th with artists Bill Barrette and Jonathan Singer, who become her assistants. The Museum of Modern Art purchases *Repetition Nineteen I* and *III*.

[Dec., n.d.]: *You must begin making small things so that starts cycle going. Doing begins things and it continues, it is always that way. As one piece leads into the next. As it was I never remember working on one thing, it always is in at least pairs and further ahead. Series actually are a material extension of working . . . doing perpetuates doing, and thinking. It works for me . . . I have to begin to learn to work and or plan and supervise others making my pieces.*

December 2: installs *Contingent* for "Art in Process IV" at the Finch College Museum of Art. Her written statement about the piece expresses her interest in dichotomies: painting/sculpture, freedom/encasement, parts/whole, opaque/translucent, cast/

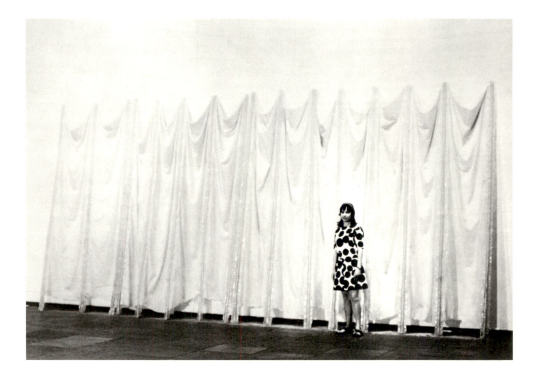

crumbled by hand, anthropomorphic/geometric. Her final comment hints at the quiet power of her work to reveal previously unknown connections with life:

it's not the new. it is what is yet not known,
thought, seen, touched but really what is not.
and that is.[51]

Reviews are laudatory: "Eva Hesse's is probably the only piece in the exhibition that has nothing to scream about, no manifesto to adhere to and no theory to back it. It is Abstract Expressionist sculpture of a higher order than I would have thought possible, an inspiration I would not have thought available to a younger artist. Her work [is] as deeply felt as expressive . . . as . . . Pollock's *She Wolf*"; "She work[s] with materials in the creative way painters and sculptors have of working with materials, and it is because she produces works, not ideas that Hesse stands out."[52]

Dec. 9: It's been a long time. April 6th. Today is December 9th. A long haul. Today is 3rd day I feel a little better, a little stronger, a little more hopeful, a little less sickness. How grateful I am. I really can be pleased, made happy and can be so grateful. I can do the other too. Go down so easy, become soulful . . . sad, lonely, depressed. But I'm up, sitting up . . . Playful . . . I am because it does mean much to me to be up—I have much to do.

Dec. 11: A day lapsed. sorry about that. Two reasons. Would like to write each day. A challenge. More than a challenge. It has a special meaning for me. I think I would rather be able to do that than anything else . . . Second reason—was feeling shitty again, and it was physical—not anything else. I had good reasons for feeling good. Whitney pickup, Janis pickup and evening opening at Finch.[53] *Not that one must feel good for those reasons but not sick either. Anyway, did go to Finch—and it was an opening and I was told how great my piece was. I enjoyed despite feeling lousy. I therefore declined dinner with friends.*

Dec. 25: Xmas day [through New Year's] in the hospital . . . Sun streaming in win-

dow . . . Opposite a lovely old German lady [who] was brought in last eve . . . [For the] Whitney Museum [show] I was so ill. Had signs but would not recognize them. One can deny anything . . . Preparations being made for Eva's flight [the drugs]. Chemicals. Today [they will] be gentler chemicals. Make it in ½ hr. No nausea. Kinder. My mind goes past today's pains . . .

1970 January: *Ennead* (see fig. 13) included in "String and Rope" at the Sidney Janis Gallery, New York (7–31 Jan.) Show also includes works by Duchamp, Schwitters, Picasso, Man Ray, Christo, Walter de Maria, Rauschenberg, Samaras, Nauman, Saret, Steve Kuehn, Sandback, Barry Flanagan, Pollock, Johns, Oldenberg, Dine, and Morris. Hesse's interview with Cindy Nemser is taped January 13, 21, 27 in Al Held's studio. Although very weak physically, she begins work on two major untitled sculptures, which would become her last works (plates 115 and 116).

[N.d.]: *The lack of energy I have is contrasted by a psychic energy of rebirth. A will to start to live again, work again, be seen, love. I fight sleep to respond to this real excitement that is frustrated because there is so little I can do . . . [I] know I must let all those who have asked to help me do so now. It's another new thing to learn . . . I have an incredible group of close friends . . . Since April 6 [1969] I have never been alone . . . I have tremendous new feelings, although there are confusions, they are strong black [and] white, none grey. I see things only in extreme positions. Love, hate, so strong, rich, poor. If only I could write . . .*

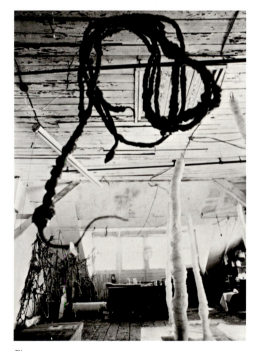

Fig. 20
Eva Hesse's Bowery studio, 1970
© The Estate of Eva Hesse. All rights reserved.
Courtesy Robert Miller Gallery, New York

February: *Artforum* photographs *Contingent* in her studio on the 5th. LIFE publishes a photo essay on new art, featuring Hesse, Benglis, Richard Van Buren, and Serra. Hesse gains her widest public exposure from this article.[54] By now she is in almost constant pain.

March: reenters hospital on the 21st. Has instructed Barrette to destroy *Untitled,* the first work she did upon her return to New York in 1965; *Long Life;* and *Total Zero.* Third operation for a brain tumor on the 30th.

April 3: one-person exhibition of her drawings (*Tori* is the only sculpture included) opens at Fischbach. Reviews praise their "powerful undercurrents of feeling," their "poetic and suggestive" qualities.[55]

May: *Vinculum I, Untitled* (plate 114), and *Untitled* (plate 116) are installed in three-person exhibition (with Tony DeLap and Frank Gallo) at Owens-Corning Fiberglas Center, New York. Exhibition opens May 14. In the hospital Hesse is shown photographs of the installation. *Contingent* is on the cover of *Artforum;* an edited version of her interview with Nemser appears inside.[56]

Week of May 22: Hesse falls into a coma. Dies May 29 at New York Hospital, age 34.

Hesse is praised as the outstanding participant in the Owens-Corning exhibition, her "primitive approach to the most sophisticated materials, her ganglions and loose fibers and knots" indicative of a personal vision. The late works are universally acclaimed, and her last piece is described as "a ballet of life and death," a work "audacious in its awkwardness and challenging to one's preconceived notions about what constitutes proper artistic form" (see fig. 20). Ironically, Hesse is described as "one of the most accomplished and promising artists of her generation," at the "outset of a brilliant career."[57] The show thus becomes her first posthumous tribute.

Notes

Unless otherwise indicated, passages quoted here are taken from Hesse's diaries, notebooks, letters, and other papers, and from the transcript of an interview in 1970 with Cindy Nemser, all in the Eva Hesse Archives at the Allen Memorial Art Museum, Oberlin College, Oberlin, Ohio. They are presented as far as possible in chronological order; dates determined from their position in the diaries are bracketed. I am indebted to Helen Hesse Charash and the Eva Hesse Estate for permission to quote from this material.

Lucy R. Lippard's excellent *Eva Hesse* (New York: New York University Press, 1976), regrettably now out-of-print, was crucial to this chronology. It provided not only the basic biographical structure but also a wealth of detail unavailable elsewhere that made it possible to place Hesse's own words within a larger, richer picture of her life. I am indebted also to the example of Ellen H. Johnson's "Order and Chaos: From the Diaries of Eva Hesse," *Art in America* (Summer 1983), wherein Hesse's own writings—in this case excerpts on art—are presented in the format of a chronology. Two books on specific areas of Hesse's oeuvre were invaluable resources as well: Johnson's *Eva Hesse, A Retrospective of the Drawings* (Allen Memorial Art Museum, Oberlin College, 1982), and Bill Barrette's *Eva Hesse: Sculpture* (New York: Timken Publishers, Inc., 1989).

This chronology was compiled with the assistance of Alison Tilghman, and I acknowledge with warm thanks her contribution. I am greatly indebted to both Ms. Tilghman and Diane Dillon for their research assistance on Hesse's diaries; to Sheryl Freedland for information on minimalism and the sixties; and to Amy S. Weisser and Jane Desmond for research into the public reception of Hesse's work.

1 This observation was made by Diane Dillon in an unpublished paper on the Eva Hesse Archives.
2 Hesse/Nemser transcript.
3 "It's All Yours," *Seventeen Magazine* (Sept. 1954): 140–41, 161.
4 Quoted in Lippard, 9.
5 Quoted in Ellen H. Johnson, "Order and Chaos: From the Diaries of Eva Hesse," *Art in America* 71 (Summer 1983): 111.
6 Hesse/Nemser transcript.
7 See the essay by Linda Norden in the present publication.
8 See the essay by Maurice Berger in the present publication.
9 D[onald] J[udd], "Don Berry, Eva Hesse, Harold Jacobs," *Arts Magazine* 35 (April 1961): 60.
10 Quoted in Johnson, 112.
11 Quoted in Ibid., 113.
12 V[alerie] P[eterson], "Reviews and Previews: New names this month," *ArtNews* 62 (May 1963): 19.
13 Undated loose paper in Hesse Archives, quoted in *Eva Hesse: A Memorial Exhibition* (New York: The Solomon R. Guggenheim Museum, 1972), unpaginated.
14 Quoted in Lippard, 28–29.
15 Quoted in Ibid., 35, 38.
16 See the essay by Robert Storr in the present publication.
17 Quoted in Lippard, 35.
18 According to Werner and Dore Nekes, German filmmakers who saw Hesse often during her stay in Germany, the artist decided on the title "An Ear in a Pond" because she was reading Thoreau's *Walden Pond* at the time she completed the relief. I thank Maria Kreutzer for conveying this information.
19 Quoted in Lippard, 35.
20 *Top Spot,* Collection of The Estate of Eva Hesse.
21 Kunstverein für die Rheinlande und Westfalen, Kunsthalle, Düsseldorf, *Eva Hesse: Materialbilder und Zeichnungen,* 6 Aug.–17 Oct. 1965.
22 Hesse is referring to a small relief she made in 1965 for the Los Angeles Peace Tower as part of a "collage of Indignation" against the Vietnam War.
23 This last work is in the Collection of Lord Peter Palumbo, London.
24 See, for example, Robert Pincus Witten, [Review], *Artforum* 4 (May 1966): 54; and John Gruen, "Ugly Young Americans," *New York Herald Tribune Magazine* (13 March 1966): 32. Gruen called *Hang Up* "a stylistically uncertain wall hanging."
25 Lucy R. Lippard, "An Impure Situation (New York and Philadelphia Letter)," *Art International* 10 (May 1966): 64.
26 M[el] B[ochner], "Eccentric Abstraction," *Arts Magazine* 41 (Nov. 1966): 58.
27 Hilton Kramer, "And Now Eccentric Abstraction: It's Art But Does It Matter?" *The New York Times* (25 Sept. 1966): section 2, p. 29. "Abstract Inflationism and Stuffed Expressionism" and "Eccentric Abstraction" can be seen as reactions to the Jewish Museum's "Primary Structures" exhibition held the previous spring and including work by LeWitt, Morris, Andre, and Smithson. Indeed this connection is made explicit in reviews of the latter by Grace Glueck and David Antin; see Grace Glueck, "New York Gallery Notes: ABC to Erotic," *Art in America* 54 (Sept.–Oct.

1966): 107; David Antin, "Another Category: 'Eccentric Abstraction,'" *Artforum* 5 (Nov. 1966): 56.

28 Collection of Israel Museum, Jerusalem.

29 According to Bill Barrette, Sculp-Metal is the trade name for an atomized aluminum modeling material that has the consistency of clay, is applied in thin layers, and dries to a very hard surface which can then be polished (Barrette, 106).

30 This work was exhibited as *Accession* in "Directions I: Options" at the Milwaukee Arts Center in June 1968. It is now in the Collection of Chester Lowenthal, Arts Four Corp, Paris. Although it has been thought that the piece was badly damaged (see Lippard, 103 and Barrette, 140), fewer than ten lengths of vinyl extrusion were missing at the end of the exhibition (according to its present owner, who purchased the work directly from the artist in 1969).

31 Quoted in Lippard, 112.

32 John Perreault, "Repeating Absurdity," *The Village Voice* (14 Dec. 1967): 18. See also Mel Bochner, "The Serial Attitude," *Artforum* 6 (Dec. 1967): 28; and David Lee, "Serial Rights," *ArtNews* 66 (Dec. 1967): 69.

33 *American Drawings, 1968* (Philadelphia: Moore College of Art, 13 Jan.–16 Feb. 1968).

34 Quoted in Lippard, 126.

35 Hesse/Nemser transcript.

36 *Accession III,* Ludwig Museum, Cologne, Germany; *Stratum* no longer exists (see Barrette, 160–61).

37 See, for example, Hilton Kramer, [Review], *The New York Times* (23 Nov. 1968): 54; John Perreault, "The Materiality of Matter," *The Village Voice* (28 Nov. 1968): 19; A. F., [Review], *Arts Magazine* 42 (Nov. 1968): 58; James R. Mellow, "New York Letter," *Art International* 13 (Jan. 1969): 54; Emily Wasserman, [Review], *Artforum* 7 (Jan. 1969): 60.

38 Cited in Lippard, 131.

39 *Aught,* University Art Museum, University of California, Berkeley; *Augment,* Kaiser Wilhelm Museum, Krefeld, Germany.

40 See Max Kozloff, "Nine in a Warehouse," *Artforum* 7 (Feb. 1969): 42; John Perreault, "A Test," *The Village Voice* (19 Dec. 1968): 19. See also Grégoire Müller, "Robert Morris Presents Anti-form," *Arts Magazine* 43 (Feb. 1969): 30.

41 "Floating Wit," *TIME* (3 Jan. 1969): 44

42 *Sans III,* Collection of The Estate of Eva Hesse; *Vinculum II,* Collection of The Museum of Modern Art, New York.

43 Stephen S. Prokopoff, "Plastics and New Art," in *Plastics and New Art* (Philadelphia: University of Pennsylvania, Institute of Contemporary Art, 15 Jan.–25 Feb. 1969), unpaginated.

44 "Soft Art," New Jersey State Museum, 1 March–27 April; "The Artist and the Factory: Drawings and Models," University of Minnesota Gallery, 19 March–16 April; "American Drawings," Fort Worth Museum, 28 Oct.–6 Dec., organized by Peter Plagens and Henry Hopkins.

45 Hesse/Nemser transcript.

46 Previously thought to be a refabricated version of a piece damaged while on exhibition at the Milwaukee Arts Center in 1968 (see Barrette, 140–41), this is in fact a wholly independent work. See note 30 above.

47 Hesse/Nemser transcript.

48 See the essay by Anna Chave in the present publication.

49 Lucy R. Lippard, *557,087* (Seattle: Seattle Art Museum, 5 Sept.–5 Oct. 1969).

50 Robert Pincus-Witten, [Review], *Artforum* 8 (Jan. 1970): 69.

51 Eva Hesse, catalogue statement in *Art in Process IV* (New York: Finch College Museum of Art, 11 Dec. 1969–26 Jan. 1970), unpaginated. The full statement is reprinted in Lippard, 165.

52 Philip Leider, [Review], *Artforum* 8 (Feb. 1970): 70; Dore Ashton, "New York Commentary," *Studio International* 179 (March 1970): 119.

53 Hesse is referring here to the Whitney Museum's acquisition and pick-up of two units of *Sans II,* and to the Sidney Janis Gallery's pick-up of *Ennead* for its January exhibition, "String and Rope."

54 "Fling, Dribble, and Dip," *Life* 68 (27 Feb. 1970): 62–66.

55 H[arris] R[osenstein], "Reviews and Previews," *ArtNews* 69 (Summer 1970): 62; Dore Ashton, "New York Commentary," *Studio International* 179 (June 1970): 275.

56 Cindy Nemser, "An Interview with Eva Hesse," *Artforum* 8 (May 1970): 59–63.

57 G. H., "Tony Delap, Frank Gallo, Eva Hesse," *ArtNews* 69 (Sept. 1970): 14; C. N., "Frank Gallo, Tony Delap, Eva Hesse at Owens-Corning," *Arts Magazine* 44 (Summer 1970): 57; James R. Mellow, "Three Sculptors in a Plastic Mode," *The New York Times* (5 July 1970): 17; Ibid.

GETTING TO "ICK": *To Know What One Is Not*

Linda Norden

Because it's not pure, it's not simple, it's not beautiful.
Sol LeWitt, 1991[1]

Picture Eva Hesse picturing Eva Hesse. What would the artist see? What would she show? Now, picture a series of canvases, relatively small, dense, somewhat crudely painted oils, each dominated by an over-large head, or hat-plus-head, abruptly cut at chin or torso. The countenances are evocative, the colors muddy, but surprising in their juxtaposition: straw-yellow hair on a brick-red ground (plate 1); creepy yellow eyes puncturing a cold, steel-gray visage (fig. 21; plate 3); an ochre, banana-boat hat dwarfing a sad, pale face, drained of all but a sallow flush of pea-green pigment. There are more, equally stark, equally intense psychologically, equally disparate image to image. One of the few dated canvases, a painting of 1961 that Hesse gave to Dr. Samuel Dunkell, her psychiatrist, may even describe a specific psychological syndrome (plate 5). Here, a Munch-like, bare-shouldered figure—long dark hair falling behind, one eye blackened, face hardened—dominates the far right of the canvas. It is shadowed by a pale apparition looming over its right shoulder.

In most of these paintings, Hesse covers the surface—along lines resembling Jasper Johns' early encaustics—with strokes that are seductively apparent and distinct, yet which, cumulatively, render the canvas as impenetrable as the faces they depict. And although the paintings differ from one another in a manner not untypical of early work, Hesse consistently gives evidence of focused inquiry at the level of subject and composition, which she limits to face, or face and upper torso. Together, the paintings intimate the presence of Hesse alone, as artist and as subject. They do not read as abstract figures, not even as personages, but as introspective portraits: self-portraits, a rare instance of Hesse picturing herself.[2]

Though hardly a representative survey of her pre-sculptural production, this portrait series serves as a reminder that Hesse had a life as an artist before 1965. To see these early paintings—and the recently exhibited ink wash drawings of the same period[3]—from the vantage point of the late eighties/early nineties, after long familiarity with Hesse's sculpture, is to see them in a way unimaginable twenty years ago. Unlike the drawings, however, the portraits are not easily assimilated into our idea of Eva Hesse, sculptor. To see them is also to wonder anew how we have come to know this artist and her work. ∎

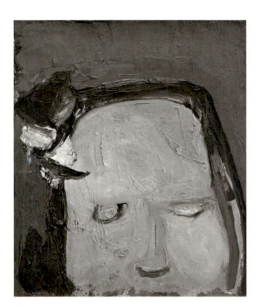

Fig. 21
Untitled, 1960
Oil on canvas
18 x 15 in. (45.7 x 38.1 cm)
The Museum of Modern Art, New York, Gift of
Mr. and Mrs. Murray Charash, 1991

Duchamp is probably mistaken: perishable materials will not prevent artists from achieving immortality in the future chronicles of art.
Harold Rosenberg, 1964[4]

Like most people who came to know Eva Hesse's art only after she died in 1970, I encountered it first through the verbal homages and photographic images that succeeded her. During Hesse's own lifetime, her uncategorizable work continually stymied reviewers and complicated efforts at description. Though sensitive to many of the distinct qualities of her sculpture, John Perreault, for example, admitted in 1968 that Hesse's "completely abstract [new works] resist any kind of single-leveled interpretation or response."[5] The early posthumous readings, aspiring to the resolution and myth-making entailed in commemoration, were less equivocal. On the one hand there is a certain intimacy in these accounts that is both compelling and contagious; on the other they assume an unusual degree of protective and authoritative control over Hesse and her art. The sculpture she produced during the last five years of her life is celebrated almost to the exclusion of all previous work. And Hesse herself—rendered symbolic as the first artist of her generation to have died, or as a female artist singled out for success—becomes inseparable from her art. A powerful, if malleable, persona emerges, at once poignant and full of contradictions.

In Lucy Lippard's seminal biography of 1976, for example, art and artist alike gain definition through a series of charged oppositions: fragile/tough, needy/generous, confident/insecure, obsessive but logical, carefully crafted yet perishable. Lippard makes a powerful case for the inseparability of Hesse's art and life through the very structure of her account, continually splicing her narrative with richly detailed descriptions of contemporaneous artworks. By juxtaposing photos or sketches of various pieces and charismatic photographs of Hesse herself, designers Sol LeWitt and Pat Steir further conflate art and artist. Over time, as much of Hesse's sculpture began to deteriorate in ways anticipated but not fully intended by the artist, the book became an evocative reclamation and displacement of a body of art no longer visible in its original state.[6]

For many who knew her, Hesse's early death was not merely tragic, but symbolic.[7] She was the first prominent artist of her generation to die in a decade possessed by the determination to live life to its fullest, and yet riddled with untimely deaths. Yoked to the sixties' heroic images of promise and anti-heroic images of ecstatic complaint—John F. Kennedy, forever forty-six and smiling; Malcolm X, Janis Joplin, Martin Luther King—are the equally resonant images of absence forced by premature, often violent death: the unabridged, seemingly endless coverage of Kennedy's funeral; photos wired from Vietnam; Andy Warhol's empty electric chairs.

Hesse's entry into this canon of dead heroes was, of course, somewhat circumscribed: she was hardly a public presence. But her symbolic importance had a great deal to do with the timing of her death. Coinciding as it did with the end of a decade, it signaled a turning point within her own circle of artist and critic friends, an artificially imposed close to the most experimental and optimistic stages of the ferment that characterized their New York art world during the mid-to-late sixties.[8] Hesse's death also catapulted her into another, very different symbolic role. Her success as a

female artist at a time when this still constituted a political oxymoron provided an ideal prototype for a new generation of artists, more politically engaged with their identity as women. That this occurred in spite of Hesse's personal resistance to a gender-based discussion of her work is but one indication of the lack of control she exercised over the perception of her art.

In fact, Hesse did little to direct the terms with and through which her work might be understood. Like most women artists of her pre-feminist generation, and like many of the male artists celebrated under the banner of Abstract Expressionism, she made her public statements within the art objects she produced. In a decade when theoretical/analytical explication was the norm, Hesse's preference for making may account for the freedom with which critics have established a framework within and against which they define her work. For whether in reaction to the critical bombast over Abstract Expressionism, the dismissive condescension incited by much Pop art, or a general dismay at the confusion generated by early minimalism, the late sixties witnessed the intense determination of many (mostly male) artists to control —through their own writing and published dialogues—both the perception of and critical response to their art.

Although Hesse wrote continuously and obsessively in diaries and notebooks from childhood on, these mainly tracked, queried, and attempted interpretations of her personal experiences.[9] That she could powerfully articulate the forces at play in her work is clear from such rare public statements as the one she drafted for the exhibition of *Contingent* (fig. 65) at Finch College in 1969.[10] But this mode of writing occurred only toward the end of the sixties, after she had come into her own as an artist and had gained recognition as a sculptor. It reprises an attitude toward art-making that she had already made concrete through her work, rather than anticipating or dictating that work's conception. And the abrupt, questioning, but incantatory style of her *descriptive* rather that *prescriptive* prose owes more to the interrogative, existential voices of some of Samuel Beckett's characters than to the sure statements of LeWitt, the carefully crafted epithets of Carl Andre, or the philosophical exegeses of Mel Bochner, Donald Judd, Dan Graham, Robert Morris, or Robert Smithson. ∎

It was my friendship with Eva that made me aware of the problems that women artists face in a world dominated by a male hierarchy (critics, editors, museum and gallery administrators). There seems to be an implicit rule (even among female critics, etc.) that a woman can never be considered the dominant practitioner of a style or idea. When the time came for the type of work that Eva Hesse was doing (a reaction to Minimalism, it was called "anti-form," whatever that may be) to be officially recognized, she was relegated to a minor role. Only later did the mistake become evident. But even now, women artists face the same intellectual blindness and sexist "put-down."
Sol LeWitt, 1978[11]

Of the many individuals who paid homage to Hesse at the time of her death, LeWitt and Lippard are probably most responsible for giving her symbolic dimension. A father-figure for many of the artists associated with the early stages of minimalism, LeWitt was one of Hesse's closest personal friends. The catalogue for his first major retrospective, which opened at the Gemeentemuseum in The Hague less than two months after Hesse died, is dedicated to her. So is the frontispiece drawing, *Vertical lines, not straight, not touching, 1970* (see fig. 22), whose inspiration LeWitt attributed directly to Hesse's frequent use of unstructured, free-falling cords.[12]

The catalogue entries, solicited by LeWitt, range from the cryptically personal, as in Andre's "Sol is our Spinoza"; to the densely analytic, as in Graham's "Thoughts on Two Structures"; to the commemorative, as in Bochner's "Either Black or White (for Sol LeWitt: Excerpts from previously published writings, 1966–68)"; to Hesse's handwritten, repetitive incantation, composed shortly before her death:

Sol LeWitt,
I have seen your work.
I have seen your work change.
I have seen your work grow.
I have seen your work.

Now it's there, where you put it.
Now it extends itself unto us.
Now we have grown to see it.

As a group, however, these writings accurately reflect the complexity, variety, and highly reflexive dialogue of LeWitt's circle, commemorated barely five years after its inception.

LeWitt's dedication to *Hesse* of this "scrapbook" of commentary, conceived and compiled as a dedication to *him*, underscores her role in this group and time as pivotal. But it is from this point on that an implicit nostalgia for the period set in, with Hesse as its symbolic incarnation. By 1984, this nostalgia would explicitly inform the tribute show "Flyktpunkter/Vanishing Points," organized at the Moderna Museet in Stockholm with the help of LeWitt and Lippard.[13] Whereas the Gemeentemuseum catalogue had gathered an array of individual artists' statements, the "Flyktpunkter" essays sought to define a moment retrospectively and to give it perspective through the "vanishing points" of Hesse's, as well as Smithson's, deaths.[14]

If for LeWitt the exhibition served as a reaffirmation of his longstanding commitment to support artists by presenting their work as directly as possible, for Lippard it offered an opportunity to reassess her earlier efforts—in kaleidoscopically self-adjusting essays and exhibitions—to define a given set of practices. With fifteen years hindsight, she distinguished between the methods and larger aims of what she described as the "purging" or "purifying" aesthetic of minimalism. As in her biography of Hesse, however, she was perhaps too anxious to find intersections between the great range of experiments that characterized the time and to attach broader social meaning to aesthetic decisions that were often hightly specific and, in the case of Hesse, too personal to categorize. Even as she acknowledged Hesse's individual and symbolic significance in the late sixties, Lippard did not consider the generative impact of Hesse's art on her peers—the ways in which her insistently personal artistic decisions and resistance to the more orthodox aesthetic constraints of minimalism helped to open up its structural potential:

Eva Hesse might be the focal point. All these artists were friends of hers . . . And the years covered by this show—1965–1970—were the years in which Hesse matured as an artist, made a brilliant series of works, and died; while the others' careers extended variously before and afterwards. All of these artists influenced Hesse's development esthetically and/or intellectually, as did others not included here, notably Carl Andre.[15]

A contradiction emerges here—as LeWitt had earlier recognized—between the desire to celebrate an individual female artist and an unwillingness to allow for her influence within the male-dominated art world from which she is assumed to be largely excluded. It is a contradiction that frequently mars early feminist efforts to draw conclusions and insights from the very varied achievements of a small number of women artists. Hesse herself protested this isolation of women artists—or their art—on the basis of gender. At the bottom of a letter from Cindy Nemser requesting her response to questions for an article on women in the arts, Hesse scribbled: "The best way to beat discrimination in art is by art. Excellence has no sex."[16]

Nemser's subsequent interviews with Hesse can be viewed as part of her larger efforts to encourage prominent women artists such as Marisol, Lee Bontecou, and Louise Nevelson to elaborate on their artistic ambitions. Collectively, these transcribed question and answer sessions yielded much information and some welcome reflection among artists not always predisposed to analyzing their art. As published in *The Feminist Art Journal* from 1972 on, they also provided a wry antidote to the proliferation of interviews and artist statements, almost invariably with or by male artists, published in *Artforum, Art International, Arts,* etc., in the late sixties: carefully controlled male "voices in print" that seem to have grown in direct proportion to the removal of persona from the artwork itself.

Read in transcript, these taped sessions offer a wonderful range of insightful commentary from Hesse. They put Nemser's role in perspective, allowing the reader to distinguish between responses she encouraged and the artist's own tentative speculations. They also reveal some of Hesse's most deeply felt artistic concerns. Restructured and edited for publication, however, much was distorted. As published in *Art-*

Fig. 22
Sol LeWitt (b. 1928)
Wall Drawing #46 (Vertical lines, not straight, not touching, uniformly dispersed with maximum density, covering the entire surface of the wall), May 1970
Black pencil
First drawn by LeWitt; first installation, Galerie Yvon Lambert, Paris, France, May 1970
Collection of the artist, Chester, Connecticut

forum the very month of Hesse's death, these interviews significantly effected the posthumous conflation of her art and life. [17]

In another curious historical coincidence, one hot topic of the early seventies involved a reassessment of the role of biography as a legitimate concern of art, a counter to the privileging of theoretical statements that had characterized so much late-sixties art criticism. Among its early proponents was Robert Pincus-Witten, whose "Eva Hesse: Last Words," published in *Artforum* in 1972, opened this particularly problematic Pandora's box. [18] An eggregious example of editorial projection and presumption, it constituted a highly questionable appropriation of Hesse's private words. Yet in his essay for Hesse's 1972 Guggenheim retrospective, Pincus-Witten reconsidered the appropriate use of her diaries. Even as he argued that her fastidious self-analyses offered a new perspective on the internal evolution of her art, he admitted that "the history of artistic creation can never be recorded in this way —the growth of a pictorial and sculptural oeuvre answers its own imperatives and not those of literature, even confessional or diaristic literature." [19]

Although Pincus-Witten's essay is rife with critical contradictions, it offers several unprecedented insights that evidence his more qualified use of the information he gleaned from Hesse's diaries and interview transcripts. Proposing a dialectical relationship between Hesse's art-making and life experiences—her forced flight from Germany, the ensuing familial tragedies, the later "abandonments" via the break-up of her marriage and her father's death—he shifted emphasis away from the tragic fact of her death to the tragic circumstances that marked key periods of her life. And he presented an unorthodox and controversial interpretation of Hesse as an expressionist artist: the first sustained argument for such a reading since her successes under the umbrella of minimalism. [20]

Hesse did struggle throughout her career with her intuitive affinities for expressionism as a mode of art-making, and with the figuring of her self in her art. And it is in these struggles that Hesse the frustrated expressionist gained most from her minimalist peers. In describing her move away from the "physical expression" or "hand-over-hand manipulation" that characterized some of her interim, experimental sculpture, Pincus-Witten worked to make her "astonishing," seemingly anomalous last works—*Contingent* (fig. 65), *Untitled* (plate 115), and *Untitled* (plate 116)—comprehensible, an outgrowth of the artist's "organic evolution." Yet his conclusion that Hesse's artistic achievement falls within the realm of the "intellectual-mystical sublime," and his implicit validation of her art through its relation to the "heroism" of Abstract Expressionism, ultimately deny the very attributes Hesse herself stressed about her work: its "absurdity" and its "ick." ∎

Repetition and recollection are the same movement, only in opposite directions: for what is recollected has been, is repeated backwards, whereas repetition properly so called is recollected forwards . . . When one has circumnavigated existence, it will appear whether one has courage to understand that life is a repetition and to delight in that very fact.
Soren Kierkegaard, 1843[21]

The most impressive recognition that emerges from looking more closely at Hesse's early years is just how far she was able to get through painting and more important, through her obsessive determination to come to terms with her own values and beliefs. In one tiny painting of 1960, the one with those strange yellow eyes (plate 3), Hesse brushes in a preposterous, over-sized, black-and-white hair ornament just offside the broad, cold, nearly rectangular brow, lending this otherwise spooky portrait a painfully poignant, almost ridiculous effect. In a larger canvas, sadder and more subtly conceived, an introverted blond clutches her elbows and averts her gaze (fig. 23; plate 1). Hesse derives tremendous emotional impact from a few roughly rendered, but carefully calculated details: another hair ornament, this time a black band or bow to the top and right of the mass of hair, and the slightest intimation of foreshortening where the skinny arms enter the short sleeves of a T-shirt.

Hesse the student of painting is evident here: the shifts in stylistic effect from one image to another intimate close scrutiny of the art of others. Several seem related to the contemporary figuration of Dubuffet (fig. 24), Nathan Oliviera, the young Leon Golub (fig. 25), and some of the Cobra painters, in particular Karel Appel, Pierre Alechinsky, and Asger Jorn.[22]

The "blond" portrait is a particularly moving image. Hesse may well have been looking to the Cobra painters for her animated, cartoonish rendering of an expressive persona. But she specifies and personalizes the image in a manner unthinkable for, say, Appel or Alechinsky. There is no trace of the anthropomorphizing so central to the Cobra's conflation of man and animal, no sense, either, of the ecstasy. Instead we see Hesse, clad in that T-shirt and oddly elegant hairbow, hugging herself, as it were. It is a private image, but an "image for nothing" too, as if by Beckett: an image "to lull me and keep me company, all ears always, all ears for the old stories . . . And this evening again it seems to be working, I'm in my arms, I'm holding myself in my arms, without much tenderness, but faithfully, faithfully."[23]

If, in some of these portraits, there is pathos, many seem humorous, almost satirical. Hesse exploits the capacity for costume, gaze, posture, and general demeanor to radically alter the affect of a given persona. This is not to say she anticipates Cindy Sherman; Hesse seems far more engaged in an earnest search for self than in any postmodern gloss on the power of artifice to displace that self. Besides, they have everything to do with paint and painting.

Like de Kooning, or Dubuffet, Hesse knew at exactly what point a figural form threatens to dissolve into an accumulation of strokes. This precariousness—of form threatening to become paint—creates a great deal of tension, psychological as well as painterly. The inverse—paint threatening to coalesce into figure—charges much of the most controversial Abstract Expressionist painting, notably the late work of

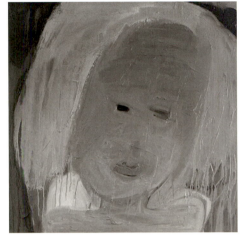

Fig. 23
Untitled, 1960
Oil on canvas
36 x 36 in. (91.4 x 91.4 cm)
I.B.J. Schroder Bank & Trust Co.

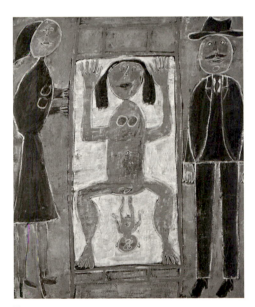

Fig. 24
Jean Dubuffet (1901–1985)
Childbirth, 1944
Oil on canvas
39½ x 31¾ in. (100 x 80.6 cm)
The Museum of Modern Art, New York, Gift of Pierre Matisse in honor of Patricia Kane Matisse

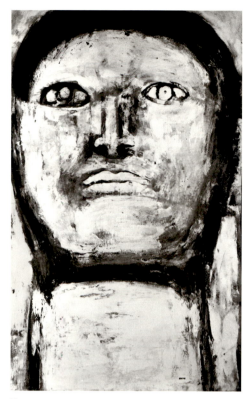

Fig. 25
Leon Golub (b. 1922)
Colossal Head, 1958
Oil and lacquer on canvas
82⅛ x 48⅝ in. (208.6 x 123.5 cm)
Photograph courtesy of Frumkin-Beck-Adams
Gallery, New York

Pollock, and was often the point around which heated debates on abstraction focused. Hesse's intuitive grasp of the implosive power contained in this "change of state" from matter/material to form/figure and vice versa may be one of the most potent lessons she learned from Abstract Expressionism and from her own early painting. It was a tension she would eventually exploit in many of her sculptures of the mid-sixties, disarming the viewer precisely by thwarting expectations of predictable form. In fact, what Hesse described as her preoccupation with opposites—soft versus hard, ordered versus tangled, etc.—might equally be understood as changes of state: the same cords that make up the ordered spheres of *Ishtar* (1965; plate 90), for example, take on a more limpid, material aspect when left to hang freely, even implying the possible unraveling of the spheres from which they emerge.

Several other canvases, related to Hesse's portraits through the quality of the color —ochres and greens, with occasional lapses into violet or patches of garish orange and red—make conspicuous use of opposition: in one, a flayed, open-legged figure presses against a smoothly solid one (plate 7). And at least two carry narrative overtones: the concrete image-idea of a veiled, otherwise nude bride-like figure crowding an unclad female nude (plate 6) may even have found its source in one of Hesse's recurring dreams.[24] By and large, however, these works lack the intensity and more subtly contrived tensions of the single-image self-portraits. Hesse is at her strongest at this point when she locates unmediated equivalents for the fundamental opposition of self/not self: inside/outside, dark/light, positive/negative, mass/void. Her ability to engage these formal dialectics, without any distracting references to narrative, charges her better known, ink wash "personnages" of 1960–61.

In fact, these contemporaneous drawings, which are usually cited as Hesse's first really independent work, must certainly grow out of her more direct self-portraits. Much of Hesse's internal, conceptual development reveals a tendency to move from the literal to the abstract, as for example in her later move from the obsessive, literal act of cutting, in the *Accession* boxes (plates 107 and 108), to the indirect use of repetition as a device with which to exaggerate an effect, as in *Repetition Nineteen III* (plate 104), the *Sans* series (plate 106), and *Accretion* (plate 105).[25] Her move from self-portrait to personage seems to be an early case of such a progression. So does her move from color to a limited and neutral palette: both in the shift from portrait painting to ink wash drawing, and from painted relief to her mature sculpture. ■

I have attempted to carry the human image (as well as other subjects dealt with in my paintings) immediately into the range of effectiveness without passing through esthetics . . . The slightest intervention of esthetics obstructs for me the efficiency of functioning and spoils the sauce. That is why I reject from my works all that could have the smell of esthetics. People with a short-sighted view have concluded from this that I enjoy painting ugly subjects. Not at all! . . .
Jean Dubuffet, 1959–60[26]

Early work can indicate both an artist's longstanding preoccupations and, just as usefully, what he or she has chosen to resist. Hesse, for example, knew early on that the way to reach her "range of [expressive] effectiveness most immediately" was, as for Dubuffet, to avoid "the intervention of esthetics." Yet the very idea of early work has long been ignored as a factor not only in Hesse's development, but in that of her contemporaries who were first celebrated under the rubrics of minimalism and conceptualism. Defining themselves and their art through resistance, such artists as Bochner, Judd, Morris, LeWitt, and Smithson—all of whom, like Hesse, had begun their careers as painters, or at least artists working in two dimensions—rejected not only the import of their early work but the concepts of formal evolution and an artist's "oeuvre" as well.[27]

Hesse herself never dismissed painting on an ideological level. Rather, the limits it imposed for her were personal, having more to do with its inherent prettiness, the pressure of "getting it right," the tediousness of plane, frame, oil, and brush. By the mid-sixties she had found the act and the fact of oil and canvas too pressuring. This is what she permitted herself to reject in Germany, as evident in her much-quoted self-liberating lines: "If painting is too much for you now, fuck it—quit—if drawing gives some pleasure—some satisfaction, do it—go ahead. It also might lead to a way other than painting, or at least painting in oil."[28] Drawings, followed by plaster and string, allowed accretion and repetition to supplant Hesse's earlier insistence on unified form, or image. But she had been painting for at least ten years before she came to this recognition.

Hesse's battles with painting—over its expressive, as well as its constructive potential—were fought initially within painting and against Josef Albers.[29] There is a great deal within Albers' rigorous pedagogy that probably proved useful to Hesse's inherent urge to make her expressivity more concrete. For instance, his well-known skepticism of "the Abstract Expressionist band-wagon" should not obscure his ardent resolve to "produce form with psychic effect, that is, form with emotional content." Frowning on "habit, dreaming, or accident," he advocated "planning." He broke down the medium and mechanics of painting into constituent elements—color being the most relative—and structural devices, which he presumed to be teachable. The latter ranged from such specific organizational constructs as color gradation—of which Hesse made much use in her relief paintings and earliest sculptures—to his famous series of controlled exercises on the "interactions of color." Even Albers' "free studies," designed to encourage the "self-expression" that the more limited, systematic, and uniform color studies precluded, aimed at "finding an order" in which, the focus being color, all colors were made "equally important." And locating his notion of the whole in the equal treatment of parts, Albers

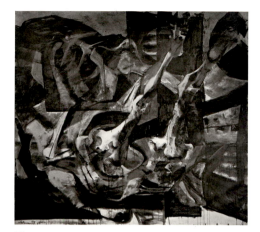

promoted opposition as the way to "invoke more distinct 'meaning' and a more precise 'reading.'"[30]

As her Yale classmate and friend Irving Petlin has pointed out, Hesse's chief concerns during these early years—her own engagement with both opposition and the wholeness of form—had more to do with authenticity. "The poetry of color in Albers' system is optical—the poetry of opposites, things that vibrate. She couldn't do this. She always looked at the emotion residing in form—the emotion that inhabited the form. This was her real struggle and what [accounts for] her early attraction to expressionism."[31] It is perhaps for this reason that painter Rico Lebrun, whose intense rivalry with Albers marked a particularly stressful period at Yale's Art School, made a distinct impression on Hesse. In such paintings as his *Study for Dachau Chamber* of 1958 (fig. 26), Lebrun revealed an unfashionable willingness to take on a type of content that had great meaning for Hesse, but that Albers rejected outright. And Lebrun's avoidance of bright color in favor of a palette limited to browns, grays, and blacks—much like the range Hesse later chose in her ink wash drawings and eventually in her sculpture—may have come as a relief to an artist who "could never find a way to attach color to significant form."[32] In this context, Hesse's remark on color in a latex piece such as *Contingent* is all the more meaningful: "Color is whatever comes out of the material and keeps it what it is."[33]

In a diary entry of 5 May 1959, toward the end of her last semester at Yale, Hesse recorded both Lebrun's and Albers' review comments on a single painting:

Yesterday Lebrun said: "knowledge of technique could facilitate a further development and means for experimentation of form. Paintings should be built in stages of washes and glazes, thin over thick is permissable. This way, you always have a choice and can constantly change, alter, and discover a new way. Then pull out from the variety of ways, what you want the forms to do."

Albers, looking at the same painting, said the following: "There is not a oneness among the forms. They lack a common unity. 'What does one head have to do with the other?' Even if you would choose great contrast in color, they must belong together." [34]

Lebrun's comments, traditional as they are, strangely prefigure Hesse's own description of her working procedures on *Contingent*. For it was in latex and epoxy rather than paint that she realized her goal of "finding out through the working of the piece . . . things you don't know," of allowing "the work itself to redefine or define the next step." [35]

Of the years between her graduation from Yale and her rejection of painting in Germany, the time Hesse lived in New York—from the fall of 1959 through the spring of 1961—was most critical to her development. It was a period when she oscillated wildly between her unbridled ambition as an artist and her equally powerful fears of being independent. Yet it was also a richly productive period artistically, one during which she sold her first work and had her first show (at the John Heller Gallery); met such friends as the Oldenburgs, the Park Place group of sculptors, and LeWitt; and officially entered the fray of the New York art world.

Although most of this biographical information has been thoroughly discussed by Lippard, one fact of major significance, given the shape and direction Hesse's later work took, has been hitherto overlooked and virtually unknown. Between January 1960 and sometime later that spring, Hesse was employed as a textile designer by the firm of Boris Kroll, known for its arts-and-crafts-quality upholstery, drapery, and tapestry. At the time, Hesse made numerous, lengthy references in her diary to her employers, as well as to some of her tasks and her frustrations with them. [36] But to my knowledge, she never subsequently alluded to the job, or to any aspect of what she might have learned from it. Her descriptions of the tensions she experienced —competition with fellow-employees, as well as fear of not producing adequate

work—indicate that she dismissed this job as "work," part of supporting herself, but not part of her art. According to co-worker Marjorie Kronengold, Hesse was "dying to paint" and left Kroll for a more menial job, so as not to expend on commercial art any of the energy she wanted to save for painting.[37]

Hesse worked primarily painting designs for jacquard looms. Taken from books, these were abstract, often Coptic or Mediterranean in origin (see figs. 27 and 28). Hesse's job was to trace a design freehand and then develop a "repeat," working first in black and white, and then, if the repeat seemed good, in color. All finished designs were executed in gouache. In the case of upholstery projects, these required a considerable amount of stippling. Finally, the painted design "repeats" were transferred to graph paper, though this job, as well as the cutting of color swatch "blankets," was generally performed by other staff.

Hesse's specific tasks were in fact quite complicated, requiring an understanding of the construction and type of fiber that would be employed, and she was frequently frustrated. It is intriguing that the very problem that plagued Hesse with Albers—articulating form through color—haunted her here. Kronengold described Hesse as "seeing things quite differently—for example, in terms of background and foreground. She would think something worked for aesthetic reasons, but didn't really understand what was being sought: she was out of touch with what was marketable." Hesse's own comments indicate her resentment of these priorities, which she found demeaning. Yet she felt pressured "by the fear of getting fired."[38]

Although Hesse, unlike such contemporaries as Warhol, Serra, and Andre, seemingly did not make conscious use of this early involvement in commercial methods and functional constructions, the sheer exposure to a range of processes and materials must have played some role as source for her later use of fiber.[39] It seems far from coincidental that when she finally broke with painting, she did so in a textile factory. More specifically, as I will later elaborate, the jacquard cards employed in this type of weaving bear an uncanny and deeply resonant resemblance to the many-corded panels that Hesse created for her *Metronomic Irregularity* series. ∎

Eva had no time for small talk . . . Cutting exact pieces of rubber, that's [her] small talk.
Rosalyn Goldman, 1988[40]

Hesse's stalemates as an artist were most extreme between 1961 and 1964, reaching a head in Germany when she was forced to "dive into the wreck" of her early childhood. Her need to find herself converged with the general move in the early sixties to open up artistic territory, to resist any legacy. As described by Doyle, it was a period in which "you only needed one good idea, but you had to find it. Either you inherited the farm (second-generation Abstract Expressionism), or you went out to explore and stake out new territory. This 'full-stop' was everyone's problem, but it was Eva's personal problem."[41] Yet it was also a period when the proliferation of ideas was overwhelming. Hesse, for example, had a particularly difficult time with Pop art, despite the fact that as a concept it offered several productive moves against Abstract Expressionism. It turned the canvas out onto the world, opened up the field, and undermined the privileging of hand and signature by introducing both non-high-art subjects and procedures into painting. Minimalism, which Robert Rosenblum has described as having a somewhat inverse relation to Pop, maintained the exploration of non-art procedures while avoiding any direct reference to content per se. Toward this end, Hesse's exposure to such concrete artistic methods and constructs as those she experienced firsthand through her design work—and again in the abandoned textile factory in which she and Doyle worked in Germany—might well have provided her with one procedural route out of painting. Yet the very processes that helped to undermine the high-art insistence on hand and gesture failed to resolve the problem of the artist's position within the art-making procedure. And this was one of the most central and longstanding problems that engaged Hesse as an artist.

Hesse's ability to generate a body of work that managed to be resolutely her own without any "signature" or direct reference to self had everything to do with the degree to which she came to know, and accept, herself. When one correlates her artistic production with specific episodes in her life and her subsequent efforts to come to terms with them, a pattern begins to emerge. Her maturation, as artist and as person, follows a coiled, or spiral path in which certain periods seem dominated by "life," others reveal a heated battle—staged by Hesse—between art and life, and still others show a near-total devotion to being an artist and making art. Yet although her decision to make art was probably motivated by the traumatic facts of her early childhood, Hesse's art itself never mirrored that life or served as a direct comment upon it. And unlike the work of a writer such as Plath, it never encompassed either a confessional or a tragic mode. Her sculpture functions instead as a bizarrely humorous, or in her words "absurd," affirmation of a life that, as recollected in her diaries, seems only painful.

From this perspective, Hesse's fourteen months in Germany, in the small town of Kettwig-am-Ruhr, offered both a traumatic and a protective isolation. Doyle describes it, chronologically speaking, as a kind of "half-time. When we came back, everything was minimalism." The intensity of Hesse's confrontation with herself, her art, her homeland, and her estrangement from her husband nearly destroyed her. Ironically, it also provided her with the space required to truly experiment, to har-

ness the humor of Pop to her own idiosyncratic statements, to leave behind not just oil painting, but her preoccupation with self as subject. If the reliefs she produced there remained anthropomorphic, they no longer described body parts per se. Conflating human organs with a surreal array of vaguely identifiable machine parts, Hesse managed both to get outside herself and to transform the tragic into a comic absurd. She emerged from Germany, and the equally terrifying year that followed, with a different order of confidence. At the same time, it is hard to imagine that Hesse could have benefitted from this period in the way she did had her engagement with her identity not already been so central to her art.

Hesse's decision to become an artist can more accurately be described as a decision to become *as* an artist. She never preoccupied herself with the questions, "What is art?" or "What makes painting painting?" Rather, she chose art to choose life, as "the one vocation that keeps a space open for the individual to realize himself in knowing himself."[42] Indeed one of the few philosophical notations in Hesse's diaries is a hand-copied entry defining solipsism: "solipsism: the theory or belief that *only knowledge of the self is possible* and that for each individual the self itself is the only thing really existent and that therefore reality is subjective."[43] In its plural form, the word had been used by Bochner—with typical minimalist deadpan—to refer to the artists engaged with LeWitt and so had some contemporary currency. But it speaks very directly to the preoccupation that gave Hesse's art its most consistent strength: not just to know oneself, but to know what one was not.

This fundamentally humanist orientation—Hesse was raised as an Orthodox Jew and remained religious throughout her life; when she married, Doyle converted to Judaism—differentiated her from her more skeptical, philosophically motivated peers, though hers was an existential humanism.[44] Hesse herself, responding to Cindy Nemser's persistent entreaty to define what she meant by the "absurd," connected the notion with her "humanism" and with the determination of a Vladimir or an Estragon to go on living, even when "doing nothing":

They go on waiting and pushing and they keep saying it and doing nothing. And it is really a key—the key to understanding me. And only a few understand and could see and that my humanism comes from there. My whole approach to living and the sad things comes from there.[45]

And her close friend Rosalyn Goldman, who has gone so far as to say that "if one does not include Hitler in discussing Eva's life and art, one is missing the boat," described the "presence" she felt in Hesse's sculpture in terms that may help to articulate how Hesse's interest in expressive, figured, even morally motivated content was consistently played against—and ultimately found its resolution in—an equally powerful urge toward abstraction:

These were not done to impress, not even to express or expound on things. This was a person's being . . . a magnificent obsessive comment on civilization and on being. This was done to broaden the horizons of experience, to show the impact of what life is: the material and the content are one. Out of necessity, in order to describe what she had to, she had to be inventive. She had to find material to express what needed to be expressed.[46]

Goldman added that "Eva felt this [presence] in front of Andre's bricks and plates," an observation Hesse corroborated indirectly in her conversation with Nemser.[47]

How, then, to reconcile this unfashionable humanism with the minimalism Hesse came home to from Germany? Most have argued that she suppressed much of her expressive urge during these years and submitted her eccentric forms to the more stable structures offered through minimalism.[48] Both moves clearly helped Hesse enlarge her statements. But in her personal quest for an art that could be a "big nothing," one can argue that Hesse gained even more profoundly from the widespread tendency to define both form and meaning through a series of negations. Even for a non-conceptual artist such as Hesse, negation—as in "not painting, not sculpture"—as much as the imposition of such constructive formats as geometric or serial form, offered a powerful method through which to clarify meaning and intent. Within the New York art world of the early sixties, Ad Reinhardt is the artist most often credited with inspiring the minimalist embrace of negation as a theoretical construct. But Hesse's use of negation was less ritualistic than Reinhardt's, less single-minded, less keyed to pinpointing the essence of painting, or even of art. It came closer to being Talmudic, in the sense that the Talmud functions as a kind of "quest for logic in the face of the absurd."[49] It is here that Hesse's intuitive existentialism dovetails with her understanding of her art. She never participated in the moves toward purification of the image or art-object inspired by Reinhardt. In fact, her most significant—and at the time, welcomed—contribution was her ability to retain the messiness, her "ick."

It is Hesse's "ick"—what LeWitt described as both her "getting into herself" and her determination to find and make an art that was "not pure, not simple, not beautiful" that attracted such discomfitted minimalists as Smithson to her during what he

Fig. 29
Inside I and *Inside II, 1967*
I: Acrylic paint over papier-mâché, twine, and wire over wood; II: Acrylic paint mixed with sawdust over wood, papier-mâché, cord, weights, and acrylic
I: 11¾ x 11¾ x 12 in. (29.8 x 29.8 x 30.5 cm);
II: 5¼ x 7 x 7 in. (13.3 x 17.8 x 17.8 cm)
The Estate of Eva Hesse. Courtesy Robert Miller Gallery, New York

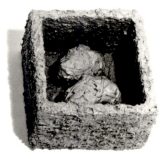

described as his own "crisis of abstraction...[away from] the Reinhardtian dogmas."[50] In his 1966 article, "Quasi-Infinities and the Waning of Space," Smithson staked out some of the parameters of an anti-anthropomorphic, anti-progressive, possibly anti-abstract domain of art. Citing Hesse's *Laocoon* (fig. 70) for "an absence of 'pathos' and a deliberate avoidance of the anthropomorphic," he further noted:

Trellises are mummified, nets contain dessicated lumps, wires extend from tightly wrapped frameworks, a cosmic dereliction [sic] is the general effect ... Her art brings to mind the obsessions of the pharaohs, but in this case the anthropomorphic measure is absent. Nothing is incarnated into nothing.[51]

LeWitt has described Hesse's "expressivity" as "much more internal than that of a Pollock—centripetal, rather than centrifugal," a description that does not contradict Smithson's reading of entropy into *Laocoon*.[52] Hesse had already intimated the introverted, repeatable, "not-self" expression she eventually realized through sculpture in her early wash drawings. One senses, however, that if her aesthetic and her resistance to both anthropomorphism and self-referential traces were heralded by some of her peers, the relationship between her art and her life continued to elude them for some time.

Hesse's mature art differs even more dramatically from Pollock's—and from Johns' for that matter—not only through its centripetal orientation or through her ability to "make Pollock concrete," as Hilton Kramer first suggested with reference to *Metronomic Irregularity II,* but through her ability to reconstruct the relationship between artist as persona and artist as maker.[53] Pollock projected himself onto his surfaces, creating a kind of objective-correlative in which traces of his body (as handprints, for example) often seem trapped. Even Johns, whose "literal" expressionism so excited Hesse early on, persisted in rendering his surfaces into corporeal "skins" from behind which the painter struggles to gaze upon the viewer (and vice versa). In contrast, one can argue that Hesse gradually removed herself from the tangles she persisted in constructing to produce obstinate objects with a life of their own.

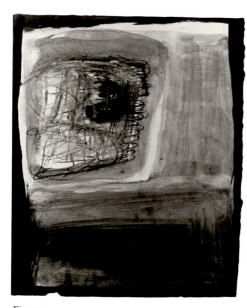

Fig. 30
Untitled, 1960–61
Black and brown ink washes and gouache on paper
10½ x 8¾ in. (26.6 x 22.2 cm)
Private Collection

In this sense, her progression from painted portrait to drawn personage anticipates her later more conscious use of negation as strategy. Allusions to self, or aspects of self, are gradually withdrawn from the tangles and containing forms to which they were once bound. One can, for example, read *Inside I* and *Inside II* of 1967 (fig. 29) as reconstructions of the same form-idea that had infused the ink wash drawing in which a blurry, black, fetal form nests within a skein of rapidly drawn and scraped lines that in turn are massed within a series of concentric boxes (fig. 30; plate 16). In the later objects, the bodily reference has been abstracted, or precipitated out, and charged with a comic weirdness. Another gouache drawing intimates a release of the body from its gestural embodiments as Hesse, or the standing figure she draws triumphantly at the base of the sheet, seems to throw off the tangling mass of lines that hovers near its top edge (plate 15).

One particularly humorous representation of Hesse's freedom from, yet proximity to, her constructs occurs in a very strange and funny photograph of the artist lying

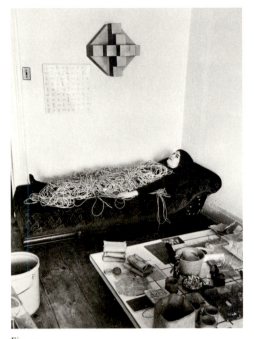

Fig. 31
Eva Hesse, ca. 1968
Reproduced from Bill Barrette, *Eva Hesse: Sculpture,*
Timken Publishers, Inc., New York, 1989, with
permission from The Estate of Eva Hesse

Fig. 32
Sol LeWitt (b. 1928)
*Buried Cube Containing an Object of Importance But
Little Value,* 1968
Steel
Approx. 10 x 10 x 10 in. (25.4 x 25.4 x 25.4 cm)
Collection of Martin Visser, Bergeyk,
The Netherlands

on a brocade chaise longue in her apartment—a psychiatric couch, by the appearance—smiling slyly, an actual pile of coiled rope on her belly (fig. 31). On the wall above are a relief by Smithson and a collage-drawing by Andre. One might even use "clastic"—Andre's term for the provisional, non-fixed, constructive relationships he established in his floor pieces—to describe the relationship between Hesse and her art suggested by this parodic photo. Yet even this term fails to describe the indirect presence Hesse was able to assert in her most mature art.[54]

It is revealing to compare the nature of Hesse's gradual retreat from overt reference to self with LeWitt's far more extreme moves in that direction. The insistent iconoclasm of his later serial and modular works obscures their provocative relationship to his early "camouflage" pieces and such works as *Buried Cube* of 1968 (fig. 32), with its buried objects of "personal, but not material value."[55] These seem to anticipate the purifying transformation into a more abstract, hidden, "delegated" presence. The aesthetic that characterizes this mature work, which borders on the ascetic in its near-total avoidance of any conspicuous evidence of human touch, nevertheless retains a mystical dimension. As in the paintings of Barnett Newman, this implied presence through absence invokes not a corporeal, human presence (except, possibly, at the level of scale: LeWitt, unlike Newman, avoided the monumental), but an abstract projection and concretization of mind. Like Hesse, LeWitt claims that his art comes "from the inside," not the outside.[56] But unlike her, he draws a line between mind and body. Their understandings of "inside" differ as radically as the forms of their art.

These thoughts came to mind during the spring of 1991, when I visited an installation, organized by LeWitt, of Hesse's sculptural series *Metronomic Irregularity I, II,* and *III.*[57] Two of the pieces, the smaller *Metronomic Irregularity I* (plate 96) and *III* (fig. 16), were exhibited as constructed by Hesse in 1966. Her startlingly large *Metronomic Irregularity II,* however, missing from at least the time of her death, was reconstructed by some of LeWitt's assistants. LeWitt has spoken of this piece as "stupendous, probably the most realized of her works." Just experiencing its scale was, indeed, exhilarating, a graphic demonstration of how powerfully shifts in scale can alter perception of the same form. Yet something about the tidiness of this particular reconstruction, its too-clean, too-conspicuous aesthetic, reminded that Hesse was never a conceptual artist. A voice seemed to whisper, "What's wrong with this installation?"

If one has never seen the original *Metronomic Irregularity II* (fig. 33), this is a difficult question to answer. Hesse herself was ambivalent on the subject of both installation and collaboration.[58] On the one hand, the works she produced during the last two years of her life could not have been realized without the assistance of others, and they gained decidedly from that participation. And if only because of its size and weight, the original installation of *Metronomic Irregularity II,* for Lippard's "Eccentric Abstraction" exhibition, required the assistance of Bochner, LeWitt, and possibly Donald Droll.[59] Yet like so much else in the interpretation of Hesse's art, the precise nature of Hesse's engagement in the making of her late work—and its importance to the resultant effect of specific works—remains difficult to pinpoint.

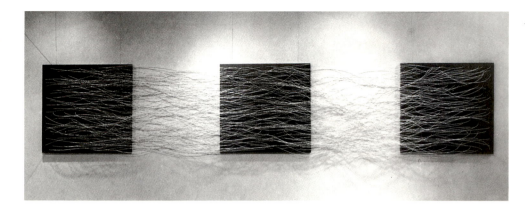

Even without considering the issue of collaboration, I had always thought *Metronomic Irregularity II* to be one of the most anomalous works in Hesse's oeuvre—a true breakthrough piece, perhaps her most conceptual, but one not fully internalized at the time of its making.[60] My earlier reference to jacquard cards (figs. 27 and 28) as a possible source, however indirect and unconscious, stems from my broader belief that Hesse was, at this point, open to a wide range of form-ideas and was aggressively experimental. Experiments in three dimensions often seem to have been followed by drawings that clarified the structural potential suggested by Hesse's initial constructions. A number of sketches that look to be preparatory for *Metronomic Irregularity* are in fact dated to 1967–68 (fig. 34). A work such as *Untitled* (fig. 10), constructed of variously sized bar clamp handles in the fall of 1965 with the assistance of Doyle—less radical than *Metronomic Irregularity,* but also anomalous—seems not to have led directly to new investigations in Hesse's sculpture. But a drawing with pencilled-in cords dangling from the ends of each rod, inspired by the piece, offers an intriguing link between this more mechanical sculpture and such organic pieces as *Ishtar* or *Ennead* of 1965–66.[61]

Hesse seems to have understood *Metronomic Irregularity II*'s power most fully through the title she gave it. On a list of possible titles, she broke up the words "Metronomic Irregularity"—"Met ro nom ic Ir reg u lar i ty"—to make them read onomatopoeically and as a visual correlative to the positive-negative rhythm created through the sculpture's structure.[62]

The magnificent rope piece *Untitled* of 1970 (plate 115)—in my opinion the most inspired manifestation of Hesse's hard-won battle to create a statement at once concrete, expressive, direct, and entirely unaesthetic—is one example of what *Metronomic Irregularity* made possible. It could as well be compared to Warhol's poisoned tunafish can "disasters"—an unexpected outcome of sorts, that turns something commonplace into something absurd—as to Pollock's painterly evocations of "chaos . . . structured as non-chaos," which was Hesse's way of describing what she had learned from him.[63] Though it was constructed collaboratively and has been repeatedly re-installed, it retains a sense of touch and spontaneous construction that keeps its corporeal dimension alive. However complete Hesse's removal of self-reference had become in her late work, there is no evidence that their final forms

could be determined by an idea. Her working method, as she noted to Nemser, remained "contingent."

Hesse's work, in the end, offers none of the ideated clarity or aesthetic transformation of LeWitt. Nor does it provide the transcendence on which the affect of Newman, Pollock, Still, and Reinhardt—to whom Pincus-Witten compared her—ultimately depends. Her persona—or rather the viewer's image and expectation of a strong persona—will continue to attract and charge much of our perception of her art even as the objects remain obstinately "unto themselves." But one of the constants in virtually everything she made was her insistence on a very matter-of-fact, non-mystical, non-heroic art that reveals her quest for what she usually referred to as honesty, her "ick." And getting to "ick" involved an unflinching determination to know both whom she was, and what she was not. Hesse herself gave powerful voice to this recognition in a very moving statement she wrote for LeWitt, at his request:

You asked me to write
Sol, closeness and not knowing enough.
Another's world.
I cannot know your world.
You write the systems,
You set up the grids
You note 1, 2, 3, 4.

I see them.
Your order their order.
Units, strength, cubes, columns—tough stances,
strong

but I see the fragile sensitivity,
the you which is and should be there.

Intuition, idea, concept followed through
no arbitrary choices,
no test
never arbitrary, never decoration.

the strength of vision and soul is there, it must.
we are left ultimately with a visual presence.
why deny that. can't deny that.
It's what we
are left with. A visual presence.
Depth: that too we must be left with.

Sol, there is depth and vision, a presence
art. [64]

Notes

1 When I asked Sol LeWitt if he thought Hesse was engaged in the theoretical discussions about art-making current in the mid-to-late sixties, he replied: "The only word she ever used to describe her art to me was 'ick.'" When I asked if he meant "ick" in the German (a pun on "Ich," or "I") or American (as in "icky") sense, he seemed surprised. "American," he answered after a pause. "Because it's not pure, it's not simple, it's not beautiful." But in a later use of the term, he confirmed what must have been its dual resonance for the artist: "Her 'ick' was getting into herself and her work" (conversation with the author, 19 April 1991).

2 Although most of these paintings are undated—the canvas with the large hat is dated 1960—they are so closely related in focus that I have chosen to read them as a series of ca. 1959–61: between Hesse's receipt of her B.F.A. from Yale and her marriage to Tom Doyle. My conviction that these are self-portraits stems from their uncanny consistency in countenance despite Hesse's highly varied formal treatment of each image. It is supported as well by Dr. Dunkell's recollection that Hesse explicitly described the painting she gave him as a self-portrait.

I first saw these paintings while assisting Bill Barrette and Jane Timken in the early stages of the preparation of Barrette's *Eva Hesse: Sculpture.* Barry Rosen, who oversees the Hesse Estate, showed us a number of early canvases, and I thank him for providing this initial viewing. To Bill Barrette, I owe a deeper debt: without his friendship and support I would not only lack a great deal of information, I may well not have been writing on Hesse at all.

3 The exhibition, "Eva Hesse: Gouaches 1960–61," was a joint venture of the Robert Miller Gallery, New York (winter 1991) and the Renos Xippas Gallery, Paris (spring 1991). The accompanying catalogue included a short, poignant essay by Elizabeth Frank, wonderfully titled "Notes Toward a Previous Life." I should add that while these works occasionally include gouache passages, they are more accurately described as ink wash drawings.

4 Harold Rosenberg, "The Art Object and the Esthetics of Impermanence," in *The Anxious Object: Art Today and Its Audience* (New York: Horizon Press, 1964), 95.

5 John Perreault, "The Materiality of Matter," *The Village Voice* (Nov. 1968): 19. Perreault was reviewing "Eva Hesse: Chain Polymers" at the Fischbach Gallery (Nov.–Dec. 1968), in which Hesse exhibited eight major works. He went on to claim that "Because of their harsh illegibility they provoke bizarre anthropomorphisms."

6 Lippard's biography reached an impressively wide-ranging readership. Now out-of-print, it nevertheless remains the text to which most people wishing to learn about Hesse turn first. It is also an unusually rich example of a first-generation feminist document.

There are several references to Hesse's "anticipation" of the potential half-life of her materials in Lippard, in the Hesse/Nemser transcript, and in Hesse's diaries. In regard to such "sleeve" units as *Untitled* of 1968 (Barrette, 196–97) and *Untitled* of 1967 (Barrette, 200–201), Lippard, for example, reports that "She anticipated that the sleeves would collapse, as they have, but said it would be all right" (123).

7 I want to thank Naomi Spector and Stephen Antonakis for their insights on this subject especially, in a conversation with the author, 11 April 1991.

8 A comparable claim could be made about Robert Smithson, whose premature death in 1973 likewise complicated the status accorded him in the seventies.

9 Like the famous posthumously published diary of the anthropologist Bruno Malinowski, Hesse's was a diary "in the strict sense of the term," a "chronicle much more difficult to write with sincerity than a mere recording of the day's events." Never intended for publication, both offer insights at once invaluable and highly controversial. See Raymond Firth, "Introduction," in Bruno Malinowski, *A Diary in the Strict Sense of the Term* (New York: Harcourt, Brace and World, Inc., 1967), xvii.

10 Hesse's statement of June 1969 is cited in full in Lippard, 165.

11 Sol Lewitt, in *Sol LeWitt,* ed. Alicia Legg (New York: The Museum of Modern Art, 1978), 114.

12 *Sol LeWitt* (The Hague: Gemeentemuseum, 1970). The exhibition opened on 25 July. See Enno Develing, "Thoughts on Sol LeWitt's Work," in Ibid., in which he cited a letter from LeWitt dated 2 June 1970: "Dear Enno, Eva Hesse has died in New York. She was my best friend and a great artist. I want to dedicate my show in The Hague to her and on the first page of the catalog to say 'this exhibition is for Eva Hesse.'" He explained he was doing a wall-drawing for her in the Galerie Yvon Lambert and he hoped it could be used in the catalogue "on the first right hand page after the dedication page. The drawing is

in black lead and free hand (no straight lines) vertical lines, very many. I want to do this drawing again in Den Haag."

Richard Serra also dedicated a piece to Hesse, *Splashing with Four Moulds, to Eva Hesse* (1969), which he illustrated in his article, "Play It Again, Sam," *Arts Magazine* (Feb. 1970).

13 See *Flyktpunkter/Vanishing Points,* org. Oleg Granath (Stockholm: Moderna Museet, 1984). The exhibition included work by Bochner, Doyle, Graham, Hesse, LeWitt, Smithson, and Ruth Vollmer. Vollmer's importance in this group, to Hesse and Smithson especially, merits more attention. She has been recognized as a kind of maternal figure for Hesse—Lippard, for example, notes that Vollmer had the same first name as Hesse's mother—but little has been said on their respective approaches to, and expectations of, their art.

14 Lippard's dedication of her biography of Hesse reads: "To Eva Hesse and the friends who supported her, and to Robert Smithson, who was one of them."

15 Lucy R. Lippard, "Intersections," in *Flyktpunkter/Vanishing Points,* 11.

16 On a page devoted to some thoughts on Hesse and feminism, Lippard published Hesse's note to Nemser, as well as a letter to fellow-artist and friend Ethelyn Honig, in which Hesse detailed the difficulties—primarily psychological—that she felt confronted any female artist; see Lippard, 205. The ideas Hesse considered there—that great art requires a "single-mindedness" and "self-confidence" unavailable to most women because of the biological and cultural "sidetracks" they must endure—owed much to Simone de Beauvoir's conception of ambitious women in a man's world as "The Second Sex." Lippard acknowledged Hesse's appreciation of de Beauvoir's eloquently argued beliefs; and she further attested to the pain Hesse felt at "the injustices she herself had suffered . . . [in] not being taken as seriously as her male colleagues." But she challenged Hesse's assertion that "excellence has no sex"; and resisting the artist's downplaying of any primarily sexual reading of her work, she ignored Hesse's capacity to accept her own sexual identity without making it either the subject or syntax of her art.

17 There is an irony at play here. The facts of Hesse's background were not widely known until the publication of this first version of the Nemser interview: "An Interview with Eva Hesse," *Artforum* 7 (May 1970): 59–63. So Hesse's biography,

her life story, became perceived as a factor in her art only at the time of her death. Nemser subsequently published a second version of the interview as "Eva Hesse: Her Life," in *The Feminist Art Journal* 2 (Winter 1973): 13–14, for which she wrote an extremely personal prologue, "My Memories of Eva Hesse," 12–13.

18 Pincus-Witten was a panelist in the symposium "Art Criticism '72: Biography is In; Formalism is Out," held at the Art Students League in New York on 22 Feb. 1972 and reported in *The Feminist Art Journal* 1, no. 1 (1972): 5.

19 Robert Pincus-Witten, "Eva Hesse: More Light on the Transition from Post-Minimalism to the Sublime," in *Eva Hesse: A Memorial Exhibition* (New York: The Solomon R. Guggenheim Museum, 1972). This was an expanded version of his earlier article—"Eva Hesse: Post-Minimalism into Sublime," *Artforum* 10 (Nov. 1971): 32–44—based on access to what Pincus-Witten described as "a considerable amount of fresh material," most of which had been made available to him through the intervention of Donald Droll, Hesse's friend and primary dealer at the time of her death.

20 Not stopping there, Pincus-Witten went on to allow that without the traumatic events provoked by her loss of father and husband, without her decision to wield art as "her weapon" against madness, Hesse's art "might have remained a matter of local interest." However outrageous, this is an interesting observation that helps differentiate Hesse from, say, Sylvia Plath, who one could argue failed in her efforts to extricate her art from her life (or vice versa.) It avoids the emphasis on Hesse's behavioral "symptoms"—the neurotic neediness Lippard couldn't dismiss—to focus instead on her ability to counter these potentially debilitating, real-life circumstances through her tremendous ambition as an artist.

21 Soren Kierkegaard, *Repetition: An Essay in Experimental Psychology,* trans. Walter Lowrie (New York: Harper Torchbooks, Harper & Row, 1941), 33–34.

22 Most of these artists were featured in "New Images of Man," Peter Selz's exhibition at the Museum of Modern Art in the fall of 1959. See note 44 below for more on this exhibition and its possible impact on Hesse.

23 Samuel Beckett, *The Collected Works of Samuel Beckett: Stories and Texts for Nothing* (New York: Grove Press, Inc., 1967), 79; originally published as *Nouvelles et textes pour riens* (Paris: Les Editions de Minuit,

1958). "Text For Nothing 1" first appeared in *Evergreen Review;* no date given.

24 In her 1959–60 diaries, Hesse described a recurring dream in which she arrived at her own wedding [she was not then married] unprepared and had to borrow her sister's wedding gown; see, for example, the entry of 13 June 1960.

25 Cutting, often in weird, bloody scenarios, was also a recurrent dream image recorded in Hesse's diaries, not coincidentally closer to the time of the *Accession* series, between 1964 and 1966. Again, if there is a correlation between some of Hesse's recorded dream-imagery and a motif in a given piece, it is equally significant that she went on to reject, or abstract, such literal associations.

26 Artist statement, *New Images of Man* (New York: The Museum of Modern Art, 1959).

27 In this context it is interesting to note that Smithson's early work was recently "unearthed" and heralded as an antidote to the aestheticizing emphasis that results from an isolated veneration of his large earthworks, in the excellent exhibition "Robert Smithson Unearthed: Drawings, Collages, Writings," curated for Columbia University's Wallach Art Gallery by Eugenie Tsai and held in the fall of 1991. See also Tsai's catalogue of the same name (New York: Columbia University Press, 1991). Yet protests about the forced removal of Smithson's early work from the market and press are problematic, as it was Smithson himself—and posthumously his closest supporters and dealers, who now celebrate the work's rediscovery—who chose not to exhibit it. Masterpiece is not the only market strategy; early work serves as the perfect chaser for a market gorged on the late, great work of a celebrated artist.

28 Diary entry of 5 Feb. 1965.

29 Hesse was first introduced to Albers' ideas at Cooper Union by one of his former students, the painter Neil Welliver.

30 Josef Albers, as quoted in, first, Mary Emma Harris, "Josef Albers: Art Education at Black Mountain College," in *Josef Albers: A Retrospective* (New York: The Solomon R. Guggenheim Museum, 1988), 55. All subsequent quotations are from Albers, *The Interaction of Color* (New Haven: Yale University Press, 1963).

31 Quotations from Irving Petlin are from two conversations with the author, 8 and 10 March 1991.

32 This is Petlin, again. Hesse's trauma with color has been noted by many of her friends. Naomi Spector recalled Hesse once showing her a box of brilliantly col-ored threads and remarking, "Look at this. Look how beautiful. I could never make these colors." Doyle remembers Hesse chastising him about the brightly colored paint he used in Germany: "'You don't wear those colors . . . ,' she said" (see note 41 below). When I asked LeWitt about Hesse's problems with color, he said simply, "Her avoidance of color probably has everything to do with being a student of Albers."

33 Hesse/Nemser transcript.

34 According to Katherine Cline, who was Hesse's roommate at Yale, Hesse was one of the few students to present the same paintings to her various professors, a fact that impresses all the more given the politically charged climate (conversation with the author, 13 Sept. 1991).

35 Hesse/Nemser transcript. Hesse's resistance to painting may also have grown out of her skepticism about the possibility of achieving the honesty she sought within the parameters of traditional, two-dimensional painting. This is why Lebrun's comments seem more descriptive of Hesse's work in latex and epoxy than oil on canvas. When Nemser responded to Hesse's comments on process—asking, "Isn't there Abstract Expressionism in what you are doing? The idea of exploration, of letting the material take its form in the way the Abstract Expressionist [painters] allowed the paint to spread out?"—Hesse replied, "Only maybe the good ones really allowed that to happen. I think the others took on a lot of the mannerisms."

36 It was Sheila Hicks, a fiber artist and fellow student of Hesse's at Yale, who recognized the name Kroll in Hesse's diaries and suggested that Hesse may have worked for his textile design firm. I thank her for this very rich observation.

37 Quotations from Marjorie Kronengold are from a conversation with the author, 18 Feb. 1991.

38 Diary entry of Tues. eve. [spring 1960].

39 On the relationship between Warhol's early training in industrial/commercial design and advertising and his development as an independent artist, see especially Donna De Salvo, *Success is a Job in New York: The Early Art and Business of Andy Warhol* (New York: Grey Art Gallery; Pittsburgh: The Carnegie Museum of Art, 1989). On Serra's exposure to steel milling, see "Richard Serra: Sight-Point '71–'75/ Delineator '74–'76," A radio interview by Liza Bear, 23 Feb. 1976; first published in *Art in America* (May/June 1976); reprinted in *Richard Serra: Interviews, Etc. 1970–1980,*

written and compiled in collaboration with Clara Weyergraf (Yonkers, NY: The Hudson River Museum, 1980), 62ff. Andre has made repeated reference to his years spent working in the railroad yards of Long Island as an influence on his later art.

40 Quotations from Rosalyn Goldman are from a series of tapes she made, now in a private collection, to which I had access while assisting Barrette in the preparation of *Eva Hesse: Sculpture.*

41 Quotations from Tom Doyle are from two conversations with the author, 20 and 26 March 1991.

42 Harold Rosenberg, "The De-Definition of Art," in *The De-Definition of Art: Action Art to Pop to Earthworks* (New York: Horizon Press, 1972), 14.

43 Undated entry [ca. 1968–69], on loose sheet of small, six-ring notebook paper.

44 The existentialist affinities of Hesse's art-life orientation relate not just to Beckett or Sartre, whose *Being and Nothingness* is often cited with reference to her, but to Paul Tillich, whose concept of "The Courage to Be" closely resembles what seems to be the driving force behind Hesse's art; see Paul Tillich, *The Courage To Be* (New Haven: Yale University Press, 1952.) Not coincidentally, Tillich's thinking also provided the philosophical basis for Peter Selz's important but controversial exhibition, "New Images of Man," at the Museum of Modern Art in the fall of 1959. Challenging the supremacy of abstraction, it highlighted art that was both figurative and morally committed. The timing of the exhibition—coinciding with Hesse's first months in New York as an independent artist after graduating from Yale—as well as its thesis and the artists it included —Dubuffet, Giacometti, Pollock, de Kooning, and Hesse's teacher Lebrun among others—seem to have had some serious impact on her. See note 22 above.

45 Hesse/Nemser transcript. Beckett's ability to convey a determination to "go on," without ever confusing this determination with hope, has often been cited as a characteristic of Holocaust survivors. See, for example, Michael Berenbaum, *After Tragedy and Triumph: Modern Jewish Thought and the American Experience* (Cambridge: Cambridge University Press, 1990).

46 See note 40 above.

47 This connection requires some clarification. Goldman was referring to Hesse's response to Andre's brick-piece installation at the 1966 "Primary Structures" exhibition at the Jewish Museum. Hesse's comments to Nemser, as quoted in the *Artforum* version of the interview, referred to his plate pieces: "I feel very close to Carl Andre. I feel, let's say, emotionally connected to his work. It does something to my insides. His metal plates were the concentration camp for me. They were those showers that they put on the gas." The transcript itself makes reference to this emotional response (the first three sentences of the quote appear), without specifying the concentration camp.

48 Credit for Hesse's "release" from painting usually goes to the lessons she learned from minimalism. In retrospect, this seems only a partial explanation. Even LeWitt, who had much to do with pointing Hesse in that direction, acknowledges: "There was an impetus at the time that she benefitted from, but it would have happened anyway. It just enlarged the scope of her own inquiry." He sees that impetus as latent in the gouache drawings, but "they didn't flower immediately. She needed something to wrap it onto, to enlarge it from the small and intimate. She had to wrap her own statement around some idea —e.g. a cube—but she subverted the minimalist unity that they were born with" (conversation with the author, 19 April 1991).

49 This is how Neil Simon recently defined Jewish humor on an NET special on the subject.

50 On the meaning of "ick" in Hesse's art, see note 1 above. Smithson is quoted in Lippard, 84.

51 "Quasi-Infinities and the Waning of Space: For many artists the universe is expanding; for some it is contracting," *Arts Magazine* (Nov. 1966); reprinted in *The Writings of Robert Smithson*, 32–35. Drawing on Judd's 1964 essay "Specific Objects," and looking to some contemporary artists for alternative paradigms and metaphors, Smithson here attempted to come to terms with "The Anatomy of Expressionism," the "biological metaphor," and "Time and History as Objects," as part of a larger effort to reassess both abstraction and expressionism.

52 Conversation with the author, 19 April 1991.

53 Hilton Kramer, "It's Art But Does It Matter?" *The New York Times* (25 Sept. 1966): section 2, pp. 27–29.

54 Hesse's receptivity to Andre's floor pieces has been mentioned by many—Lippard as well as Grace Wapner among others. In alluding to Hesse's attraction to Andre's "clastic" manner of laying pieces down together, I am suggesting that she was also responding to the underlying eroticism that Andre has long claimed is inherent to

all art. An early collage of Andre's—*Limbs of 1965*—makes this connection graphically and indicates just how successful Andre was in retaining a sense of the body without any anthropomorphic references in his later sculpture. This fact must have impressed Hesse, whose sculpture is also charged by an erotic dimension. One wonders if in fact Hesse read an erotic dimension into Andre's work, as well as an emotional response that she associated with the concentration camps, as she had done earlier in response to Lebrun's more direct allusions to specific camps. See note 47 above.

55 Doyle has suggested that some of LeWitt's early striped pieces might be compared with Hesse's admittedly more obsessive use of wrapping and binding in her cord reliefs.

56 Quoted in Lucy Lippard, "The Structures, The Structures and the Wall Drawings, The Structures and the Wall Drawings and the Books, " in *Sol LeWitt,* ed. Alicia Legg, 26.

57 This was held at the Stein-Gladstone Gallery, Mercer Street, New York, April–May 1991.

58 Barrette says of *Untitled* (plate 115): "I have come to the conclusion that there is no 'right' way to install the work"; he adds that Hesse's annotated drawing of November 1969 for the work (now in the Timpanelli Collection), supports this conclusion (234). Hesse herself wrote in 1968, in reference to *Accession* and *Repetition Nineteen III:* "I don't ask that *Accession* be participated with other than in thought. I don't ask that pieces be moved or changed; only that they could be moved and changed. There is not one chosen preferential format, other than the specific idea inherent in the specific piece" (notation dated June 21 regarding her participation in "Directions I: Options" at the Milwaukee Arts Center.

59 Hesse was probably assisted only in mounting the piece onto the wall.

60 My sense of *Metronomic Irregularity II* as anomalous would seem to be corroborated by the general interpretation of the piece as one marking not only a "big change in terms of scale and orientation," but an "emergence from a long and difficult period of self-absorption and confinement" (Barrette, 100). It is also worth recalling Lippard's surprise at *Metronomic Irregularity II* precisely because it was constructed for a show she had conceived around what she had thought to be characteristics then central to Hesse's art: "At the time, I was somewhat surprised at the pre-

cision of *Metronomic Irregularity II* . . . I was even a little disappointed, selfishly, not because the piece wasn't beautiful, but because I had conceived this exhibition in terms of the more organic character of Hesse's work . . . *Metronomic Irregularity*'s delicacy and assurance, its understatement and focus on structure, put me in the frustrating position of a critic whose generalizations have been proved untenable" (Lippard, 83).

61 A detail of this drawing is illustrated in Barrette, 52.

62 Hesse's use of her titles as a means of coming more fully to terms with what she had discovered within a given piece is a topic in and of itself. While acquaintances vary in their interpretation of the role these titles played for her, all evidence points to Hesse titling her works after they were made.

63 Eva Hesse, statement in "Fling, Dribble, and Dip," *Life* 68 (27 Feb. 1970): 66, cited in Lippard, 172.

64 This statement is among the loose sheets on file in the Hesse Archives at Oberlin. As with most of these loose sheets, it was undated and lacked any label or inscription. Neither LeWitt nor anyone immediately connected with the archive has been able to identify the text, but its style—both its configuration as a poem and the anticipation of a reader that that configuration implies—differs radically from Hesse's regular journal entries. It is much closer to the statements Hesse wrote for *Contingent* or for LeWitt's Gemeentemuseum retrospective catalogue and would therefore seem to date from 1969 or 1970. My own opinion is that this was an early version of the letter-poem Hesse eventually submitted to the LeWitt retrospective catalogue. However differently these two texts read, it would not be untypical of Hesse to move from a more extended to a more condensed expression.

THE WOUND AND THE SELF:

Eva Hesse's Breakthrough in Germany

Maria Kreutzer

In June of 1964, Eva Hesse traveled to Germany with her husband Tom Doyle at the invitation of Arnhard Scheidt, a textile manufacturer and art collector who was enthusiastic about Doyle's sculpture. Far removed from the intensity of the New York art scene, the two lived for fourteen months in semi-rural isolation in Kettwig-am-Ruhr, a suburb of Essen. Yet only a dozen miles away lay the city of Düsseldorf, then the focus of artistic activity in West Germany and to this day one of the most important centers for established and avant-garde artists alike.

In the mid-1960s, the diversity of Düsseldorf's art scene assured its vitality and increasing stature. Joseph Beuys, who in 1961 at the age of forty had been appointed Professsor of Monumental Sculpture (Professor für Bildhauerei) at the Staatliche Kunstakademie there, made full use of the advantages of his position to establish contact with a wide range of local and international artists.[1] Many of the most innovative of these—including Robert Morris—exhibited their work at the gallery of Alfred Schmela, a strong advocate of avant-garde art.[2] Important Fluxus events, greatly influenced by John Cage and involving, notably, George Maciunas and Nam June Paik, were staged in Düsseldorf between 1962 and 1964.[3] And at the time of Hesse's stay, the founders of the Zero group, Otto Piene and Heinz Mack, together with their close associate Günther Uecker (whose work would be of special significance to Hesse), were perhaps the most widely known and provocative members of this extensive artistic community. As their reputation grew, they attracted many like-minded figures to exhibit in Düsseldorf, including Arman, Pol Bury, Piero Manzoni, Jesús Rafael Soto, Daniel Spoerri, Jean Tinguely, and Yves Klein, who with Lucio Fontana had exerted a major, formative influence on Zero art in the late 1950s. Piene, Mack, and Uecker's renown in particular was assured when their work drew considerable acclaim at "Documenta 3," the 1964 international exhibition in Kassel.[4]

While collaboration was central to the international art scene in the 1960s, German artists were in fact obsessively determined to reestablish their own artistic heritage, which had been disrupted by the war and subordinated to America's increasing economic and cultural hegemony. It was Beuys whose work would eventually clarify this objective and serve as a model for its achievement. By the end of the sixties, he had begun to establish himself as the cult figure and teacher—in his words, the "shaman"—who would lead German art and society out of the trauma of the past

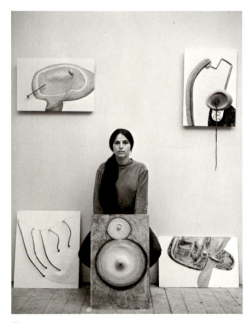

Fig. 35
Catalogue cover, "Eva Hesse: Materialbilder und Zeichnungen," 1965
© Manfred Tischer, Düsseldorf
Clockwise from u.l.: *Legs of a Walking Ball, An Ear in a Pond, Two Handled Orangekeyed Utensil, Ringaround Arosie, Tomorrow's Apples (5 in White)*

into a healed present. Central to Beuys' philosophy were the inseparability of art and life and the assertion that art is, by its very nature, inflected with personal, autobiographical meaning. Yet his intensely poetic and self-referential imagery, rooted in the German Romantic notion that everything is necessarily complemented by its opposite, assumed an insistent universality as well. Through it Beuys explored the regenerative power of organic, biological cycles and attributed to the work of the individual a collective and ultimately healing role.

Hesse, whose art and life spanned the poles of American and European experience, found in Germany both an opportunity to come to terms with the innovations of Pop art and minimalism, which dominated the New York art scene, and exposure to alternative ways of thinking about art that would prove essential to the resolution of her mature style. The months she spent there also led her to delve into deeply buried childhood memories: born of Jewish parents in Hamburg the year after the Nuremberg Laws denied citizenship to Jews, she was only three when her family fled a Nazi pogrom and resettled in New York. The fears and insecurities she suffered as a very young child left an indelible print on the rest of her life. An artist's need to retrieve and to repeat, or "reenact," such formative events and experiences plays a fundamental—if often underestimated—role in art-making.[5] And the ability to effect such a retrieval, to reconcile one's past and present (unconscious and conscious) selves in one's art, depends on the kind of leap in the dark—or breakthrough—that Hesse dared in Germany. While her most literal and obvious breakthrough came in her move from two to three dimensions (fig. 35), it is equally apparent that in her exposure to avant-garde German art Hesse made an even more fundamental breakthrough, finding in it a model for her own exploration and pursuit of a sense of wholeness or "self" in her art.

It took some time for Hesse to establish links with Düsseldorf's lively local scene. When she visited "Documenta 3" less than three weeks after arriving in Germany, the paintings of the classic French modernist Fernand Léger seem to have made as strong an immediate impression on her as did contemporary German art.[6] Hesse's enthusiasm for Léger—she continued to admire his work at exhibitions in Paris and Basel that fall—is not altogether surprising. Fresh from New York, she must have been aware that he was a powerful source of inspiration for American Pop artists.[7]

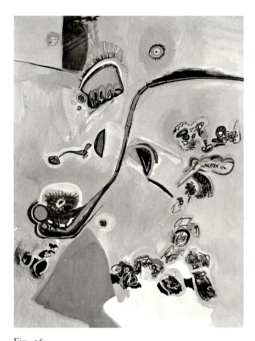

Fig. 36
Untitled, 1964
Oil on canvas
81½ x 60⅔ in. (207 x 154 cm)
Collection of F. A. Scheidt, Kettwig

While the very first oil painting Hesse completed after settling into her Kettwig studio depicts a torrent of emergent figurative forms—among them eyes, ears, hands, and sexual organs—that seem to have nowhere to settle within the picture plane (fig. 36; plate 10), her final efforts at painting there are strongly reminiscent of Léger's art. *Untitled* of 1964 (fig. 37; plate 11), for example, recalls both his mechanical, inorganic shapes and his handling of paint. The diffuseness characteristic of much of Hesse's earlier work is curbed by stricter compositional principles that she seems also to have adapted from Léger. The juxtaposition of a number of clearly defined color fields divides the painting into several more discrete areas. And black lines contribute to an overall sense of stasis by articulating a single color field or emphasizing the separation of one color from another.

The fractured space, forms, and rhythms in both paintings, however, suggest a kind

of dismemberment or—to use the term coined by French psychoanalyst and theoretician Jacques Lacan, in his account of the predicament of the eighteen-month old child—a kind of "fragmented body" (*"image morcelée du corps"*).[8] Lacan argues that the infant is caught between a symbiotic relationship with its mother, on whom survival depends, and an equally necessary but threatening process of severance. Yet for the acquisition of language, which is a process of symbol-creation, the developing ego requires a narcissistic, fictive ideal of wholeness. In this respect, the ego itself is a work of fiction, forever rooted in a structure of misapprehension.

This essential dichotomy is invoked whenever extreme experiences assail one's false and hence fragile sense of wholeness. One could argue that in Hesse's case, the assault on her fictional notion of unity became the motive that drove her to create. In her art-making, as in her life, the chaotic and the rigorous confront each other and aspire to conjoin. Doubt and uncertainty haunted her, often obstructing her sense of achievement even as she hoped to refute them in her work, if not herself. So it was that shortly after arriving in Germany, she confessed in her diary that "I still am agonized about my painting but at least now the agony is in and about work. And if I work that will most probably change into another kind of feeling. And if it remains it is better placed there, than back into myself."[9]

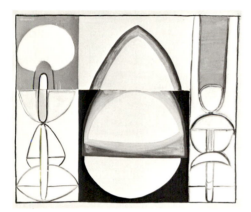

Fig. 37
Untitled, 1964
Oil on canvas
34½ x 41½ in. (87.5 x 104.5 cm)
Collection of F. A. Scheidt, Kettwig

Hesse had studied painting at Yale, and despite ongoing frustration and dissatisfaction with her work in oil, it remained her primary concern and objective when she arrived in Germany. Indeed, she cannot be counted among those artists of the sixties —including Sol LeWitt, Donald Judd, and Robert Morris—whose unequivocal rejection of painting signaled their subordination of style to such varying imperatives as systematization, materiality, and ideation. Having struggled unsuccessfully for years to find her own voice in painting, Hesse was deeply conflicted about abandoning that goal. Her first three-dimensional piece, begun on December 4, 1964, involved a screen through which she threaded pieces of plaster-soaked cloth.[10] Although she asserted in her diary that "For me painting has become [anti-climactic] . . . The Art, the history, the tradition is too much there," she was anxious about this new direction in her work, writing to Rosalyn Goldman a few days later that "I already question [its] validity, worth, meaning, antecedent etc."[11] Refocusing her efforts on drawing, Hesse did not commit herself to working in three dimensions until the following spring.

While the mechanical, inorganic theme in Léger's work first caught Hesse's imagination in Germany, it was the discarded machine parts and other scrap materials in the textile mill where she had her studio that provided an essential stimulus from the real world, first for the "machine-part" drawings she began to make early in 1965, and ultimately for her reliefs. Hesse's work on the latter in fact paralleled and was perhaps precipitated by her cutting up and collaging of the former. It was through this literal destruction of the picture plane that she seems to have found a definitive way out of painting.

The fourteen reliefs Hesse produced between March and July of 1965 combine found and constructed elements in an essentially rectilinear format—only *Cool Zone* (plate 84) broke totally with the "easel" model. Despite whimsical nuances, their artificial

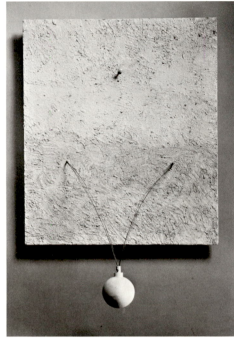

Fig. 38
C-Clamp Blues, July 1965
Painted concretion of various materials, metal wire,
painted bolt, and painted hollow plastic ball with
rattle on particle board
25⅝ x 21⅝ x 1½ in. (65.1 x 54.9 x 3.8 cm)
The Estate of Eva Hesse. Courtesy Robert Miller
Gallery, New York

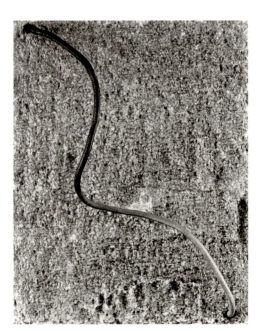

Fig. 39
Up the Down Road, July 1965
Aluminum paint, tempera, styrofoam, and cloth-
bound cord on masonite
25¾ x 19¾ x 7½ in. (65.4 x 50.2 x 19 cm)
The Estate of Eva Hesse. Courtesy Robert Miller
Gallery, New York

and dissonant colors—characteristic of her earlier drawings and paintings—
contribute to a markedly distancing effect that emerges as well from the sexual con-
notations implicit in Hesse's juxtaposition of mechanical and organic forms. Hesse
extolled her machine drawings, and by extension her reliefs, as "real nonsense," thus
underlining the transformation of reality into a semantic dimension and locating the
construction of meaning in an oxymoron that emphasizes her work's underlying
absurdity.[12] Her improvisations around mechanical elements, which she either
used—often quite mimetically—as the source material for drawings, or incorpo-
rated directly into her reliefs, display a strong, innate sense of the absurd that was
certainly reinforced by her reading of Samuel Beckett and Franz Kafka. Clean, hard
lines, related to those in technical diagrams, depict useless machine parts in her
drawings, while in the reliefs such soft materials as cord and papier-mâché fulfill a
similarly inverted, illogical function. The more abstractly—that is to say, free-
ly—such objects developed within the poetic, associative world Hesse began to
carve out in Germany, the more they prefigured work she did after her return to
New York. Hesse herself charted this development in her 1970 interview with Cindy
Nemser:

*I varied materials a lot, but they would always be built up with the cords, and I kept the scale. In
Europe they were fairly small, and when I came back to America, I varied the materials even
further and didn't keep the rectangles . . . and then they just grew, they came from the floor, the
ceiling, the walls, then it just became whatever it became.*[13]

Hesse kept pictorial incident to a minimum in *C-Clamp Blues* (fig. 38; plate 86) and
Up the Down Road (fig. 39), the two reliefs that most clearly anticipate the formal and
thematic concerns she would explore in *Hang Up* of 1966 (plate 91), which she
described as her first important work. In each of the two reliefs, a frameless support
serves as a neutral ground from which more active elements project or hang. A small
pink bolt firmly affixed to the support in *C-Clamp Blues* acts as a subtle counterpoint
to the larger, potentially mobile ball suspended from v-shaped wires; and in *Up the
Down Road,* a purple, painted cord describes a curve as it emerges from and reenters
the support at its upper left and lower right corners. With *Hang Up,* Hesse's subver-
sion of the conventional relationship between picture plane and frame is far more
explicit. The frame, that which was traditionally peripheral or extraneous, is here
privileged. Recalling the cord in *Up the Down Road,* a cord-wrapped steel tube pro-
jects from the upper left, loops down to the floor, and reenters the frame at the lower
right. This loop might be taken to indicate an empty spot on which the viewer could
stand. It further signifies painting's demise as a medium too limited to contain
within its frame the meaning and absurdity of Hesse's art.

Discussing *Hang Up* with Nemser, Hesse referred to its affinities with her German
work, acknowledging that the breakthrough in her art began with her reliefs: "It is
like those things that I did in Europe that come out of nothing and are very surreal
and yet very formal." Further asserting her work's uniqueness, she allowed that "All
I wanted was to find my own scheme. My own world. Inner peace or inner turmoil
but I wanted it to be mine."[14] Latent in this statement is the fact that Hesse's German
work represented an encounter between Pop art and minimalism. Recalling Lacan's

Fig. 40
Günther Uecker (b. 1930)
White Picture, 1959
Nails on canvas on wood
21¾ x 23¾ in. (55.5 x 60 cm)
Kaiser-Wilhelm-Museum, Krefeld

Fig. 41
Günther Uecker (b. 1930)
Cork Picture II, 1959–60
Cork on canvas, overpainted with white binding
paint
39 x 39 in. (100 x 100 cm)
Kunstmuseum Düsseldorf

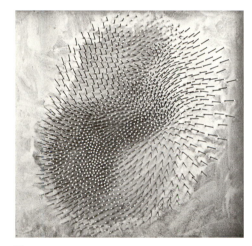

Fig. 42
Günther Uecker (b. 1930)
Greenbox II, 1962
Nails on canvas on wood, paint
42½ x 42½ in. (108 x 108 cm)
Wissenschaftliche Sammlung der Landesregierung,
Düsseldorf

evocation of the fragmented body, her quest for something of her own involved a reconciliation of opposites, of conscious self and its elusive, non-identical but complementary "other": the unconscious. While Hesse's insistent embrace of such polarities—of form as well as meaning—relates to the existential pairing of extremes that implode into the absurd, it suggests parallels as well to Beuys' emphasis on art's transformative power, its ability to achieve a balance between past and present, the material and the spiritual, the personal and the universal. For Hesse, too, art and life were linked in an almost mythical way. It is hardly surprising, then, that she sought to give expression to unconscious material through her psychotherapy and diary-writing as well as her art.

Hesse's relationship with minimalism in particular was insistently and irrevocably problematized by her experience in Germany. In its absolute negation of emotional and subjective content as well as its willful embrace of the anonymity of industrial fabrication, minimalism invoked a literal shape that can be described as the inorganic, the non-conscious, or the dead. It was the strict minimalist ideal to leave a geometric form with all its purity intact. Fortuitous, anomalous elements were subordinated to hard, inflexible structure. LeWitt's cubes, Judd's metal boxes, and Carl Andre's slabs do not invite the viewer's subjective participation: at no point does the subject, in the sense of the "self," acquire a transcendental status or take precedence over the object. By visualizing this loss of subjectivity and the increasing anonymity of the artist's process, minimalism implicitly embodied the wound of Western civilization. This was an essential theme for Hesse as well; but her European affinities are apparent in her use of wounds and lesions to *counter* rather than express the inorganic and insentient. And whereas minimalism used repetition and serial structure to *eschew* opposition in favor of structural organization, Hesse embraced both repetition and the paradigm of polar opposition to suggest variation as well as the process of transformation. Her deeply personalized feeling for materials shared much with Beuys and the artists of the Zero group, particularly Uecker: it was organic, visceral, and ultimately symbolic.

Inspired in part by their fascination with machines and serial structures, the Zero artists rejected the hierarchy of painting in favor of architectural designs and envi-

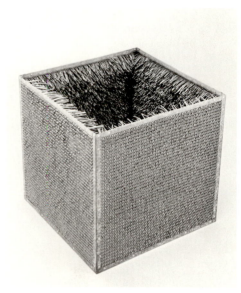

Fig. 43
Accession II, completed April 1969
Galvanized steel and plastic tubing
30¾ x 30¾ x 30¾ in. (78.1 x 78.1 x 78.1 cm)
Detroit Institute of Arts, Founders Society Purchase,
Friends of Modern Art Fund, and Miscellaneous
Gifts Fund

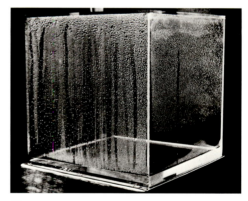

Fig. 44
Hans Haacke (b. 1936)
Condensation Cube, 1963/65
Acrylic plastic and water climate in area of display
12 x 12 x 12 in. (30.5 x 30.5 x 30.5 cm)
Courtesy of John Weber Gallery
© Hans Haacke/VAGA, New York 1991

ronments in which such contrasting elements as light and shade, noise (or motion) and stillness, immateriality and gravity, were made to merge and dissolve. Speaking on behalf of the group, Piene described "the purity of color, the workings of natural processes, the freedom of the new spatial sense, and the fascination of light" as the forces that "define the direction of our efforts."[15] Their hard-won participation in "Documenta 3" drew considerable attention to their work and perhaps encouraged Hesse's eventual abandonment of painting. Günther Uecker's nail objects (figs. 40 and 42), three of which Hesse would have seen at "Documenta 3," seem to have been of particular importance to her later work.[16] Evolving from the all-white dot pattern reliefs Uecker began to make with such materials as cork in 1957 (fig. 41), they paradoxically both established and disrupted a geometrical order. The optical effect of these objects, in which the structural significance of the interstices was equivalent to that of the nails themselves, is itself a play on opposites: of light and shadow, motion and stillness, reality and illusion. Transformation is implicit not only in this vibratory appearance but in the works' construction and conception as well. For the nail, which had great symbolic and material significance for Uecker, is both the material guarantor of each object's concrete reality and the conceptual purveyor of its own inverse: the hole, the lack, the wound.[17]

Hesse's sculptures and drawings came closest to Uecker's work between 1966 and 1967. Included in this category would be *Cincture* as well as a number of drawings which emphasize a circular form. Other works, such as *Accession II* (fig. 43; plate 108) also recall Hans Haacke's *Condensation Cubes* of 1963–65, which Hesse most likely saw on her numerous visits to Haacke's studio in Cologne.[18] Just as the Zero artists like Uecker were engaged with transformative natural processes, so too was Haacke concerned in his *Condensation Cubes* with the maintenance of changing states: often biological or physical systems subject to transformation, as in water changing into mist, ice, or droplets (fig. 44). Hesse, however, addressed primitive and unconscious levels of awareness that do not belong exclusively to these realms of phenomenological or conscious perception. Her work persistently draws one's attention inward, not only to the mind's unconscious, but to the body turned inside out, flayed and exposed. The galvanized steel exterior of *Accession II,* for example, is perforated by a regular array of holes, so that inside and outside seem to change places. Within this artificial container, inorganic matter takes on an alarmingly animate presence. The dense, spiny crop of plastic tubes suggests a sense of wounding which is far closer to the sentiment conveyed by Uecker's nail objects than to the cool objectivity of Haacke's process-oriented *Cubes.*

Ultimately, Hesse's preoccupation with polarities, of self as well as materials—hard and soft, technological and natural, inorganic and organic—comes closest to the principles guiding Beuys' art. His concepts of the "Expanded definition of Art" and "Social Sculpture" purposefully conjoin mythic and rationalistic elements. If these at first seem wildly disjunctive, they in fact demonstrate the essential polarity that distinguishes the human condition. Beuys' World War II service in the German Luftwaffe certainly contributed to his preoccupation with the themes of death and wounding, but also with their polar opposites, life and healing. To the extent that an

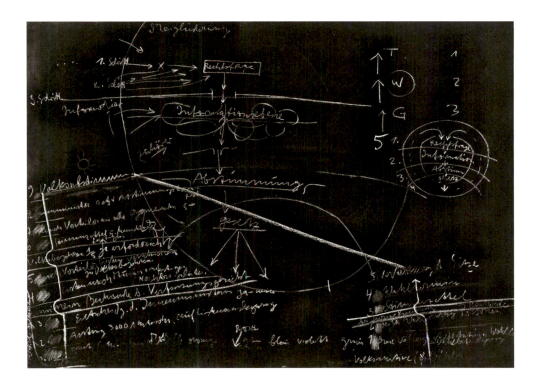

individual can address collective, historical guilt, Beuys' work represents the process whereby the German psyche came to terms with its grief.

Beuys took as his theme the human being in his encounter with the world and its demands and sought a formulation to express an altered, revolutionized human condition. While he accepted the prevalence of the inorganic, he assigned supreme significance to the wound—both in his own life and in the history of his times—arguing for symbols of wounding or lesion as a way to break through the insentient. In his autobiographical notes, he described his birth as an "exhibition of a wound drawn together with plaster"; and his *Bathtub* of 1960 was concerned with the initial trauma of birth, by which man is first exposed to the cruelty of the outside world.[19] In this context it is interesting to note that Hesse herself remarked that the frame in *Hang Up* looked like a bandaged (plastered) limb.

The circle in Beuys' work usually appears as a sign for the cosmos. To indicate its disintegration, or wounding, at the hands of technological control and instrumental reasoning, he arranged the individual components of many of his installations in disrupted and dislocated circular patterns. In one of the most important of these, titled "Show Your Wound" (*Zeige deine Wunde*) of 1976, Beuys made significant use of elements that suggest a circle without ever completing one.[20] Likewise in drawings, especially on blackboards where he summarized his theories, circles are frequently segmented, interrupted, or diagrammatically abbreviated (fig. 45).

For Hesse, the circle was as much a sign of unending effort as of perfection: she once noted in her diary, "I go in O circles. maybe therefore my drawings."[21] Even the circles in her serial drawings of 1967, for example, evoke a fragility that undermines the plenitude of the circular form. Less equivocally, she often broke her circular and

spiral forms wide open, as in the four-part *Compart* of 1966 and the related, three-part *Untitled* of 1966–67 (fig. 46; plate 97). Within the former's vertically arranged, square components, circles of wound cord appear intact (top) and sliced through, with sections removed; in the latter, the intact circle is omitted altogether. In these severed wholes, Hesse gave visual form to discontinuity, to the concept of the wound or lesion, and so to the anchoring of her art—her subject—in herself. It is the wound that lends the individual work, and the artist's oeuvre in general, its singularity. As Roland Barthes has written:

Where there is a wound, there is a subject: "die Wunde! die Wunde!" says Parsifal, thereby becoming "himself"; and the deeper the wound, at the body's center (at the "heart"), the more the subject becomes a subject: for the subject is intimacy . . . *Such is love's wound: a radical chasm (at the "roots" of being), which cannot be closed, and out of which the subject drains, constituting himself as a subject in this very draining.*[22]

The wound is not only an inner feeling, however; it is also an opening to the outside world. In the modern age, it signifies the disruption of the anthropomorphic notion that an object owes its identity to an organic whole, a soul. This is why Gilles Deleuze and Félix Guattari speak of "wish machines," wherein desire—no longer a matter of inner emotion and its expression—confronts the subject with his or her own dissolution. In defiance of transcendental interpretations, subjectivity thus manifests itself in the polarity between fear and desire.[23] The individual experiences it as an irremediable lack, an inner dichotomy, and also as the unplumbable depths of the self. This dual meaning is expressed again and again in Hesse's diaries and notes. Upon her return to New York, her work became a perpetual translation of her quest for an object that lies between fear and desire: a quest motivated and sustained by her awareness of her own wound, that absence of meaning or oneness in response to which an artist creates a work.

Fig. 46
Untitled, 1966–67
Acrylic paint, cord, and papier-mâché over masonite
H. installed, 38 in. (96.5 cm); top section,
10 x 10 x 1½ in. (25.4 x 25.4 x 3.8 cm); middle section,
11 x 11 x 1½ in. (27.9 x 27.9 x 3.8 cm); bottom section,
12 x 12 x 2¼ in. (30.5 x 30.5 x 5.7 cm)
Private Collection, Chicago. Courtesy Rhona
Hoffman Gallery

Notes

For valuable conversations, I would like to thank Mr. and Mrs. A. Scheidt, Dore and Werner Nekes, Erika Tischer, and the former director of the Kunstverein in Düsseldorf, Dr. Hering.

Translated from the German by David Britt.

1 These artists included, among others, Blinky Palermo, Sigmar Polke, Gerhard Richter, Klaus Rinke, Rainer Ruthenbeck, Katharina Sieverding, Imi Knoebel, Imi Giese, Henning Christiansen, and Jörg Immendorf.

2 Hesse noted seeing Morris' exhibition at the Galerie Schmela in October of 1964.

3 Fluxus was not a movement but a loose international affiliation of artists who staged concerts, performances, and other public events in support of the principle that the practice and experience of the various arts should not be segregated from each other, or from life in general. Beuys participated in a number of Fluxus events in both Düsseldorf and Berlin.

4 The three exhibited in New York at the Howard Wise Gallery that same year ("On the Move: Kinetic Sculptures," 9 Jan.–1 Feb.), and at The Museum of Modern Art in 1965 ("The Responsive Eye," 23 Feb.– 25 April). See also note 15 below.

5 Of particular relevance here is the degree to which Beuys' art was rooted in his World War II experiences in the German Luftwaffe.

6 Léger was well-represented at "Documenta 3" by a group of fourteen paintings, dating from 1920 through 1951, and twelve drawings of 1909 through 1945. Among the contemporary German sculptures exhibited were Beuys' *Queen Bee I, II,* and *III* (1952) and *SaFG-SaUG* (1953–58), and three works by Pol Bury. It should be noted as well that Lee Bontecou, whose importance to Hesse is discussed by Robert Storr in the present publication, exhibited three reliefs at "Documenta 3."

7 See Lippard, 215 n.8.

8 Jacques Lacan, *Ecrits: A Selection,* trans. Alan Sheridan (New York: W. W. Norton and Co., Inc., 1977).

9 Diary entry of 1 July 1964.

10 Diary entries of 4 and 10 Dec. 1964.

11 Diary entry of 10 Dec. 1964; letter of 14 Dec. to Rosalyn Goldman, quoted in Lippard, 28.

12 Hesse used the expression "real nonsense," as well as "crazy like machines" and "weird," to describe these drawings in a letter of 18 March 1965 to Sol LeWitt.

13 Hesse/Nemser transcript.

14 Ibid.

15 Otto Piene, quoted in *Westkunst: Zeitgenössische Kunst Seit 1939,* ed. Laszlo Glazer (Cologne: DuMont Buchverlag, 1981), 252. Piene, Mack, and Uecker declared their "light space" installation at "Documenta 3" to be an *Homage to [Lucio] Fontana.* It is particularly interesting to note, in this regard, that Hesse's later use of spheres in such pieces as *Sequel* of 1967 (plate 103) may have been influenced by a 1967 exhibition of Fontana's sphere sculpture at the Marlborough Gallery, an exhibition she admired; see Barrette, 158.

16 Uecker exhibited *Bewegtes Feld III* and *IV* of 1964, and *Spirale* of 1963, at "Documenta 3." The latter two were then owned by the Galerie Schmela.

17 Uecker declared that "Contemporary structural devices can be interpreted as the language of our mental existence . . . The way I use nails as structural devices, I do not want them to be interpreted as nails" (statement of June 1961, quoted in the exhibition catalogue *Mack, Piene, Uecker* [Hanover: Kestner-Gesellschaft, 1965], 166).

18 Among diary entries recording Hesse's visits to Haacke's home and studio are those dated 1 Aug. 1964, 5 Dec. 1964, and 27 March 1965.

19 Cited in Götz Adriani, Winfried Konnertz, and Karin Thomas, *Joseph Beuys: Leben und Werk* (Cologne: DuMont Schauberg, 1973), 9. See also Caroline Tisdall, *Joseph Beuys* (New York: Thames and Hudson, Inc., 1979), 8–9.

20 For more on this work, see Armin Zweite, *Joseph Beuys: Zeige deine Wunde* (Munich: Städtische Galerie im Lenbachhaus, Verlag Schellmann & Klüver, 1980), vol. 1.

21 Undated diary entry of [July] 1966.

22 Roland Barthes, *A Lover's Discourse. Fragments,* trans. Richard Howard (New York: Hill and Wang, 1978), 189.

23 Gilles Deleuze and Félix Guattari, *Anti-Oedipus: Capitalism and Schizophrenia,* trans. Robert Hurley, Mark Seem, and Helen Lane (Minneapolis: University of Minnesota Press, 1983). See also Manfred Frank, "Steinherz und Geldseele," in *Das kalte Herz und andere Texte der Romantik* (Frankfurt am Main: Insel Taschenbuch, 1978).

DO THE WRONG THING: *Eva Hesse and the Abstract Grotesque*

Robert Storr

PICTURE NOTE: The images interspersed throughout this text have been chosen to provide a visual context for the basic argument regarding the emergence in the late fifties and early sixties of a quasi-representational or sometimes wholly abstract grotesque. The purpose is not to suggest a specific genealogy of form, since many of the works included are obscure enough within the given artist's overall production to make inferences of that kind arguable at best. Rather, the point is to show a coincidence of spirit and experimental method among the artists represented. Additional works by them or by other artists might just as easily have been included. The important thing is that these examples show how, in this period—as in other transitional moments in art history—different artists thought differently and largely independently about the same general set of possibilities. The enduring strangeness of Hesse's contribution has at least something to do with the fact that being completely of that moment, her creative activity was also confined to it, and thus through her we rediscover its particular character and promise in the purest state of suspended animation.

It is the best letter that one contemporary artist has sent another. The date was April 14, 1965 and the recipient, Eva Hesse. Sol LeWitt was the writer. Hesse had been living for almost a year in Kettwig-am-Ruhr, Germany with her husband Tom Doyle, whose industrialist-patron had invited them both to set up shop in one of his vacant factories. Still to begin working in three dimensions, she painted and drew profusely but with increasing restlessness. Provoked by his correspondent's characteristically defiant and fretful description of her latest artistic struggles, LeWitt responded with a blast of exhortative energy:

You seem the same as always, and being you, hate every minute of it. Don't! Learn to say "Fuck You" to the world once in a while. You have every right to. Just stop thinking, worrying, looking over your shoulder, wondering, doubting, fearing, hurting, hoping for some easy way out, struggling, gasping, confusing, itching, scratching, mumbling, bumbling, grumbling, humbling, stumbling, rumbling, rambling, gambling, tumbling, scumbling, scrambling, hitching, hatching, bitching, moaning, groaning, honing, boning, horse-shitting, hair-splitting, nit-picking, piss-trickling, nose-sticking, ass-gouging, eyeball-poking, finger-pointing, alleyway-sneaking, long waiting, small stepping, evil-eying, back-scratching, searching, perching, besmirching, grinding grinding grinding away at yourself. Stop it and just DO.

. . . Don't worry about cool, make your own uncool. Make your own, your own world . . . You must practice being stupid, dumb, unthinking, empty. Then you will be able to DO! I have much confidence in you and even though you are tormenting yourself, the work you do is very good. Try to do some BAD work. The worst you can think of and see what happens but mainly relax and let everything go to hell.[1]

Percussive and dense with studio savvy, LeWitt's crescendo riff was a loyal harangue and a declaration of independence. At stake—and for young artists there is no higher one—was Hesse's freedom to get down to her own business. LeWitt's vehemence, however, voiced not just his concern for a friend, but the collective frustration of much of the generation to which they both belonged.

The dual focus of that frustration was the by then solemnly overdetermined "intuitions" of 10th Street Expressionism and the overweening "good taste" of high-style formalist abstraction. Of the two, the latter was LeWitt's own greater nemesis. Shifting in 1969 from scatological jive-rant to terse syllogism, he set forth the bases

for his rejection of formalist thinking in the first four of his thirty-five "Sentences on Conceptual Art":

1. Conceptual artists are mystics rather than rationalists. They leap to conclusions that logic cannot reach.
2. Rational judgments repeat rational judgments.
3. Irrational judgments lead to new experience.
4. Formal art is essentially rational.[2]

LeWitt then enumerated the ways in which art is betrayed by waivering intention and false hierarchies of materials and procedures, pausing in sentence 32 to close the final escape hatch of mindless "good taste" with the warning, "Banal ideas cannot be rescued by beautiful execution."[3] The irony or apparent contradiction in so categorical an indictment of "rational" art-making and art appreciation is that LeWitt's own rhetorical stance and recommended artistic method are bluntly systematic. Every potential and consequence of that system, however, is predicated on "leaping to conclusions," that is on the insistent absurdity of one's initial working premise and the faith that rigorously conjugating an arbitrarily chosen artistic "verb" will, of necessity, yield surprising truths. It was a Pascalian, though secular, wager on the actuality of the ideal that LeWitt has shown—over many years and in various media —pays off handsomely.

Fig. 47
Jasper Johns (b. 1930)
NO, 1961
Encaustic, collage, and Sculp-Metal on canvas with objects
60 x 40 in. (152.4 x 101.6 cm)
Photograph courtesy of Leo Castelli Gallery
© Jasper Johns Estate/VAGA, New York 1991

"These sentences comment on art, but are not art," LeWitt concluded his dicta.[4] Words, nevertheless, regularly served him and his contemporaries as a primary medium and as a link between or catalyst for other media. In all their instrumentalities, words were certainly crucial to Hesse. Language was her aesthetic scout and emotional confidant. Although she was more confident in her command of form than in her writing—"Maybe," she awkwardly told Cindy Nemser, "I would like the best way to communicate it [her experience] would be words, but I haven't been able to achieve that"[5]—nevertheless, it was as much by verbal as by plastic means that she daily unburdened her imagination and probed its contents, diligently indexing thoughts and thereby restructuring her thinking. This practice—and its gradual evolution away from run-on confession to a fragmentary matter-of-fact prose —defines her corresponding separation from the artistic generation in whose shadow she was educated and her growing integration into the one with which she came of age. Incompatible with the image of the artist as inarticulate oracle of the ineffable fostered by Abstract Expressionist mythogogues, Hesse's exacting linguistic obsession drew her into the community of younger artists she henceforth most counted upon for attention and support. Members of this diverse and loose knit group—which included Robert Smithson, Nancy Holt, Robert and Sylvia Mangold, and Frank Lincoln Viner—counted upon each other for intellectual nourishment. As LeWitt noted in his fourteenth proposition, "The words of one artist to another may induce an idea chain, if they share the same concept."[6] In the exchange among these artists, manuals, lexicons, mathematical treatises, and philosophical texts were common currency. Mel Bochner's gift of a thesaurus confirmed Hesse's custom of compiling the lists of words, along with their synonyms, antonyms, and homonyms, from which she drew her sculptures' hermetic titles.

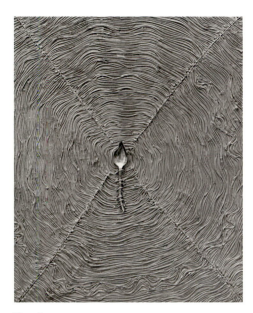

Fig. 48
Lucas Samaras (b. 1936)
Untitled, 1961
Liquid aluminum and spoon
30 x 24 in. (76.2 x 61 cm)
Photograph courtesy of The Pace Gallery, New York

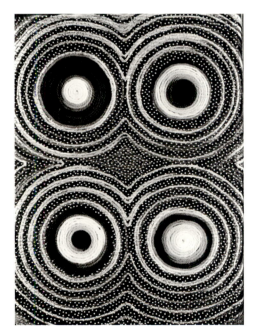

Fig. 49
Lucas Samaras (b. 1936)
Untitled (Quadruple Spiral Target), 1963
Pins and wool over wood
15¾ x 11½ x 2⅝ in. (40 x 29.2 x 6.7 cm)
Richard Brown Baker Collection

Throughout her life Hesse recorded her private thoughts and feelings as well, though more intermittently and telegraphically as her ideas came together and her career took off. Prone to anxiety and doubt, she filled diaries with admonitions, project outlines, ambitious declarations, and detailed accounts of her troubled days. While the arcane usages found in her word catalogues opened up aesthetic possibilities and anticipated her work's "effects," this habitual soulsearching gave worried voice to her art's psychological causes. Predictably, these journal entries resound with youthful clichés and urgencies, dwelling, as they do, on the narcissistic dialogue between the young woman as good girl and the artist as bad—that is flawed and self-reproachful—girl. In public Hesse tried hard to be "good" and she succeeded. Winner of scholastic art prizes, intern at *Seventeen* magazine, and later at Yale a favored pupil of Josef Albers, she had a recognized capacity to shine seemingly in direct proportion to the dark moodiness that threatened at all times to engulf her. Yet if the tone in which she expressed herself was in many respects typical of her age, the actual sources of her sadness and disquiet were exceptional and extreme, including the suicide of her mother when she was ten, her father's subsequent and unwelcome remarriage, and his early death in 1966 at just the moment when her future seemed to open up. Backgrounding all were the lingering fear and depression that shadowed refugee families which, like hers, had experienced the Holocaust. Hesse's fatal illness compounded and completed these calamities with a terrible closure.

Mention of the artist's melancholic predisposition and its biographical origins is important not only because these factors contributed substantially to the authentic dilemma on which her achievement hinged, but also because they have tended to justify a grim sentimentality that sometimes encroaches upon and distorts that achievement. With the passage of time and the undue emphasis placed upon her premature death, what happened to Hesse has acquired the aura of dramatic predestination. As a result, she has been turned into a heroine of a doomed romantic sort, another, this time female, art martyr.[7] To that extent, her fate would seem to align itself with those of Diane Arbus and Sylvia Plath, with whom she shares the double-edged distinction of having been both pretty and precocious. Such comparisons are misleading, however, insofar as the most basic fact of Hesse's tragedy does not match that of the other two women. Plath and Arbus killed themselves out of despair; Hesse, who succumbed to cancer, very much wanted to live and continued working to the absolute limit of her energies. "Art and work and art in life is very connected," she insisted in her interview with Nemser shortly before her death. "And I never really separated them . . . And they became closer enmeshed, and absurdity is the key word. It's been the key focus to my life unless you want to make it really sad and get sentimental and romanticize"[8]

Hesse did not need to romanticize her suffering, nor did she "get sentimental" about it. Quite the contrary. Free of self-pity and determined to resist, she was capable of treating the disease with a startling, even amused frankness. Victor and Sally Ganz —close friends and major collectors of Hesse's work—once failed to recognize her when she ran into them after several months separation wearing a blond wig to cover the loss of hair caused by chemotherapy. Unnaturally round-faced from cortisone treatments but smiling broadly she said, "I know you don't know me, I'm Eva."

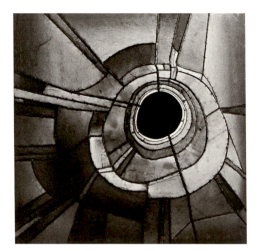

Fig. 50
Lee Bontecou (b. 1931)
Untitled, 1959
Relief construction of welded steel, wire, and cloth
58⅛ x 58½ x 17⅜ in. (147.5 x 148.5 x 44 cm)
The Museum of Modern Art, New York, Gift of
Mr. and Mrs. Arnold H. Maremont

Although her condition alarmed the Ganzes, Hesse seemed pleased by the success and extravagance of her disguise.[9] She also spoke of her plight with a kind of amazed satisfaction at the bizarre coincidences that typified it, explaining to Nemser that her hated stepmother, who was also named Eva, had been diagnosed with a brain tumor and released from the hospital two years to the day before she herself entered the same hospital under the same doctor and surgeon's care. In all, Hesse remained candid about the emotional extremes she experienced and consequently maintained her poise between them.

Maybe because my life has been so traumatic and so absurd—there hasn't been even one normal, happy, even happy [thing]—and I'm the most easiest person to make happy and the easiest person to make sad too, because I think I have gone through so much. I mean it never stops.[10]

And, it didn't. Nevertheless, a friend, Gioia Timpanelli, recalled the general levity precipitated by one of the sketches for her last major work, *Untitled* of 1970 (plate 116), a strange hanging ensemble of L-shaped forms made of translucent fiberglass and wire. "I laughed and said it was the funniest piece I'd ever seen and she [Hesse] said she was glad because she thought so too . . . It was a drawing of this foot. . . ."[11]

Despite her Job-like afflictions, then, the most direct link between Hesse's art and her life was neither earnest long-suffering nor brooding morbidity but a quick gallow's wit anchored in a stubborn will to track and fully experience the painfully unpredictable, at times preposterous, facts of existence. A vital dimension of her conduct during the six last and most productive years of her career, this same antic sensibility erupts in her letters, studio notes, and remembered conversation. In contrast to the angst-ridden phrases of her diaries and the intellectual dialect of her dictionary games, Hesse's spontaneous terms of praise were slangy and playful. If she liked a new piece she celebrated it as "ridiculous," "silly," "dumb," "ludicrous," and "crazy." The choice of words represents something beyond a merely hip inversion of superlatives in which "bad" means "good." Paired with and qualifying the sensuality, disconcerting invention, and compulsive refinement of her work, these adjectives properly named the very qualities that distinguished her most original creations. When, in his letter, LeWitt urged her to "practice being stupid, dumb, unthinking, empty" and "to do some BAD work. The worst you can think of," he was reinforcing a respect for the vernacular and the uncanny that Hesse herself was then on the verge of identifying in the "nonsensical" products of her hand. What "just DOING" did for Hesse—as she reported in the letter that provoked LeWitt's liberating jag—was to release in her the generative power of what she aptly dubbed her own "weird humor."[12]

Far from the benign, e.e. cummings-like capriciousness of a Calder, the oblique, rebellious, and slyly profane spirit that Hesse thus acknowledged in herself, she also readily recognized in other artists. Her early commentaries on exhibitions foreshadow these affinities. "Dubuffet is really good," she noted. "I enjoy his drawings, mainly for his humour—his esthetic is there and is there with ease. He makes no obvious contention with that aspect alone."[13] Of her more immediate elders or near contemporaries, this oddfellows pantheon included Alfred Jensen, Allan Kaprow, Lucas Samaras, Jean Tinguely, Robert Rauschenberg, and Jasper Johns, whose mod-

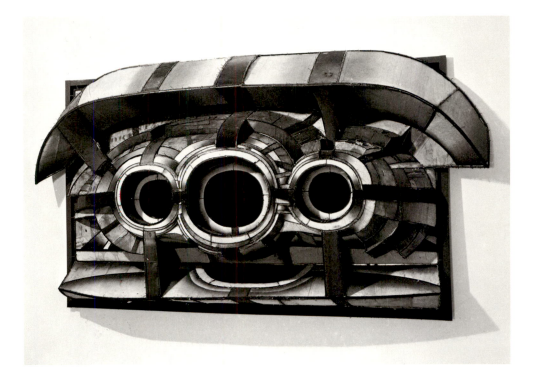

Fig. 51
Lee Bontecou (b. 1931)
Untitled, 1962
Welded steel on canvas
65 x 111 x 20 in. (165.1 x 281.9 x 50.8 cm)
Photograph courtesy of Leo Castelli Gallery

ulated grids and centric "targets" prefigure hers in obvious but equally in contrasting ways.[14] Also high on her list was Claes Oldenburg, an acquaintance since 1959 of whom she said, "Oldenburg is an artist, [if] I have to pick, that I would really believe in . . . I respect him, his writings, his person, his energy, his art, the whole thing . . . He has humor." Hesse was quick, however, to announce her independence from those whose work she admired. "I don't think I ever picked up on Oldenburg's use of materials," she added. "I don't think I have ever done that with anybody's work."[15] Her keen attraction to confidently off-beat talents led her to select her role models from among women as well as men, so signaling the changing perspectives of emerging artists in the 1960s. Key among her choices was Ruth Vollmer, the host to artists' gatherings Hesse attended and the creator of mathematical puzzles and objects as subtle and compact as her counterpart Alfred Jensen's were on the whole exuberantly garish, clotted, and expansive. Of still greater importance to Hesse was Lee Bontecou. These days all too seldom seen, Bontecou's constructed wire and canvas reliefs were ubiquitous in the mid-1960s; and in their looming semi-abstraction, they were far closer to Hesse's sensibility than were Vollmer's platonic exercises. Prickly, orifice-riddled, and—because of its reversably graduated tones and interlocking facets—optically unstable, Bontecou's signature work epitomized an art that was simultaneously distanced and aggressive, controlled and eccentric, "cool" and "uncool." From Bontecou, Hesse learned not only what it was possible to do, but what it took to do it. "Incredible!" she jotted in her diary in 1965,

Spent evening with [Bill] Giles and Lee Bontecou . . . I am amazed at what that woman can do. Actually the work involved is what impressed me so. The artistic result I have seen and know. This was the unveiling to me of what can be done, what I must learn, what there is to do. The complexity of her structures, what is involved absolutely floored me.[16]

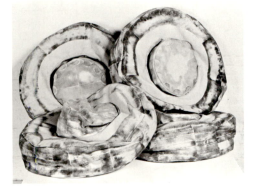

Fig. 52
Claes Oldenburg (b. 1929)
Soft Tires for Airflow—Scale 5 (Model), 1965
Canvas filled with kapok, impressed with
patterns in sprayed enamel
DIAM. each, 30 in. (76.2 cm); D. 7½ in. (19 cm)
Courtesy of the artist
© 1992 Claes Oldenburg/ARS, N.Y.

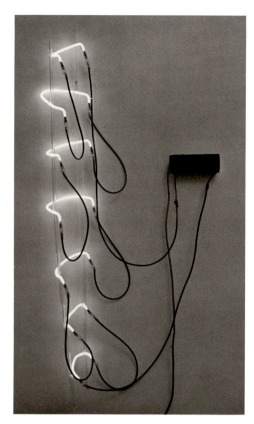

Fig. 53
Bruce Nauman (b. 1941)
Neon Template of the left half of My Body Taken at 10 Inch Intervals, 1966
Neon tubing
H. 70 in. (177.8 cm)
Collection of Philip Johnson
© 1992 Bruce Nauman/ARS, N.Y.

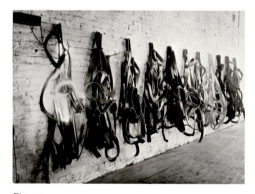

Fig. 54
Richard Serra (b. 1939)
Belts, 1966–67
Vulcanized rubber and neon (blue)
84 x 288 x 20 in. (213.4 x 731.5 x 50.8 cm)
Photograph courtesy of Leo Castelli Gallery
©1992 Richard Serra/ARS, N.Y.

Notably absent from Hesse's roster of mentors were the major Pop artists, who in the context of the early 1960s were still widely perceived as the Abstract Expressionists' crass antithesis. As late as her German sojourn, Hesse's loyalties remained with Gorky, the oneirocritical impersonator, and de Kooning, whose weird sexual humor must have subliminally appealed to her own. Even the fact that her husband had been Lichtenstein's student in Ohio did not make them or their circle more sympathetic to Pop's brash appropriations of commercial imagery and forms. Other than Oldenburg, who was in many ways a bridge between fifties and sixties sensibilities, the striking exception to this rule turned out to be Andy Warhol. Despite her existing allegiances, Hesse gravitated to his sardonic insistence on the unity between art and life, a unity that matched in degree although not at all in kind the integration of artistic identity she revered in the Abstract Expressionists. Warhol's seamlessly "impersonal" style was, she understood, the rigorous proof of his radical and totalizing vision. "Andy Warhol. He too is high up on my favorite list. He is the most artist that you could be. His statement and his person, they are equivalent. He and his work are the same and they are connected. [It is] what I want to be, the most Eva can be as an artist or a person."[17]

The unflappable and inscrutably open face Warhol presented to the world was, Hesse accurately sensed, a far cry from the ingratiating superficialities of much contemporaneous and apparently like-minded work. Although she was initially drawn to Marisol's assemblages, Hesse's eventual reservations about them say a good deal about her general disinclination toward Pop, and more still about the problems she saw in pictorial obviousness and predictable jokiness. To her elder's credit, Hesse wrote, "Marisol does all [the] work herself. She will try anything. Experiment with any media, incorporating all things." This imaginative pragmatism notwithstanding, Hesse lamented that "What she does do though is leave too much on the surface. Design, decoration. Mystery is lost. She cannot any longer just attach dime store paraphernalia all over, over everywhere. It sits there and is no longer even humour. Because one can expect it and there it is."[18]

Taking these remarks as one coordinate—and the substance and tone of her correspondence with LeWitt as another—the matrix of options, expectations, and enthusiasms Hesse confronted in the mid-sixties is easier to map and her zigzagging course through them easier to follow. Goaded by her own frustration into unleashing her "weird humor," Hesse nevertheless eschewed indulging either herself or her audience in any way that would render her humor's motivating absurdity and ambivalence any less mysterious or disturbing than it was. The rush of new forms and formats and the rapid changes in discursive attack seen in her paintings and drawings of this transitional period testify to the prodigiousness of her pent-up energies and the suddenness of their release. Whereas dense shapes blotted and inscribed in grays, sepias, and blacks on small, sometimes miniscule sheets had been the rule prior to 1963, saturated colors, bold lines, pneumatic tubes and ovoids, and off-square grids on wide white pages were typical thereafter. Between 1963 and 1965, Hesse's images—once seemingly organic in their ingrown, cellular structures—evolved into what appeared to be anatomical studies of some robotic species. It was as if Gorky of the humid fields and barbed biomorphs had had a close encoun-

ter of the Third Kind and returned to earth the Vesalius of a new science fiction of sex. Or maybe it is better to imagine Duchamp, that genre's gender-bending originator (who, incidentally, Hesse had cited as another of her favorite artists), as having slipped definitively into his feminine persona and recast the *Large Glass* in that light.

Unhappy bride that she was, Hesse had at last stripped bare the erotic machinery of her imagination and so emancipated her art. Rather than cushion the impact of her imagery, the "dumb" cartooniness of her new graphic manner banished all trace of artful hesitation and all vestiges of romance from her self-proclaimed "crazy machines."[19] The fourteen reliefs Hesse made while in Kettwig are an evident but vigorously "illogical" extension of her previous drawings and paintings, though only two, *Two Handled Orangekeyed Utensil* and *Legs of a Walking Ball,* were worked out in any detail on paper . Although few of the drawings she made in Germany bore titles—one that Hesse called *See and Saw* now seems a precedent for Neil Jenney's genially boneheaded Saussurian wordgames—several of these first three-dimensional pieces have catchy or overtly comic names: *Ringaround Arosie, Oomamaboomba, 2 in 1, Up the Down Road,* and *Eighter from Decatur.*[20] The cheerfulness of these singsong malapropisms and bad puns is belied by the alien, sometimes rude physicality of the work. Shallowly modeled plaster and rows and whorls of cord glued over particle board or masonite establish the basic topography of Hesse's forms: low craters, welts, nipples, wings, gills, and rough elephant-hide surfaces. From this undulating, corrugated ground protrude nobs, curled sections of string, arcing sutures, and wrapped levers. Bright, clashing hues predominate. In diaries of around this time Hesse chided herself for her schematic use of color: "I cannot stand the color I use and yet it mostly develops in this same way. This I should change since I decided I like it not. It is amazing how this happens again and again . . . I end up with red, yellow, blue, green, and I hate it."[21]

Unlikable perhaps, even lurid, her palette was in fact anything but standard, tending as it did toward acid blues, yellows, chartreuse, purple, and hot pinks. The sexual connotations of her images were at times rendered wholly unambiguous by the assignment of a particular color to a given element, especially when, by shading that color over the expanse or length of the form, Hesse gave the impression that it was in the very process of engorgement. She readily acknowledged to LeWitt in her letter of March 1965 that the two concentric mounds of *Ringaround Arosie* (plate 79) looked like a "breast and penis," and the roseate clitoral button in the cord-fringed and otherwise monochromatic *Pink* (plate 85) would seem to be an equally obvious sexual allusion.[22]

On her return to the United States after completing this series of reliefs, Hesse abandoned polychroming in favor of painting her sculptures in modulated monochromatic tonalities. *Untitled* of October 1965 (fig. 10), with its flushed screw-in-handles, was the last compromise between these two ways of working. Still, her handling of shapes retained and enlarged upon the bizarre allusiveness of the wall reliefs. Bound, herniated, bulbous, pendulous, phallic, and off-scale, *Ingeminate, Several, Total Zero, Vertiginous Detour,* and *Long Life* are thoroughly unhousebroken presences (see fig. 13; also plates 87, 88, and 94). *Long Life,* destroyed at the artist's request two months

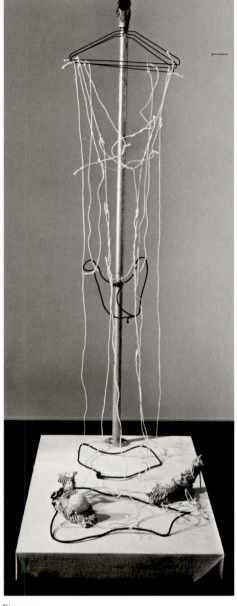

Fig. 55
Claes Oldenburg (b. 1929)
Ghost Wardrobe for MM, 1967
Cord, hangers, plaster, metal, wood, and canvas
120 x 26 x 44 in. (304.8 x 66 x 111.8 cm)
Courtesy of the artist
© 1992 Claes Oldenburg/ARS, N.Y.

before the end of her very short life, was described by Robert Pincus-Witten as "a slapstick ball and chain which might easily pass for an anarchist's bomb designed by a color blind obsessive-compulsive."[23] Apparently intent on damning the novelty of her work with vivid description but faint praise, Pincus-Witten at least seized upon the methodical contrariness of Hesse's sensibility. Hers was not a clownish iconography, but the shapes did embody the pathos and latent violence of "slapstick," the paradoxical principle of which is that something may cause one to laugh 'til it hurts or hurt 'til one laughs.

Stripping away the overt funkiness of these early sculptures, her next major piece, *Hang Up* of 1966 (plate 91), represented a quantum leap toward the essential extremes to which she always and instinctively aspired. Her description of its look and importance cannot be improved upon. It was, the artist later told Nemser,

the most important early statement I made . . . It was the first time where my idea of absurdity or extreme feeling came through. It is huge, six feet by seven feet. It is a frame, ostensibly, and it sits on the wall and it is a very simple structure . . . The frame is all tied up like a hospital bandage—like if someone broke an arm . . . The whole thing is absolutely rigid, neat, cord around the entire thing. It is very pure and naive like a primitive. It is also the extreme—that is I like it and I don't like it. It is so absurd [that rod] out of that structure—this little thing comes out here and there. And it comes out a lot—about ten or eleven feet out and it is ridiculous. I mean that is the most ridiculous structure I have ever made and that is why it is really good . . . Oh more absurdity. The whole thing is ludicrous.[24]

Worthy indeed of all her preferred adjectives of praise—"absurd, ludicrous, ridiculous"—*Hang Up* is of signal importance, however, because it fulfilled her ambition by means that were completely abstract. As in the best of minimalist art, the work's implicit figuration derives from the body with which it interacts. A physical and perceptual double-negative, the piece is conceived in such a way that no body can ever satisfactorily locate itself in relation to the piece and the areas framed by it. Playing sculptural devices off painting conventions, it is the sum of its empty enclosures and the very definition of pictorial spaces that contain nothing and fade to nowhere while simultaneously roping the viewer in and fencing him/her out of his/her habitual place.

Laocoon (fig. 70), Hesse's snakes-and-ladders reconfiguration of the classical theme, closely followed the completion of *Hang Up*. Together these two works display the formal constants and expressive dynamics thereafter emblematic of her work. In both pieces, rigid grids are juxtaposed with malleable linear elements. Inasmuch as the quadrilateral module of the former evokes a dependable universe in which the relations of part to whole are consistent and regulated, the variability of the latter demonstrates the involuntary responsiveness of matter to the uncontrollable forces of chance and circumstance. Weighing upon the wrapped cable and cord of *Hang Up* and *Laocoon*—as well as upon the soft strings and pliant rubber tubing of later works such as *Ennead, One More Than One, Addendum* (plate 101), *Vinculum I* (plate 109) and *II,* and the coated cheesecloth sheets of *Expanded Expansion* (fig. 19) and *Contingent* (fig. 65; see also plate 113) of 1966 through 1969—gravity is depicted or directly operates as the agent of chaos in apparently simple, orderly structures or, as in the

Fig. 56
H. C. Westermann (b. 1922)
The Plush, 1963
Metal pipe, fabric (carpet), and wood
62 x 29 x 21 in. (157.5 x 73.7 x 53.3 cm)
In the collection of The Corcoran Gallery of Art, Gift of Samuel J. Wagstaff, Jr.
© H.C. Westermann/VAGA, New York 1991

Fig. 57
Richard Artschwager (b. 1924)
Hair Box, 1990
Acrylic on rubberized horsehair with wood backing
(Edition of 100)
5 x 10¼ x 14¼ in. (12.7 x 26 x 36.3 cm)
© 1992 Richard Artschwager/ARS, N.Y.

case of the last two pieces, defines their erratic contours. Lacking any supporting or countervailing grid, *Right After* of 1969 and *Untitled* of 1970 (plates 111 and 115) are all snarl and sag. Drooping, dangling, twisting, Hesse's soft skeins and extrusions entwine but do not resolve themselves into fixed or intelligible knots. (The inherent meaning of this slippage becomes maddeningly obvious if one is ever called upon to hang such work, for try as one might one cannot recreate the exact interlacings documented in previous studio or gallery installations.) Never changing in its simple components, the best of Hesse's sculpture is ever changing in its exact disposition.

Equal in significance to this built-in impermanence—which also extended to the chemical instability of the synthetic materials the artist adopted—is the sheer ungainliness of her forms and their intended postures. Although increasingly subtle in their pigmentation and textures, and often elegant in their rhythmic progressions, with very few exceptions Hesse's sculptures remained insistently gawky rather than graceful in their overall presence. Far from inadvertent, this awkwardness posed a frontal challenge to the oldest of notions about the relation of human to aesthetic scale, particularly as it reemerged in the thoughts and practice of the Abstract Expressionist painters. Thus de Kooning's oft-quoted remark about determining the size of his pictures by the extent of his reach, revised the old Vitruvian equation according to which man was the measure of all things actual or ideal. Even Pollock, circling the floor around his vast unfurled canvases or ranging from end to end of his frieze-like ones, did not fundamentally alter the idea that form was calibrated by gesture and format by "natural" permutations of anthropomorphic dimensions. The calculated disproportion of Hesse's work upset that expectation, and she rejoiced in the freedom of doing so:

I was always aware that I would take order versus chaos, stringy versus mass, huge versus small, and I would try to find the most absurd opposites or extreme opposites. And I was always aware of their absurdity, and also their contradiction formally. And it was always more interesting than making something average, normal, right size, right proportion.[25]

Fig. 58
Richard Artschwager (b. 1924)
Handle, 1962
Wood
30 x 48 x 4 in. (76 x 121.9 x 10 cm)
Collection of Kasper Koenig
© 1992 Richard Artschwager/ARS, N.Y.

Fig. 59
Lucas Samaras (b. 1936)
Untitled, 1964
Pins on wood
18 x 18 x 18 in. (45.7 x 45.7 x 45.7 cm)
Photograph courtesy of The Pace Gallery, New York

Complementing her earlier experiments with off-color polychromy and her abiding preference for intensely tactile, off-putting surfaces, *Hang Up* affirmed the artist's penchant for abnormal proportions and uneasy placements. Repetition was another, but essential, device for achieving the same disorienting effects. Gertrude Stein long ago argued that plainspoken reiteration could restore significance to a word. As proof she offered her litany "a rose is a rose is a rose," claiming that by thus repeating the noun stripped of all its conventional adjectives and corresponding metaphoric uses, for the first time in literature in centuries, a rose was simply a flower. Hesse saw the clear implications of such tautological thinking in reverse. Any nonsense became more nonsensical—but seemingly less arbitrary—as it approached infinite restatement. How big a thing should be was to that extent a function of how many times one had to replicate its basic structure in order to show that if need be one could go on forever. "If something is meaningful maybe it's more meaningful said ten times. It's not just an aesthetic choice. If something is absurd, it's much more greatly exaggerated, more absurd, if it's repeated."[26]

While Pollock's paintings pulsed with boundless energy and variety, syntactically similar works such as Hesse's *Metronomic Irregularity I, II and III* (plate 96; figs. 33 and 16) describe an entropic infinity charged by erratic fluctuations in otherwise endlessly repeating patterns. This emphasis on the mesmerizing absurdity of sheer enumeration or accumulation is intoned by titles such as *Addendum, Accretion, Augment,* and *Repetition Nineteen.* The mind-boggling realization of how much concentration it would take to thread each cilium-like length of vinyl through each of the myriad of punched metal holes on each side of a single work such as *Accession I* of 1967—not to mention the entire series of *Accession* boxes (see plates 107 and 108)—brings the message home more forcefully still. That the artist resumed and persevered in this endeavor after her first collapse makes the poignancy of thus "marking time"—and so by analogy the hopeful obstinacy of all human projects pitted against time—achingly apparent. Without melodrama, certainly, but with every bit of fatalistic and improbable industry she could muster, Hesse used repetition to test Samuel Beckett's deadpan declaration of survival and continuity of will: "I can't go on, I'll go on." By the same token, she was in full agreement with Doc Watson's observation that "Life is just one damn thing after another."

Mournful resignation was not Hesse's style, however, any more than monotony per se was her aesthetic object. Estrangement was. Repetition could therefore be orderly or disorderly, neat or messy, as mood or the need to counter expectations and break habits dictated. In *Schema* (plate 102) she ranked latex nodules on a latex rug; in *Sequel* (plate 103) she piled kindred capsules in random array. Both procedures suited the same basic end, and each was chosen with the other clearly in mind. In larger works, these organizational strategies were conflated. Looking like so many dented wastebaskets, the two versions of *Repetition Nineteen* of 1967 and 1968 (fig. 17 and plate 104), with their vacant, vulnerable, and individuated units, might easily be taken as a parody of minimalism's severely regimented seriality. Nemser asked Hesse whether that had been her intention in such work, but while the artist acknowledged the element of satire, it was, she insisted, directed at her own work. "I don't think I was punning another movement or punning anything except my own vision," Hesse

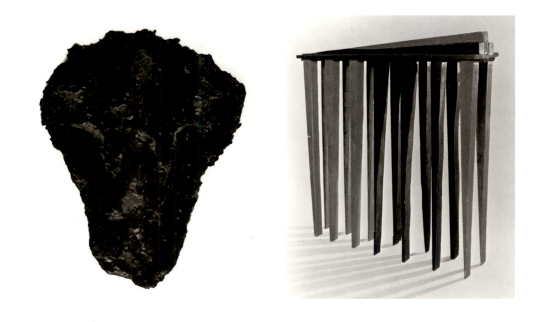

said, proceeding to explain how such "punning" occurred in *Area* (fig. 18), one of the floppiest and most displaced of her later sculptures:

Area is made out of a mold of another piece, Repetition Nineteen [III]. *And it is the insides that we took out. And then I made it into another piece. Totally. I mean there is no connection whatsoever except if you really saw it—it is very clear. This* [Repetition Nineteen III] *was empty containers and you have that sexual [connotation]. It is anthropomorphic, and these* [Area] *aren't . . . I mean they can't be more different . . . They are totally disconnected. Yet to me—and I mean this is not information for the world—it was just for me. It was like an inside joke.*[27]

Turning techniques back upon themselves and shapes inside out gave rise to a host of eccentric by-products. Formally and poetically, the inside jokes Hesse was telling were at her own expense. Process engendered, her experiments' mutant offspring possessed uncanny morphologies. As coherent wholes or isolated parts, these bizarre organisms were the substance and residue of emotions. The sexual connotations she attributed to *Repetition Nineteen,* for example, may have referred to Hesse's regret over not having had a child. The hollowness of its component vessels, like that of the empty pods of *Tori* (plate 112) and the husk-like quality of other fiberglass pieces, hence alludes to barrenness and infertility. In Hesse's sculptural laboratory, ordinary human fecundity was impossible, but evidence of mitosis abounds in the marvelously peculiar range of latex warts, cysts, shells, membranes, flakes, and skin-like envelopes that filled the glass storage shelves she used for test pieces. Here again, LeWitt was the catalyst. The bakery display boxes she collected on the Bowery for this purpose were his discovery. The surreal aspect of these specimen cases has less to do with strict minimalist cataloguing, however, than with the unnatural science of Robert Smithson or the pack-rat archaeologies of Joseph Beuys' vitrines. Smithson's and to a still greater degree Beuys' imagery was anal or fecal, and degenerative. At once visceral and void, Hesse's metamorphic iconography was genital but symbolically sterile or unregenerative.

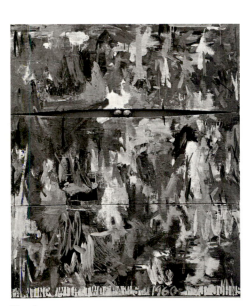

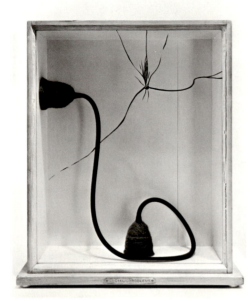

Fig. 63
H. C. Westermann (b. 1922)
Social Problems, 1964
Pine, glass, rubber, steel wool, metal, and paint
22½ x 18¾ x 7½ in. (57.2 x 47.6 x 19 cm)
The Museum of Modern Art, New York, Robert E.
and Anna Marie Shapiro, Barbara Jakobson, and The
Norman and Rosita Winston Foundation, Inc. Funds
© H.C. Westermann/VAGA, New York 1991

And grotesque. The word is inescapable yet easily misunderstood. By now certainly the term encompasses an aesthetic approach far different from the one it originally designated. Although variations on its antique paradigms have appeared in avowedly anachronistic art throughout this century—for example, in the caprice and filigree found in much neoclassical painting, sculpture, and decoration of the 1920s and 1930s—the essential sensibility it describes is broad, perennial, and fully as much modern as it is ancient. Indeed, it is the only term that will properly accommodate the extraordinarily diverse range of work by other artists with which Hesse's ultimately shares not merely common attributes but spiritual resonance. Already mentioned among her own favorites have been Duchamp, Dubuffet, Bontecou, Samaras, Oldenburg, Jensen, Kaprow, Tinguely, and even at times Rauschenberg. Other candidates for a comprehensive list of contemporary masters of the grotesque would include H. C. Westermann, Öyvind Fahlstrom, Richard Artschwager, and, at the limit of refinement and discretion, Duchamp's American heir and Hesse's brief acquaintance, Jasper Johns. Bruce Nauman and Louise Bourgeois, two of the artists chosen along with Hesse for inclusion in Lucy Lippard's 1966 show "Eccentric Abstraction," also belong in this company. Of recent generations, one should in particular add Elizabeth Murray, whose roiling shaped canvases enlarge upon the unrealized possibilities of Hesse's early reliefs and otherwise constitute the richest painterly expression of this tendency we have yet witnessed. Indeed, since the mid-1950s, under various and often discriminatory rubrics, the spirit of the grotesque has been a principal but largely unacknowledged force in American aesthetics, standing at a critical distance from Pop and tensely between the antitheses of expressionism and formalist abstraction.

As was true of its classical antecedents, what distinguishes the contemporary grotesque from both the Apollonian ideal embodied in the latter tendency and the Dionysian impulses vented in the former is an unrelenting ambivalence toward the extremes each represents, coupled with the knowledge that the only hope of reconciling these opposites entails essential distortions of both. Fueled by deep emotion, the grotesque carries feeling to the point of farce. Perversely evocative of genuine longing to transcend the human condition, it caricatures or exhausts contemplation by taking meditative disciplines to absurd lengths. Hesse's work responds to and illustrates both sides of this paradox. The artist's obsession with the grid is a matter of sincere excess. In her, wakeful reasoning produced monsters, as if the metaphysical geometries of reductive modernism had metastasized and Barnett Newman's exclamatory "Onement," Ad Reinhardt's terminal "one painting," or Agnes Martin's dimensionless perfection had been made unchecked and denatured flesh. And flesh, so easily ridiculous in arousal or sexual incapacity and so soon marked by decay, is essentially grotesque. Just as past practitioners of the genre favored masks and puppets as their expressive means, in her turn Hesse invented a new set of corporeal surrogates, which, like the earlier ones, exaggerated characteristics of the bodies they concealed or replaced.

At the heart of the grotesque, then, is contradiction, or more exactly a compulsion to point out and exacerbate contradiction. Into the grotesque, whatever its particular form, collapse the dichotomies we use to order the imagination and to protect our-

selves from full cognizance of the simultaneous incidence of the ridiculous and the sublime. So Thomas Mann would write, "The striking feature of modern art is that it has ceased to recognize the categories of tragic and comic . . . It sees life as tragicomedy, with the result that the grotesque is its most genuine style."[28]

Hesse grasped this truth completely. "Weird humor" had freed her from agonies of self-doubt, and for the remainder of her life she called upon it to exorcise her lingering demons. In her drawings and sculptures the howl of the 1950s is answered with the disabused laughter of the 1960s. A personal, existential triumph certainly, the laughter her work can provoke nevertheless signals the elusiveness of the very synthesis Hesse sought as well as the persistent dividedness of the self she projected in and through her art.

"Joy," Baudelaire observed, "is unity. Laughter is the expression of a double or contradictory feeling, and it is for this reason that a convulsion occurs. From the artistic point of view: the comic is an imitation; the grotesque a creation."[29] The dream of joy, one might say, is the essence of the utopian modernist styles Hesse approached then retreated from. The comic, that is the imitation of the ludicrous as it occurs naturally, is correspondingly the essence of Pop and most Funk art, which Hesse likewise considered and rejected. Abstract rather than mimetic, yet skeptical of the platonic precedents for abstraction, Hesse's work provoked laughter in herself and others. In sum, her challenge consisted in finding convincing and compelling forms to describe the fusion of wholly incompatible states of body and mind. The wit she applied to that task was her candid admission of the absurdity of the enterprise and, whether overt as in the early work or subtle as in the later, the trace element of her particular genius.

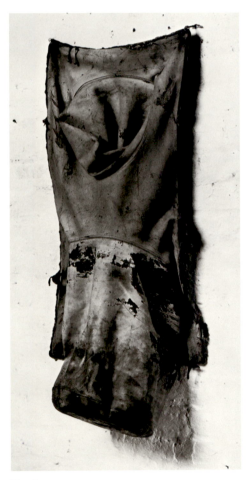

Fig. 64
Richard Serra (b. 1939)
Inverted Bucket, 1967; destroyed
Rubber and fiberglass
Approx. 36 x 12 in. (91.4 x 30.5 cm)
© 1992 Richard Serra/ARS, N.Y.

Impatient as she was with false beauty—"pretty pictures and pretty sculptures, decorations on the walls, pretty colors, red, yellow, and blue, nice parallel lines make me *sick*"—and as quick as she was to deflate highfalutin attitudes—"I can't stand romanticism"—the pull of the sublime still remained an innate characteristic of her thinking and her work.[30] At the most basic level, her interest in infinitely expanding forms manifested this attraction. Rather than negate enthrallment with boundless space and form—and the dreams of transcendence, however thwarted, they arouse—the disconcerting and self-mocking overtones of Hesse's work made such enthrallment believable to skeptical temperaments such as her own. That skepticism is the general, if not universally determining, fact of contemporary artistic life. Poking fun at the insuperable contradictions and incongruities of the modern condition, the grotesque represented—according to Mann—"the only way in which the sublime may appear" in our day.[31] This perverse sublime produced what Luigi Pirandello called a "wavering state of consciousness."[32] On encountering Hesse's sculpture, Robert Smithson felt something similarly "vertiginous."[33] If vertigo dismays or frightens some, others it makes giddy. With one eye on a strange, at times nearly featureless horizon, and another on the abyss, Hesse experienced all these conflicting emotions, all at once, all the time. The body of work she left behind, each part of it a synthetic fossil of a bodily cell or sinew, remains suffused with that remote, congealed, and disorienting energy.

Notes

1 Cited in Lippard, 35.
2 Sol LeWitt, "Sentences on Conceptual Art," in *Sol LeWitt,* ed. Alicia Legg (New York: The Museum of Modern Art, 1978), 168. (First published in *0–9* [New York, 1969] and *Art-Language* [England, May 1969].)
3 Ibid.
4 Ibid.
5 Hesse/Nemser transcript.
6 Sol LeWitt, "Sentences on Conceptual Art," 168.
7 Robert Pincus-Witten's transcriptions of the last seven pages of the artist's diary notes, which appeared as "Eva Hesse: Last Words" in *Artforum* 11 (Nov. 1972): 74–76, set the tone for the sometimes ghoulish attention paid to the artist's death. It should be added here that the countervailing regard for Hesse's humor and its sophistication—which is the principle theme of this essay—was first present in the criticism of Lucy Lippard and has since been a feature of texts by Ellen Johnson, Eleanor Heartney (*Eva Hesse: The Reliefs 1965* [New York: Robert Miller Gallery, 1989]), and others.
8 Hesse/Nemser transcript.
9 As told to the author by Mrs. Victor Ganz, in a telephone conversation, 9 Nov. 1991. Mrs. Ganz also recalled that when Hesse came to dinner, she would lay out on the table the large quantity of pills she was obliged to take with the same method she applied to her work but without any appeal for pity.
10 Hesse/Nemser transcript.
11 Quoted in Lippard, 178. Demonstrating the influence of one artist upon another is a constant preoccupation of art historians and the bane of creators whose imaginations rarely progress from external "cause" to studio "effect" in anything like a direct manner. The *confluence* of distinct aesthetics is another matter. A case in point; sometime during the period when Hesse was working on the "feet" in *Untitled* (1970; plate 116) she visited Nancy Graves, who was then in the process of fabricating the milling and skeletal legs of her *Variability of Similar Forms* (1970). One of Graves' studio assistants for that project was Susan Rothenberg, whose paintings would, by the late seventies, be animated by bone fragments and cropped images of horses' legs. Why this image in particular fascinated these three women would be the subject of an interesting study. That it prompted such different and powerful work underscores the fact that who got

there first is far less interesting than where each of the artists took the idea, and why.
12 Hesse to Sol LeWitt, 18 March 1965, quoted in Lippard, 34.
13 Diary entry of Tues. [Dec. 1960].
14 Hesse and Johns met through their mutual friends Victor and Sally Ganz. The Ganzes were major collectors of both artists, and their apartment offered not just the location for the artists' brief encounter but the best place in which to study their indirect but sustained aesthetic dialogue.
15 Hesse/Nemser transcript.
16 Diary entry of Wed. eve. [13 Dec. 1965].
17 Hesse/Nemser transcript.
18 Undated diary entry [May 1966], cited in Ellen H. Johnson, "Order and Chaos: From the Diaries of Eva Hesse," *Art in America* 71 (Summer 1983): 115.
19 Hesse described her new drawings to LeWitt as being "clear but crazy like machines" (see note 12 above).
20 While it would seem that Hesse rarely titled her early drawings, in fact it appears that some which are now listed as untitled, came to be so after having their original names reassigned to sculptures made shortly after their completion and exhibition. Lippard writes, "All fourteen of the relief-constructions made and shown at the Kunsthalle Düsseldorf in August 1965 were titled. Some of these titles had been used previously for drawings in a group show at the same museum at Christmas, though they were not studies for those sculptures. The only two drawing titles *not* applied to sculptures were "See and Saw" and "Try to Fly"; presumably the former, like the latter, was sold" (Lippard, 215 n.9). *Try to Fly* is owned by Dr. Erika Tischer. The whereabouts of *See and Saw* are unknown.
21 Diary entry of 1 July 1964.
22 Quoted in Lippard, 34 and 38.
23 Robert Pincus-Witten, [Review of exhibition at Graham Gallery], *Artforum* 4 (May 1966): 54. Also destroyed were *Untitled* and *Total Zero* (see fig. 13).
24 Hesse/Nemser transcript.
25 Ibid.
26 Ibid.
27 Ibid.
28 Thomas Mann, quoted in Frances K. Barasch, "The Meaning of the Grotesque," in Thomas Wright, *A History of Caricature and Grotesque in Literature and Art* (New York: Frederick Ungar Publishing Co., 1968), viii.
29 "The Essence of Laughter, and generally of the Comic in the Plastic Arts," in *Baudelaire: Selected Writings on Art & Artists,* trans. P. E. Charvet (Cambridge: Cam-

bridge University Press, 1972), 150.
30 Hesse/Nemser transcript.
31 Mann, quoted in Barasch, xxi.
32 Luigi Pirandello, quoted in Barasch, xii.
33 Robert Smithson, "Quasi-Infinities and the Waning of Space," *Arts Magazine* 41 (Nov. 1966): 30; quoted in Lippard, 192.

EVA HESSE: *A "Girl Being a Sculpture"*

Anna C. Chave

Around 1967 Eva Hesse was musing about a "girl being a sculpture," a phrase she jotted on a dance program. She may have made a slip of the pen, of course, while intending to ponder a "girl being a sculptor."[1] But the slip, if it was one, is telling, for Hesse cared deeply about both these possibilities: whether or how she could inscribe her femininity in her art, and how she could establish herself as a practitioner in a medium dominated by men. In her diary in 1965, she worried, "Do I have a right to womanliness? Can I achieve an artistic endeavor and can they coincide?"[2] And in a letter to an artist friend the same year, she anguished over whether

we are unique, I mean the minority we exemplify. The female struggle, not in generalities, but our specific struggles. To me insurmountable to achieve an ultimate expression, requires the complete dedication seemingly only man can attain. A singleness of purpose no obstructions allowed seems a man's prerogative. His domain. A woman is sidetracked by all her feminine roles from menstrual periods to cleaning house to remaining pretty and "young" and having babies . . . She's at disadvantage from the beginning . . . She also lacks conviction that she has the "right" to achievement. She also lacks the belief that her achievements are worthy. Therefore she has not the steadfastness necessary to carry ideas to the full developments. There are handfuls that succeeded, but less when one separates the women from the women that assumed the masculine role. A fantastic strength is necessary and courage. I dwell on this all the time. My determination and will is strong but I am lacking so in self esteem that I never seem to overcome.[3]

Reading *The Second Sex* helped sensitize Hesse to her predicament. Simone de Beauvoir had shown that historically "woman is object" not subject, Hesse noted in her diary, adding that woman "has been made to feel this from first experiences of awareness. She has always been made for this role. It must be a conscious determined act to change this."[4] In the brief span of her activity as a sculptor, between 1965 and 1970, Hesse resolutely pursued such change, overcoming the obstacles that faced her as a young woman making her mark in avant-garde circles in New York. She succeeded, not by assuming "the masculine role," but by shaping an alternate role—a feat she accomplished before the flowering of the women's movement, which took place only after she died. Nor was Hesse a self-identified feminist, though she confided to her diaries her resentment at the slights she suffered from fellow artists, dealers, and critics on account of her sex. An often coquettish woman, the sculptor was highly attentive to her figure, her attire, and her attractiveness to men. "I have

this awful trait in competing with 'male' artists, which is to say almost everyone. Then [as if] that's not bad enough I compete then as a 'woman' with women in 'female' area. It is another major area to be thought about."[5] To assuage her dual professional and personal insecurities, Hesse liked to tell herself, "My work is good, I am pretty, I am liked, I am respected."[6]

Though she did not regard herself as a feminist, Hesse became a crucial figure for numerous feminist and female artists to follow, as her work effectively anticipated some feminist mandates that were formulated only after her death. Layered as it is with abstract references to female anatomy—with forms suggestive of breasts, clitorises, vaginas, fetuses, uteruses, fallopian tubes, and so forth—Hesse's art might be considered a visual demonstration of *écriture féminine,* the practice of a woman "writing the body" recently espoused by some French feminists. *Écriture feminine* was conceived as a counter to a patriarchal regime in which women figure as "scene, rather than subject, of sexuality"; transposed into visual terms, it could serve as a counter to a visual regime in which "the female body is constructed as object of the gaze and multiple site of male pleasure" such that female spectators are assigned to "a zero position, a space of non-meaning."[7] As promulgated by Hélène Cixous, *écriture feminine* involves a subversive "act which will not only 'realize' the decensored relation of woman to her sexuality . . . ; it will give her back her goods, her pleasures, her organs, her immense bodily territories which have been kept under seal."[8] While refusing, in her art, those stock, disembodied or two-dimensional figures of feminine sexuality—the siren or whore, the Madonna, the virgin, and the *femme-enfant*—Hesse found new and different terms with which to articulate a feminine

Fig. 65
Contingent, completed 16 November 1969
Fiberglass, polyester resin, and latex over cheesecloth
Each of eight units, 114–168 x 36–48 in.
(289.6–426.7 x 91.4–122 cm)
Collection, Australian National Gallery, Canberra

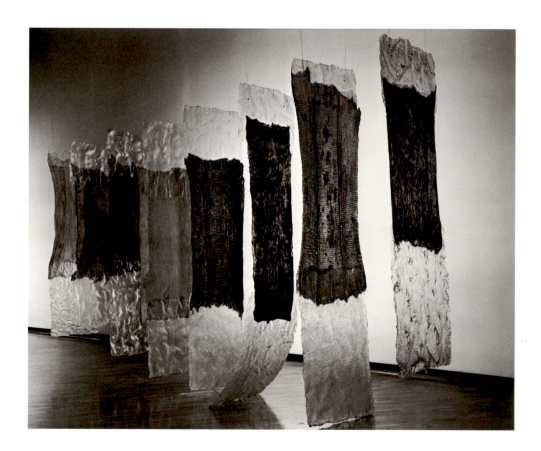

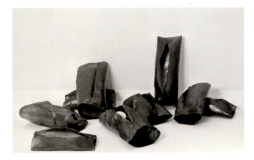

Fig. 66
Tori, August 1969
Fiberglass and polyester resin over wire mesh
Each of nine units, 30–47 x 12½–17 x 11¼–15 in.
(76.2–119.4 x 31.7–43.2 x 28.6–38.1 cm)
Philadelphia Museum of Art, purchased with funds
contributed by Mr. and Mrs. Leonard Korman, Mr.
and Mrs. Keith Sachs, Marion Boulton Stroud, Mr.
and Mrs. Bayard T. Storey and various funds

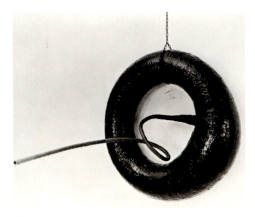

Fig. 67
Total Zero, February 1966; destroyed by request of
the artist, 1970
Rubber, plastic, epoxy, acrylic paint, polyurethane,
metal, and papier-mâché over inner tube
27 x 27 x 36 in. (68.6 x 68.6 x 91.4 cm)

sexual subjectivity. But the "goods" in question in her sculpture prefigure less a body vibrant with libidinal feeling than a body in pain: a body—not always female, but often bigendered, and sometimes male in its sexual markers—mutilated, dismembered, or flayed.

Critics detected images of the body, including the artist's own, in Hesse's sculpture from the first, despite her art's abstractness. "Hesse worked *out* from a body identification into a physical identification with the sculpture itself, as though creating a counterpart of herself," Lucy Lippard argued.[9] Her work's "sexual metaphors . . . take their spur from closely lived experience. They are always a function of the actual events of a life painful from the first," was Robert Pincus-Witten's overly literal assertion.[10] For her part, Hesse wanted to make objects that were erotic and darkly humorous; she referred in her diary to "abstract objects that produce unmistakable sensations attachable to, though not necessarily interpretable as the erotic," citing a phrase of Lippard's.[11] The "sick" and "weird humor" at play in her "crazy forms" is that of the grotesque, as she aimed to keep her work in the "ugly zone" and out of the "beauty zone."[12] At once repellent and alluring, the grotesque body, as Peter Stallybrass and Allon White define it, is identifiable for its emphasis on "orifices and symbolic filth . . . , [and the] physical needs and pleasures of the 'lower bodily stratum'," the sexual organs.[13]

Not all of Hesse's sculptures are explicit in their sexual references. The eight fiberglass, latex, and cheesecloth draperies that compose *Contingent* of 1969 (fig. 65; see also plate 113), while looking like a ghastly array of giant, soiled bandages or, worse yet, like so many flayed, human skins (distantly evocative of the Nazis' notorious use of human flesh to make lampshades), might be seen as sexually undifferentiated. In *Repetition Nineteen III* of 1968 (plate 104), the dented, fiberglass canisters could be construed as simultaneously vaginal and phallic, but only in a vague, abstract way.[14] By contrast, the stiff, sausage-like forms recurrent in Hesse's art, as in *Several* of 1965 (plate 88), are comically obscene in their flagrant phallicism. Conventionally, of course, it is men who have the opportunity to buy the flesh of women, as if it were so much meat; but here a woman has deviously and crudely equated men with meat, while casually tacking these penile forms to the wall like so many vulgar hunting trophies. And in *Tori* of 1969 (fig. 66; plate 112), the nine scattered, slit, cylindrical units fabricated of a loosely flesh-like, translucent fiberglass create an effect as of dismembered, squashed, and discarded female genitalia. By reducing the body to its genitals, Hesse in a sense usurped the male role of the pornographer and graffitist, who render men metonymically as "pricks" and women as "cunts."

In the "stylisation of graffiti," as Angela Carter observes, "the male is positive, an exclamation mark. Woman is negative. Between her legs lies nothing but zero, the sign for nothing, that only becomes something when the male principle fills it with meaning."[15] "Total Zero" was Hesse's scathing nickname for the woman her husband lived with after leaving her; and it was the title she gave a contemporaneous sculpture (fig. 67) comprised of an inner tube to which she grafted a long, twisted, phallic rod that punctured the space in front of it. Like the units in *Repetition Nineteen III, Tori,* and numerous other works by Hesse, *Total Zero* featured a description of a hole or void—an image bearing multiple associations, though the sexual or biologic,

and the emotional or psychological are what suggest themselves here. In 1960, Hesse had recorded experiencing "A vacant, absent feeling . . . A void which [word illegible] to be filled. In either case it is loneliness and emptiness which I constantly feel," at a time when she was pondering her "link with mother": a link central to the formation of her feminine identity.[16] For a while this sense of emptiness, "the feeling I had just that I could do and be nothing," a zero, stymied her artistically.[17] But by the end of the decade, "a really big nothing" became precisely "one of the things that I so much wanted to be able to do": that was her description of what she liked about the tangled rope piece, *Right After* of 1969 (plate 111), in its initial stages.[18]

Using flexible and pliable materials conducive to random shapes or shapelessness, and creating objects that have no fixed arrangement or order—works that others could rearrange at will, as in *Repetition Nineteen III* and *Untitled* of 1970 (fig. 68; plate 115)—Hesse purposely conjured a vision involving what she termed "non forms, non shapes non planned."[19] Sensing herself at times a nonentity made the sculptor want her work to be "non-work," as she declared in 1968; or, as she put it in more complicated terms the following year:

I wanted to get to non art, non connotive,
non anthropomorphic, non geometric, non, nothing,
everything, but of another kind, vision, sort.
from a total other reference point . . .
that vision or concept will come through total risk,
freedom, discipline.
I will do it.

. . .

it's not the new. it is what is yet not known,
thought, seen, touched but really what is not.
and that is.[20]

Ultimately, Hesse's painful sense of emptiness and annihilation, of being "helpless. Insufficient. Stupid," and of "Always feeling what I do is wrong," became fodder for the art that was her only "weapon."[21]

Rather than use her art to refuse the sociohistorically invisible position of being a woman, Hesse worked to attest to that very sense of vacancy or absence and the pain it entails. For that matter, testimonies of pain are rife in the art and literature of women in the modern period in general, and have come to serve as tacit markers of the authenticity of expression of the "Other," the marginalized or repressed.[22] Those female artists and writers who endured exorbitant suffering and died relatively young, whether or not by their own hands, have lately commanded a special veneration in our culture, moreover: besides Eva Hesse, there are Frida Kahlo and Diane Arbus, or Virginia Woolf, Sylvia Plath, and Anne Sexton, all of whom made pain a central theme of their work. It is as if martyrdom were the price demanded of women who demonstrate their creativity in defiance of patriarchal constraints and norms, as if the woman who successfully seizes and wields the phallic pen must pay with her life for assuming a male prerogative.

While female artists who report effectively on women's misery occupy a special

place in the affections of many feminists, some other feminists have argued that such reports may actually help to reinforce "the association, within patriarchal configurations, of femininity with the pathological," to borrow a phrase from Mary Ann Doane. "Disease and the woman have something in common," Doane observes; "they are both socially devalued or undesirable, marginalized elements which constantly threaten to infiltrate and contaminate that which is more central, health or masculinity."[23] There is, moreover, the risk that in enacting a kind of self-mutilation in their art—as Hesse might be said to have done—female artists may reinscribe ideas of an endemic female masochism. In art by women where "pain is not opposed to pleasure but becomes a privileged signifier in the field of sensations which the artist coordinates in the name of self-expression," what emerges may be less the sexual body, than a body "whose guarantee of truth is grounded in the painful state," as artist and critic Mary Kelly suggests; and "this type of art practice is not necessarily in opposition to the dominant discourse of art."[24] If we have begun to hear appeals for more salubrious content in the work of female artists, however, we cannot deny our lasting interest in stories of another kind: ghoulish tales of the spirited, gifted young woman who struggles to find her voice only to have it choked off by disease—disease that she makes, for as long as she is able, a centerpiece of her art.

Evocations of disease are rife in Hesse's art, with its pervasive suggestions not only of mottled and yellowing skin and of extruded and exposed female anatomy—the internal externalized as it is in surgery, or due to gruesome accidents, or acts of violence—but of medical paraphernalia, such as surgical hose, bandages, restraints, and blood-pressure cuffs. Hesse was no stranger to medical procedures: it is well known that she died tragically young (at the age of thirty-four) of a brain tumor first diagnosed in 1969. But it is not so well known that she was more or less seriously ill throughout her life, and that she almost always viewed herself as sick.[25] "I am now 28 afraid to say almost 29 and really fear never getting well," she wrote in 1964; "I seem to have felt like this since 8 years old."[26] Her diaries are riddled with notations

Fig. 68
Untitled, completed March 1970
Latex over rope, string and wire
H. each of three units, 144, 126, and 90 in. (365.8, 320, and 228.6 cm); width varies with installation
Whitney Museum of American Art, New York; Purchase, with funds from Eli and Edythe L. Broad, the Mrs. Percy Uris Purchase Fund and the Painting and Sculpture Committee

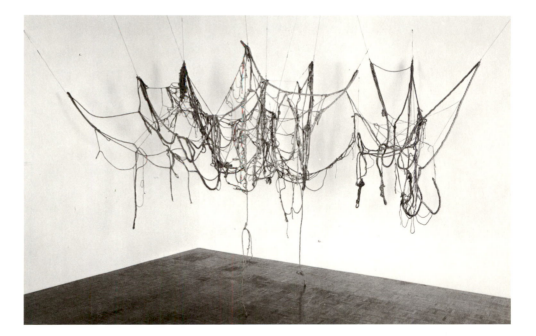

such as "I am sick again! Went to doctor second day of uncomfort instead of three weeks later. Sulphur pills and penicillin shot"; and "Last Wed. depression also recurred. Sun eve. and Monday—all day—Also real physical infections and pains"; and "I am very sick. I know it but don't know what to do . . . Like I feel I'm cracking up and would almost be relieved if it would happen already."[27]

For years, Hesse tried to preserve her equilibrium by taking anti-depressants.[28] But she had a sense of herself as exceptionally feminine and, for a woman whose mother had been mentally ill, the feminine was equated with the pathological—especially, though not exclusively, with "mental sickness" and dependency.[29] In the 1950s and early 1960s, femininity in general was associated with helplessness and childlikeness, but Hesse carried it to an extreme: "I must always compete with another woman and prove like my mother that I am incapable and sick. Is this still in my mind synonymous with femininity?"[30] The answer was yes. At times, she virtually prided herself on her illness: "sickest—competition? competitive—how much I suffer —my value, like by how sick I am," one note reads.[31] She felt that she was fated to die a suicide, as her mother had, and contemplated killing herself.[32] For that matter, the bandaging effects found occasionally in Hesse's art—as in *Hang Up* of 1966 (plate 91)—may bespeak her sense of identification with the woman she sometimes referred to as her "mummy," evoking a dead body bandaged head to foot.[33]

Hesse sometimes suspected that there was a relation between her emotional illness and at least some of her physical problems, that her suffering was, to an extent, self-generated.[34] In therapy for many years, and fairly fluent for a layperson in the language of psychoanalysis, Hesse identified herself as subject to both masochism and hysteria. In hysteria, which is often called "the paradigmatic female disease, the body is in sympathy with the psyche to the extent that there is no differentiation between them," as Doane has explained; "Illness affects and defines her whole being."[35] In his famous case study of "Dora," Freud described how, for the hysteric, "falling ill involves a saving of psychical effort; it emerges as being economically the most convenient solution when there is a mental conflict (we speak of a 'flight into illness')."[36] Freud identified the hysterical symptom, further, as "the memory-symbol of the operation of certain (traumatic) impressions and experiences . . . a substitute, produced by 'conversion', for the reactivation of these traumatic experiences by association."[37] He associated the traumas in question specifically with memories of—or, by his revised account, fantasies of—seduction by the father. While Hesse's childhood traumas were more diverse, she answered Freud's description of the hysteric in this, as in other particulars; for she was plagued by guilt and "fear of incestuous relationship to father," imagining herself having wishfully prompted her mother's suicide by displacing her father's attentions during her chronic, childhood illnesses: "I was sick and bad and therefore got father"; "My father left my mother. She killed herself."[38]

A diminutive woman, Hesse associated her feelings about her childlike stature with her family history: "Shame of height is shame of incest. An obvious (seen) shame covering for a hidden shame."[39] In a monograph on Hesse, her friend Lucy Lippard stressed the artist's childishness; and Hesse often examined herself about her juvenile behavior: "I really feel I keep blocking my growth. Why? What does being adult

have seen an analogue to her own family situation in this theatrical Hellenistic sculpture (which she saw during her stay in Europe); for her father alone among the members of his family had foreseen Hitler's threat in time to escape, and while enduring serious afflictions of his own, had become the primary caretaker for his two children after their mother's desertion and suicide. In Hesse's version of the subject, however, there are no human figures, but only the rigid, orderly skeleton of a cage overrun by abstract, slithering snakes.

"Spent afternoon dying cord," Hesse noted in her diary in 1966. "5:30 Phaler came. He is very bright, verbal great . . . I unfortunately get caught in the web. The only web I know inside my dumb guts— . . . Lock myself in a cage. I darken it besides."[57] Surrounded mainly by loquacious men—artists such as LeWitt, Bochner, and Smithson, who bandied about concepts for hours at a time—Hesse saw herself as inarticulate and unlettered, and even wondered, in her sense of alienation from language, whether men were innately more intelligent than women.[58] "Sometimes I feel there is something wrong with me. I don't have that kind of a precise mind . . . I don't know if I stand alone but I don't stand on a kind of—I don't have that kind of a system," she worried.[59] In the end, however, Hesse purposely separated her practice from the explicitly theorized work of her peers: "I can't go on a sheer program. And at times I thought 'the more thought the greater the art,' but I wonder about that and I do have to admit I think there's a lot that I'll just as well let happen," she told Nemser.[60] For that matter, her resistance to implementing in her own art the kind of simple, totalizing systems favored by LeWitt, Carl Andre, and Donald Judd may bespeak her greater experience with the effects of totalizing systems; for within the New York artists' community to which she belonged, Hesse was uniquely aware of the damage totalitarian regimes can do. The work of Andre, in particular, reminded her of "the concentration camp. It was those showers where they put on the gas." Such was her chilling reaction to his stark "plains," with their square, flat, metal plates lined up on the floor.[61]

Hesse refused the rigid, strong, industrial materials employed by her minimalist peers (as well as the orthodox sculptural materials of stone and bronze), favoring such soft substances as fibers, fiberglass, and latex—materials not identified with major sculpture. Working with malleable materials lent itself to avoiding fixed and systematic form. "Finished my two last pieces . . . *Laocoon* and titleless [one] so far. Cords everywhere. Will do one that does not come from a form, that is endless totally encroaching and irrational. With its own rationale, even if it looks chaotic," she noted in her diary in 1966.[62] While many of her peers stressed formal and conceptual order, (phallic) rigor and closure, Hesse was privileging (feminine) permeability and a structure that could be "ordered yet . . . not ordered"; "chaos . . . structured as non-chaos."[63] She referred to Jackson Pollock's poured pictures, with their tangled skeins of paint, in discussing the process of making her tangled rope pieces.[64] But however chaotic Pollock's paintings may appear, they were entirely fixed in their (dis)order once the painter completed them, whereas much of Hesse's work is necessarily reordered each time it is installed: in a radical gesture, she left many of her works perpetually open to the participation of others in (re)composing them.

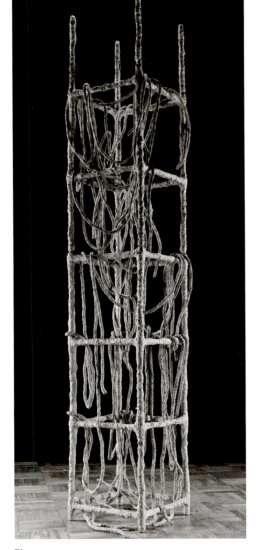

Fig. 70
Laocoon, completed June 1966
Acrylic paint, cloth-covered cord, wire, and papier-mâché over plastic plumber's pipe
130 x 23½ x 23 in. (330.2 x 59.7 x 58.4 cm)
Allen Memorial Art Museum, Oberlin College, Fund for Contemporary Art and gift of the artist and Fischbach Gallery

If Hesse tended to favor malleable and comparatively fragile materials over hard and durable ones, and if her work often projects a vulnerability inimical to the work of her peers, such factors did not necessarily prevent her art from exhibiting a degree of toughness. There is, for example, a subtly menacing quality to the big, irregular "webs" Hesse wove, due in part to the conventional association between spiders—those web-spinning arachnids—and treacherous women, especially older (virgin) spinsters who ensnare unsuspecting men. As it happens, around the time she was spinning these sculptural webs, Hesse felt herself in a state of sexual decay: "I feel myself, my insides, outsides, I am 30, I am living alone, all the time, lonely, celibate."[65] If the spider symbolizes the frustrated female as would-be man-eater, however, it can also be emblematic of the productive female artist; thus, for instance, the poet Emily Dickinson "imagine[d] herself as a spider silently spinning out her subversive spells."[66]

Spinning and weaving, sewing and knitting, wrapping and bandaging: working with fiber is conventionally women's work, and Hesse—like many women of her generation—learned as a matter of course how to sew, knit, and crochet.[67] Historically, needlework has signaled women's confinement in the household and the limitation of their accepted creative outlets to activities that are, in the first instance, domestic chores.[68] From one perspective, then, Hesse's extensive use of fiber might be seen as a symbolic concession to the constricting roles of dutiful daughter and wife. But in becoming a professional sculptor—one who courageously refused both academic and avant-garde orthodoxies—Hesse effectively declined such stultifying roles, while inverting the means and materials of women's work into a mode of self-empowerment. Her rope pieces are not like dainty, controlled displays of needlecraft, but like needlework gone berserk, like a madwoman's overgrown macramé project. Literature provides some precedents for the willful needlewoman: such "powerful weaving women" as the fairytale characters of "The Three Spinners," or the "Fates or the Norns, remind us of figures like Philomel and Penelope, both of whom also exercise their art subversively and quietly in order to control the lives of men," observe Sandra Gilbert and Susan Gubar.[69] As they sever the thread of human life at will with a snip of their shears, the Fates especially exemplify the potential threat of the (spider-like) figure who spins, ties, and cuts her threads.

Spinning and needlework may conjure diverse and contradictory associations both for the worker and for the recipient of her labors, in short. But in the poems of Emily Dickinson, as Gilbert and Gubar have pointed out, the "stitch of art" emerges as "provident and healing, 'a stitch in time'."[70] And Hesse also hoped that her bound, laced, and knotted cords would have an anodyne effect on one who had chronically endured "Tearing apart insides—outsides damages unknown. Repairs possibly possible not . . . ," as she once incoherently described her feelings.[71] Symbolically, Hesse sought to bind the wounds of "The Eva who grew up sick and unhappy in the sickest of environments, but therefore must make a new world where this does not exist."[72] As with the art of Joseph Beuys, which she admired, we may discern a ritualistic attempt in Hesse's work to find liberation in the present by dressing the wounds of the past.[73] Whereas Beuys framed the sufferings he endured as a downed Luftwaffe pilot in a global, political context, however, Hesse, who was a tiny child at

the onset of the war, framed her own art in more narrowly personal and more formal terms. Though she was highly conscious of her identity as a Holocaust survivor—a consciousness fostered by the scrapbooks her father scrupulously kept for her of the political events of her girlhood—for Hesse the political was above all experienced as personal through the drastic effects it had on her own and her family's well-being.

From another perspective, Hesse's immersion in the private spheres of the body and the self may be seen in relation to the accepted protocols of femininity: because of "the exacting and normalizing disciplines of diet, make-up and dress" imposed on women, as feminist critic Susan Bordo argues, "we are rendered less socially oriented and more centripetally focused on self-modification."[74] In a related vein, Gubar notes that, historically, "Unable to . . . obtain the space or income to become sculptors, gifted women . . . have had to work in private, using the only materials at hand—their bodies . . . women could at the least paint their own faces, shape their own bodies." As for those exceptional women who managed to do more, to become actual artists,

many . . . experience their own bodies as the only available medium for their art, with the result that the distance between the woman artist and her art is often radically diminished; [further,] one of the primary and most resonant metaphors provided by the female body is blood, and cultural forms of creativity are often experienced as a painful wounding . . . the woman artist who experiences herself as killed into art may also experience herself as bleeding into print.[75]

Hesse not only endured grave wounds, she *was* a wound, inasmuch as the bleeding wound is "a standard Freudian symbol of femininity, representing both woman's fertility and the apparent [or supposed] imperfection of her body."[76] Whereas the male artist is said to overcome his wounds, transfiguring his suffering into his art, the female artist is denied the possibility of escape, and so of establishing the expected measure of distance between her art and her life.[77] Gubar points out, however, that "Not a few of the most exciting experiments of women artists . . . grow out of a self-conscious attempt to obliterate aesthetic distance."[78] The art of Eva Hesse unmistakably belongs in that category. In this light, her concentration on the body renders her work not apolitical, but political in another way: for the body is "a surface on which the central rules, hierarchies, and even metaphysical commitments of a culture are inscribed," as Bordo puts it. "The body is not only a *text* of culture. It is also . . . a *practical,* direct locus of social control."[79] What was specifically inscribed on Hesse's body, and what she inscribed in her art, were above all the debilitating effects of tyranny, whether sociopolitical, sexual, or physical, as in the tyranny of disease.

Hesse had lamented (to reiterate) that "A woman is sidetracked by all her feminine roles from menstrual periods to cleaning house to remaining pretty and 'young' and having babies."[80] Feeling not only subjugated but practically obliterated by the social expectations imposed on her as a woman, she protested, "I cannot be so many things. I cannot be something for everyone . . . Woman, beautiful, artist, wife, housekeeper, cook, saleslady all these things. I cannot even be myself, nor know what I am."[81] As these plaints suggest, Hesse's consciousness of her femininity and her fertility, of her "bleeding wound," was enmeshed with her sense of her artistic

productivity; she recorded the arrival of her menstrual periods in the same notebooks where she made notes on her sculpture and her activities as an artist.[82] Further, the phenomenon of the cycle, prefigured by a circle, became vital to her vision of the structure of both her life and art, as evidenced by the language she used in her diary entries, as well as by such works as *Ringaround Arosie, Untitled* of 1966–67 (plate 97), and *Compass* of 1967 (fig. 71).

"Coming close to answers but go in circles," Hesse noted in her diary in 1966; "Not in work. Yes in work."[83] A circle is (among other things) a zero, a way of configuring nothingness, as Hesse hoped to do; "all circles—grasping holding nothing 'a great gesture around nothing,'" she noted in 1966, citing a phrase used by Bochner to describe her work.[84] For Hesse the circle signified also the self-defeating emotional pattern in which she felt locked: the "vicious circle" or "painful cycle" she referred to particularly in the period when she lost her husband and her father, in 1965 and 1966. "I get depressed from such low spirit low accomplishment low everything another cycle"; "sadism, masochism same thing other side of coin—break this cycle"; "The painful cycle. The sad sickness that did not change quite enough," read several of the passages in her diaries.[85] Further, the month of her birthday, January, was the month her mother had plunged to her death, and thereafter winter's arrival precipitated a "yearly fall into the pit of darkness."[86] In her interview with Nemser in 1970, Hesse emphasized the "time element" signified by the motif of the circle: "the sequence of change and maturation"; but, she added, "I think I'm less involved in it now."[87]

Among the forms Hesse became involved with instead was the freestanding, open box, as in *Accession II* of 1969 (fig. 72; plate 108). Like the minimalist artists, who made extensive use of the box (see, for instance, fig. 73), Hesse often made her boxes of commercial and industrial materials. But where her peers' boxes sharply denied the hand of the maker, being commercially fabricated with unembellished materials, hers were unabashedly subjectivized, displaying the hand labor involved in their making and alluding abstractly to the female body. Hesse's art emerged into public view around the same time as that of Judd and Robert Morris, artists who flaunted a rhetoric of virility and power in promoting a visual mode as deindividualized as possible.[88] Likewise with Pop art, which came to public attention in the same years: "I think we are talking of impersonality as style," as Claes Oldenburg put it.[89] Hesse's art stands as a tacit corrective to the minimalists' and the Pop artists' suppression and disembodying of the (sexed) subject. But her gender also places Hesse's project in a distinct position from her peers': if it was a radical gesture for a male artist to try to deconstitute or deny his subjectivity, for a woman it was a radical gesture instead to claim and to declaim her subjectivity.[90] Critics recognized that gesture as the central fact of Hesse's art: "one reads the work as one read the person," observed Lippard. Hesse was "telling us to see her art and her life as one," noted Arthur Danto; "It is a priceless key."[91]

From the first, Hesse was determined to "paint *against* every rule I or others have invisibly placed," to "go against every 'major trend.'"[92] Her resistance to the prevailing currents of the avant-garde earned her the respect of some of her peers: "In

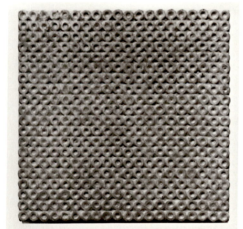

Fig. 71
Compass, 1967
Steel washers and Sculp-Metal on wood
10 x 10 x 1 in. (25.4 x 25.4 x 2.5 cm)
Marilyn Cole Fischbach, New York

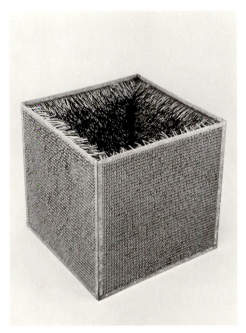

Fig. 72
Accession II, completed April 1969
Galvanized steel and plastic tubing
30¾ x 30¾ x 30¾ in. (78.1 x 78.1 x 78.1 cm)
Detroit Institute of Arts, Founders Society Purchase,
Friends of Modern Art Fund, and Miscellaneous
Gifts Fund

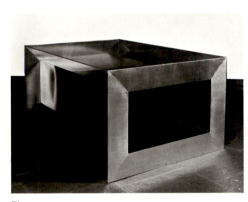

Fig. 73
Donald Judd (b. 1928)
Untitled, 1968
Stainless steel and plexiglass
33 x 68 x 48 in. (83.8 x 172.7 x 122 cm)
Collection of Whitney Museum of American Art,
New York; Purchase, with funds from the Howard
and Jean Lipman Foundation

that heyday of 'rigor' and 'structure,' Hesse seemed 'very radical or very eccentric,' Bochner recalls. 'She was never afraid of that. She wasn't afraid of being old-fashioned or of the work being about certain other issues, which right now looks very courageous, to be able to go up against public opinion like that.'"[93] The "other issues" that concerned Hesse included the politics and poetics of the body and of femininity. Thus while boxes in general are symbolically associated with the female genitalia, Hesse's *Accession* boxes are particularly sexual in their dark, hirsute, and spiky-looking interiors, which may evince the myth of the vagina dentata with its treacherous mouthful of teeth (a modern recrudescence of which is the slang term "snatch" for a vagina). Hesse toyed here with another image of a "man-trap," at once flaunting and implicitly confounding a misogynist trope, reclaiming and revising an insidious stereotype of femininity. Like much of her sculpture, Hesse's boxes appear at once repulsive and alluring as they draw the touch— however ambivalent—of the spectator. Nor were viewers discouraged from handling and rearranging the stubby ends of the knotted rubber tubing covering the insides of these boxes.

The image of a seductive but dangerous box is of course familiar from the ancient myth of Pandora's box. Pandora is the equivalent figure in Greek mythology to Eve (or Eva) in biblical history: the first mortal woman.[94] Zeus created Pandora to punish Prometheus for stealing fire and intelligence from the gods for man; and she arrived on earth armed with a box holding all the terrors and ills that could afflict humanity. Though warned by the gods to keep her box sealed, Pandora succumbed to curiosity—as Eve did in tasting the apple—and so doomed humanity to suffer ever after. Feminine curiosity thus emerges as an uncontrollable and transgressive desire to investigate, an impulse bound to culminate in disaster, while female sexuality is implicated as the source of all evil.

As for Hesse, she was determined to make the "wrong" box. In fact, she worried that *Accession* was "too right. I'd like to do a little more wrong at this point."[95] What was "wrong" about *Accession II* was not only its odd, oddly sexual intermixture of geometric and biologic morphologies, but the extreme obsessiveness that visibly attended the box's facture: the hand-tying of knots in plastic tubing threaded through more than 30,000 holes. "That's obsessive repetition," Hesse noted; "but then the form it takes is a square and it's a perfect square. And then the outside is very, very clear . . . The inside looks amazingly chaotic."[96] The sculptor recognized that obsessive or "endless repetition"—which surfaces often in her art—"can be considered erotic" (an observation she took from Lucy Lippard).[97] But obsessive activity also entails, as Catherine Clément has argued, a kind of exceeding and caricaturing of "limits in the direction of law, constraint, and conformity . . . In adding more to the rigidity of structures, and in adding more to ritual, he [the obsessive person] works destructively."[98]

Finally, Eva's Pandora's box—the box she opened in all her art (figuratively speaking)—is not only the taboo box of a woman's sex, but also a voice box courageously, mischievously articulating a feminine critical subject. "It just seems to me that the 'personal' in art if really pushed is the most valued quality and what I want so much is to find it in and for myself," Hesse noted in her diary in 1964.[99] If anyone could push

it, she could; for she was, or became increasingly, a woman with nothing to lose. "All my stakes are in my work," she determined; "I have given up in all else. Like my whole reality is there—I am all there."[100] Not only Hesse's gender but also her family history help account for her insistence, even after she became too frail to shape her own work, on the presence of an authorial subject, visible in the idiosyncratic, irregular, and handmade quality of her sculpture's forms and surfaces. For Hesse, the specter of the extinction of the individual subject in the technological era could never be just a sociopolitical abstraction to be met with further abstractions. The prospect of obliteration had been a concrete and pressing one for her almost from the moment she was born, owing first to the genocidal programs of the Nazis and then to an onslaught of family and personal calamities. Hesse knew something—more than most of us ever will—about desperation, terror, and pain: "That terror stands so in my way. It is a haunting paralyzing experience, one of which I stand in dread of occurring, and when it happens it is even worse than what I anticipated."[101]

The subject whose survival Hesse emphasized in her art, then, was not a model being—healthy, whole, and integrated—but one prone to disintegration, as was her art. "My life is falling apart," she noted in her diary in August 1966; and, soon thereafter, "Some of my work is falling apart"; or, as she pithily observed to Cindy Nemser when she knew she was dying, "Life doesn't last, art doesn't last."[102] The noisome scent of decay which seems to emanate from Hesse's sculpture helps explain its chilling effect on viewers, as it plays on our fears of contamination and dissolution, on our gnawing sense of our own mortality. "The relationship between images of disease and the representation of internalized feelings of disorder is very close," Sander Gilman has observed.[103] But it may be especially close for women, for there are "ways in which patriarchal socialization literally makes women sick, both physically and mentally."[104] Besides the innumerable pains associated with the routine functioning, and the frequent dysfunctioning, of the complex plumbing of the female reproductive system (seemingly a favorite source for Hesse's imagery), there are the pains which follow from women's inferior social status and the indoctrination that prepares them to assume that status.[105] As Gilbert and Gubar argue, "To be trained in renunciation is almost necessarily to be trained to ill health, since the human animal's first and strongest urge is to his/her *own* survival, pleasure, assertion."[106] From a certain perspective, then, a female artist is virtually bound to be a pathological figure, one who may well center her art around her pathology; for she has been "literally or figuratively crippled by the debilitating alternatives her culture offers her."[107]

Critics sympathetic to Eva Hesse's art often hesitate in relating her life's story, foreseeing that the exceptional interest of the artist's biography may eclipse the, nonetheless exceptional, interest of her sculpture. Yet we cannot accurately account for Hesse's art without examining the story of her life; for, in a real sense, she made her art out of her illnesses, which substantially defined her identity as a woman and (to a lesser degree) as a Jew, as one of the disempowered and despised.[108] "A steady motif in the feminist literature on female disorder is that of pathology as embodied *protest*," notes Susan Bordo; "—unconscious, inchoate, and counterproductive protest without an effective language, voice, or politics—but protest nonetheless. American and

French feminists alike have heard the hysteric speaking a language of protest, even or perhaps especially when she was mute."[109] In desperation, the hysteric expresses with physical symptoms those emotions she feels incapable of, and discouraged from, expressing in any other less debilitating way. But Eva Hesse was as much Pandora as Dora; as much an irrepressible rebel as a sickly figure of suppressed rebellion. She spoke not only mutely and pathetically, with her body, but also audibly and eloquently, with her body through her art, as a "girl being a sculpture."

"By writing herself," Hélène Cixous envisioned, "woman will return to the body which has been more than confiscated from her, which has been turned into the uncanny stranger on display—the ailing or dead figure, which so often turns out to be the nasty companion, the cause and location of inhibitions. Censor the body and you censor breath and speech at the same time."[110] In exploring the body of the ailing figure, and especially that of the ailing woman, through her sculpture, Eva Hesse found not only her subject, but also her own, differently pitched voice, and the courage to raise it: "My work . . . is my strength, my energy . . . It draws upon all my faculties," reads a typical, heartening entry in her diaries.[111] Not only in spite of, but because of, the ailments and afflictions that dogged her too brief life, Hesse succeeded in performing "a radical act of remembering."[112] She demystified or demythologized the female body by inverting or revising, with a sly, gallows humor, some of the degrading or alienating images used to represent it. At the same time, Hesse succeeded in *re*mythologizing the female body by articulating, in her own inventive and vivid terms, elements of that which is so often denied or repressed about feminine experience: its repugnant and piteous inheritance of pain.

Notes

I am grateful to Ann Gibson, Lisa Saltzman, and William Taylor for their comments on the manuscript of this essay.

1 Cited in Lippard, 15, and 215 n.5.

2 Diary entry of March 1965, cited in Ibid., 34. Eight years earlier, in a letter to her psychotherapist, the twenty-one year old Hesse—then enrolled in the art school at Yale—had similarly queried, "are my needs for developing artistically and intellectually incompatible with my role as a woman? Am I incapable of satisfying man's needs of supremacy? Must I take an actor's prompting from a director? Is my role to be there when a man wants me? Why am I a masochist . . . ?" (letter to Helene [Papanek], 20 Dec. 1957, Eva Hesse Archives).

3 Letter to Ethelyn Honig, cited in Lippard, 205.

4 Diary entry of Thurs., 19 Nov. [1964]. Hesse felt she had found a "spokesman" in the French writer, and she urged Honig in the same letter (cited above) to read *The Second Sex*, which she was just finishing; see Lippard, 205.

5 Diary entry of Wed. [May 1966].

6 Cited in Lippard, 70.

7 Teresa de Lauretis, *Alice Doesn't: Feminism, Semiotics, Cinema* (Bloomington: Indiana University Press, 1984), 27, 149, 75.

8 Hélène Cixous, "The Laugh of the Medusa," in *New French Feminisms*, ed. Elaine Marks and Isabelle de Courtivron (New York: Schocken Books, 1981), 250.

9 Lippard, 197.

10 Pincus-Witten proposed, for instance, a cause-and-effect link between the "'uterine' motif" in Hesse's mature (post-1964) work and the gynecological problems she suffered in 1960 while at Yale; see Robert Pincus-Witten, "Eva Hesse: More Light on the Transition from Post-Minimalism to the Sublime," in *Eva Hesse: A Memorial Exhibition* (New York: Solomon R. Guggenheim Museum, 1972), n.p. A somewhat more convincing example of such a reading: "Cutting gestures, surely not unrelated to Hesse's cutting her hair at this time, play a very important role in the series of *Accession* boxes" (Barrette, 138).

11 Undated entry [after Spring 1967], on loose sheet attached to small, six-ring

notebook. This and other passages on three such notebook sheets consist of Hesse's reading notes (unattributed) from Lippard's article "Eros Presumptive," *Hudson Review* (Spring 1967); copying in slightly abbreviated form a passage on Claes Oldenburg, in whose work Hesse had a not unexpected interest, she noted: "as eroticism his work is abstract. The stimuli arise from pure sensation rather than direct association with objects depicted"; see also Lippard, 217 n.32. Others whose work dealt with the body, the erotic, and the grotesque in this period include Bruce Nauman, Lucas Samaras, Paul Thek, and Lynda Benglis; Hesse knew Thek and Benglis (the former was a friend), and she explicitly admired Samaras and Nauman.

12 The first three phrases cited in this sentence are from a letter from Hesse to Sol LeWitt, 18 March 1965, cited in Lippard, 34; the last two phrases, from the Hesse/Nemser transcript.

13 Other characteristics of the grotesque body, also relevant to Hesse's work, include "impurity . . . , heterogeneity, . . . protuberant distension, disproportion, exorbitancy, . . . decentred or eccentric arrangements, . . . materiality and parody" (Peter Stallybrass and Allon White, *The Politics and Poetics of Transgression* [Ithaca, NY: Cornell University Press, 1986], 23). For a discussion of the grotesque in relation to Hesse's work, see the essay by Robert Storr in the present publication.

14 Hesse herself was ambivalent about assigning specific sexual referents to individual sculptures. *Repetition Nineteen* was made of "empty containers and you have that sexual [connotation]. It is anthropomorphic," she noted to Nemser. At a different point in the same series of interviews, however, in response to Nemser's perception that *Repetition Nineteen* evokes both male and female genitalia, Hesse fervently denied, at the same time as she contradictorily acknowledged, her awareness of such allusions: "I don't see that at all. I'm aware that that can be thought of as that even in the process of making them. But I am not making that. I am not saying female/male when I work at it . . . even though I recognize that that is going to be said. You could say that this is erect and some of them are semi-erect" (Hesse/Nemser transcript).

15 Angela Carter, *The Sadeian Woman and the Ideology of Pornography* (New York: Pantheon, 1978), 4.

16 Diary entries of Wed. [13 July 1960] and

Tues., 12 July [1960].

17 Diary entry of Mon., 13 July [1964].

18 Hesse/Nemser transcript; Hesse felt that she lost this effect in the finished work. Lippard also related Grace Wapner's recollection of the sculptor finding an object in the street that impressed her, calling it a "nothing" and saying that what she wanted to make was "nothings" (56).

19 Cited in Lippard, 172.

20 Both statements were issued publicly. The first, of June 1968, was included with a press release for Hesse's exhibition at Fischbach Gallery (*Eva Hesse: Chain Polymers,* Nov.–Dec. 1968); reprinted in Lippard, 131. The second is from Hesse's catalogue statement for *Art in Process IV* at Finch College Museum of Art (Dec. 1969–Jan. 1970); reprinted in Lippard, 165. Hesse exhibited *Contingent*.

21 Diary entries of 2 a.m. [24 Aug. 1966]; "Sat., Aug. 13 or 14" [1966]; and 2 a.m. [24 Aug. 1966].

22 "Surrounded as she is by images of disease, traditions of disease, and invitations both to disease and to dis-ease, it is no wonder that the woman writer has held many mirrors up to the discomforts of her own nature" (Sandra M. Gilbert and Susan Gubar, *The Madwoman in the Attic: The Woman Writer and the Nineteenth-Century Literary Imagination* [New Haven, CT: Yale University Press, 1979], 57). I am also indebted to Gilbert and Gubar for the epigraph to this essay (45).

23 Mary Ann Doane, "The Clinical Eye: Medical Discourses in the 'Woman's Film' of the 1940s," in *The Female Body in Western Culture: Contemporary Perspectives,* ed. Susan Rubin Suleimann (Cambridge, MA: Harvard University Press, 1986), 152.

24 Mary Kelly, "Re-Viewing Modernist Criticism," in *Art After Modernism: Rethinking Representation,* ed. Brian Wallis (New York: The New Museum of Contemporary Art, 1984), 97. Kelly refers in particular to the performance art of Gina Pane, and credits Judith Barry and Sandy Flitterman for anticipating some of her insights.

25 At the age of two, illness caused Hesse to be separated from her sister when they were sent from Germany to safety in the Netherlands on a children's train. The suicide of her mother, who jumped from a window when Hesse was ten, caused her to "throw up daily" and to refuse to go to school. This horrifying experience also prompted her initiation into psychotherapy, which she would continue for much of her life. While a student at Yale, Hesse suffered from excessive bleeding

and excruciating cramps during her menstrual periods, for which affliction she underwent an operation. In Germany, in 1964–65, she developed crippling pains in her legs and debilitating fatigue, which were diagnosed (according to Hesse) as a result of circulatory problems and abnormally low blood pressure; during the same sojourn she recorded contracting German measles and pneumonia. From 1969 until her death in 1970, she suffered from problems caused by her brain tumors and the treatments she received for them. She had had premonitions of her own "untimely, premature death" in dreams set in surroundings that evoke Nazi Germany, through references, for instance, to her being in a "camp-like place" where she was being "pursued, tortured, poisoned" (see diary entry of 6 a.m., Sun. [March 1960]). And she traced some of her own chronic maladies to her family's plight: "Problem of my past; of my past sickness—of the scars of my early beginnings. The deep-rooted insecurity which has made any relationship, meaningful one, impossible—" (entry of 12 Dec. 1960).

26 Diary entry of Mon., 19 Oct. 1964.

27 Diary entries of 17 Feb. [1961]; Tues. [April 1961]; and 6 March 1965.

28 Hesse recorded in numerous diary entries between 1964 and 1966 that she was on "strong drugs, anti-depressants"; she at times specifically mentioned taking librium.

29 "Equate femininity with mental sickness" (diary entry of Fri. [March 1960]); in the same diary, entry of 13 June 1960, Hesse wrote, "I am like my mother who was dependent, 'feminine' and she was sick. Somewhere, somehow, this is important!"

30 Diary entry of 7:30 a.m., Tues. [April 1961].

31 Undated entry in spiral notebook/Memo Book.

32 "I do now think I am just like my mother was and have the same sickness and will die as she did. I always felt this. I have almost never had a day in my life since memory allows me to recall—had a day without this kind of suffering described today. I know I am more of a person than this sickness allows me to be—I can never see without a mucked up vision" (diary entry of 12:30 a.m. [27 March 1965]). That Hesse contemplated suicide emerges in correspondence between her psychotherapists when she suffered a breakdown while at Yale; see letter from Helene Papanek to Dr. Lawrence Friedman at the Yale University Health Services, 30 March 1959, Eva Hesse Archives. There is no record of her ever having attempted suicide.

33 *Hang Up* features a long, looping steel tube extruding from an empty stretcher "all tied like a hospital bandage, like if someone broke an arm," as Hesse described it (Hesse/Nemser transcript).

34 For instance: "Why do the cuts and bruises I receive not clear up faster and totally. My symptoms are real, my fears one of a hypochondriac" (diary entry of Tues. [26 Jan. 1960]). Also, "I am slowly getting both sicker in mind as well as body. I wish it were all psychosomatic, but it exists and I am no Dr. to judge" (entry of Sat. eve. [19 Feb. 1965]); and in the same diary, "I have no more energy to struggle with the way I make myself suffer" (entry of 8 Jan. 1965).

35 Doane, "The Clinical Eye," 173. Hesse's references to her "hysteria" or "hysteria fit[s]" may be found in half a dozen diary entries dating between 1960 and 1966.

36 Sigmund Freud, "Fragment of an Analysis of a Case of Hysteria" (1905), in *Dora: An Analysis of a Case of Hysteria* (New York: Macmillan/Collier, 1963), 59–60 n.27 (note dated 1923).

37 Sigmund Freud, "Hysterical Phantasies and their Relation to Bisexuality" (1908), in Ibid., 149.

38 Diary entry of Wed. [31 Aug. 1966]; undated entry [Jan. 1967]; and entry of Mon. eve. [Nov. 1966]. Also, "closeness of relationship with father, alone,—probably sexual and otherwise" (entry of 14 Sept. [1960]); and "Shame of having father to self—incest" (undated entry [Jan. 1967]). (There is no unambiguous evidence of an actively aberrant sexual relationship between them.) Noted Freud, "The motives for being ill often begin to be active even in childhood. A child . . . notices that the whole of their [the parents'] affection is lavished upon it once more whenever it arouses their anxiety by falling ill. It has now discovered a means of enticing out its parents' love" ("Fragment," 61).

39 Undated diary entry [Jan. 1967].

40 Diary entry of Sat., 21 Nov. [1964].

41 Diary entry of 25 March [1965].

42 Diary entry of Thurs. eve. [19 Jan. 1961].

43 Diary entry of Fri., 3 July [1964].

44 Calendar/diary entry of 4 July [1964].

45 Diary entry of Wed., 1 July [1964].

46 Lesley K. Baier notes that the nursery rhyme in question "originated with the Great Plague in London, when young and old were indiscriminately struck down. Bodies were tossed into the charnel houses and burned" (note to the author, Oct. 1991). Hesse named the work for a friend, Rosalyn Goldman, who had recently become pregnant; see Barrette, 20.

47 Quoted in Lippard, 28.

48 Undated diary entry [Feb. 1960]. The "problem of support was a central theme in her sculpture and was intertwined with her recurrent dependence on other artists for technical assistance," observed Bill Barrette, a former studio assistant of Hesse's (Barrette, 84).

49 Calendar/diary entry of 20 June [1965]; and diary entry of 7 March 1966.

50 Hesse/Nemser transcript.

51 "It has been observed that Hesse was always anxious about being 'connected' emotionally to other people, as articulated formally by her relentless use of cords and elements which gropingly reach out to the viewer," noted Linda Shearer, relating an insight gleaned from Hesse's psychotherapist, Dr. Samuel Dunkell ("Eva Hesse: Last Works," in *Hesse: A Memorial,* n.p.).

52 Diary entry of Wed. [1964–65?], on loose sheet inserted into diary begun on 2 Nov. 1960; and diary entry of 28 May [1964]. Ambivalence emerges also in Hesse's repeated (though not invariable) misspelling of the word "abandonment" as "abondment."

53 Diary entry of Fri., 19 June [1964].

54 Diary entry of 17 Aug. 1966.

55 Diary entry of 1:30 a.m., Thurs. [18 April 1966].

56 In naming this work, perhaps Hesse also had in mind Clement Greenberg's famous essay, "Towards a Newer Laocoon," published in 1940.

57 Diary entry of Tues. [May 1966].

58 "I wonder if men are more intelligent, more capable of abstract thinking, more able to be intellectual," mused Hesse, according to Cindy Nemser, "My Memories of Eva Hesse," *Feminist Art Journal* 2, no. 1 (Winter 1973): 13.

59 Hesse/Nemser transcript; see also Lippard, 200.

60 Hesse/Nemser transcript.

61 Ibid. This reaction to Andre's work did not keep Hesse from admiring it, however.

62 Diary entry of Sat. [May 1966].

63 Hesse/Nemser transcript; and Eva Hesse, statement in "Fling, Dribble, and Dip," *Life* 68 (27 Feb. 1970): 66, cited in Lippard, 172.

64 Hesse/Nemser transcript; see also Lippard, 172.

65 Undated diary entry [Oct. 1966].

66 Gilbert and Gubar, *Madwoman,* 525.

67 In 1964, Hesse amusingly described making her husband a scarf that sounds as if it anticipated certain of her sculptures: "Needless to say we bought the most wild wool we could find. Of this they had only five skeins. I keep unraveling so I can hope-fully get required length. The width keeps diminishing till now it can get no skinnier" (diary entry of Sat., 21 Nov. [1964]).

68 That needlework has paradoxically provided "a source of pleasure and power for women while being indissolubly linked to their powerlessness" has been shown by Rozsika Parker, *The Subversive Stitch: Embroidery and the Making of the Feminine* (New York: Routledge, 1989), 11.

69 Gilbert and Gubar, *Madwoman,* 521. "More bitter than death [is] the woman whose heart is snares and nets; whoso pleaseth God shall escape from her, but the sinner shall be taken by her," warns Ecclesiastes 7:26 (cited in Ibid., 524).

70 Gilbert and Gubar, *Madwoman,* 639; also: "both in the subtle subversiveness of her sewing and in the striving toward wholeness her sewing expressed, Dickinson was enacting and exploiting a traditional metaphor for the female artist . . . women have used their looms, thread, and needles both to defend themselves and silently to speak of themselves . . . they have sewed to heal the wounds inflicted by history . . . they have sewed . . . to hide the pain at the heart of their lives" (641–42).

71 Diary entry of Mon., 19 Oct. 1964.

72 Diary entry of Sat. [May 1966].

73 According to Doyle, Beuys' "ideas—the felt and the 'fat corners' intrigued her" (quoted in Lippard, 33).

74 Susan R. Bordo, "The Body and the Reproduction of Femininity: A Feminist Appropriation of Foucault," in *Gender/ Body/Knowledge: Feminist Reconstructions of Being and Knowing,* ed. Alison M. Jaggar and Bordo (New Brunswick, NJ: Rutgers University Press, 1989), 14.

75 Susan Gubar, "'The Blank Page' and the Issues of Female Creativity," in *The New Feminist Criticism: Essays on Women, Literature, and Theory,* ed. Elaine Showalter (New York: Pantheon, 1985), 296–97.

76 Gilbert and Gubar, *Madwoman,* 330.

77 The canonical study regarding the suffering of the male artist is Edmund Wilson's *The Wound and the Bow* (Boston: Houghton Mifflin Co., 1941).

78 Gubar, "'The Blank Page'," 299.

79 Bordo, "The Body," 13. (Bordo credits Michel Foucault and Pierre Bourdieu for informing her observations.)

80 Cited in Lippard, 205 (see note 3 above).

81 From a diary entry of 4 Jan. 1964, cited in Lippard, 24–25.

82 Regarding Hesse's attitude toward motherhood, Barrette suggests she suffered from frustrated maternal longings (20), but her diary writings from the period when she was active as a sculptor reveal

that she was ambivalent about having children, and there is no evidence that she ever attempted to become pregnant.

83 Diary entry of 2 a.m., 24 Aug. [1966].

84 Diary entry of Fri. [July 1966].

85 Diary entries of 16 Feb [1965]; Fri. [22 Apr. 1966]; and 4 Aug. 1966.

86 Diary entry of 12 Dec. 1965, cited in Lippard, 56.

87 Hesse/Nemser transcript.

88 See Anna C. Chave, "Minimalism and the Rhetoric of Power," *Arts Magazine* 64 (Jan. 1990): 44–63.

89 Quoted in Bruce Glaser, "Oldenburg, Lichtenstein, Warhol: A Discussion," *Artforum* 4 (Feb. 1966): 22.

90 "Because the female subject has juridically been excluded from the polis, and hence decentered, 'disoriginated,' deinstitutionalized, etc., her relation to integrity and textuality, desire and authority, is structurally different," argues Nancy K. Miller, "Changing the Subject: Authorship, Writing, and the Reader," in *Feminist Studies/Critical Studies,* ed. Teresa de Lauretis (Bloomington: Indiana University Press, 1986), 106. See also Kaja Silverman, "The Female Authorial Voice," in *The Acoustic Mirror: The Female Voice in Psychoanalysis and Cinema* (Bloomington: Indiana University Press, 1988).

91 Lippard, 17; Arthur C. Danto, "Growing up Absurd," *Art News* 88 (Nov. 1989): 119.

92 Passage "written Oct. 28 [1960]" and evidently transcribed into the diary begun 2 Nov. 1960 some days later; diary entry of 5 Feb. 1965, cited in Lippard, 32.

93 Lippard, 199.

94 That "the parallel between Pandora and Eve was a favorite motif of Milton's" is noted by Dora and Erwin Panofsky, *Pandora's Box: The Changing Aspects of a Mythical Symbol* (New York: Pantheon, 1956), 64; the Panofskys show also how an association between the mythical box and the female genitals has been invoked by numerous artists, including Paul Klee.

95 Hesse/Nemser transcript.

96 Ibid.

97 Undated entry [after Spring 1967], on loose sheet attached to small, six-ring notebook. The observation is one of many Hesse noted from Lippard's article, "Eros Presumptive"; see note 11 above.

98 Hélène Cixous and Catherine Clément, "The Untenable," in *In Dora's Case: Freud, Hysteria, Feminism,* ed. Charles Bernheimer and Claire Kahane, 2nd ed. (New York: Columbia University Press, 1990), 289.

99 Diary entry of Fri., 19 June [1964]; see also Lippard, 25.

100 Diary entry of 12 Dec. 1965, on loose sheet stapled into diary inscribed 26 Mar. 1965.

101 Diary entry of April 1968, cited in Lippard, 126.

102 Diary entry of Mon., 29 Aug. 1966; diary entry of Sun. eve. [4 Sept. 1966] in same notebook; and Hesse/Nemser transcript.

103 Sander L. Gilman, *Disease and Representation: Images of Illness from Madness to AIDS* (Ithaca, NY: Cornell University Press, 1988), 3.

104 Gilbert and Gubar, *Madwoman,* 53.

105 "The statistical overrepresentation of women among the mentally ill has been well documented by historians and psychologists . . . By the middle of the nineteenth century, records showed that women had become the majority of patients in public lunatic asylums. In the twentieth century, too, we know that women are the majority of clients for private and public psychiatric hospitals, outpatient mental health services, and psychotherapy; in 1967 a major study found 'more mental illness among women than men from every data source'" (Elaine Showalter, *The Female Malady: Women, Madness, and English Culture: 1830–1980* [New York: Penguin, 1987], 3).

106 Gilbert and Gubar, *Madwoman,* 54. In a related vein, Barbara Johnson observes (in discussing the heroines of stories by Nathaniel Hawthorne and Charlotte Perkins Gilman) that "The cost of [women] attaining a valued status in the world is to become an object in someone else's reality and, hence, to have, in fact, *no* status in the world . . . Femininity, in other words, is by nature a 'normal ill'" ("Is Female to Male as Ground is to Figure?" in *Feminism and Psychoanalysis,* ed. Richard Feldstein and Judith Roof [Ithaca, NY: Cornell University Press, 1989], 262).

107 Gilbert and Gubar, *Madwoman,* 57.

108 On Jewishness and illness, see Sander L. Gilman, "The Madness of the Jews," in *Difference and Pathology: Stereotypes of Sexuality, Race, and Madness* (Ithaca, NY: Cornell University Press, 1985).

109 Bordo, "The Body," 20.

110 Cixous, "The Laugh," 250.

111 Diary entry of Sat. eve. [11 March 1961].

112 Doane, "Woman's Stake: Filming the Female Body," *October* 17 (Summer 1981): 25.

OBJECTS OF LIBERATION: *The Sculpture of Eva Hesse*

Maurice Berger

It is the unknown quantity from which and where I want to go.

As a thing, an object, it acceeds to its non-logical self.

It is something, it is nothing.

Eva Hesse, June 1968

A sense of absurdity comes to mind each time I encounter Eva Hesse's sculpture *Repetition Nineteen III* of 1968 (fig. 74; plate 104), a group of nineteen fiberglass "buckets" that stand on the floor in "aimless but congenial order."[1] Entering into the terrain of the piece—a phenomenological landscape of strange and nameless things—I apprehend the forms one by one as they swing into visual and visceral focus. Approaching each squat cylinder, leaning over to assume a bird's-eye view into its hollow center, I begin to realize distortions of form. One cylinder is nearly perfect, almost rigid in its uprightness. Others are battered. Some look like they might collapse. My visceral response intensifies as the bubbles and imperfections of the forms' translucent surfaces evoke human skin. Eventually, the tension between the intellectual awareness of the work's intuitive order and the sensory pleasure of merely experiencing it dissipates. As I interact with these provocative and sensual forms that literally stand at my feet, I become increasingly cognizant of my own

Fig. 74
Repetition Nineteen III, July 1968
Fiberglass and polyester resin
H. each unit, 19–20¼ in. (48.3–51.4 cm);
DIAM. each unit, 11–12¾ in. (27.9–32.4 cm)
The Museum of Modern Art, New York, Gift of
Charles and Anita Blatt, 1969

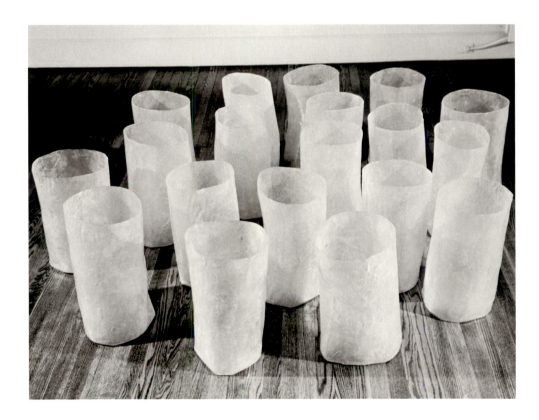

body moving through space. And in my repetitive and awkward choreography, I am able—if only for a moment—to psychically center myself through this experience of sensory discovery.

This relationship between body and object is central to Hesse's mature work. Inverting formalist understandings of sculptural space and functioning out of an intense identification with her materials, she strove for abstract form that would engender a "strong, virtually visceral identification" with the viewer's body.[2] The art critic Lucy Lippard, referring to this aesthetic phenomenon as "body ego," observed that Hesse's humor and eroticism emerged not so much from form itself as from "the combination of shape and highly sensuous textures, the way forms swell or sag, lie or lean, the ways in which one can feel one's own body assuming those positions or relating to those shapes as to another body."[3] The eroticism of Hesse's art, overt in early sculptures and reliefs that often resemble breasts or phalluses, was increasingly predicated on the relationship of the viewer's eye and body to abstract but no less provocative forms. This relationship, rather than demanding a passive and fixed viewing of precious objects, granted the viewer the freedom to explore. Walking along a row of fifty vertical fiberglass poles that lean against a wall (*Accretion*, 1968; plate 105), peering into the mysterious fur-like interior of a brutalist steel box (*Accession II*, 1969; plate 108), or resisting the impulse to touch a skin-like, latex-coated "curtain" (*Test Piece for "Contingent,"* 1969; plate 113), one is eased into a deeply charged sensual experience.

Such works speak of Hesse's rebellion against prevailing aesthetic conceits and preconceptions. Even a decade earlier as a student at the Yale School of Art and Architecture, the young artist had battled with contradictory impulses: "Does sentiment interfere with intellectual thought?" she questioned in her diary.[4] Indeed, Hesse's struggle to transcend both the rigidity of formalist systems and the intellectual emptiness of pure expression constituted a central paradox in her work. Perhaps nowhere was her discomfort with the seeming mutual exclusivity of the systemic and the emotional in modernist art more apparent than in her early relationship to painting and her response to conservative teachers at Yale, particularly the venerated Josef Albers. To Hesse, whose "Abstract Expressionist" paintings and drawings of this period were intuitive and organic ("ultra alive," as she described them), Albers' hard-edged, formulaic lectures were "a doctrine of thought, all inclusive [and] based on one idea." "How much more can be done with this notion?" she concluded.[5] By the winter of 1960, Hesse was writing of her need to break free of the restraints of traditional easel painting:

I will abandon restrictions and curbs imposed on myself. Not physical ones, but those restrictive tabs on my inner being . . . I will strip me of superficial dishonesties. I will paint against every rule I or others have invisibly placed . . . I should like to achieve free, spontaneous painting delineating a powerful, strong, structured image. One must be possible with the other. A difficult problem in itself but one which I shall achieve.[6]

The process of painting, however, would ultimately prove too restrictive. "For me painting has become . . . [anti-climactic]. 'Making art, painting a painting.' The Art, the history, the tradition is too much there," she wrote in December 1964. "I

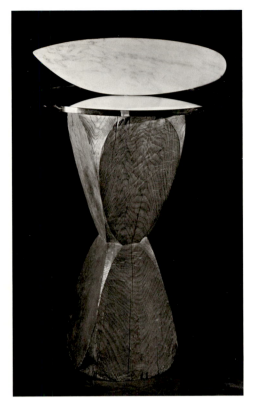

Fig. 75
Constantin Brancusi (1876–1957)
The Fish, 1922
Marble, mirror, and oak
Marble, 5¼ x 16⅞ in. (13.3 x 42.9 cm);
DIAM. mirror, 17 in. (43.2 cm); H. oak, 24 in. (61 cm)
Philadelphia Museum of Art, The Louise and Walter
Arensberg Collection

want to be surprised. To find something new."[7] It was in this period that Hesse's attitude toward art and self-expression began to change, as her conviction that she could take painting into new territory gradually waned. The frustration evident only the month before in her diary—"Why is it that I cannot see *objectively* what I am about? My vision of myself and of my work is unclear, clouded. It is covered with many layers of misty images. Inconsistent. I do want to simplify my turmoil"—gave way in December to a new enthusiasm when she constructed her first serious sculpture from materials found in the abandoned factory that was her Kettwig studio.[8] The untitled work, which was eventually destroyed or lost, consisted of a stretched, heavy mesh screen through which she threaded and knotted pieces of plaster-soaked cord: a contrast of softness and rigidity, spontaneity and order, that prefigured the conceptual and formal relationships of her mature work.[9] The piece also initiated Hesse's own emotional process of relinquishing the need to validate herself through the act of painting. By the spring of 1965 she would abandon traditional painting altogether, concentrating instead on a series of provocative reliefs.[10]

Hesse's attitude toward sculpture, like that of a number of her contemporaries in the avant-garde, proved no less rebellious; her mature work overtly questioned contemporaneous critical understandings of sculptural space and its relation to the spectator. One of the most influential and paradigmatic treatises on modern sculpture appeared as a chapter in philosopher Susanne Langer's influential and widely read *Feeling and Form* (1953). Hesse attended Langer's guest lectures at Yale in the late-1950s and read at least three of the theorist's books, including *Feeling and Form*, which she described as "discourses on language and symbolism" from which she "got nothing."[11] Essentially, Langer asserted that the most resonant sculptural form functions as a "powerful abstraction from actual objects and the three-dimensional space which we construe by means of them, through touch and sight" (see, for example, fig. 75).[12] She reasoned that by establishing a direct analogy between itself and the human body, the sculptural object functioned as a center of three-dimensional space, "a virtual kinetic volume, which dominates a surrounding space, and this environment derives all proportions and relations from it, as the actual environment does from one's self."[13] As such, sculpture constituted a "semblance" and "objectification" of a living self, an organic parallel to the viewer's body.

Such organic metaphors, inherent to most formalist discussions of sculpture in the 1950s and 1960s, are to a great extent contradicted by Hesse's mature work.[14] If sculpture represented for Langer an autonomous recreation of the self whose resonance yielded to the static act of *viewing,* it became for Hesse an object of engagement. Fundamentally Langer analogized sculptural form to an organic being whose paradoxes and contradictions, rather than dependent on a temporal interaction with a viewer, were self-contained within the object's own complex composition. Hesse's forms, on the contrary, are neither a metaphor for the human body nor an abstract reduction from reality. She described her sculpture as nothing more or less than a "dumb" or "absurd" presence inserted directly into the spectator's sensory field.[15] The viewer was free to relate to these forms on a number of levels, a relationship established not by a passive contemplation of sacred aesthetic objects but by a complex process of perception and discovery. An undated note of 1968–69 from Hesse's

diaries suggests this inner-directed and personal formation of meaning and selfhood: "solipsism: the theory or belief that *only knowledge of the self is possible* and that for each individual the self itself is the only thing really existent and that therefore reality is subjective."[16] The issue of art as a vehicle through which the "self" could be realized or understood was important to Hesse both in relation to the viewer and to herself—a private and liberatory search for the "self" that ultimately extended to the solipsistic relationship between object and viewer as well.[17]

Hesse's notation parallels the solipsistic imperatives of a number of so-called minimalist artists and dancers of the 1960s and early 1970s, including Yvonne Rainer, Robert Morris, Richard Serra, Carl Andre, and Robert Smithson. Rosalind Krauss has characterized this phenomenon as a refusal "to give the work of art an illusionistic center or interior." By denying their work a preordained organic meaning, these artists were "simply re-evaluating the logic of a particular *source* of meaning rather than denying meaning to the aesthetic object altogether. They [were] asking that meaning be seen as arising from . . . a public, rather than private space," from a distinct temporal relationship between the viewer and the sculptural object or installation.[18] Searching for art forms that could critique the repressive space of late capitalism as well as engender experiences that were self-validating and recuperative, Robert Morris, for example, centered on the winding and circuitous paths of the labyrinth (fig. 76)—"a metonym of the search for the self, [as] it demands a continuous wandering, a relinquishing of the knowledge of where one is."[19]

Rather than relinquishing this knowledge and the concomitant ideological meaning this process held for Morris, Hesse allowed aspects of the self to emerge out of an intimate identification between the viewer's body and the sculptural object. Unlike

Fig. 76
Robert Morris (b. 1931)
Philadelphia Labyrinth, 1974; destroyed
Installation for the Institute of Contemporary Art, Philadelphia, March 1974
Plywood and masonite painted gray
H. 96 in. (243.8 cm); DIAM. 360 in. (914.4 cm); DIAM. passageway, 18 in. (45.7 cm)
Photograph courtesy of Leo Castelli Gallery

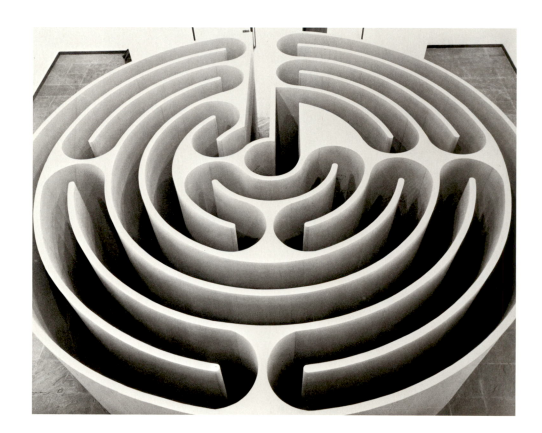

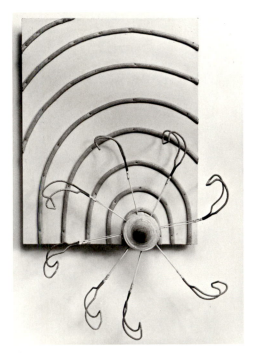

Fig. 77
Eighter from Decatur, July 1965
Enamel, tempera, cord, and metal-weaving machine
part on particle board
27⅛ x 21¼ x 7½ in. (68.9 x 54 x 19 cm)
Museum Wiesbaden, Germany

the hard-edged, prefabricated plinths, tiles, cubes, and labyrinths of the minimalists, her objects maintain a spontaneous quality; their seductiveness turns on their ability to arouse desire, to engender a selfhood rooted in sexuality. The self, then, is formulated as a sensuous being in response to forms that "swell or sag, lie or lean." While these sculptures do not entirely refuse Langer's notion that sculptural form defines the meaning and quality of its surrounding space, their erotic meaning can be both felt and apprehended only through direct, sensory experience. In other words, they elicit desire not by depicting sexual forms viewed safely from a distance, but by inserting themselves into the viewer's tactile and visual field as contradictory, demanding, abstract objects.

Even in Hesse's more overtly sexual reliefs and small-scale constructions of the mid-1960s, meaning is complex and fractured. By refusing to project an unparadoxical semblance of the "self," these forms confront the viewer with fragile contradictions. Some disorient by suggesting bizarrely attenuated sexual organs or a convergence between sexual and machine forms: in *Cool Zone* of 1965 (plate 84), a thick magenta cord drops from the center of a small, breastlike base for a sculpture stand; and *C-Clamp Blues,* a relief from 1965 (plate 86), contains a small pink push button (actually the painted head of a bolt), an enticing nipple that teases the viewer to activate Hesse's absurd "machine." Other works of the same year employ duplication or repetition to skew overtly sexual allusions. The macabre humor of *Ingeminate* (plate 87) and *Several* (plate 88) rests on their repetition of sausage-like forms, replicated and oversized phalluses that are severed from their hosts. Likewise, the obsessive circles of wound cord in such reliefs as *Ringaround Arosie* (plate 79), *Eighter from Decatur* (fig. 77), and *2 in 1* (plate 83) suggest disconnected breasts. Still other works like *Untitled or Not Yet* of 1966 (plate 95), whose hanging black net bags filled with polyethylene masses resemble disembodied, pendulous breasts or severed scrota, allude to male and female anatomy simultaneously. Overall, these erotic sculptures refuse to project sexuality as static or univalent. Instead their meanings oscillate between unreconciled and contradictory polarities—male/female, soft/hard, seductive/repulsive, ordinary/strange—a sensibility that would dominate Hesse's work until her death in 1970. Having asserted that "absurdity is the key word" in her art and life, Hesse consciously embraced such contradictions:

I remember always working with contradictions and contradictory forms, which is my idea that in life—the whole absurdity of life—everything has always been opposites. Nothing has ever been in the middle. I was always aware that I would take order versus chaos, stringy versus mass, huge versus small, and I would try to find the most absurd opposites or extreme opposites. And I was always aware of their absurdity, and also their contradictions formally. And it was always more interesting than making something average, normal, right size, right proportion.[20]

The conflicted sense of self that emerges for the viewer through the experience of these early erotic objects and reliefs recalls the work of Marcel Duchamp.[21] What Hesse gleaned from Duchamp had less to do with the Marxean implications of his readymade strategy and more with his conception of the erotic self as multivalent and unstable. If the declarative mode of the readymade established Duchamp as responsible for naming as art an ordinary object in the world, the psychosexual cen-

Fig. 78
Marcel Duchamp (1887–1968)
Objet-Dard, 1951
Bronze cast
2¾ x 7¼ x 2⅜ in. (7 x 18.6 x 6 cm)
Philadelphia Museum of Art, Gift of Arne Ekstrom

Fig. 79
Man Ray (1890–1976)
Marcel Duchamp as Rrose Sélavy, ca. 1920–21
Gelatin silver print
8½ x 6¹³⁄₁₆ in. (21.6 x 17.3 cm)
Philadelphia Museum of Art, The Samuel S. White
III and Vern White Collection

ter of the artist's work remained deliberately ambiguous.[22] The male/female associations of the urinal form in *Fountain* (1917), the simultaneous depiction of the volume of the penis and the void of the vagina in *Objet-Dard* (1951; fig. 78), Mona Lisa's mustache and goatee in the assisted readymade *LHOOQ* (1919), or Duchamp's collaborative self-representation as his female alter ego Rrose Sélavy in a photograph by Man Ray (ca. 1920–21; fig. 79), all suggest the complexity of our sexuality and the insufficiency of language to define or name our divided self.[23]

Duchamp's exteriorization of the erotic attempted "to divorce and elevate the idea of eroticism from [a] merely sexual . . . satisfiable biological function . . . to a semiotic order."[24] If Duchamp constructed a complex relation between words and things in which the arbitrariness of language was contrasted against its rigid linguistic systems, Hesse built her entire aesthetic world around an attempt to reconcile this fundamental division between the arbitrary and the systemic—between spontaneous, expressive forms and the grid (one of culture's most durable gestalts), or between absurd, virtually unnamable forms and the socially encoded words the artist culled from a dictionary and thesaurus to name them: *addendum, augment, compart, compass, contingent, schema, sequel, stratum.* This oscillation between contradictory possibilities—an instability that parallels the fundamental division of the linguistic order —permits a seduction of the spectator that extends well beyond the banal projection of erotic objects. Instead, linguistic and structural conditions are comfortably, and to a great extent abstractly, inserted into the aesthetic field, involving the viewer in an experience that is simultaneously familiar and mysterious.

The seductive tension in Hesse's work between the arbitrary and the motivated, between the familiar and the mysterious, is no more evident than in her handling of materials. With *Accession* of 1967–68, the first work to be in part fabricated to her specifications, the artist reached an important transitional point in her oeuvre, as the sensibility of the erotic object was extended into larger and more abstract works.[25] The piece, a waist-high, grid-perforated steel box through which Hesse herself handwove plastic tubes, posits visual and sensual contradictions between the hard edge of its exterior and its dense, bristling interior. (Indeed, in its cool, calculated exterior and erotic, mysterious core, *Accession* suggests a stylistic collision between one of Donald Judd's minimalist aluminum boxes and Meret Oppenheim's Surrealist fur-covered teacup of 1936 [fig. 80].)[26] The work also commences Hesse's transformatory attitude toward materials: as part of her personal program to liberate the art object, she permitted heretofore repressive industrial materials such as wire, fiberglass, galvanized steel, plastic tubing, latex, and plaster to also suggest conditions of softness or fragility. By allowing the surface of latex and fiberglass-coated cheesecloth pieces (*Expanded Expansion* and *Contingent,* both of 1969 [figs. 19 and 65]) or fiberglass works (*Repetition Nineteen III* and *Sans II* of 1968 [plate 106]) to swing between states of gumminess or glassiness and the illusion of human skin, Hesse desublimated these materials without changing their innate qualities or resorting to a simplistic anthropomorphism.[27]

While a number of art historians have relegated Hesse's mature work to the category of "process art," her attention to the objectness of sculpture and its effect on the viewer suggests a more independent position in the world of the 1960s avant-

garde.[28] As Hesse herself stated, "I think for me the great involvement is [using] the material to arrive at the end. I am not that conscious of the material as a beautiful essence."[29] While her mature work remained deeply personal, its aesthetic and ideological sensibility was to some extent, however, commensurate with a significant manifestation of the process-oriented art of the period: anti-form. The term—coined in 1968 by the editors of *Artforum* as the title of an important and controversial essay by Robert Morris—denotes a sensibility in art that was, in many respects, a liberatory response to the repressive, hard edge of minimal sculpture. Describing the latter's obsession with quality and closure as a form of commodity fetishism, Morris challenged its conservatism, its concern with comparisons between static, similar objects within closed sets.[30] With anti-form, he ascribed to a number of young artists (including Hesse) a new sensibility in which

the focus on matter and gravity as means results in forms which were not projected in advance. Considerations of ordering are necessarily casual and imprecise and unemphasized . . . chance is accepted and indeterminacy is implied since replacing will result in another configuration. Disengagement with preconceived enduring forms and orders for things is a positive assertion. It is part of the work's refusal to continue aestheticizing form by dealing with it as a prescribed end.[31]

The ideological mission of anti-form, problematic though it may have been, proposed the dismantling of the institutional hierarchies that defined the art object, mandated its form and appearance, and brokered its sale and distribution. While the resolute abstraction of anti-form removed it from any immediate engagement with the class, race, gender, and antiwar politics of the 1960s, these works embraced an indirect cultural politics concerned with spectatorship and capitalist institutions. While Hesse's sculpture was less ideological, less chance-oriented, and more ordered than Morris' understanding of anti-form suggests, it nevertheless shared anti-form's call for freedom from the repressiveness of traditional formalist painting and sculpture. "I am interested in finding out through the working of the piece some of the potential and unknown and not preconceived," Hesse told Cindy Nemser in 1970. "I think the more you allow yourself to be open—at least that is one of my interests now, in what is happening and what can happen—and be completely free to let that go and change, that is one of the things that I really want to work on, where I have less preconceived plans and let things go." And in the context of discussing her use of materials, she further asserted: "There isn't a rule. I don't want to believe in any rules. I don't want to keep any rules. I want to sometimes change the rules."[32]

Ultimately, the anti-form concept posed a crucial question about the nature of advanced art. Could the form of the art object be desublimated in order to upset the repressive nature of its exhibition and display? In 1969, Morris addressed this question in "9 at Leo Castelli," a group show at the dealer's Upper West Side warehouse. Isolating the formal and intellectual problems associated with the anti-form concept, the exhibition—which included works by Hesse (*Augment* and *Aught* of 1968), Alan Saret, Claes Oldenberg, Bill Bollinger, Keith Sonnier, Bruce Nauman, Richard Serra, and Steve Kaltenbach—refused the limitations of closed forms in favor of an exploration of sensuality and nontraditional materials. Castelli's warehouse reverberated with piles of felt; rivers of spattered lead (fig. 81); electro-chemical reactions; magnetic fields; sheets of rubber, latex, and plastic; neon and fluorescent light; and

Fig. 80
Meret Oppenheim (1913–1985)
Object, 1936
Fur-covered cup, saucer, and spoon
H. overall, 2⅞ in. (7.3 cm); DIAM. cup, 4⅜ in.
(11.1 cm); DIAM. saucer, 9⅜ in. (23.8 cm); L. spoon,
8 in. (20.3 cm)
The Museum of Modern Art, New York, Purchase
© Meret Oppenheim/VAGA, New York 1991

raw steel. Materials—deployed as recognizable, unprecious, ordinary substances—no longer aspired to represent values or things in the world (fig. 82). Wood did not suggest the organic, plastic did not embody modernity or technology, and steel did not mean brutality. Objects scattered on the floor neither ascended to the sky nor transcended literal earthly conditions. They simply existed in their base material state as the physical residue of the transitive.[33] And while the liberation of form through chance relationships alluded to the earlier innovations of Surrealism, the show, in fact, was rooted in such fundamental tenets of minimal art as truth to materials, the acceptance of gravity, and the freeing of the object from the constraints of composition.

Hesse's sculptures—objects that waver between literalness and allusion, order and chaos, chance and control—to some extent depart from Morris' particular understanding of anti-form. But her work did maintain one strong parallel to the anti-form sensibility: its entry into an abstract, psychosexual dimension. To one degree or another, this dimension allowed anti-form to challenge the purity and aloofness of formalist sculpture. It was a confrontation accomplished through the most disparate of strategies—from the randomness of Morris' unraveled felt pieces to the formal integrity of Hesse's objects. Yet for the most part, the psychosexual dimension of the work of Hesse, Morris, Serra, Nauman, Oldenburg, and other artists of the period eluded the puritanical formalist methodologies of most minimalist criticism. Lippard observed that some writers, however, had speculated that the 1966–67 art season would be the "Erotic Season"—an answer to the Pop, Op, and Primary Structure seasons past. "For at least two years," she wrote, "rumors have been rife of wickedness stored up in the studios waiting for the Trend to break."[34] (One is reminded here of Duchamp's assertion that "I believe in eroticism a lot, because it's truly a rather widespread thing throughout the world, a thing that everyone understands. It replaces, if you wish, what other literary schools called Symbolism, Romanticism. It could be another 'ism,' so to speak.")[35]

Lippard herself had explored these ideas in an exhibition she organized in 1966 at the Fischbach Gallery in New York. Entitled "Eccentric Abstraction," the show considered the "emotive or 'eccentric' or erotic alternatives to a solemn and deadset Minimalism which still retained the clarity of that notion."[36] Along with Louise Bourgeois' erotic latex membranes, Bruce Nauman's rubber streamers, Alice Adam's "giant chain link womb form," Don Potts' undulating wood and leather sculptures, as well as works by Gary Kuehn, Keith Sonnier, and Frank Lincoln Viner, Hesse was represented by three pieces—the sausage-like *Several* and *Ingeminate,* and *Metronomic Irregularity II* of 1966 (fig. 33), a 20-foot abstract construction in which a mass of cotton-covered wire was strung across three gridded wood boards. While Lippard's understanding of the eroticism of these works would appear to be more appropriate to Hesse's later sculpture, her reading is no less insightful:

Eccentric abstraction thrives on contrast, but contrast handled uniquely, so that opposites become complementary instead of contradictory . . . Evocative qualities or specific organic associations are kept at a subliminal level . . . Ideally a bag remains a bag and does not become a uterus, a tube is a tube and not a phallic symbol. Too much free association on the viewer's part is combat-

Fig. 81
Richard Serra (b. 1939)
Casting, 1969; destroyed
Lead
300 x 180 in. (762 x 457.2 cm)
Photograph courtesy of Leo Castelli Gallery

Fig. 82
Robert Morris (b. 1931)
Untitled, 1968; destroyed
Thread, mirrors, asphalt, aluminum, lead, felt,
copper, and steel
Approx. 360 x 360 in. (914.4 x 914.4 cm)
Photograph courtesy of Leo Castelli Gallery

ted by formal understatement, which stresses a non-verbal response and often heightens sensuous reactions by crystallizing them.[37]

This emphasis on the erotic and the sensual was not without political justification; indeed, in the teeming intellectual and cultural ferment of New York in the mid-1960s, the idea that the liberation of late-capitalist culture was grounded in the desublimation of repressed sexuality was widespread. The theoretical cornerstone for such thinking in the United States and Europe was Herbert Marcuse's *Eros and Civilization* (1955), a philosophical critique of Freud that argued for a recognition of the essentially political nature of this repression. The book, widely read in the New York avant-garde, vehemently disputed Freud's identification of "civilization" with repression.[38] Freud had reasoned that to function in an ordered society, the individual must yield to society's conscious and unconscious mechanisms of restraint and suppression; the base urges of "pleasure" must never overcome the pragmatic needs of "reality." For Marcuse it was precisely this acquired self-repression—so central to society that it is handed down from one generation to another like the tenets of law —that inhibited freedom and liberation. What began as subjugation by force, reasoned Marcuse, soon resulted in "'voluntary servitude,' collaboration in reproducing a society which made servitude increasingly rewarding and palatable."[39]

Freud saw the sacrifice of libido as necessary to orient society toward labor rather than leisure. (Hence, the libidinal or desublimating labor of the artist was most often viewed in bourgeois society as wasteful if not ridiculous.) In this sense, society's motive in enforcing the reality principle was "economic, since it has not means enough to support life for its members without work on their part, it must see to it

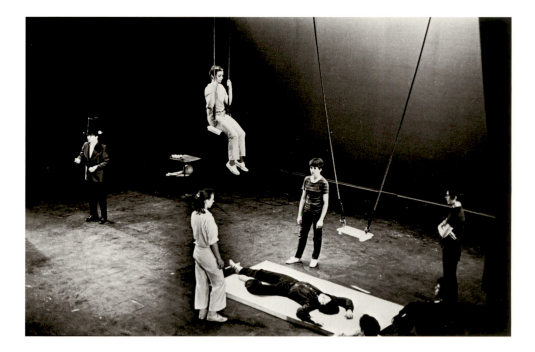

Fig. 83
Yvonne Rainer (b. 1934)
"Act," from *The Mind is a Muscle*, 1966
Photograph courtesy of Peter and Barbara Moore

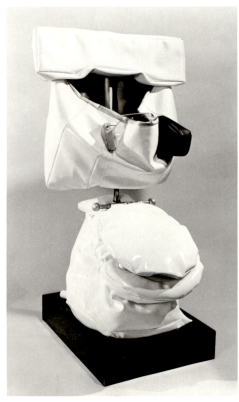

Fig. 84
Claes Oldenburg (b. 1929)
Soft Toilet, 1966
Vinyl filled with kapok, painted with liquitex,
on wood base
52 x 32 x 30 in. (132.1 x 81.3 x 76.2 cm)
Collection of Whitney Museum of American Art,
50th Anniversary Gift of Mr. and Mrs. Victor W.
Ganz, 79.83
© 1992 Claes Oldenburg/ARS, N.Y.

that the number of these members is restricted and their energies directed away from sexual activities on to their work."[40] Rather than regarding repression as injurious, Freudian psychoanalysis to some extent invested in its virtues, validating its role in the formation of the symbolic order of language and ultimately of society.[41] For Marcuse, the battle for social and cultural freedom would be best served by challenging this socially ingrained mechanism of sexual and sensual denial. In a revised "Political Preface" for *Eros and Civilization,* written in 1966 at the moment of the great liberation struggles in Vietnam, the Congo, South Africa, and the ghettos of America's "affluent society," Marcuse restated this connection:

'Polymorphous sexuality' was the term I used to indicate that the new direction of progress would depend completely on the opportunity to activate repressed or arrested organic, biological needs: to make the human body an instrument of pleasure rather than labor. The old formula, the development of prevailing needs and faculties, seemed to be inadequate; the emergence of new, qualitatively different needs and faculties seemed to be the prerequisite, the content of liberation.[42]

Calling for a "revolution in perception, a new sensorium," a revolution committed to exposing the sham of formalism, Marcuse imagined a material and intellectual reconstruction of society rooted in a new aesthetic environment—one that abandoned rational forms and rigid techniques in favor of perception, freedom, and pleasure.[43] It is no surprise then that the central tenets of anti-form and to some extent "Eccentric Abstraction" parallel certain ideas expressed by the Marcuse-influenced art critic Ursula Meyer in her important text "The Eruption of Anti-Art." In addressing the issue of anti-art in the 1960s, Meyer suggested that the rediscovery of Dada had resulted in a new sensibility that called for the "desublimation" of cultural values in art. Building her argument on Marcuse's notion of a desublimated society, Meyer cited his influential *An Essay on Liberation* (1969), in which he

suggested that "the radical character, the 'violence' of the reconstruction in contemporary art, seems to indicate that it does not rebel against one style or another, but against 'style' itself, against the art-form of art, against the traditional 'meaning' of art."[44] For Meyer (unlike Marcuse, who thought in terms of more conventional art forms), anti-art was most radical when it undermined the conventions and the form of the static art object—objects specifically created to meet the self-serious demands of the museum and its patrons. "If Anti-Art exists at all—not only in terms of an art historical (Duchampian) oddity, but in the context of a revolutionary present," Meyer concluded, ". . . it has to be defined on the basis of its temporariness."[45]

With such calls for anti-art pervasive on a number of fronts, the late-1960s—the realm of Hesse's most self-validating intellectual and aesthetic development—were characterized by a "revolution in perception, a new sensorium." Through performance, dance, film, and the plastic arts, cultural producers were questioning the very nature of aesthetic form and were exploring the possibility of desublimating culture via a celebration of theatricality, temporality, absurdity, eroticism, and pleasure. Indeed, the institutional spaces of high culture had become home to numerous acts of aesthetic liberation. The dances of Yvonne Rainer (whom Hesse admired) employed simple, task-oriented movements through arbitrary and often playful cues. In the circuslike ambience of *Act,* a section of *The Mind is a Muscle, Part 1* (1966; fig. 83), Rainer involved dancers in swinging, acrobatic, and gymnastic movements, culminating in a playful magic act. Carolee Schneemann's *Meat Joy* (1964; fig. 85), one of the most overtly erotic dances choreographed at the Judson Dance Theater, employed scantily clad male and female dancers in a lustful frolic of bodies and raw meat. The large-scale soft sculptures of Claes Oldenburg (with whom Hesse strongly identified) whimsically extended Duchamp's readymade sensibility into an

Fig. 85
Carolee Schneemann (b. 1939)
Meat Joy, 1964
Photograph courtesy of Peter and Barbara Moore

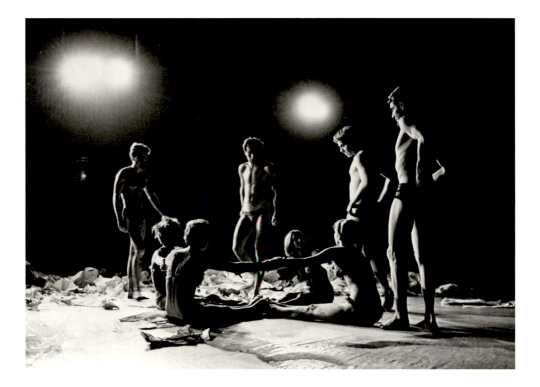

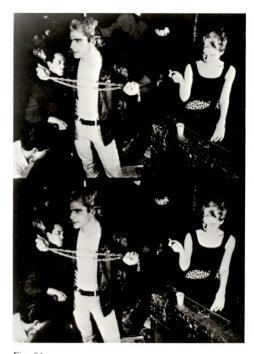

Fig. 86
Andy Warhol (1930–1987)
Still from *Vinyl*, 1965
16mm, sound, black-and-white film
Courtesy of The Museum of Modern Art Film Stills
Archive

erotic and theatrical realm (fig. 84). And Andy Warhol (another "high" on Hesse's "favorite list") directed a group of films—*Blow Job* (1963), *Vinyl* (1965; fig. 86), *My Hustler* (1965), *Beauty #2* (1965), *The Chelsea Girls* (1966)—that constitute some of the most provocative and liberatory statements on sexuality to emerge from the 1960s avant-garde.

Hesse, while admiring these groundbreaking achievements, neither embraced the explicit eroticism of body-oriented art nor anti-form's dissolution of the art object into base materials. On one hand, her objects engage the *viewer's* body in a theatrical experience of phenomenological exploration, characterized, for example, by my own awkward "dance" around *Repetition Nineteen III*.[46] On the other, in works such as *Right After* of 1969 (plate 111)—a hanging, intertwined mass of fiberglass-coated string—the art object unravels into a magical "order that could be chaos," introducing into the aesthetic field such qualities as humor, playfulness, and absurdity.[47] Hesse's concern with eroticism, play, and sensual discovery is apparent in the unattributed reading notes she took directly from Lippard's essay, "Eros Presumptive" (1967), an examination of the abstract, phenomenal eroticism of recent desublimatory art. They accompanied work notes for several of the artist's major sculptures, including *Sans, Addendum, Repetition Nineteen, Schema,* and *Stratum:*

Eroticism in the visual arts curious combination of specific and generalized sensation. rhythmic and sequential . . . abstract objects that produce unmistakable sensations attachable to though not necessarily interpretable as erotic . . . not symbols for something else. no allusive factors.

[Robert] Morris: neutralizing nudity into a condition like any other condition. Thus isolating and demythologizing of conventional ideas. . .

Oldenburg: as eroticism his work is abstract. The stimuli arise from pure sensation rather than direct association with objects depicted.

Simultaneous detachment and involvement. Opposites are witnesses to ultimate union—or the neutralization of their own opposing characteristics. . .

endless repetition can be considered erotic. . . [48]

Although Hesse's notes from Lippard do not constitute an explicit declaration of intention, their presence is most significant since the artist rarely, if ever, entered extensive notations from critical writings into her work notes. Implicit in Lippard's essay—and in Hesse's works of the period—is a condition central to the functioning of art that is both "abstract" and "erotic": the coexistence of opposites. Recapitulating the contradictions and conflicts inherent in both anti-form objects and "Eccentric Abstraction"—between industrial and natural states, hardness and softness, geometry and intuition, the sensual and the clinical, chaos and order—Lippard affirmed a visual aesthetic in which eroticism was both "specific and generalized," "sensation[al] and thought[ful]," in which nudity was demythologized into "a condition like any other condition." In effect, this recontextualization of abstract art concerns the mapping of contradictions at a moment when the intellectual and formal integrity of modernism itself was being questioned, when writers such as R. D. Laing, Gilles Deleuze, and Félix Guattari viewed the "self" as shaped through fracture and conflict rather than stability. Even the "polymorphous" sexuality championed by Marcuse as an antidote to oppression was fundamentally about the accep-

tance of conflict; it envisioned a world where the boundaries between male and female, and the univalence of sexuality itself, would give way to a sexuality that was fluid and adventurous. Ultimately, the transgressiveness of this period would even sanction the reformation of the abstract art object, as artists like Hesse pushed it closer and closer to the edge.

It is perhaps fitting to end this discussion of Hesse's sculpture with one of her most overtly transgressive works, *Hang Up* of 1966 (plate 91). Self-described as "the most important early statement I made . . . It was the first time where my idea of absurdity or extreme feeling came through," *Hang Up* consists of a cloth-wrapped stretcher out of which a gracefully bent cord-wrapped steel rod projects.[49] The work reads as a kind of swan song to painting—a complex structure that simultaneously suggests Hesse's frustration with and attraction to the medium. It also prefigures most of the stylistic devices of her mature work: conflation of painterly and sculptural properties, erotic projection of form into the spectator's space, theatricalization of a passive setting, and oscillation between contradictory conditions such as softness and rigidity or arbitrariness and order. "That is the most ridiculous structure I have ever made," said Hesse of the piece, "and that is why it is really good . . . There was nobody doing anything like this at the time. I mean this was totally absurd to everybody at that time."[50] Indeed, in its humor and optimism, the work alludes not only to the "hang-ups" associated with "mastering" the act of painting but to the broader cultural relationship between sexual and social hang-ups and the lack of personal freedom. "I had an insight . . . that I deny myself pleasure, and that I'm desirous of pleasure nevertheless," wrote Hesse concerning her own rejection of the restrictive "rules" of formalist painting.[51] In the process of breaking these rules, she extended modern sculpture toward "what is yet not known"[52]—an abstract field where humor, eroticism, and discovery were permitted and ultimately celebrated.

Notes

1 Lippard, 108. Hesse wrote to her friend Rosalyn Goldman in the summer of 1967 that she was "working out an idea for a gas," which would take the form of little "buckets" with hoses coming out of them. For more on the evolution of *Repetition Nineteen I, II,* and *III,* see Lippard, 106–10.

2 Ibid., 187.

3 Ibid.

4 Diary entry of 7 Sept. [1958]. Hesse's entire career was shaped by this battle between emotional and intellectual impulses. Writing in 1959 (diary entry of 15 Feb.), the artist asserted that she was "making an effort to remain rational and objective and less emotional," an effort that "thus far seem[ed] fruitless." Hesse saw this imperative to combine intellectual and emotional impulses as a personal psychological need to balance the "conflicting forces inside Eva," forces that she divided into the realm of her mother ("unstable, creative, sexual . . . Sadistic—aggressive") and father and stepmother ("Good little girl, obedient, neat, clean, organized—masochistic") (undated diary entry [May 1966]).

5 Hesse described her work as "ultra alive" in an undated diary entry of Feb. 1960: "I have and still continue with a series of drawings in ink with my main tool a crudely shaped wrong side of small brush. The drawings can at best be described as imagined organic and natural forms of 'growth.' They are essentially quite free in feeling and handling of medium. 'Ultra alive.'" She characterized Albers' lectures in a diary entry dated Wed., 15 April 1959. And in 1970 she told Cindy Nemser that "I loved Albers' color course but I had it at Cooper. I did very well with Albers. I was Albers' little color studyist . . . And he

always said every time he walked into the classroom, 'What did Eva do?' I loved it. I didn't do it out of need or necessity. I loved those problems. But he [Albers] couldn't stand my painting, and of course I was much more serious about the painting. But I had the Abstract Expressionist student approach, not Albers', [Rico] Lebrun's, [Bernard] Chaet's idea. And if you didn't follow their idea it wasn't an idea" (Hesse/Nemser transcript).

6 Passage "written Oct. 28 [1960]" and evidently transcribed into the diary begun 2 Nov. 1960 some days later.

7 Diary entry of 10 Dec. 1964.

8 Diary entry of Mon., 16 Nov. [1964]. The complex interrelationship between Hesse's sculptural and drawing processes did not extend to painting, which proved an unacceptable medium into which the artist could translate her paradoxical forms. "I had a great deal of difficulty with painting and never with drawings. The drawings were never very simplistic. They ranged from linear to complicated washes or collages. And the translation or transference on a large scale and in painting was always tedious. It was not natural and I thought to translate it in some other way. So I started working in relief and the line. The ropes that now are so commonly used started by the drawings becoming so linear. And I really translated the lines" (Hesse/Nemser transcript).

 Hesse seems to have accidentally made her first object in Woodstock, New York in the summer of 1962. A group of artists, including Hesse, organized a traveling art carnival that was supposed to "entertain the art capitals of the world." One of the projects was a "Sculpture Dance," where artists danced inside and around their large-scale sculptural creations. Hesse's contribution, according to Tom Doyle, was "really floppy . . . a beautiful piece, a tube of soft jersey and chicken wire" (quoted in Lippard, 21).

9 Hesse's enthusiasm for the piece is evident in her diary entry of 10 Dec. 1964: "Plaster! I have always loved the material. It is flexible, pliable, easy to handle in that it is light, fast working. Its whiteness is right. I will take those screens. Finish one I began in lead. Then get cloth cut in strips and dip in plaster and bring through screen. *I needed a structure that is perfect.*"

10 The artist's attitude about the sharply defined art historical boundaries between painting and sculpture, however, remained ambivalent. In a certain sense, she never entirely abandoned the painterly processes and formal sensibility that characterized her earlier, Abstract Expressionist inspired

student work. On the relationship of her sculpture to painting, Hesse observed: "Where does drawing begin and where does drawing end and painting begin? . . . Really the drawings could be called paintings legitimately and a lot of my sculpture could be called paintings and a lot of it could be called nothing—a thing or an object or any new word you want to give it because they aren't traditional . . . I don't know if the last piece I had at Finch College [*Contingent*] can be called painting or a sculpture. It is really hung paintings in another material more than they are sculpture" (Hesse/Nemser transcript).

11 Diary entry of 14 April [1959]. Hesse's note reads: "I got nothing from Miss Langer's discourses on language and symbolism. Or if I did, I do not feel it." Two years later when she was no longer a student, however, she wrote: "Reading Langer's *Problems of Art*. Enjoying it. My—what pressure I was under when I formerly read her other 2 books, *Philosophy in a New Key, Feeling and Form*" (diary entry of Sat. [25 March 1961]).

12 Susanne K. Langer, "The Modes of Virtual Space," in *Feeling and Form: A Theory of Art* (New York: Charles Scribner's Sons, 1953), 90. In addition to sculpture, Langer's theoretical purview included painting, architecture, literature, music, dance, drama, and film.

13 Ibid., 91.

14 For other formalist readings of sculpture in an organicist mode, see Clement Greenberg, "The New Sculpture" (1948/58), in *Art and Culture: Critical Essays* (Boston: Beacon Press, 1961), 139–45; Donald Judd, "Jacques Lipchitz," *Arts* 34 (Dec. 1959), reprinted in *Donald Judd: Complete Writings, 1959–1975* (New York: New York University Press, 1975), 7; and Michael Fried, "Art and Objecthood," in *Minimal Art: A Critical Anthology*, ed. Gregory Battcock (New York: E.P. Dutton, 1968), 116–47.

15 Hesse continuously referred to her objects as "dumb" and "absurd." See, for example, her letter of 18 March 1965 to Sol LeWitt (cited in Lippard, 34), and the transcript of her 1970 interview with Cindy Nemser.

16 Undated entry [ca. 1968–69] on loose sheet of small, six-ring notebook paper. A number of other references to the word solipsistic appear in Hesse's writings. As an undated diary entry [ca. May 1967], for example, it appears as a single, capitalized word—SOLIPSISTIC—in the top margin of an otherwise blank page. In another entry [Oct. 1966], she wrote: "new piece /"Solipsistic" / 5 x 5' / 3 inches thick/ sculp metal surface?/ drill holes (can you drill through

sculp metal?)/rubber base/ painted (sprayed before rubber hose. flat black)."

17 Hesse observed in her diary in 1966: "When I am responsible for self I will be able to decide on what is 'free' for me, creative, spontaneous, and what should be controlled, organized, and substantial" (entry of 10:00 Fri. [April 1966]).

18 For more on the formation of the self and the phenomenological imperatives of minimalist sculpture, see Annette Michelson, "Robert Morris: An Aesthetics of Transgression," in *Robert Morris* (Washington, D.C.: Corcoran Gallery of Art, 1969), 7–79; and Rosalind Krauss, "The Double Negative: A New Syntax for Sculpture," in *Passages in Modern Sculpture* (New York: The Viking Press, 1977), 243–87. The latter also contains a groundbreaking analysis of formalist understandings of sculptural space and volume, and the inversion of these ideas in "minimalist" practice, a reading that liberally informs my own understanding of Hesse's complex phenomenological and spatial constructions.

19 Robert Morris, "Aligned with Nazca," *Artforum* 14 (Oct. 1975): 36. For more on the issue of solipsism, selfhood, and the avant-garde, see Maurice Berger, *Labyrinths: Robert Morris, Minimalism, and the 1960s* (New York: Harper & Row, 1989), 129–66.

20 Hesse/Nemser transcript.

21 The strategies of Hesse's early work are, at the very least, formalistically related to Duchamp. In addition to her erotic puns and use of found objects, certain of her imagery relates directly to his work. The breast-forms, for example, appear to have their origin in several works by Duchamp —especially *Prière de toucher* (1947), a hand-colored, foam-rubber breast that appeared on the cover of the catalogue *Le Surréalisme en 1947*. The machine-like imagery of the untitled study for *Legs of a Walking Ball* (1965) bears a striking resemblance to the "Realm of the Bachelors" in Duchamp's *La Mariée mise à nu par ses célibataires, même (Le Grand Verre)* (1915–23). The title "Ring-around Arosie" appears to be both a reference to Hesse's friend Rosalyn Goldman and a pun on the name of Duchamp's alter ego Rrose Sélavy. In 1970, Hesse acknowledged her relationship to Duchamp and the feeling of "total absurdity" engendered by his work (Hesse/Nemser transcript).

22 For more on the declarative structure of Duchamp's readymades, see Benjamin H. D. Buchloh, "Ready Made, Objet Trouvé, Idée Reçue," in *Dissent: The Issue of Modern Art in Boston* (Boston: Institute of Contemporary Art, 1986), 108.

23 Mason Klein, in his insightful Lacanian analysis of Duchamp's construction of the self, writes: "The myth of a unified 'self' (along with its implied acquisition of a sexual identity based on ego development and/or the maturation of the drives) was hardly endorsed by Marcel Duchamp, whose . . . [self-professed] female creativity [was] integrated into his alter ego, Rrose Sélavy, if not completely resolved with his readymades. Unlike his Surrealist colleagues, Duchamp's interrogation of the unity of the subject—its fictive coherence—ultimately addresses the discourse of sexuality itself as it parallels the internal and arbitrary division of language" ("Towards a Phenomenology of the Self: Marcel Duchamp's *Etant donnés . . .*" [Ph.D. diss., The City University of New York, forthcoming]). For more on Duchamp and the divided self, see Annette Michelson, "*Anemic Cinema:* Reflections on an Emblematic Work," *Artforum* 12 (Oct. 1973), reprinted in *Looking Critically: 21 Years of Artforum Magazine,* ed. Amy Baker Sandback (Ann Arbor, MI: UMI Research Press, 1984), 143–48.

24 Ibid.

25 As a series, the *Accession* boxes (1967–69) collectively represent the first of the artist's works to be fabricated. The works were produced in aluminum and rubber tubing (*I*), galvanized steel and plastic tubing (*Accession* of 1967–68, which was exhibited at the Milwaukee Arts Center and is now in the Collection of Chester Lowenthal, Arts Four Corp, Paris; and *II* of 1969 [plate 108]), fiberglass and plastic tubing (*III*), and galvanized steel and rubber tubing (*IV* and *V*).

26 The formal connections between *Accession* and Oppenheim's *Object* may be more than just coincidental. In her appointment book, Hesse noted on 24 June 1965 that she had met the "lady who in 1935 [sic] made the fur-lined teacup."

27 On her refusal to alter the innate qualities of materials, Hesse stated: "I do have certain feelings now that keep things as they are. I mean I have a very strong feeling about honesty, also extremely heightened since I have been so ill. And in the process—it sounds corny—true to whatever I use, and use it in the least pretentious way and the most direct way . . . If a material is liquid, I just don't leave it or pour it. I can control it, but I don't really want to change it" (Hesse/Nemser transcript). For more on Hesse's complex processes, see Barrette, 12–17.

28 For discussions of Hesse as a process artist, see Krauss, 272; and Robert Pincus-Witten, "Eva Hesse: More Light on the Transition from Post-Minimalism to the

Sublime," in *Eva Hesse: A Memorial Exhibition* (New York: Solomon R. Guggenheim Museum, 1972), n.p.

29 Hesse/Nemser transcript. When Nemser questioned Hesse directly on the issue of "process art" in relationship to her work, the artist commented: "Well, process—well that is the mold that I felt I was going to be put in. I don't really understand it. Everything is process and the making of my work is very interesting, but I never thought of it as 'Now I am throwing, now I am scraping, now I am putting on the rubber.' For any reason other than the process—that that was necessary to what I was going to get to."

30 See Robert Morris, "Notes on Sculpture, Part IV: Beyond Objects," *Artforum* 7 (April 1969): 54.

31 Robert Morris, "Anti-Form," *Artforum* 6 (April 1968): 33–35.

32 Hesse/Nemser transcript.

33 This "rejection" of geometry, reason, and order may have been more an idealization than a reality in most anti-form work. The artist Allan Kaprow, for example, wondered whether anti-form could transgress the traditional art object while continuing to exist in relation—even negative relation—to the space of the gallery and museum. He also questioned the extent to which such work was actually against form, observing that most anti-form pieces maintained a distinct shape and, like a Pollock painting, an internal rhythmic composition. See Kaprow, "The Shape of the Art Environment: How anti form is 'Anti-Form,'" *Artforum* 6 (Summer 1968): 32–33.

34 Lucy Lippard, "Eros Presumptive," *Hudson Review* (Spring 1967), reprinted in a slightly revised version in Battcock, *Minimal Art,* 210.

35 See Pierre Cabanne, *Dialogues with Marcel Duchamp,* trans. Ron Padgett (New York: The Viking Press, 1971), 88. Although Lippard believed that "an audience visually sophisticated enough to appreciate and at times prefer non-objective works of art as concrete objects in themselves, rather than associative look-alikes, [would] also prefer the heightened sensation that can be achieved by an abstractly sensuous object" ("Eros Presumptive," 209–10), abstract eroticism never achieved the status of an art movement, its interests being represented only indirectly by such curatorial constructions as anti-form, "Eccentric Abstraction," and "Erotic Symbolis[m]." The "Erotic Symbolist" concept—which formulated a relationship between abstract art and erotic impulses—originated with a panel discussion that took place at the

School of Visual Arts in New York in February 1967. In addition to Hesse, the panelists included Louise Bourgeois and Paul Thek among others.

36 Lippard, 83. In addition to shows by Morris and Lippard, several other exhibitions explored the post-minimal manifestations of "anti-form," including "Anti-Illusion: Procedures/Materials" (1969) at the Whitney Museum of American Art and Harald Szeeman's international survey "When Attitudes Become Form" (1969) at the Kunsthalle Bern. Hesse, associated by many writers and curators with the anti-form/process art sensibility, was represented in both shows.

37 See Lucy Lippard, *Eccentric Abstraction* (New York: Fischbach Gallery, 1966), quoted in Lippard, 83. For an important critique of this exhibition and of Hesse's work therein, see M[el] B[ochner], *Arts Magazine* 41 (Nov. 1966): 57–58.

38 For a discussion of the influence of Herbert Marcuse's politics of sexual liberation on the avant-garde and particularly its relationship to Morris' anti-form concept, see Berger, *Labyrinths,* 47–79. Also see Herbert Marcuse, *Eros and Civilization* (Boston: Beacon Press, 1966).

39 Marcuse, xiii–xiv.

40 Sigmund Freud, *A General Introduction to Psychoanalysis* (New York: Garden City Publishing, 1943), 273.

41 Yet even Freud himself openly postulated that the very neuroses he sought to cure by psychoanalysis might be due to this repression. Indeed, Freud had argued that by prohibiting sexual intercourse except in monogamous marriage, "civilization" was contributing to the rapidly spreading incidence of nervous illnesses in "present-day society." See Sigmund Freud, "'Civilized' Sexual Morality and Modern Nervous Illness" (1908), in *The Complete Psychological Works of Sigmund Freud,* vol. 7, ed. James Strachey (London: Hogarth, 1959), 182–87.

42 Marcuse, xv. Marcuse's utopian position and his intense resistance to mass media strategies, of course, made his cultural position most problematic within the context of 1960s radical politics.

43 Moreover, Marcuse's theory of aesthetics was tied to this notion of libidinal liberation. It was ultimately the artist's commitment to rational form and rigid, repressive techniques, he argued, that prevented art from entering into a liberating or revolutionary praxis. See Ibid., 39.

44 Herbert Marcuse, *An Essay on Liberation* (Boston: Beacon Press, 1969), 40. For an analysis of Marcuse's idea of anti-art in relation to the politics of the art world, see Gregory Battcock, "Marcuse and Anti-

Art," *Arts Magazine* 43 (Summer 1969): 17–19.

45 Ursula Meyer, "The Eruption of Anti-Art," in *Idea Art,* ed. Gregory Battcock (New York: E. P. Dutton & Co., Inc., 1973), 133. The above paragraphs on anti-form, Marcuse, and anti-art represent a somewhat altered and abbreviated version of a section of a chapter in Berger, *Labyrinths,* 61–62, 64, 72.

46 It is indeed interesting that most of the artists Hesse admired—Duchamp, Rainer, Sartre, Beckett, Oldenburg, Warhol —were involved in overtly theatrical or cinematic strategies. While Hesse herself never executed a performance piece or film, she was very much attracted to these temporal and liberating strategies. An entry in her Kettwig diary (3 a.m., 26 Jan. [1965]) directly quotes Zelda Fitzgerald's *Save Me the Waltz:* "At night she sat in the window too tired to move, consumed by a longing to succeed as a dancer. It seemed that, reaching her goal, she would drive the devils that had driven her—that, in proving herself, she would achieve that peace which she imagined went only in surety of one's self—that she would be able, through the medium of dance, to command her emotions, to summon love, or pity or happiness at will." This quotation was followed by Hesse's words: "Just substitute painting—that is all." After her first operation in 1969 for a brain tumor, Hesse actually considered making films. And a loose page in the Hesse Archives, headed by the title *Cues,* appears to be a series of notations for a task-oriented performance piece, perhaps by the artist herself.

47 Hesse discussed the "concept of order that could be chaos" in reference to a related construction of latex-dipped cord, *Untitled* of 1970 (plate 115). See Eva Hesse, "Fling, Dribble, and Dip," *Life* 68 (27 Feb. 1970): 66.

48 Undated entry [after Spring 1967], on loose sheet attached to small, six-ring notebook. See note 34 above.

49 Hesse/Nemser transcript.

50 Ibid.

51 Passage "written Oct. 28 [1960]" and evidently transcribed into the diary begun 2 Nov. 1960 some days later; see note 6 above.

52 In her catalogue statement for *Art in Process IV* at the Finch College Museum of Art (reprinted in Lippard, 165), Hesse used this phrase to describe her goal for her art. The exhibition opened in December 1969; Hesse exhibited *Contingent.*

EVA HESSE: *A Retrospective*

PAINTINGS

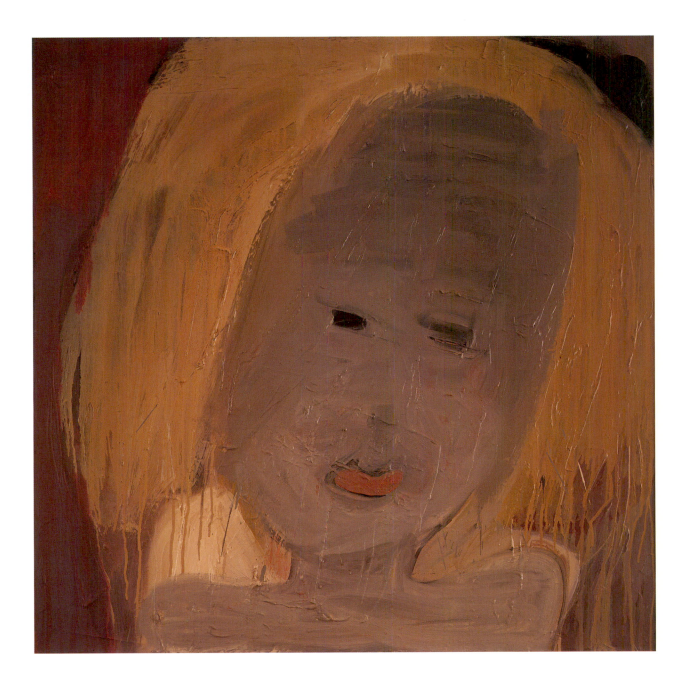

Untitled, 1960
Oil on canvas
36 x 36 in. (91.4 x 91.4 cm)
I.B.J. Schroder Bank & Trust Co.
Plate 1

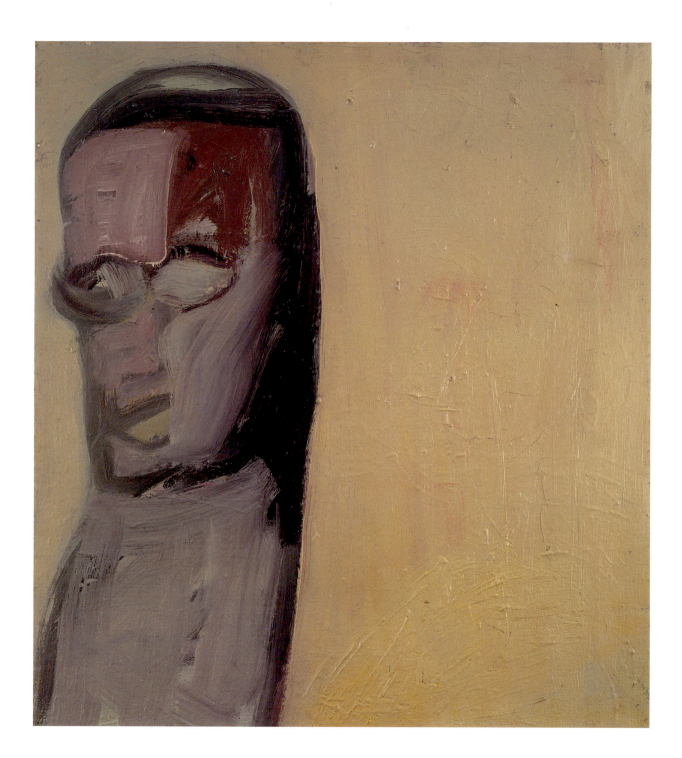

Untitled, 1960
Oil on canvas
18 x 16 in. (45.7 x 40.6 cm)
Collection Galerie Sophia Ungers, Cologne
Plate 2

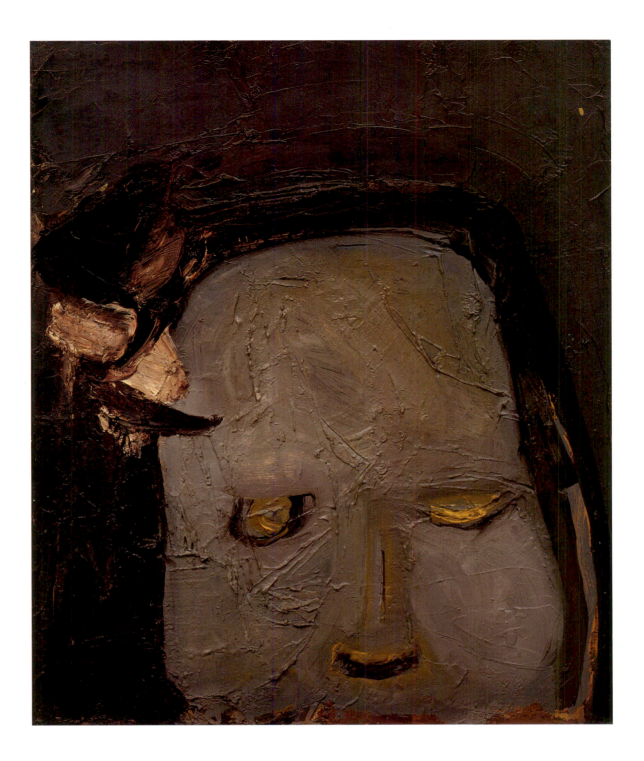

Untitled, 1960
Oil on canvas
18 x 15 in. (45.7 x 38.1 cm)
The Museum of Modern Art, New York,
Gift of Mr. and Mrs. Murray Charash, 1991
Plate 3

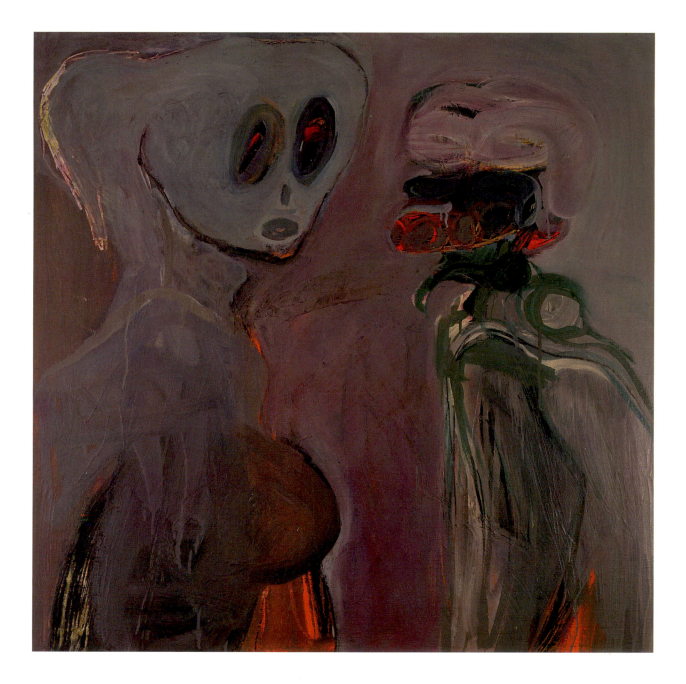

Untitled, 1960
Oil on canvas
36 x 36 in. (91.4 x 91.4 cm)
The Estate of Eva Hesse. Courtesy Robert
Miller Gallery, New York
Plate 4

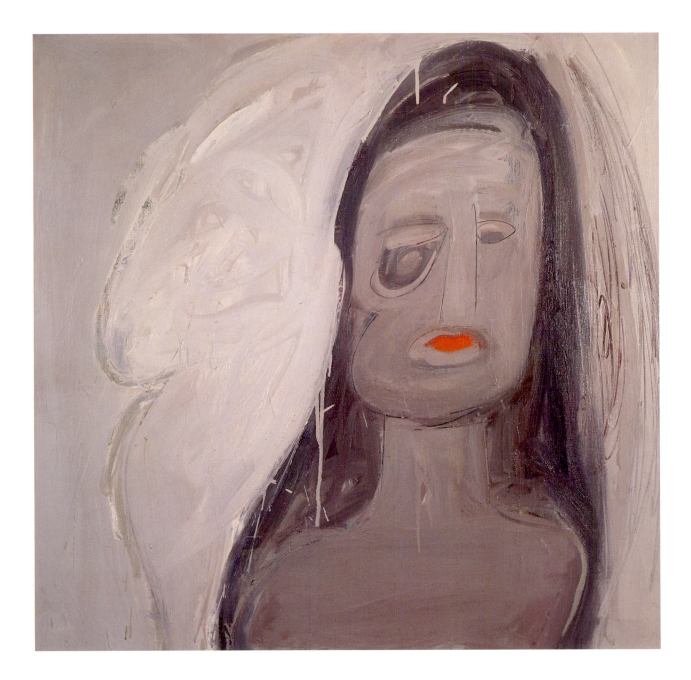

Self-Portrait, 1961
Oil on canvas
36 x 36 in. (91.4 x 91.4 cm)
Signed and dated on reverse: Eva Hesse 1961
Collection of Ruth and Samuel Dunkell
Plate 5

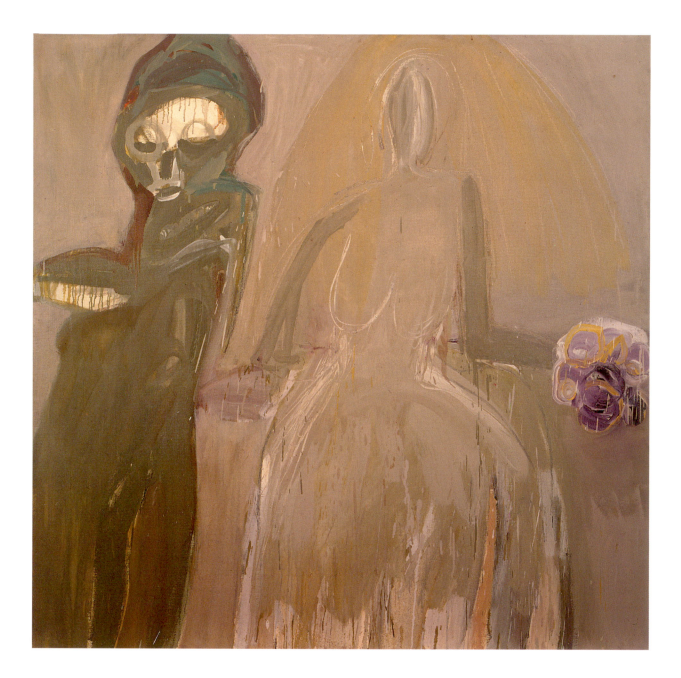

Untitled, 1960–61
Oil on canvas
49½ x 49½ in. (125.7 x 125.7 cm)
The Estate of Eva Hesse. Courtesy Robert
Miller Gallery, New York
Plate 6

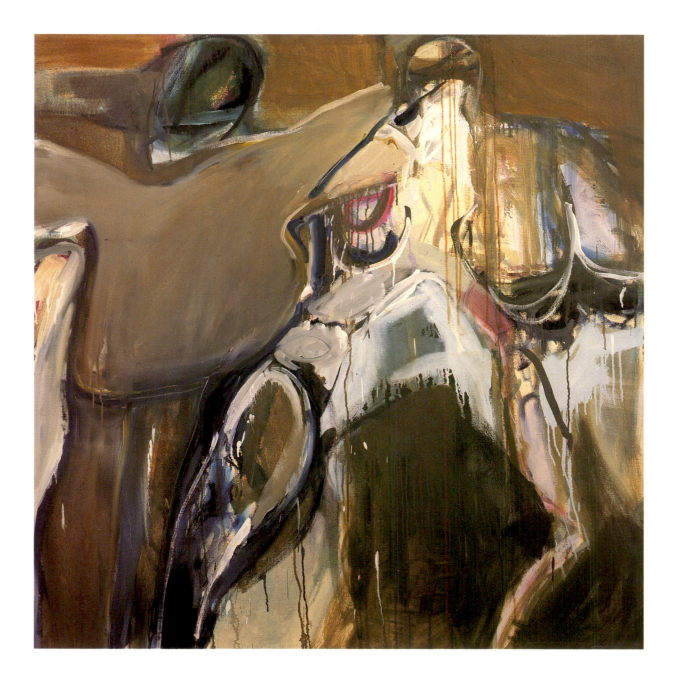

Untitled, 1960
Oil on canvas
49¼ x 49½ in. (125.1 x 125.7 cm)
The Estate of Eva Hesse. Courtesy Robert
Miller Gallery, New York
Plate 7

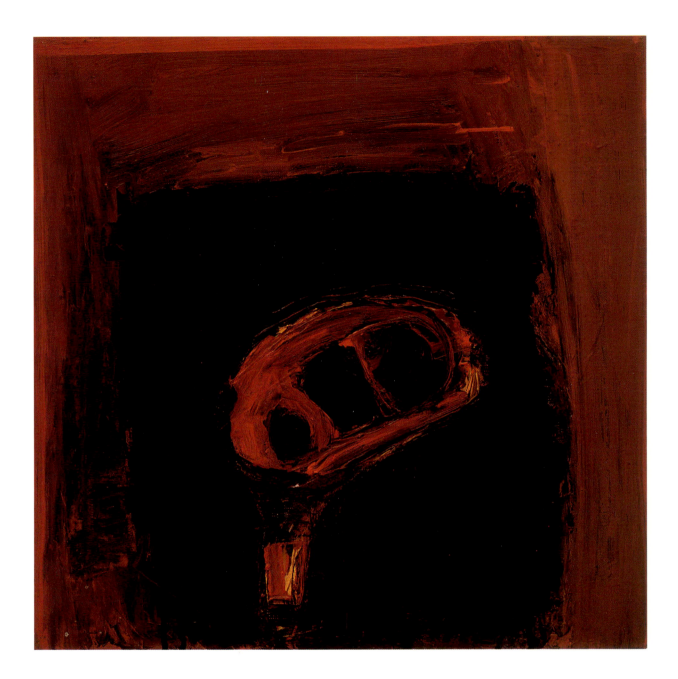

Untitled, 1960
Oil on canvas
16¼ x 16 in. (41.3 x 41 cm)
The Museum of Modern Art, New York,
Anne W. Marion, Mrs. Frank Y. Larkin, and
Mr. and Mrs. Gifford Phillips Funds, 1991
Plate 8

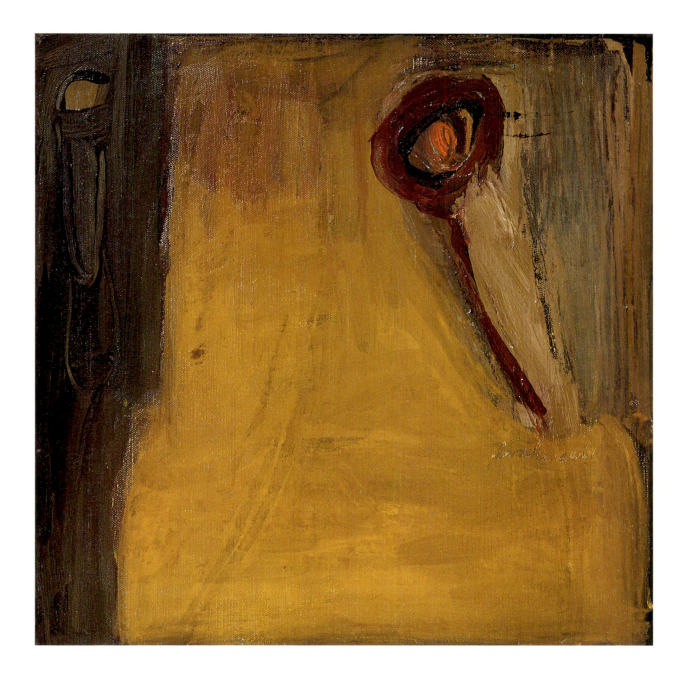

Untitled, 1961
Oil on canvas
16 x 16 in. (40.6 x 40.6 cm)
Signed and dated on the right: evahesse 61
The LeWitt Collection. Courtesy of the
Wadsworth Atheneum, Hartford, CT
Plate 9

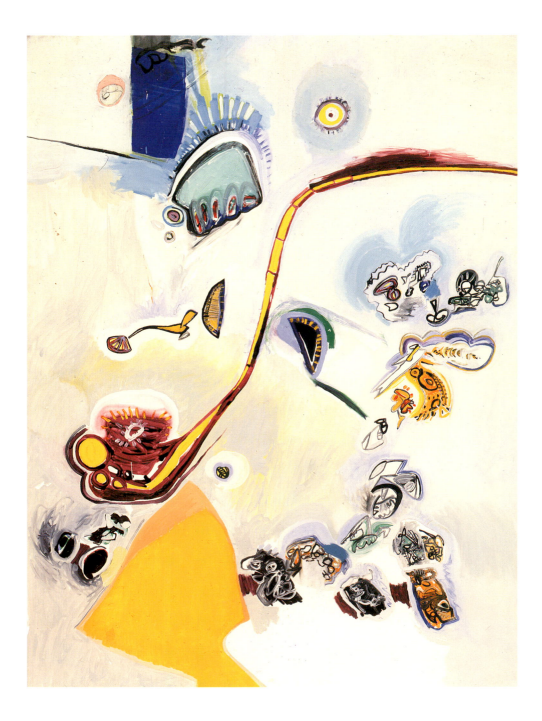

Untitled, 1964
Oil on canvas
81½ x 60⅔ in. (207 x 154 cm)
Collection of F. A. Scheidt, Kettwig
Plate 10

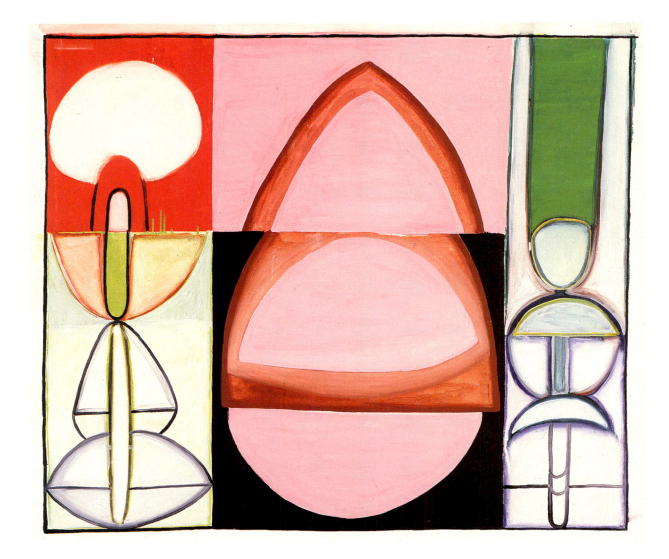

Untitled, 1964
Oil on canvas
34½ x 41⅐ in. (87.5 x 104.5 cm)
Collection of F. A. Scheidt, Kettwig
Plate 11

WORKS ON PAPER

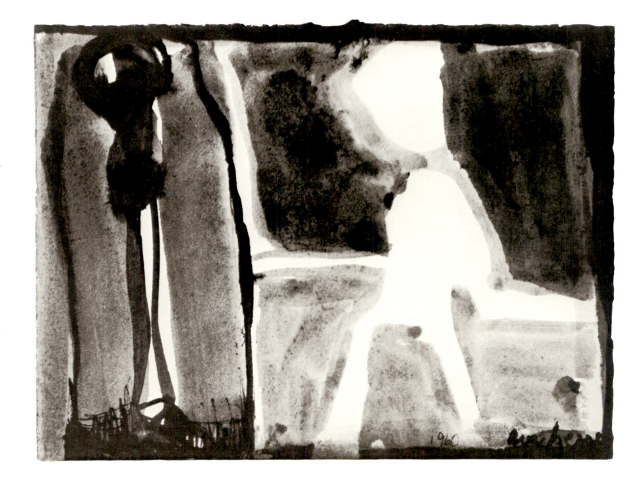

Untitled, 1960
Ink wash and gouache
4½ x 6 in. (11.4 x 15.2 cm)
Signed and dated lower right: 1960 eva hesse
Private Collection
Plate 12

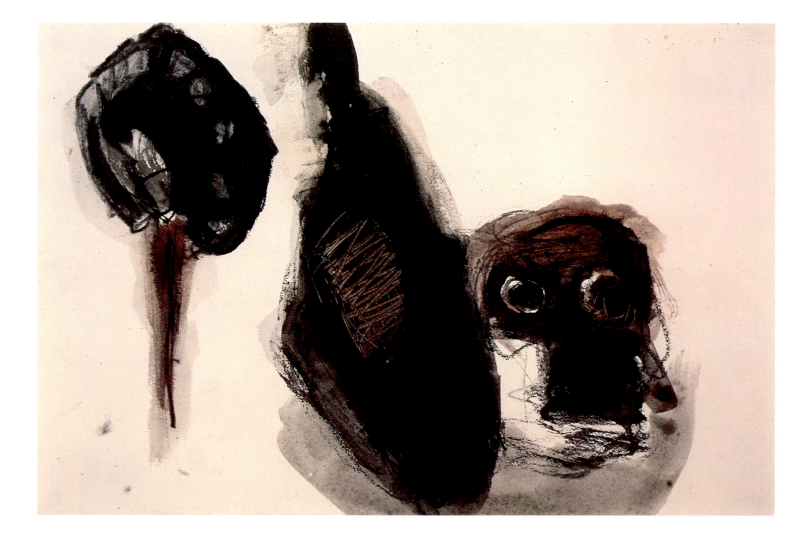

Untitled, 1960
Black and brown ink washes, crayon,
and gouache
6 x 9 in. (15.2 x 22.9 cm)
Private Collection
Plate 13

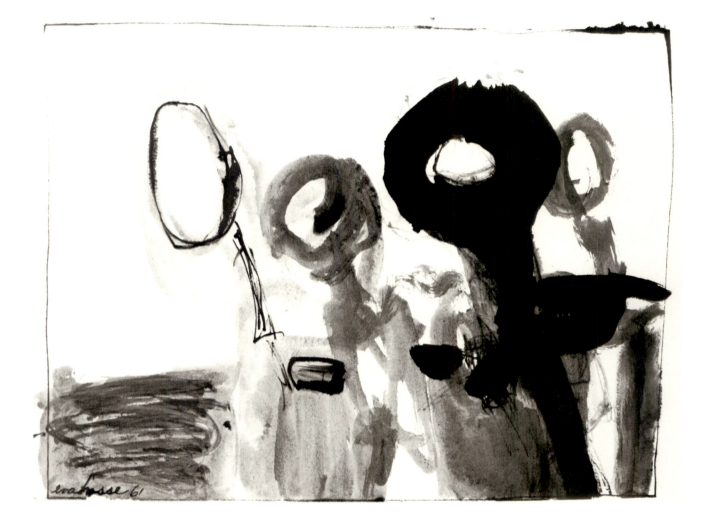

Untitled, 1961
Black ink wash
9 x 12 in. (22.9 x 30.5 cm)
Signed and dated lower left: evahesse 61
Private Collection
Plate 14

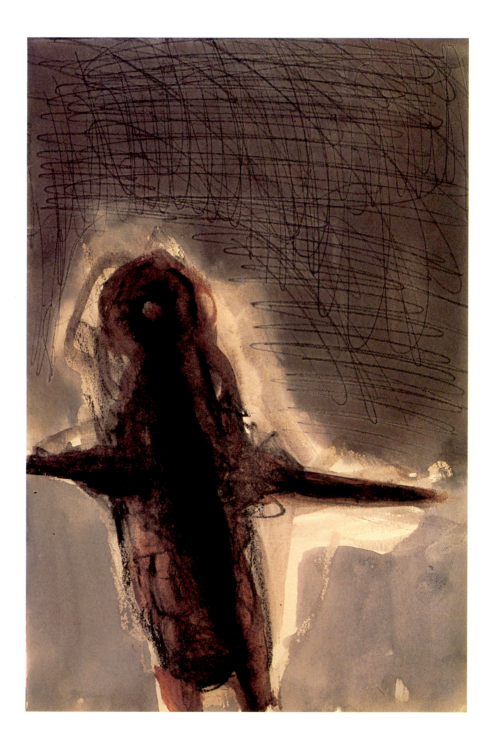

Untitled, 1961
Black and brown ink washes, crayon,
gouache, and pencil
9 x 6 in. (22.9 x 15.2 cm)
Private Collection
Plate 15

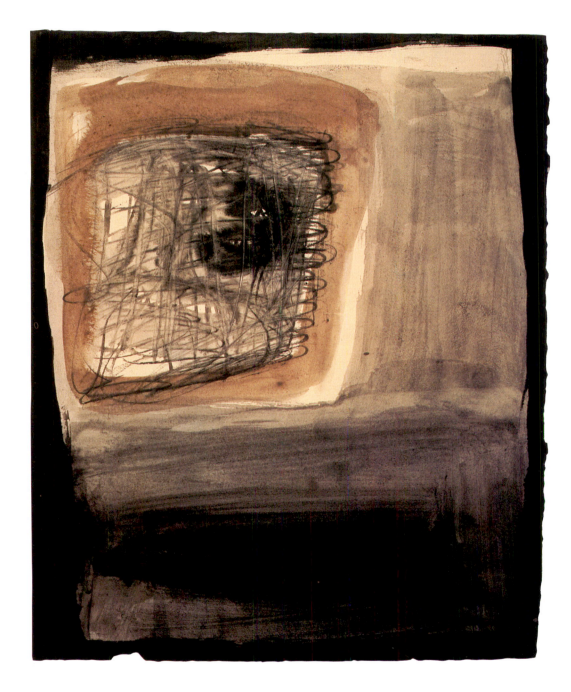

Untitled, 1960–61
Black and brown ink washes and gouache
10½ x 8¾ in. (26.6 x 22.2 cm)
Private Collection
Plate 16

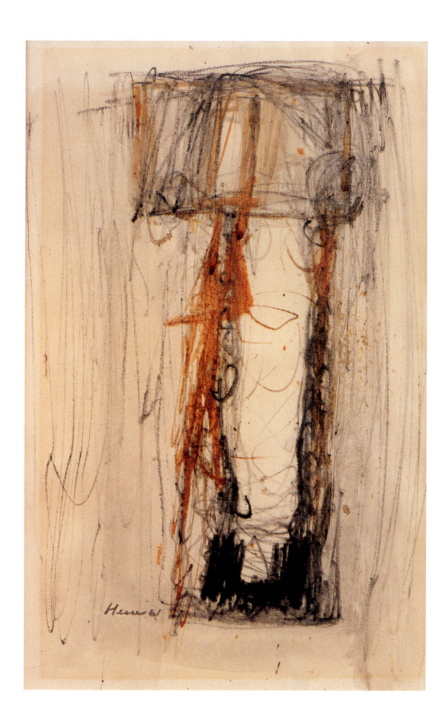

Untitled, 1961
Brown and black ink washes, gouache,
and crayon
9½ x 6 in. (24.1 x 15.2 cm)
Signed and dated lower left: Hesse 61
Lucy R. Lippard
Plate 17

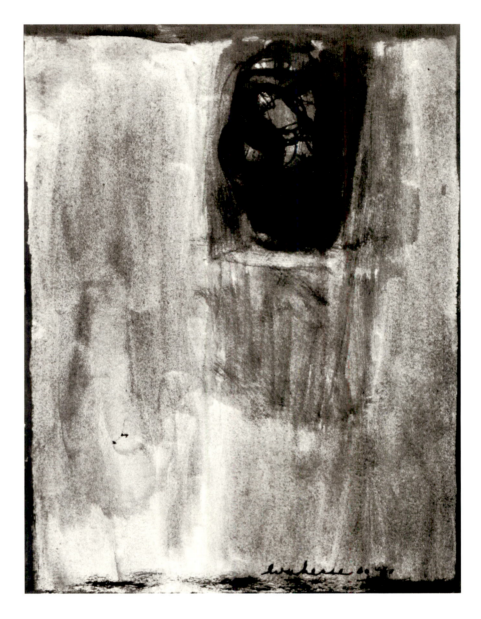

Untitled, 1960–61
Ink wash and gouache
6 x 4½ in. (15.2 x 11.4 cm)
Signed and dated lower right: evahesse 60–61
Collection John Eric Cheim, New York
Plate 18

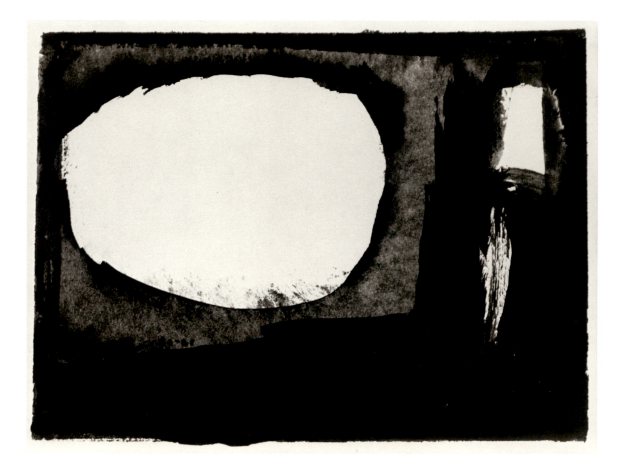

Untitled, 1960–61
Black and brown ink washes and gouache
4½ x 6 in. (11.4 x 15.2 cm)
Signed and dated lower left: eva hesse 60–61
Private Collection
Plate 19

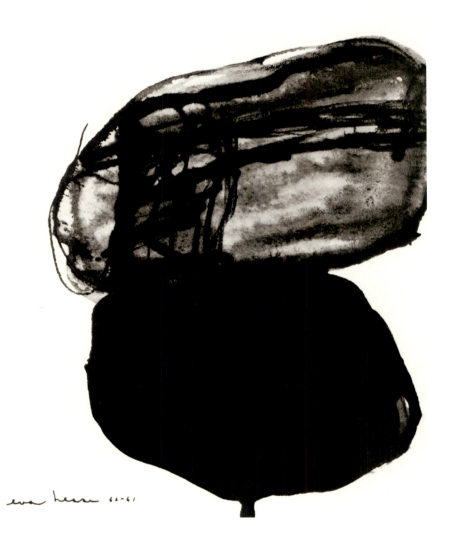

Untitled, 1960–61
Black ink wash and gouache
6 x 4½ in. (15.2 x 11.4 cm)
Signed and dated lower left: eva hesse 60–61
The Estate of Eva Hesse. Courtesy Robert
Miller Gallery, New York
Plate 20

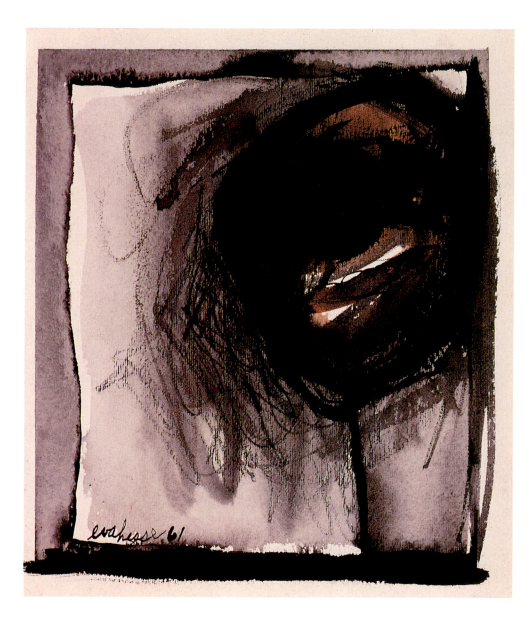

Untitled, 1961
Black and burnt umber ink washes, gouache,
pencil, and crayon
10½ x 9⁵⁄₁₆ in. (26.7 x 23.6 cm)
Signed and dated lower left: evahesse 61
The Baltimore Museum of Art, Gift from
the Estate of the Artist
Plate 21

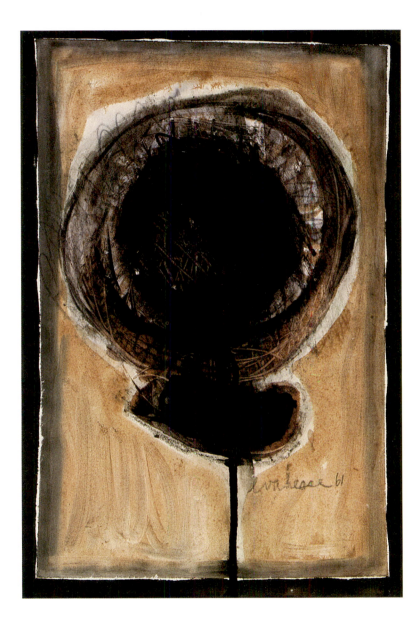

Untitled, 1961
Black and brown ink washes, gouache,
crayon, and pencil
9 x 6 in. (22.9 x 15.3 cm)
Signed and dated lower right: eva hesse 61
Ellen H. Johnson
Plate 22

Untitled, 1961
Ink wash and gouache
6 x 4½ in. (15.2 x 11.4 cm)
Signed upper right: E.H.
The Estate of Eva Hesse. Courtesy Robert
Miller Gallery, New York
Plate 23

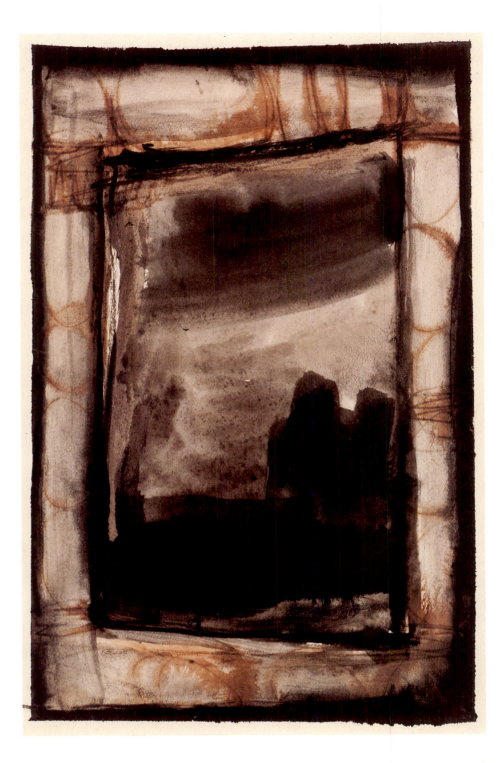

Untitled, ca. 1961
Black and brown ink washes
8⅞ x 5⅝ in. (22.5 x 14.3 cm)
Collection Mr. and Mrs. Tony Ganz
Plate 24

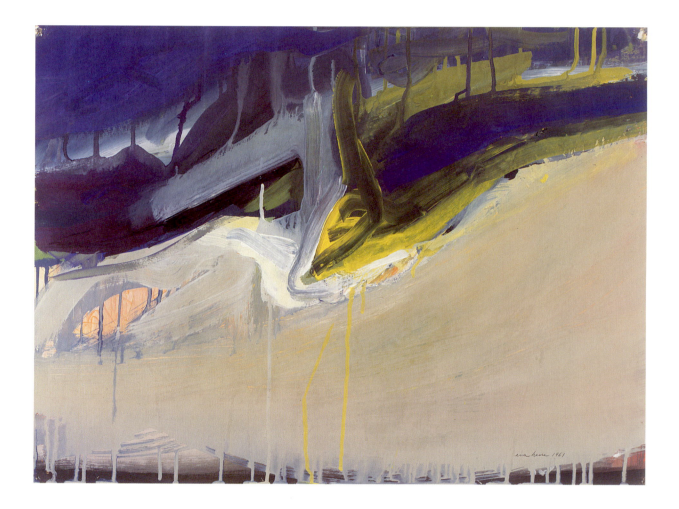

Ashokan, 1961
Casein
18 x 24½ in. (45.7 x 62.2 cm)
Collection Barry Rosen
Plate 25

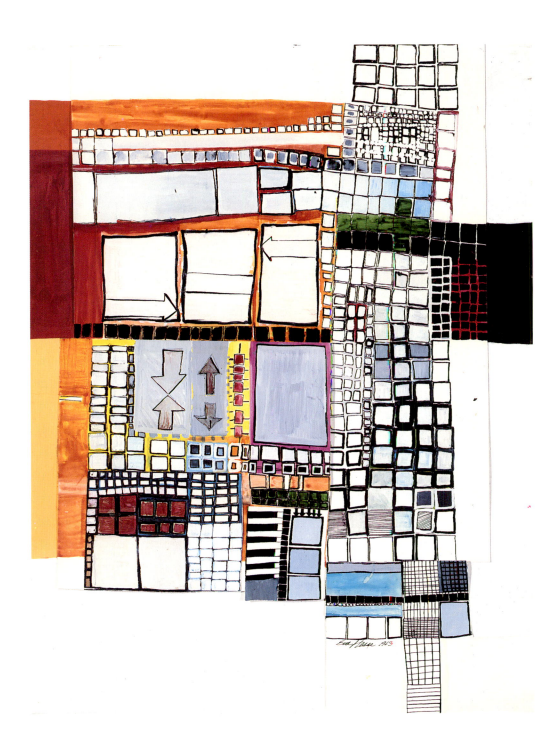

Untitled, 1963
Collage with gouache, black ink, and
watercolor on paper and corrugated
cardboard
36⅝/₁₆ x 27¾ in. (92.2 x 70.5 cm)
Signed and dated lower right: Eva Hesse 1963
Private Collection
Plate 26

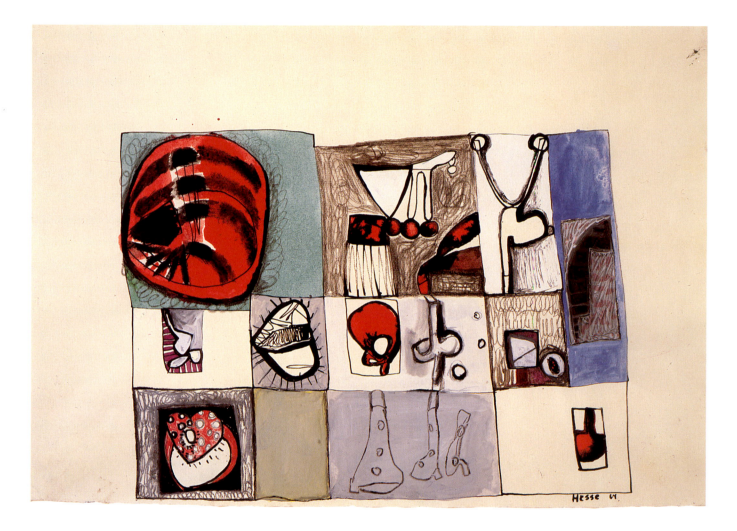

Untitled, 1964
Ink wash, gouache, watercolor, crayon,
and pencil
11½ x 16¼ in. (29.2 x 41.3 cm)
Signed and dated lower right: Hesse 64
Private Collection.
Courtesy Anthony Ralph Gallery
Plate 27

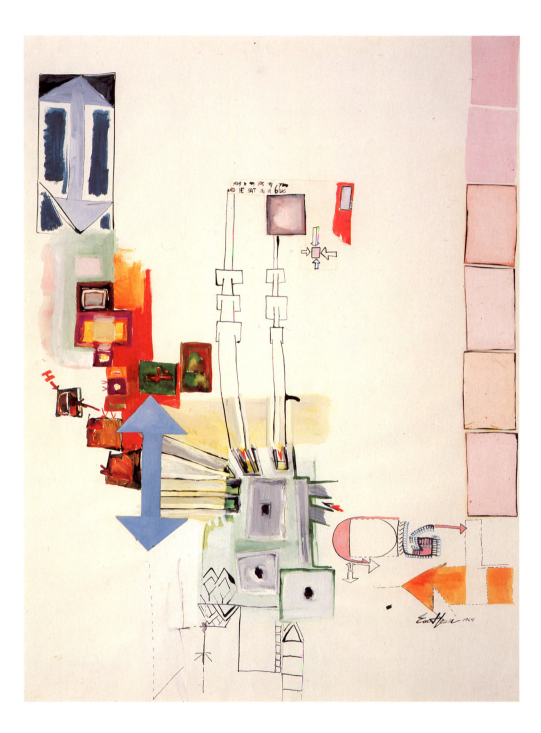

And He Sat in a Box, 1964
Collage with ink, gouache, and watercolor
30 x 22 in. (76.2 x 55.9 cm)
Signed and dated lower right: Eva Hesse 1964
Barbara Gross Galerie, Munich
Plate 28

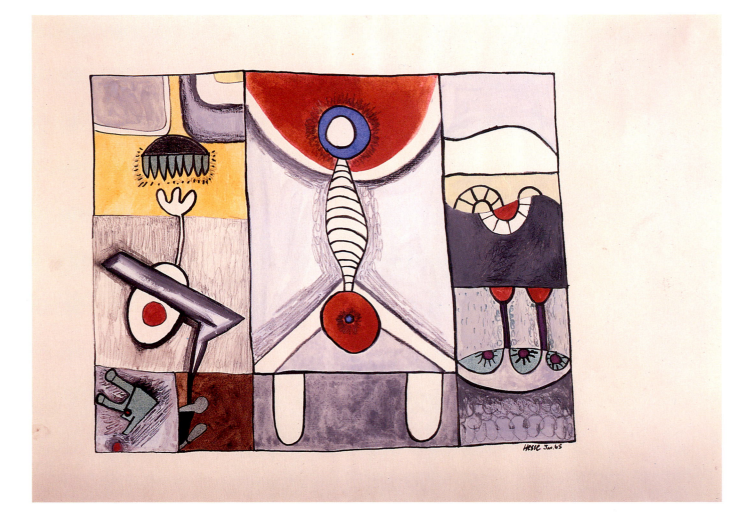

Untitled, 1965
Black ink wash, gouache, watercolor,
crayon, and pencil
11¾ x 16½ in. (29.9 x 41.9 cm)
Signed and dated lower right: Hesse Jan. 65
Museum Wiesbaden, Germany
Plate 29

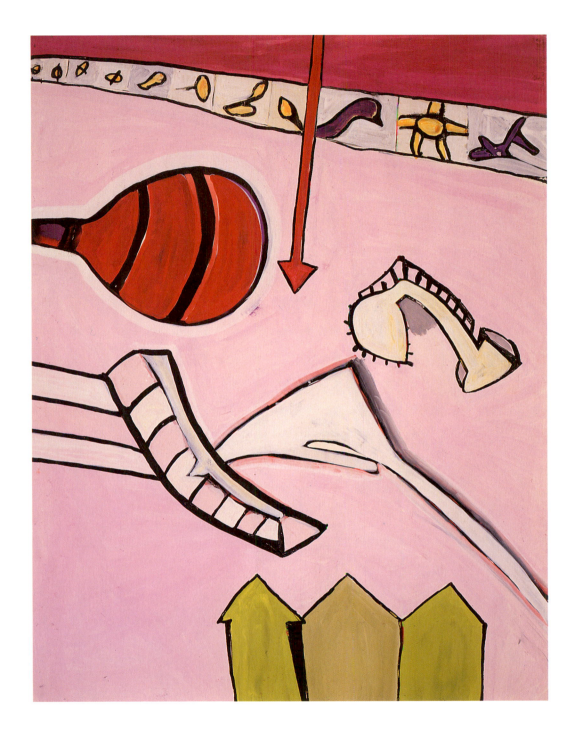

Untitled, 1964
Gouache, ink wash, and watercolor
25½ x 19⅝ in. (64.8 x 49.8 cm)
The Estate of Eva Hesse. Courtesy Robert
Miller Gallery, New York
Plate 30

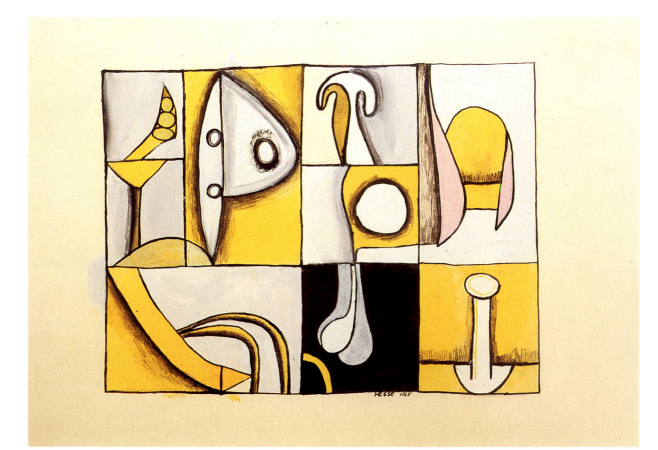

Untitled, 1965
Black ink wash, gouache, watercolor,
and crayon
11½ x 16½ in. (29.9 x 41.9 cm)
Signed and dated right of center: HESSE 1/65
Werner H. and Sarah-Ann Kramarsky
Plate 31

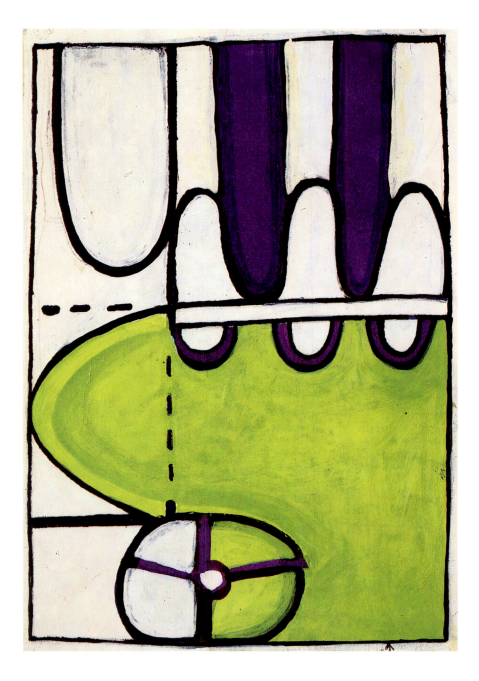

Untitled, 1965
Ink wash, gouache, and pencil
6½ x 4½ in. (16.5 x 11.4 cm)
The Estate of Eva Hesse. Courtesy Robert
Miller Gallery, New York
Plate 32

Mechanical drawings, as shown in their
original installation in F. A. Scheidt's
greenhouse, May 1965. Photograph courtesy
of F. A. Scheidt, Kettwig

Untitled, 1965
Black ink and pencil cutout
11¹¹⁄₁₆ x 6⅜ in. (28.1 x 16.2 cm)
Allen Memorial Art Museum, Oberlin
College, Gift of Helen Hesse Charash, 1981
Plate 33

Untitled, 1965
Black ink and pencil cutout
8¾ x 7⁹⁄₁₆ in. (22.3 x 19.2 cm)
Allen Memorial Art Museum, Oberlin
College, Gift of Helen Hesse Charash, 1981
Plate 34

Untitled, 1965
Black ink
11⅝ x 8¼ in. (29.6 x 21 cm)
Collection of F. A. Scheidt, Kettwig
Plate 35

Untitled, 1965
Black ink
11⅝ x 8¼ in. (29.6 x 21 cm)
Collection of F. A. Scheidt, Kettwig
Plate 36

Untitled, 1965
Black ink and pencil cutout
11¹³⁄₁₆ x 9¹⁄₁₆ in. (27.5 x 23 cm)
Allen Memorial Art Museum, Oberlin
College, Gift of Helen Hesse Charash, 1981
Plate 37

Untitled, 1965
Black ink and pencil cutout
12¹⁄₁₆ x 6⅝ in. (30.6 x 16.3 cm)
Allen Memorial Art Museum, Oberlin
College, Gift of Helen Hesse Charash, 1981
Plate 38

Untitled, 1965
Black ink and pencil cutout
8¹⁵⁄₁₆ x 6¹¹⁄₁₆ in. (22.6 x 17 cm)
Allen Memorial Art Museum, Oberlin
College, Gift of Helen Hesse Charash, 1981
Plate 39

Untitled, 1965
Black ink and pencil cutout
9½ x 6¼ in. (24.5 x 15.8 cm)
Allen Memorial Art Museum, Oberlin
College, Gift of Helen Hesse Charash, 1981
Plate 40

Untitled, 1965
Black ink and pencil cutout
7½ x 7⅛ in. (19.1 x 18.1 cm)
Allen Memorial Art Museum, Oberlin
College, Gift of Helen Hesse Charash, 1981
Plate 41

Untitled, 1965
Black ink and pencil cutout
9 x 6⅛ in. (22.2 x 15.6 cm)
Allen Memorial Art Museum, Oberlin
College, Gift of Helen Hesse Charash, 1981
Plate 42

Untitled, 1965
Black ink
8¼ x 11⅝ in. (21 x 29.6 cm)
Collection of F. A. Scheidt, Kettwig
Plate 43

Untitled, 1965
Black ink
8¼ x 11⅝ in. (21 x 29.5 cm)
The Estate of Eva Hesse. Courtesy Robert
Miller Gallery, New York
Plate 44

Untitled, 1965
Black ink
8¼ x 11⅝ in. (21 x 29.6 cm)
Collection of F. A. Scheidt, Kettwig
Plate 45

Untitled, 1965
Black ink
8¼ x 11⅝ in. (21 x 29.5 cm)
The Estate of Eva Hesse. Courtesy Robert
Miller Gallery, New York
Plate 46

Untitled, 1965
Black ink
8¼ x 11⅝ in. (21 x 29.5 cm)
Gioia Timpanelli
Plate 47

Untitled, 1965
Black ink and gouache
9 x 6¼ in. (22.9 x 15.9 cm)
The Estate of Eva Hesse. Courtesy Robert
Miller Gallery, New York
Plate 48

Untitled, 1965
Black ink
8¼ x 11⅝ in. (21 x 29.5 cm)
The Estate of Eva Hesse. Courtesy Robert
Miller Gallery, New York
Plate 49

Untitled, 1965
Black ink
8½ x 11⅝ in. (21.6 x 29.5 cm)
The Estate of Eva Hesse. Courtesy Robert
Miller Gallery, New York
Plate 50

Untitled, 1965
Black ink
11⅝ x 8¼ in. (29.6 x 21 cm)
Signed lower center: EH
The Estate of Eva Hesse. Courtesy Robert
Miller Gallery, New York
Plate 51

Untitled, 1965
Black ink
11⅝ x 8¼ in. (29.6 x 21 cm)
Collection of F. A. Scheidt, Kettwig
Plate 52

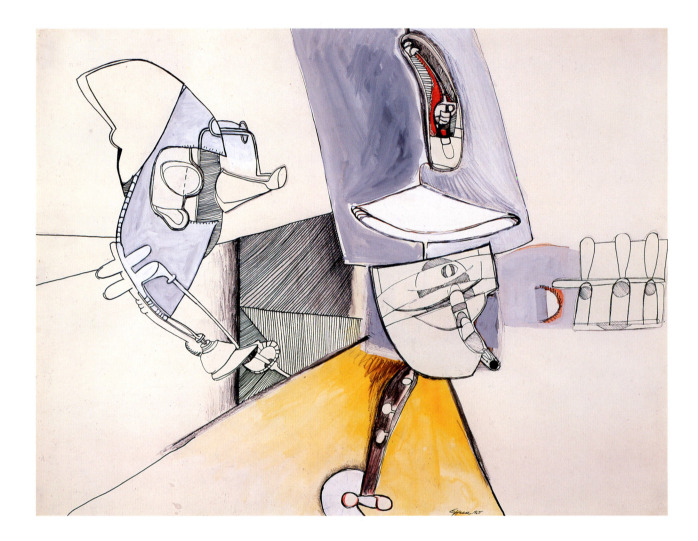

Untitled, 1965
Collage with black ink, watercolor, gouache,
pencil, crayon, and ballpoint pen
19½ x 25½ in. (49.5 x 64.7 cm)
Signed and dated lower right of center:
EHesse 1965
Collection Mr. and Mrs. Tony Ganz
Plate 53

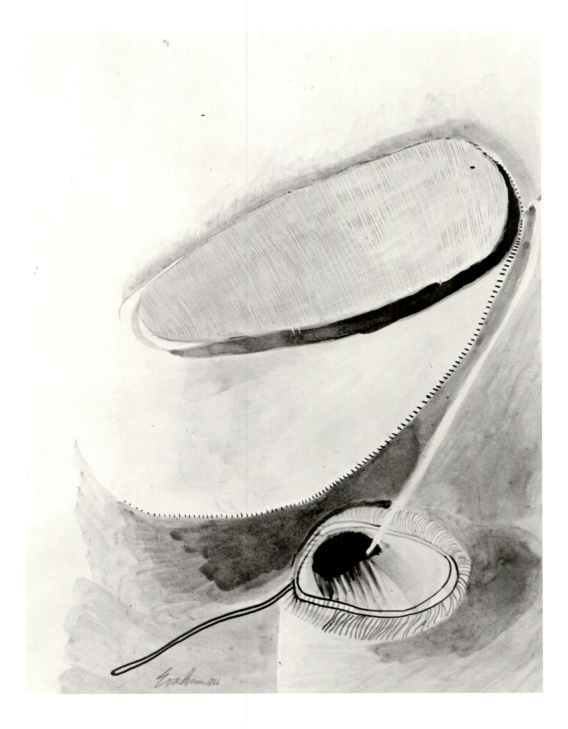

Untitled, 1966
Black ink, watercolor, gouache, and pencil
11¾ x 9 in. (29.9 x 22.9 cm)
Signed and dated lower left: Eva Hesse 1966
Yoshio Kojima, Japan
Plate 54

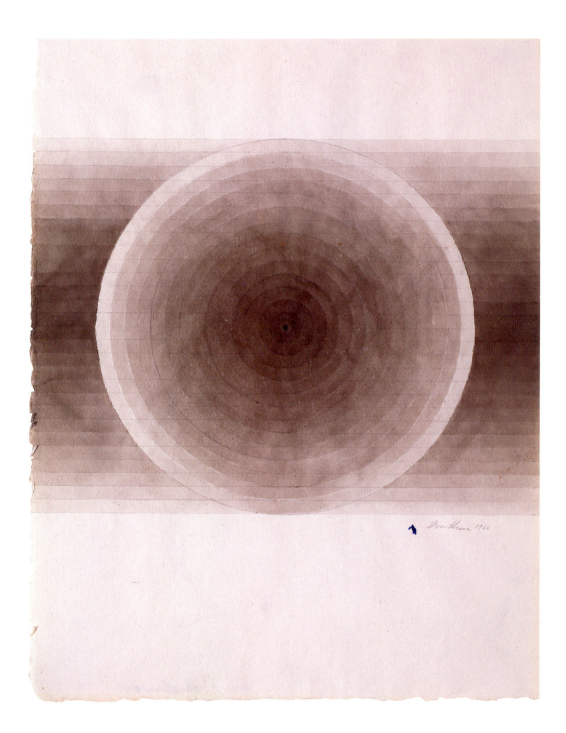

Untitled, 1966
Brown ink wash and pencil
13¾ x 10¾ in. (34.9 x 27.3 cm)
Signed and dated lower right: Eva Hesse 1966
Marilyn Cole Fischbach
Plate 55

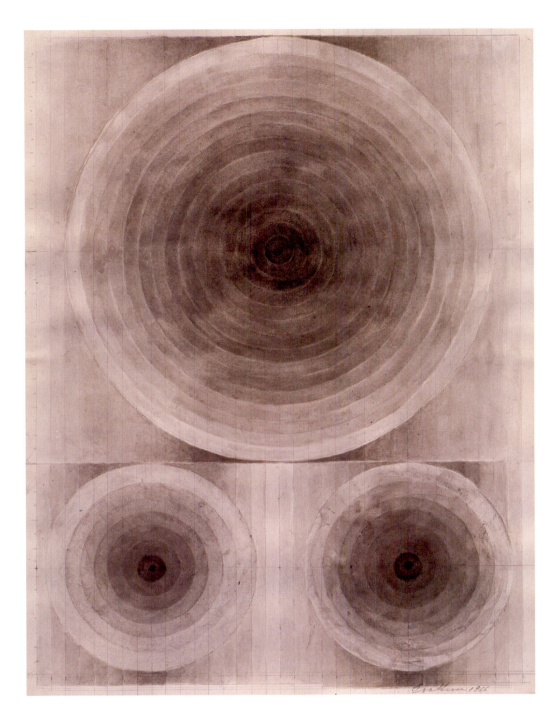

Untitled, 1966
Black ink wash and pencil
11¾ x 9 in. (29.8 x 22.9 cm)
Signed and dated lower right: Eva Hesse 1966
Collection Mr. and Mrs. Tony Ganz
Plate 56

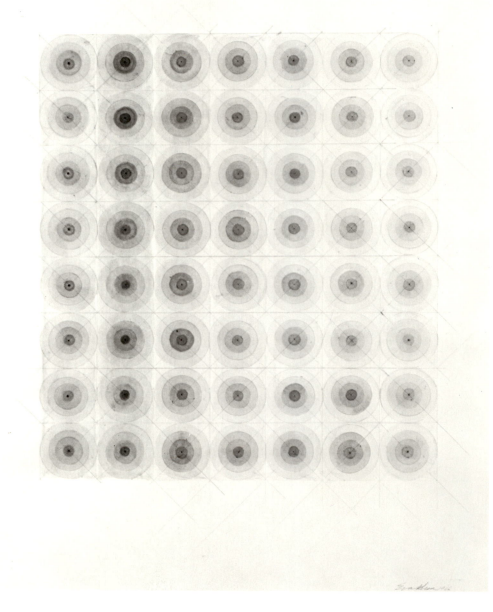

Untitled, 1966
Brown ink wash and pencil
11⅞ x 9⅛ in. (30.2 x 23.2 cm)
Signed and dated lower right: Eva Hesse 1966
The Museum of Modern Art, New York,
Gift of Mr. and Mrs. Herbert Fischbach
Plate 57

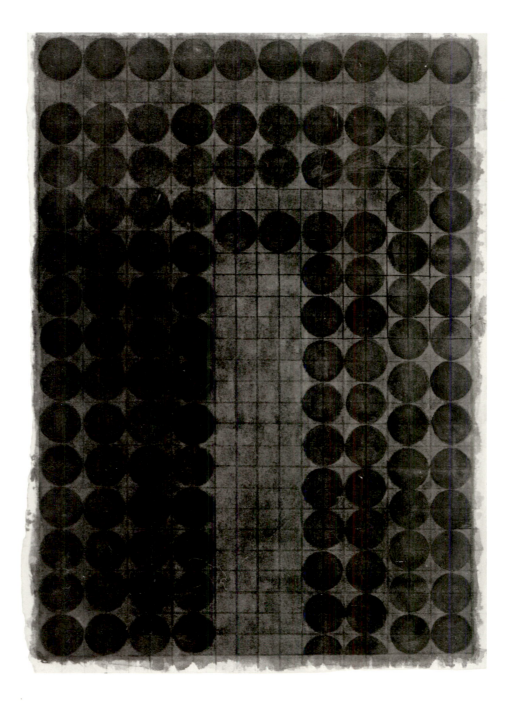

Untitled, 1966
Ink wash and pencil
15½ x 11⁷⁄₁₆ in. (39.3 x 29 cm)
Collection of F. A. Scheidt, Kettwig
Plate 58

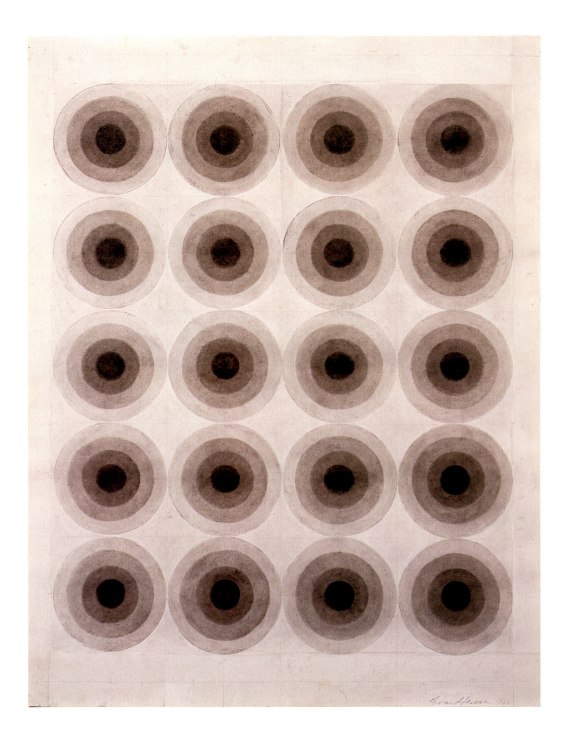

Untitled, 1966
Black ink wash and pencil
11½ x 9 in. (29.9 x 22.9 cm)
Signed and dated lower right: Eva Hesse 1966
Private Collection
Plate 59

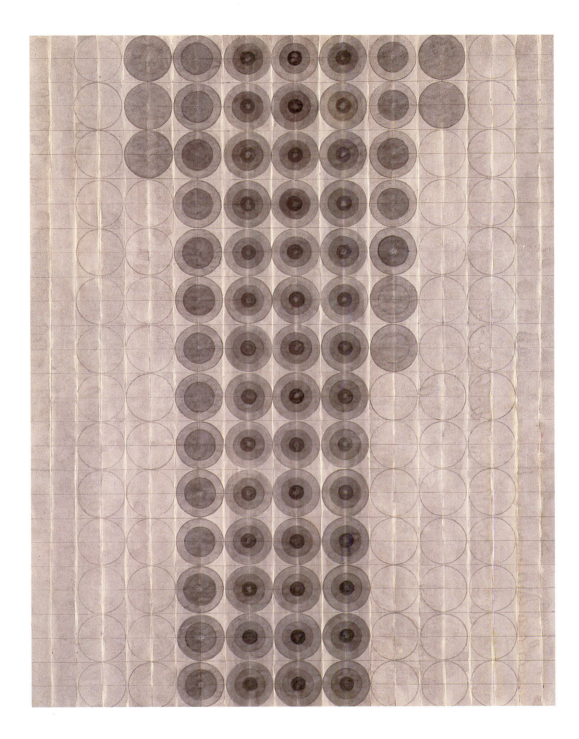

Untitled, 1966
Black ink wash and pencil
13¾ x 10¾ in. (35 x 27.3 cm)
Paul F. Walter
Plate 60

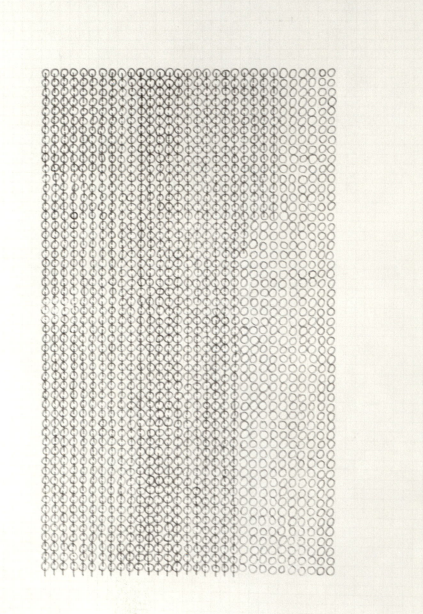

Untitled, 1967
Black ink on graph paper
10¾ x 8¼ in. (27.3 x 21 cm)
Weatherspoon Art Gallery, The University of
North Carolina, Gift of Helen Hesse Charash
Plate 61

Untitled, 1967
Black ink on graph paper
11 x 9 in. (28 x 22.9 cm)
Signed and dated lower right: Eva Hesse 1967
Private Collection
Plate 62

Untitled, 1967
Black ink on graph paper
10¾ x 8⅜ in. (27.4 x 21.4 cm)
Signed and dated lower right: Eva Hesse 1967
Collection of Grace and Gerald Wapner
Plate 63

Untitled, 1967
Black ink on graph paper
11 x 8½ in. (28 x 21.6 cm)
Werner H. and Sarah-Ann Kramarsky
Plate 64

Untitled, 1967
Black ink on graph paper
11 x 8½ in. (28 x 21.6 cm)
Signed and dated lower right: Eva Hesse 1967
Allen Memorial Art Museum, Oberlin
College, Friends of Art Endowment Fund
Plate 65

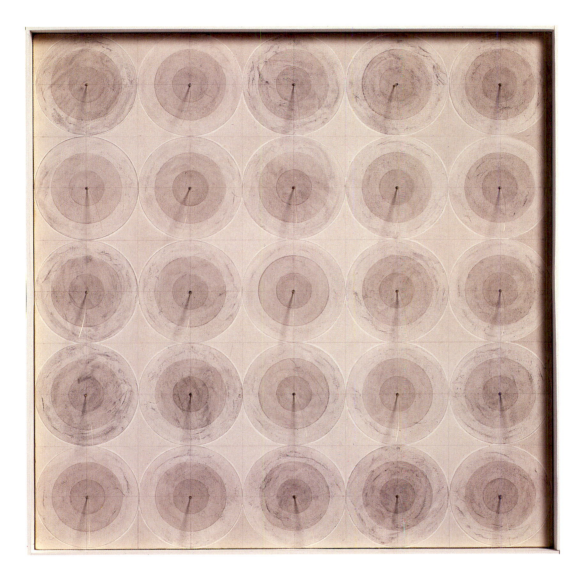

Untitled, 1967
Ink wash and pencil on paper on board with
nylon string
14⅞ x 14⅞ in. (37.8 x 37.8 cm)
Collection Mrs. Victor W. Ganz
Plate 66

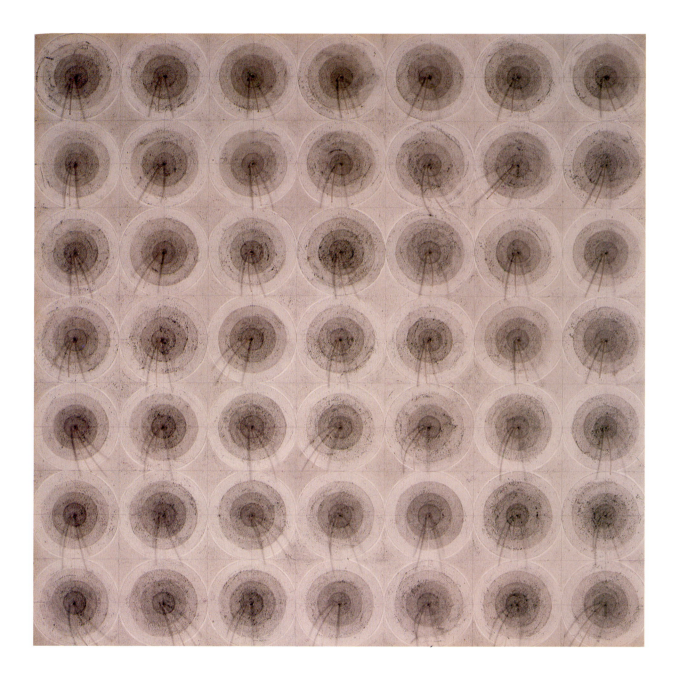

Untitled, 1967
Black ink wash and pencil on paper with
nylon string
14 x 14 x 1¼ in. (35.6 x 35.6 x 3.2 cm)
Inscribed on reverse: For Donald and Roy, Maine
Private Collection, Switzerland
Plate 67 · Yale only

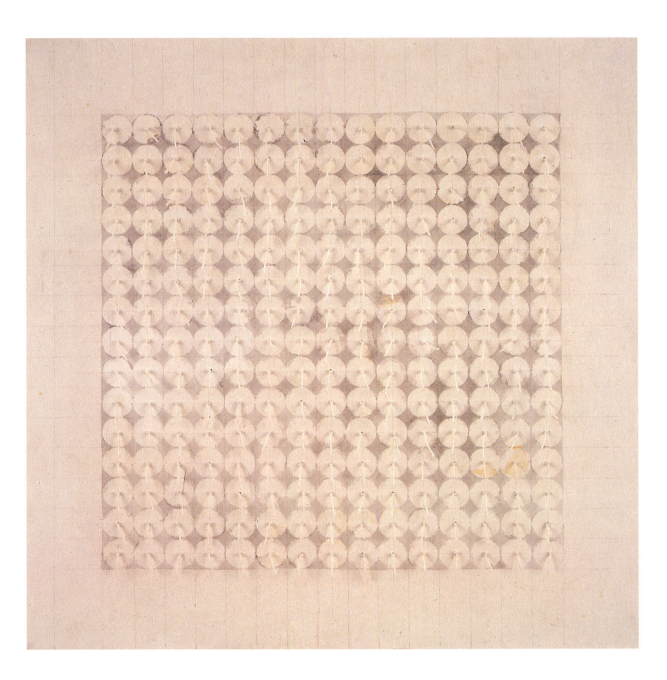

Untitled, 1967
Ink wash and pencil on paper on board with
cotton string
15¼ x 15¼ in. (38.7 x 38.7 cm)
Signed and dated on reverse: EVA HESSE 1967
Weatherspoon Art Gallery, The University of
North Carolina, Dillard Collection
Plate 68

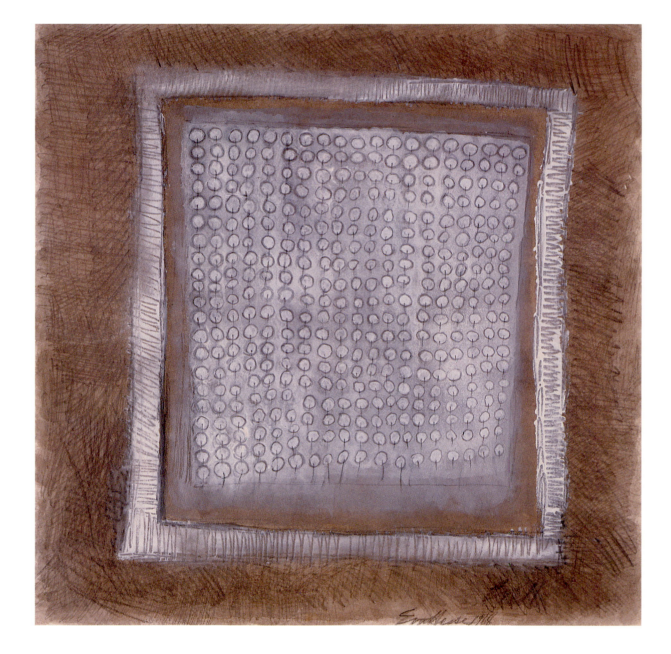

Untitled, 1968
Pencil, brown wash, and gouache
12⅛ x 12³⁄₁₆ in. (30.8 x 30.9 cm)
Signed and dated lower right of center:
Eva Hesse 1968
The Saint Louis Art Museum, Gift of
Dr. and Mrs. Edward Okun
Plate 69

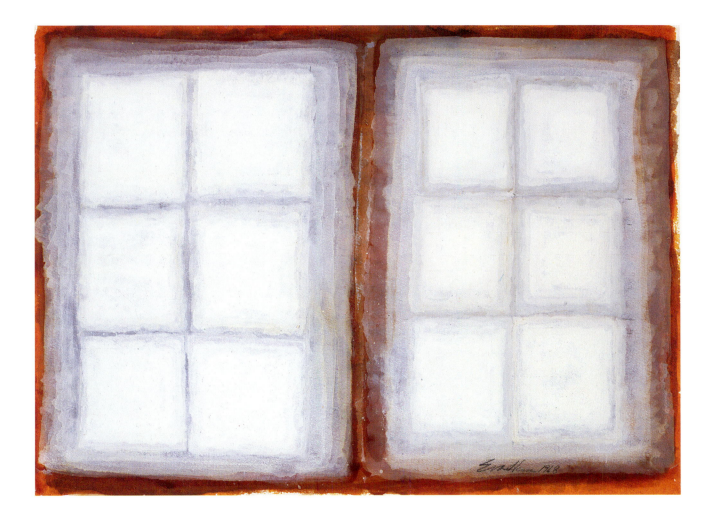

Untitled, 1968
Black and brown ink washes and gouache
11 x 15 in. (29.9 x 38.1 cm)
Signed and dated lower right: Eva Hesse 1968
Collection of Neuberger Museum, State
University of New York at Purchase, gift of
Roy R. Neuberger
Plate 70

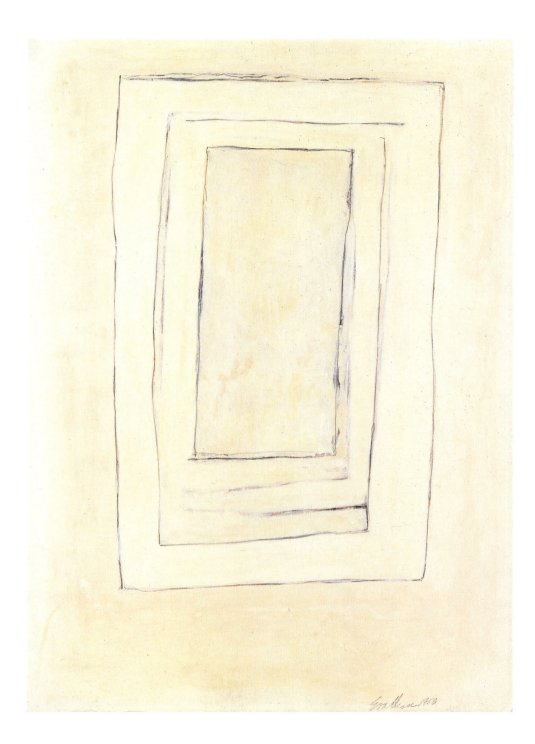

Untitled, 1968
Gouache, waterolor, and pencil
15½ x 11¼ in. (39.4 x 28.6 cm)
Signed and dated lower right: Eva Hesse 1968
Collection of F. A. Scheidt, Kettwig
Plate 71

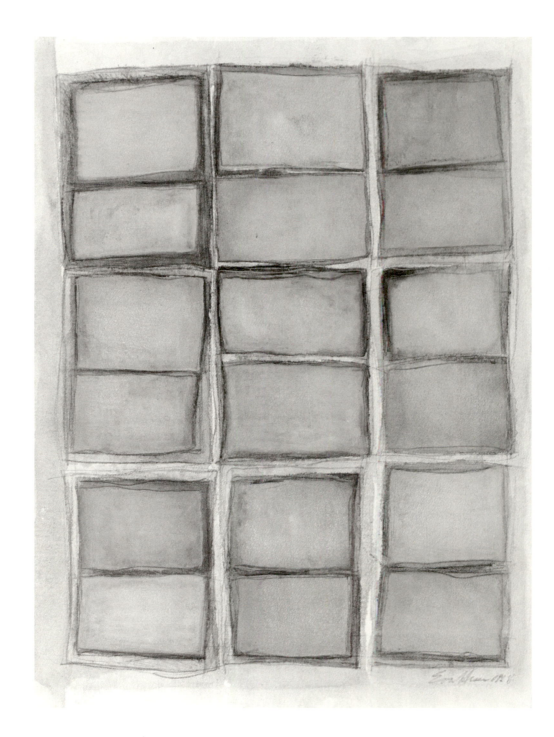

Untitled, 1968
Gouache, watercolor, and pencil
14¾ x 11⅛ in. (37.5 x 28.2 cm)
Signed and dated lower right: Eva Hesse 1968
Private Collection
Plate 72

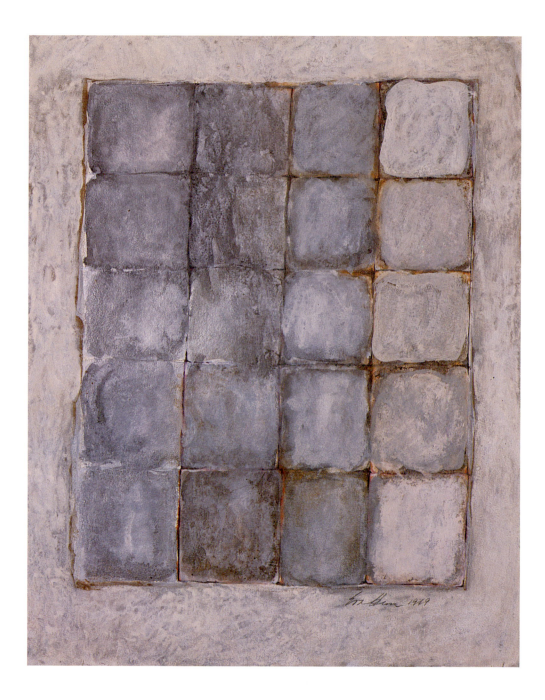

Untitled, 1969
Gouache, watercolor, silver and bronze paint
21¾ x 17¼ in. (55.2 x 43.8 cm)
Signed and dated lower right: Eva Hesse 1969
Private Collection, New York
Plate 73

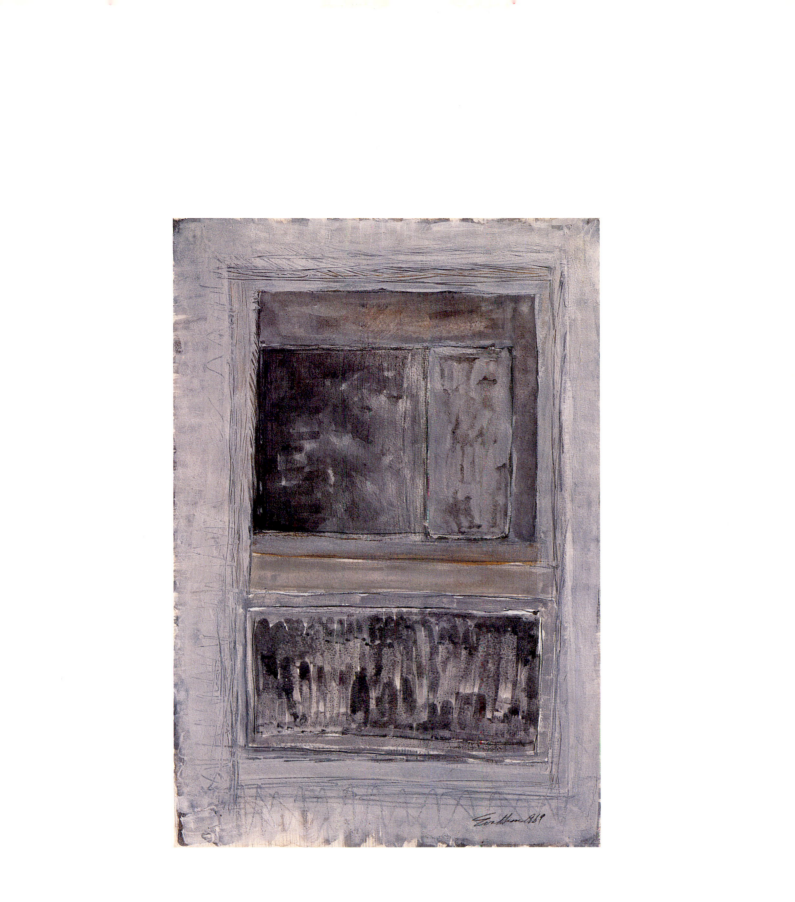

Untitled, 1969
Gouache, black ink, watercolor, silver paint,
and pencil
22⅛ x 15 in. (56.2 x 38.2 cm)
Signed and dated lower right: Eva Hesse 1969
Collection Mr. and Mrs. Tony Ganz
Plate 74

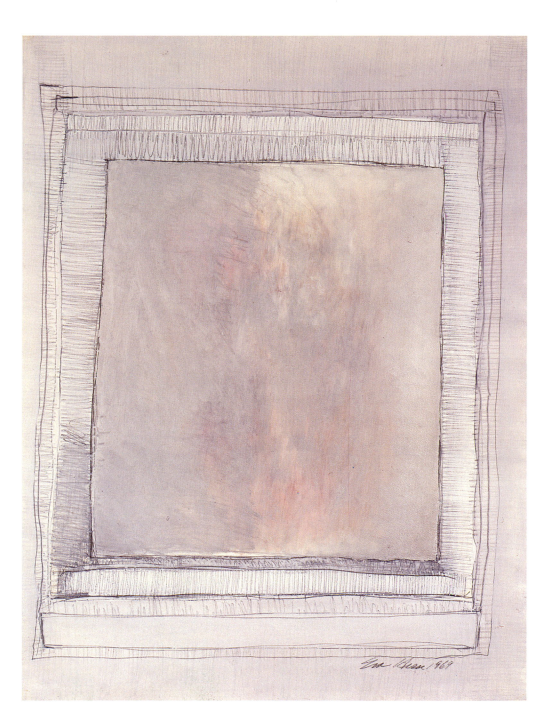

Untitled, 1969
Gouache, watercolor, pencil, and silver paint
23 x 17¼ in. (58.8 x 45.1 cm)
Signed and dated lower right: Eva Hesse 1969
Private Collection
Plate 75

Untitled, 1969
Gouache, watercolor, and pencil
23 x 17¼ in. (58.4 x 43.8 cm)
Signed and dated lower right: Eva Hesse 1969
Sondra and Charles Gilman Jr. Collection
Plate 76

Untitled, 1969
Gouache, watercolor, pencil, colored inks,
and crayon
22 x 17 in. (55.9 x 43.2 cm)
Signed and dated lower right: Eva Hesse 1969
Gioia Timpanelli
Plate 77

Untitled, 1969–70
Gouache and brown ink wash
30.1 x 22.4 in. (76.5 x 57 cm)
Private Collection, Germany
Plate 78

SCULPTURE

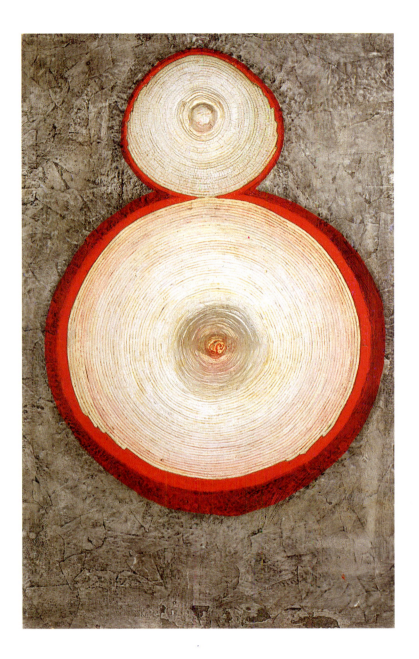

Ringaround Arosie, March 1965
Pencil, acetone, varnish, enamel paint, ink,
and glued cloth-covered electrical wire on
papier-mâché and masonite
26⅜ x 16½ x 4½ in. (67 x 41.9 x 11.4 cm)
Martin Bernstein
Plate 79

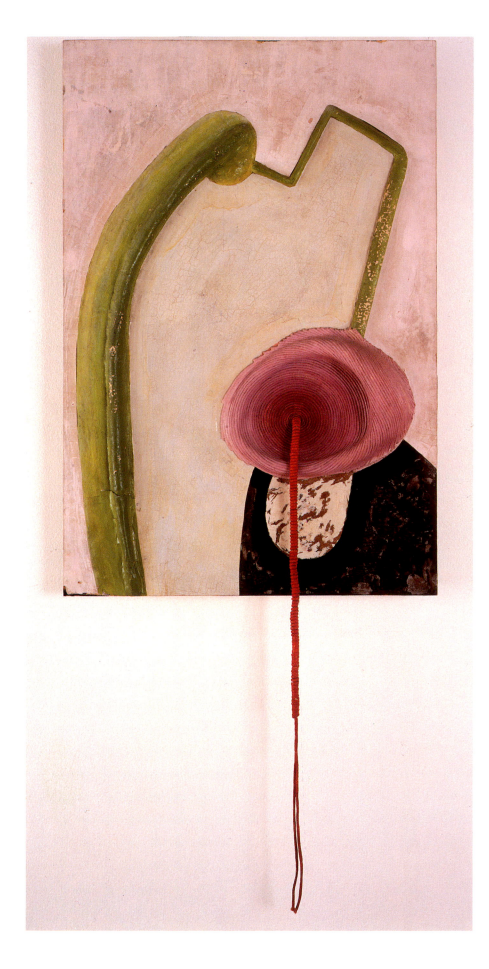

An Ear in a Pond, completed April 1965
Enamel and tempera paints, paper, plaster,
and cord on masonite
26⅜ x 17¾ x 7¾ in. (67 x 45.1 x 19.7 cm)
Inscribed on back: turp., varnish, tempera,
black is enamel, "An Ear in a Pond"
Private Collection
Plate 80 · not in exhibition

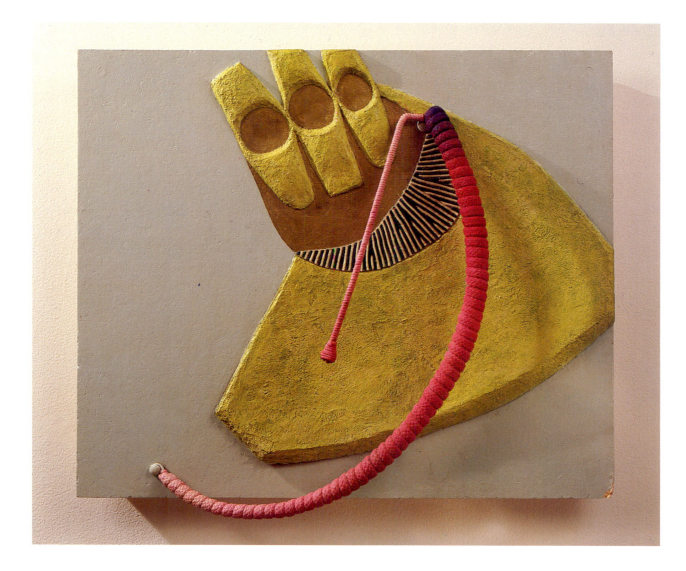

Oomamaboomba, May 1965
Paint, cord-wrapped metal, and plaster on
masonite
21¼ x 25⅝ x 5 in. (54 x 65.1 x 12.7 cm)
The Estate of Eva Hesse. Courtesy Robert
Miller Gallery, New York
Plate 81

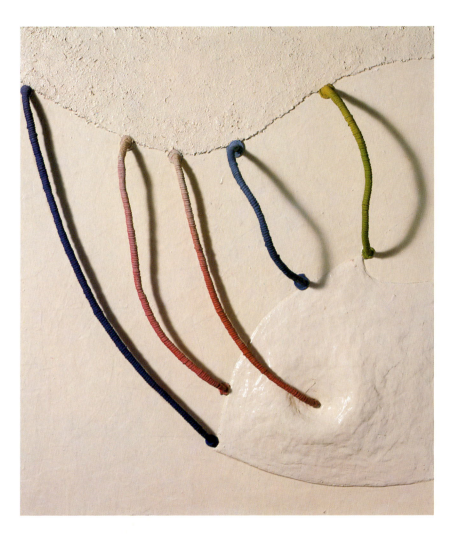

Tomorrow's Apples (or **5 in White**), 1965
Enamel paint, gouache, varnish, cord,
concretion of various materials, and papier-
mâché mounted on chipboard
25¾ x 21⅞ x 6¼ in. (65.4 x 55.6 x 15.9 cm)
Signed, dated, and inscribed on back: Eva
Hesse, 1965, "5 in white," white is Ducolux
enamel 88–50, colors are gouache (Scminke),
varnish alcohol
Tate Gallery, Purchased 1979
Plate 82

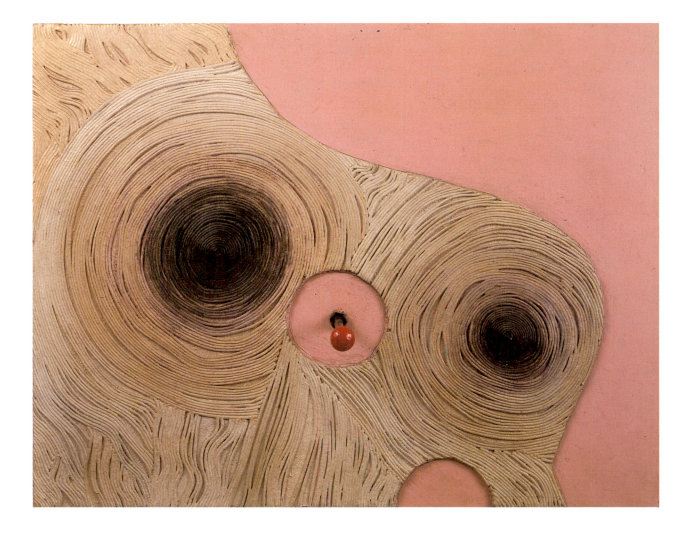

2 in 1, June 1965
Enamel and tempera paints, purple ink,
cord, and painted metal bolt on
particle board
21¼ x 27⅛ x 9 in. (54 x 68.9 x 22.9 cm)
Private Collection
Plate 83

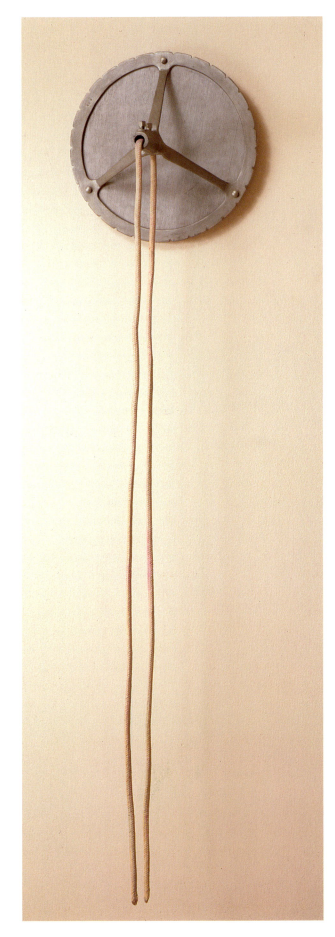

Cool Zone, June 1965
Aluminum found object (base for a sculpture
stand) and painted cloth-bound cord
DIAM. stand, 15 in. (38.1 cm); L. cord, 45 in.
(114.3 cm); D. 10 in. (25.4 cm)
Audrey and Sidney Irmas, Los Angeles
Plate 84

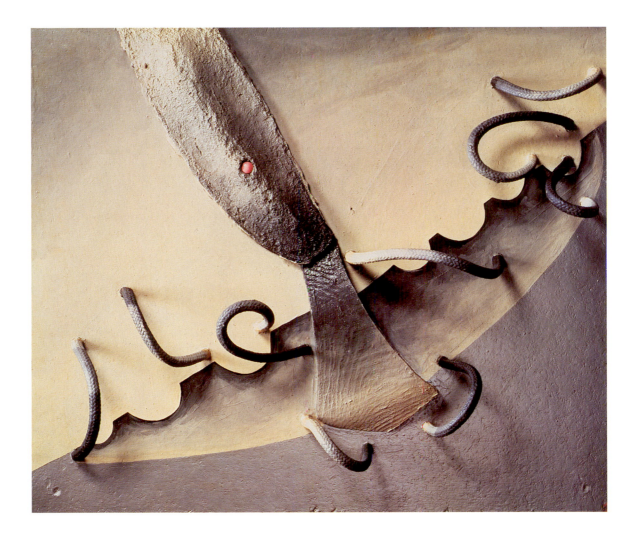

Pink, July 1965
Silver and enamel paints, wood, plaster,
painted cotton cord, and painted metal
button on masonite
21⅝ x 25⅝ x 5¾ in. (54.9 x 65.1 x 14.6 cm)
Kunstmuseum Winterthur, on permanent
loan from Volkart Foundation
Plate 85

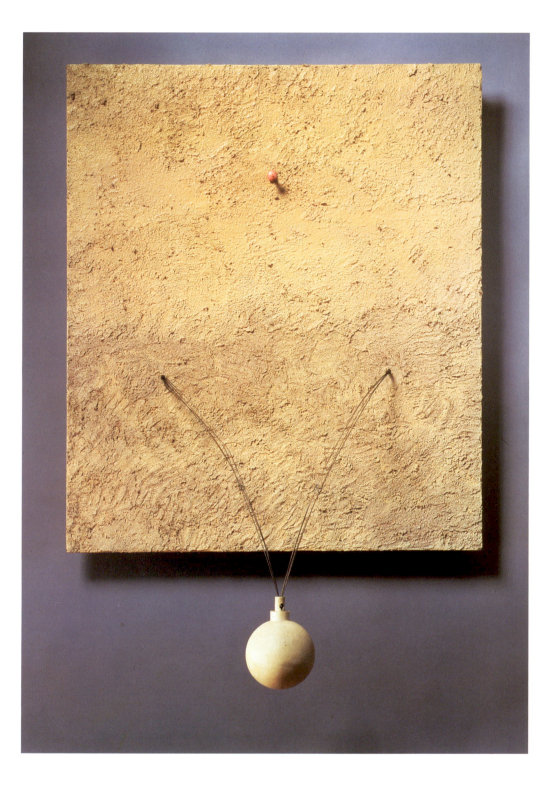

C-Clamp Blues, July 1965
Painted concretion of various materials,
metal wire, painted bolt, and painted hollow
plastic ball with rattle on particle board
25⅝ x 21⅝ x 1½ in. (65.1 x 54.9 x 3.8 cm)
The Estate of Eva Hesse. Courtesy Robert
Miller Gallery, New York
Plate 86

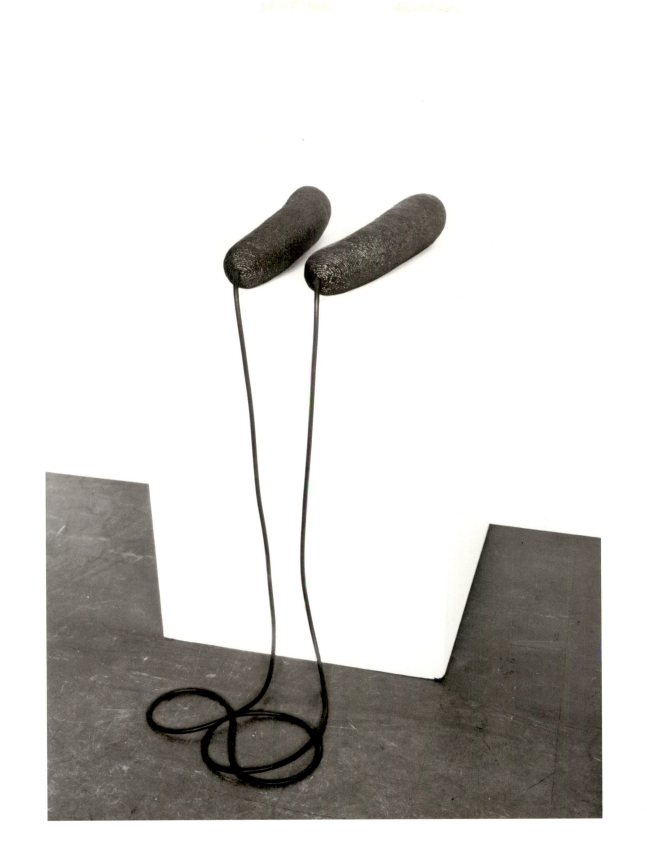

Ingeminate, November 1965
Sprayed enamel paint, papier-mâché, and
cord over two balloons connected with
surgical hose
L. hose, 144 in. (365.8 cm); each element,
22 x 4½ in. (55.9 x 11.4 cm)
Courtesy Thomas Ammann Fine Art, Zurich
Plate 87

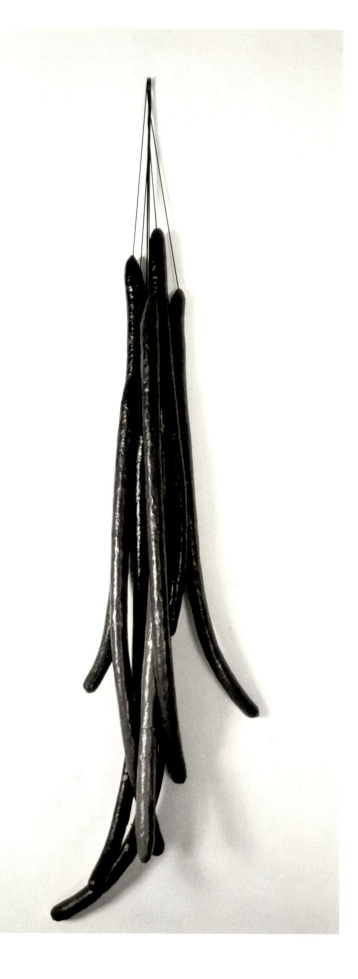

Several, November 1965
Acrylic paint and papier-mâché over seven
balloons with rubber cord
84 x 11 x 7 in. (213.4 x 27.9 x 17.8 cm)
Saatchi Collection, London
Plate 88 · not in exhibition

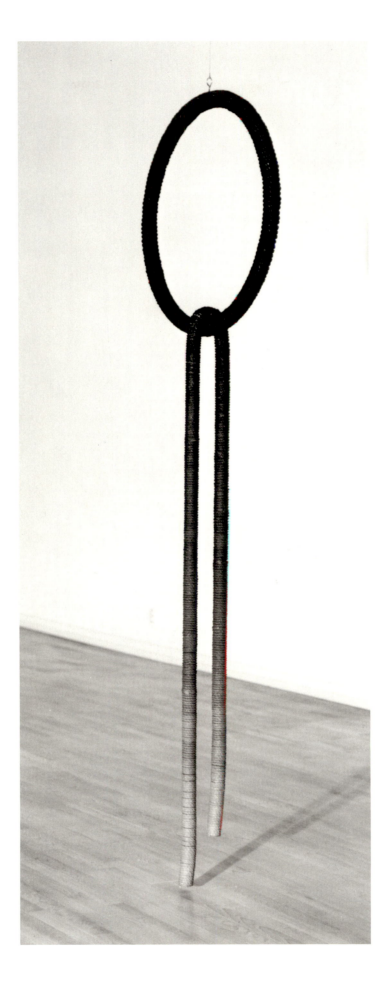

Untitled, November 1965
Enamel-painted cord over wood (or metal)
ring and hose
L. hose, 148 in. (375.9 cm); L. hose and ring
(variable), approximately 106 in. (269.2 cm);
DIAM. ring, 32 in. (81.3 cm)
Moderna Museet, Stockholm
Plate 89

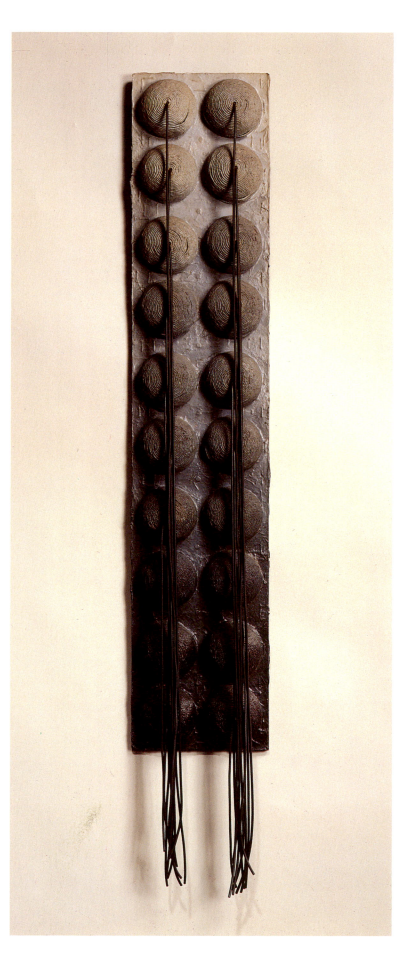

Ishtar, December 1965
Twenty cord-bound and painted hemispheres
with black plastic cords protruding from
their centers, mounted on heavy paper
stapled and nailed to wood; paper gessoed
and painted with acrylic
36 x 7½ x 2½ in. (91.4 x 19 x 6.3 cm);
H. with cords, 42½ in. (107.9 cm); DIAM.
each hemisphere, 3 in. (7.6 cm)
J. J. N. Collection
Photograph courtesy Bill Barrette, *Eva
Hesse: Sculpture,* Timken Publishers, Inc.,
New York
Plate 90

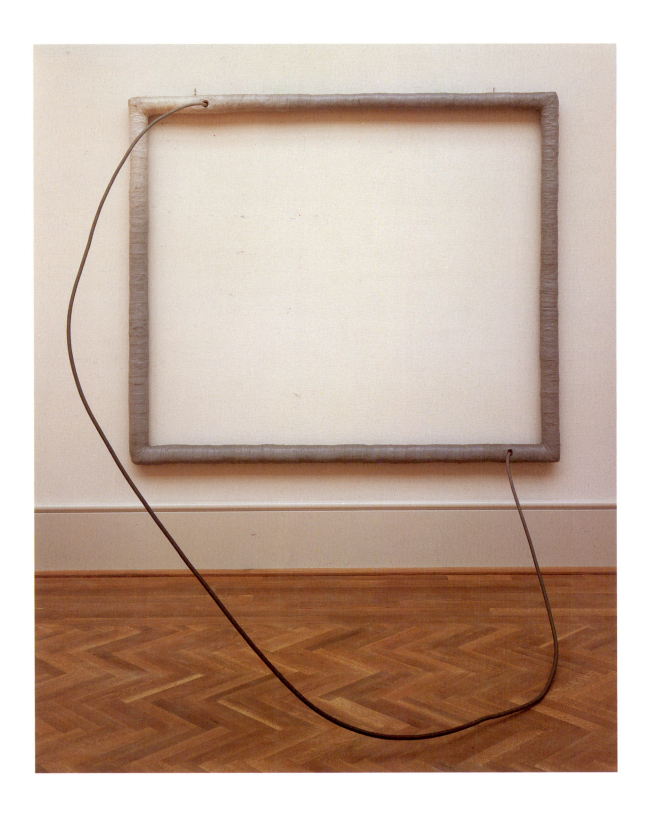

Hang Up, January 1966
Acrylic paint on cloth over wood; acrylic
paint on cord over steel tube
72 x 84 x 78 in. (182.9 x 213.4 x 198.1 cm)
The Art Institute of Chicago, Gift of Arthur
Keating and Mr. and Mrs. Edward Morris
by exchange
Plate 91

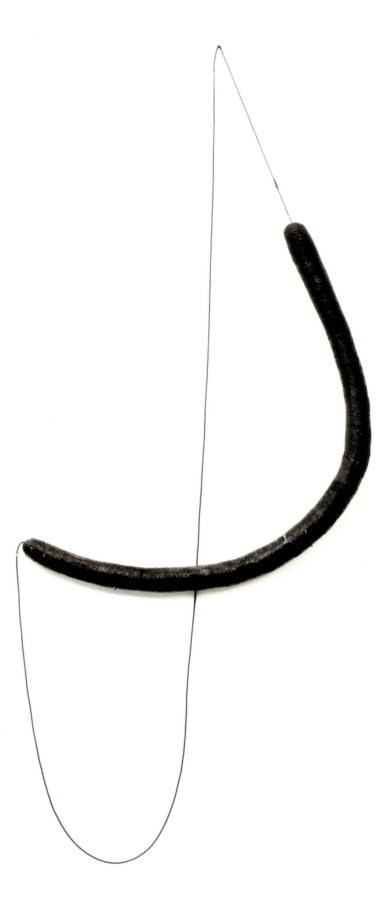

Untitled, 1966
Enamel paint and cord over papier-mâché
and latex balloon with elastic cord
H. rigid element, 33½ in. (85 cm); DIAM.
variable, 2–2½ in. (5.1–6.3 cm); overall
height varies with the installation
The Museum of Modern Art, New York,
Ruth Vollmer bequest, 1983
Plate 92

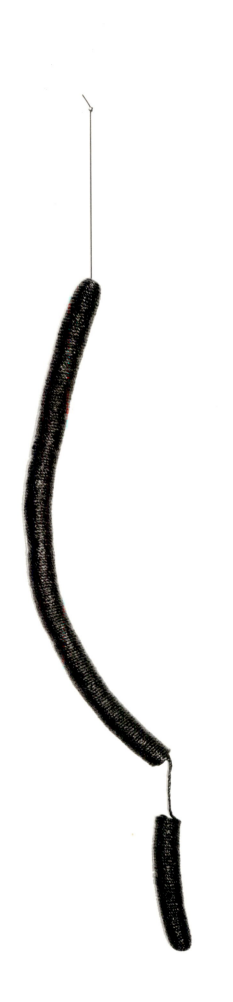

Untitled, 1966
Enamel paint and cord over papier-mâché
and latex balloon with rubber cord
46½ x 11½ x 2½ in. (118.1 x 29.2 x 6.3 cm)
The LeWitt Collection. Courtesy of the
Wadsworth Atheneum, Hartford, CT
Plate 93

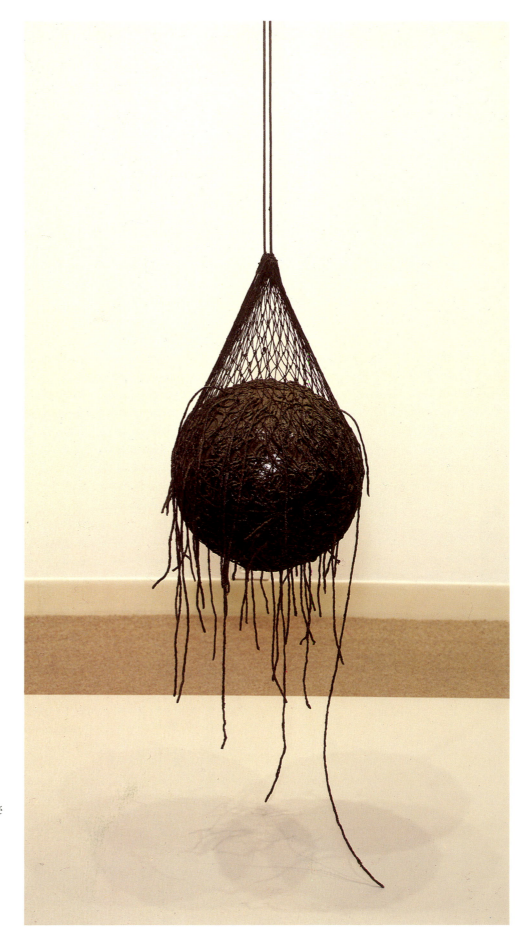

Vertiginous Detour, March 1966
Enamel paint, cord, plaster, and papier-mâché
over a beach ball (?) with dyed net and rope
DIAM. ball, approximately 16½ in. (41.9 cm);
L. rope, approximately 154 in. (391.2 cm)
Hirshhorn Museum and Sculpture Garden,
Smithsonian Institution, The Joseph H.
Hirshhorn Purchase Fund, 1988
Plate 94

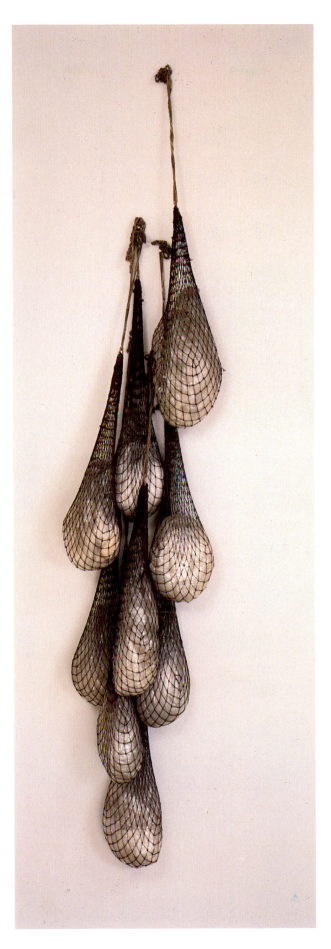

Untitled or Not Yet, March 1966
Nine dyed bags filled with weights wrapped
in clear polyethylene
72 x 24 x 14 in. (182.9 x 61 x 35.6 cm)
Collection Mrs. Victor W. Ganz
Plate 95

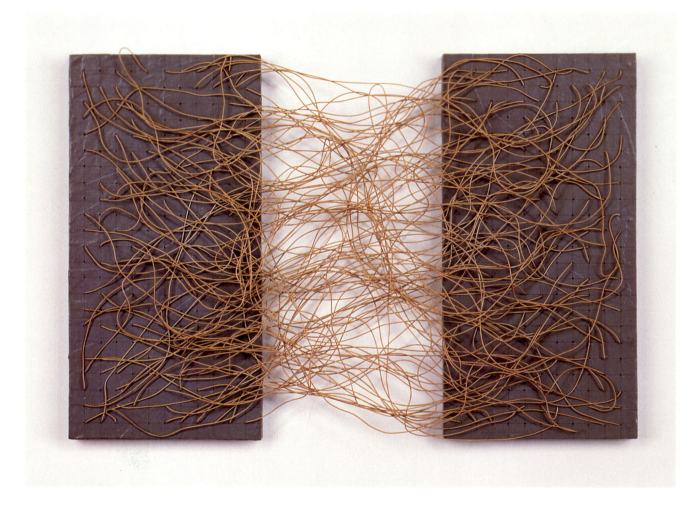

Metronomic Irregularity I, 1966
Acrylic paint and Sculp-Metal over two wood
panels connected by cotton-covered wire
12 x 18 x 2 in. (30.5 x 45.7 x 5.1 cm)
Wiesbaden Museum, Germany
Plate 96

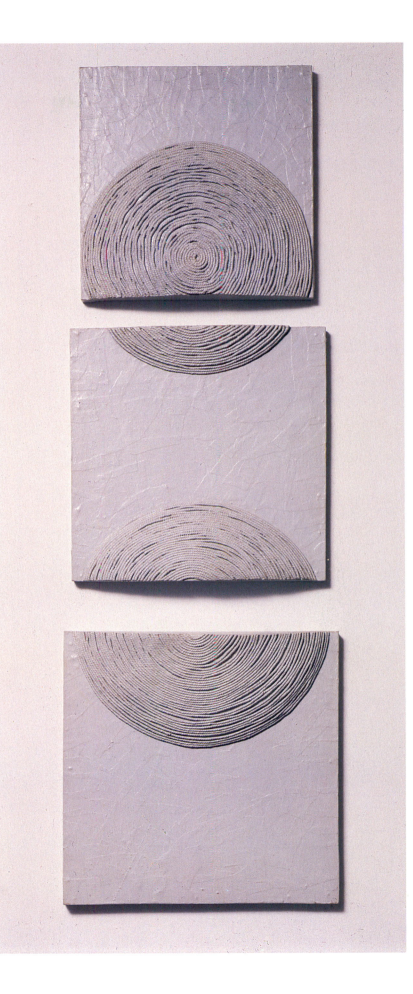

Untitled, 1966–67
Acrylic paint, cord, and papier-mâché over masonite
H. installed, 38 in. (96.5 cm); top section,
10 x 10 x 1½ in. (25.4 x 25.4 x 3.8 cm);
middle section, 11 x 11 x 1½ in.
(27.9 x 27.9 x 3.8 cm); bottom section,
12 x 12 x 2¼ in. (30.5 x 30.5 x 5.7 cm)
Private Collection, Chicago. Courtesy
Rhona Hoffman Gallery
Plate 97

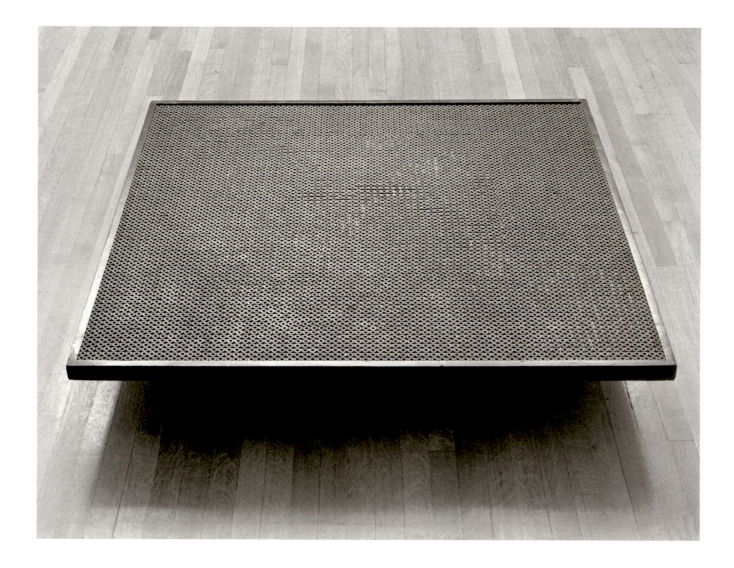

Washer Table, 1967
Rubber washers on wood and metal; base
built by Sol LeWitt
8¼ x 49½ x 49½ in. (21 x 125.7 x 125.7 cm)
The LeWitt Collection. Courtesy of the
Wadsworth Atheneum, Hartford, CT
Plate 98

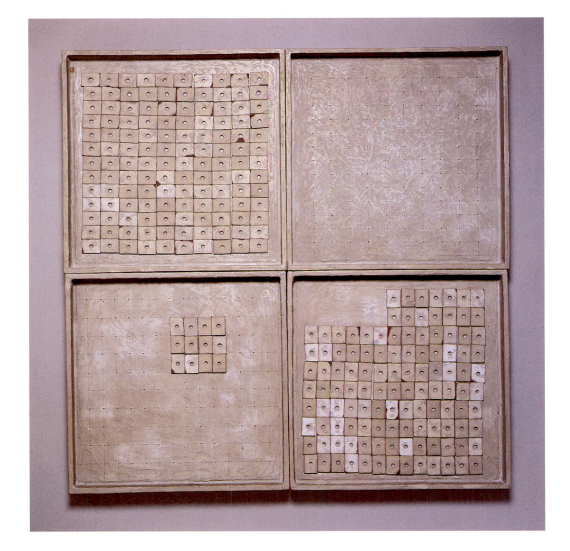

Magnet Boards, 1967
Sculp-Metal on wood and magnets
Each of four units, 12 x 12 x 2 in.
(30.5 x 30.5 x 5.1 cm); assembled,
24 x 24 x 2 in. (61 x 61 x 5.1 cm)
Signed and dated on back, upper right:
Eva Hesse 1967
Louise R. Noun
Plate 99

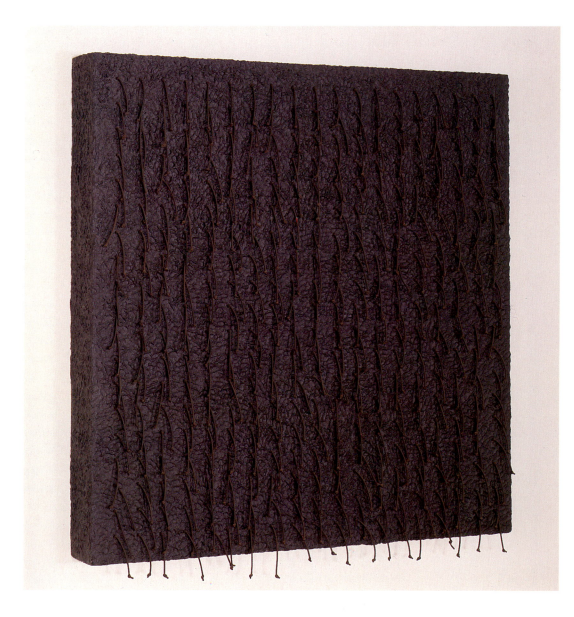

Constant, 1967
Acrylic paint, wood shavings and glue on
masonite with rubber tubing
60 x 60 x 5¾ in. (152.4 x 152.4 x 14.6 cm)
Collection Mrs. Victor W. Ganz
Plate 100

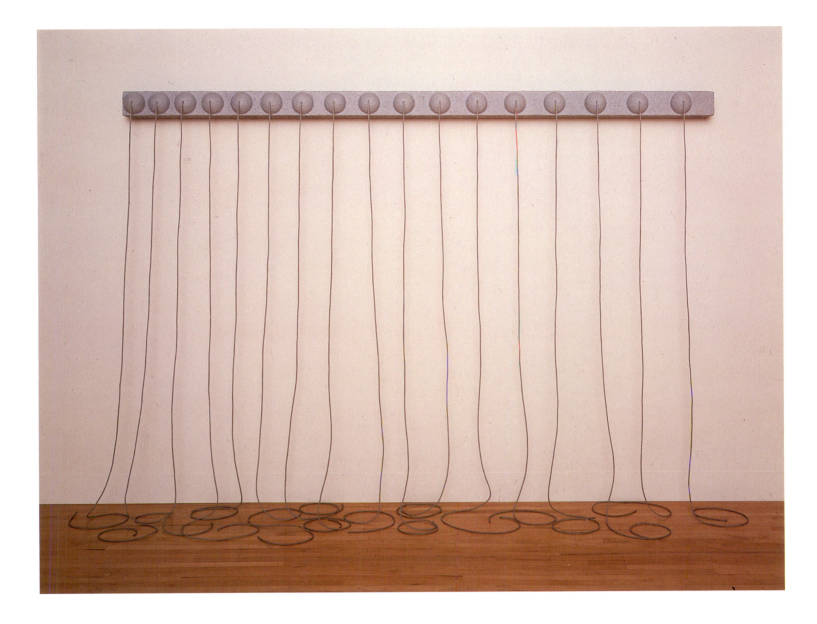

Addendum, 1967
Painted papier-mâché, wood and cord
4⅞ x 119¼ x 5⅞–8⅛ in.
(12.4 x 302.9 x 14.9–20.6 cm)
L. cords, approximately 118⅛ in. (300 cm)
Tate Gallery, Purchased 1979
Plate 101

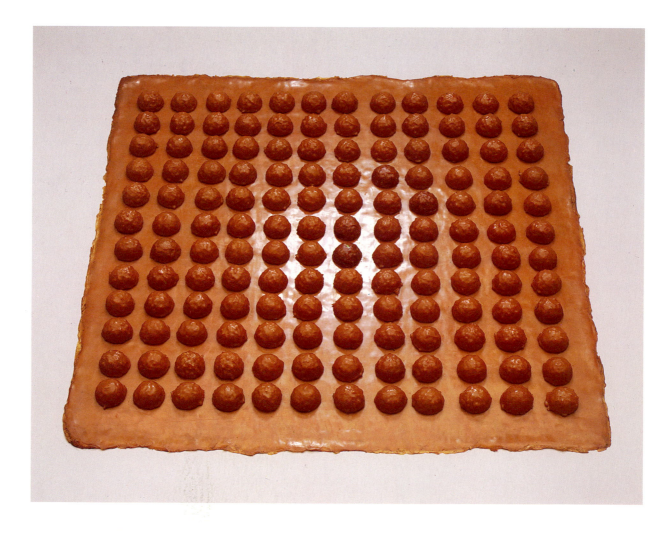

Schema, 1967
Latex
42 x 42 in. (106.7 x 106.7 cm); 144 latex
hemispheres, DIAM. each approximately
2½ in. (6.4 cm)
Philadelphia Museum of Art, Gift of Helen
Hesse Charash
Plate 102

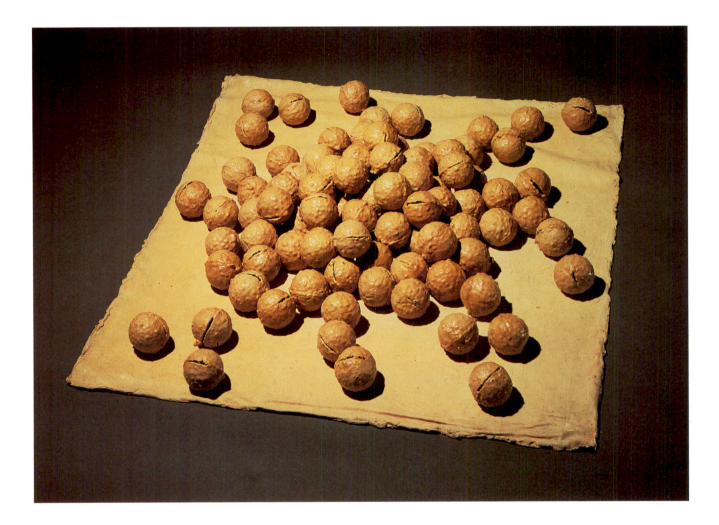

Sequel, 1967
Latex mixed with powdered white pigment
30 x 32 in. (76.2 x 81.3 cm)
Collection Lannan Foundation, Los Angeles
Plate 103

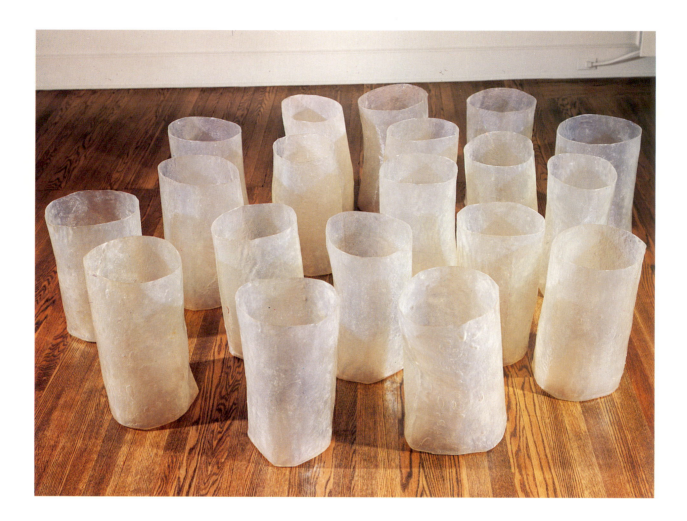

Repetition Nineteen III, July 1968
Fiberglass and polyester resin
H. each of nineteen units, 19–20¼ in.
(48.3–51.4 cm); DIAM. each unit, 11–12¾ in.
(27.9–32.4 cm) with minor variations
The Museum of Modern Art, New York,
Gift of Charles and Anita Blatt, 1969
Plate 104

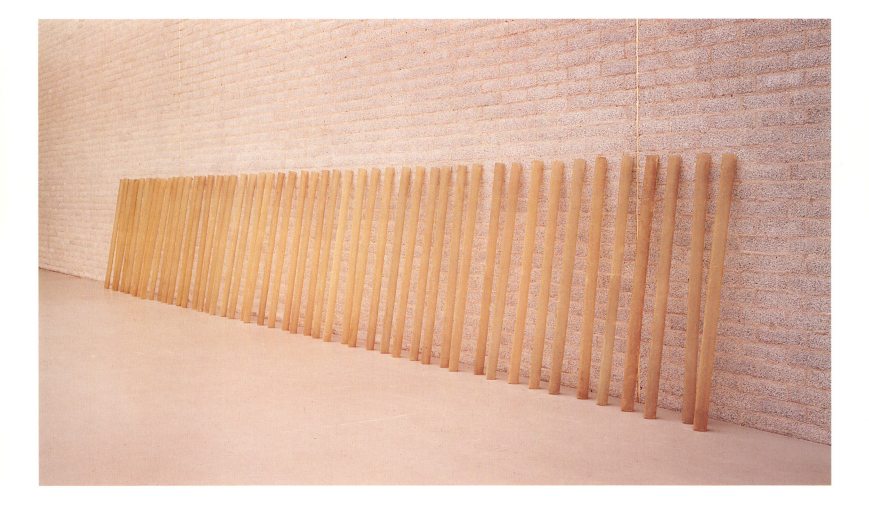

Accretion, summer 1968
Fiberglass and polyester resin
L. each of fifty units, 58½ in. (147.5 cm);
DIAM. each unit, 2½ in. (6.3 cm) with minor
variations
State Museum Kröller-Müller, Otterlo,
The Netherlands
Plate 105

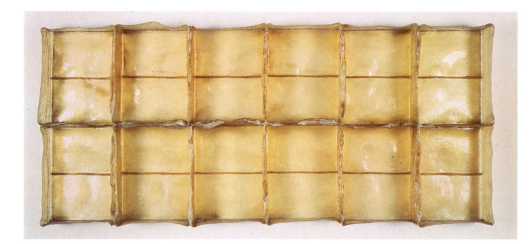

Sans II, 1968 (one of five units)
Fiberglass and polyester resin
Each of five units: 38 x 86 x 6⅛ in. (96.5 x
218.5 x 15.5 cm.) with minor variations

One unit each lent by Dr. and Mrs. Norman
Messite, New York; Refco Group, Ltd.; and
a Private Collection. Two units lent by the
Whitney Museum of American Art, New
York; Purchase, with funds from Ethelyn
and Lester J. Honig and the Albert
A. List Family
Plate 106

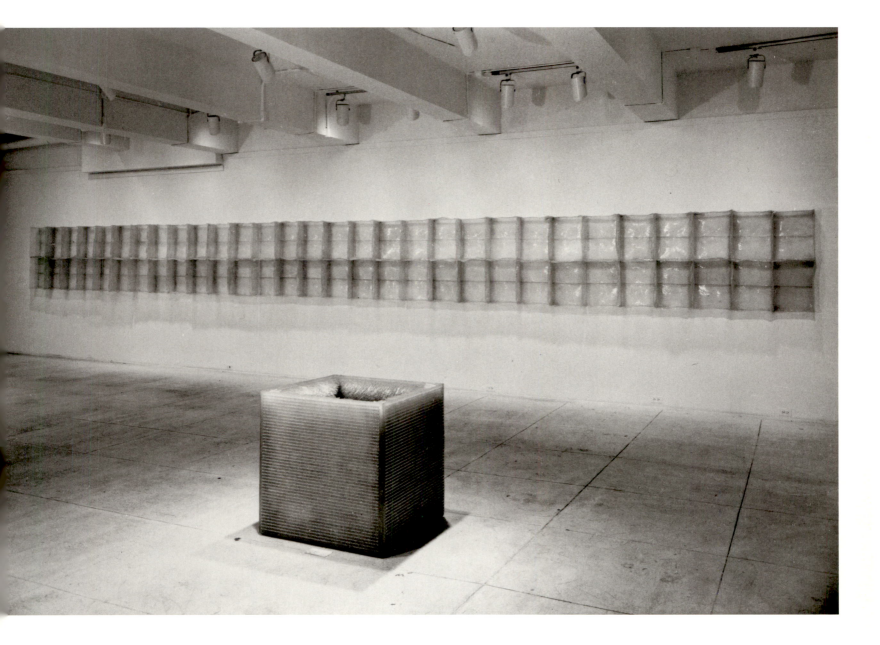

Sans II, as shown in its original installation at the Fischbach Gallery, New York, 1968. In the foreground, *Accession III* (Ludwig Museum). All five units of *Sans II* have been reassembled for the first time in the current exhibition.

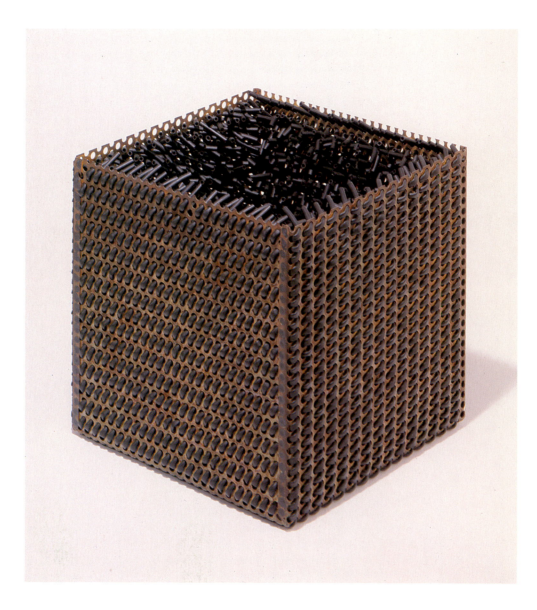

Accession V, 1968
Galvanized steel and rubber tubing
10 x 10 x 10 in. (25.4 x 25.4 x 25.4 cm)
The LeWitt Collection. Courtesy of the
Wadsworth Atheneum, Hartford, CT
Plate 107

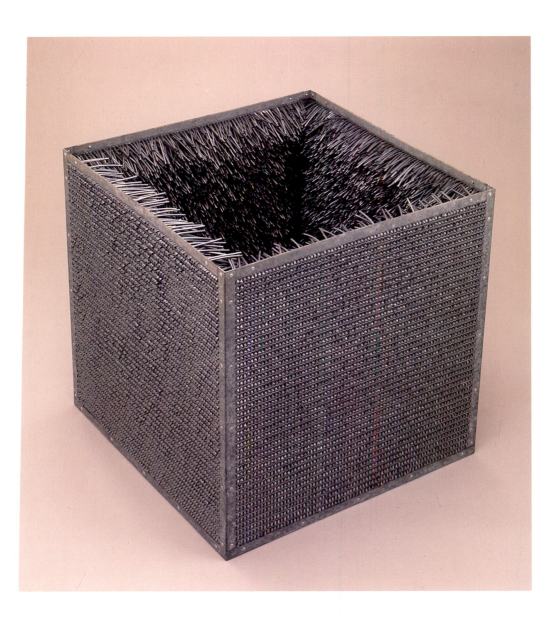

Accession II, completed April 1969
Galvanized steel and plastic tubing
30¾ x 30¾ x 30¾ in. (78.1 x 78.1 x 78.1 cm)
Detroit Institute of Arts, Founders Society
Purchase, Friends of Modern Art Fund, and
Miscellaneous Gifts Fund
Plate 108

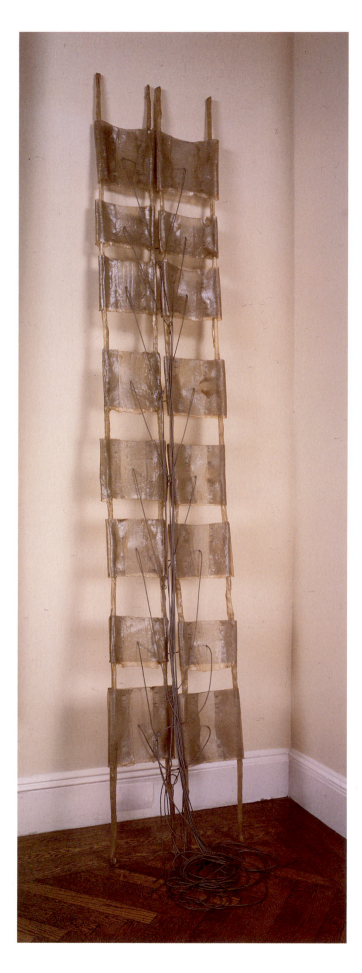

Vinculum I, March 1969
Fiberglass and polyester resin, vinyl tubing,
and metal screen
Each of two units, 104 x 8½ x 2 in.
(264.2 x 21.6 x 5.1 cm)
Collection Mrs. Victor W. Ganz
Plate 109 · Yale only

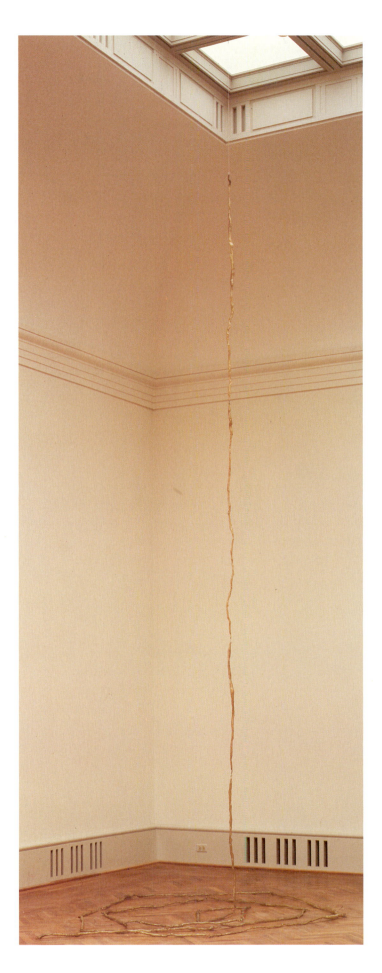

Untitled, 1969
Fiberglass and polyester resin over cloth-covered wire
732 x 1 x 1 in. (1,859.3 x 2.5 x 2.5 cm)
The Art Institute of Chicago, through prior gift of Arthur Keating
Plate 110

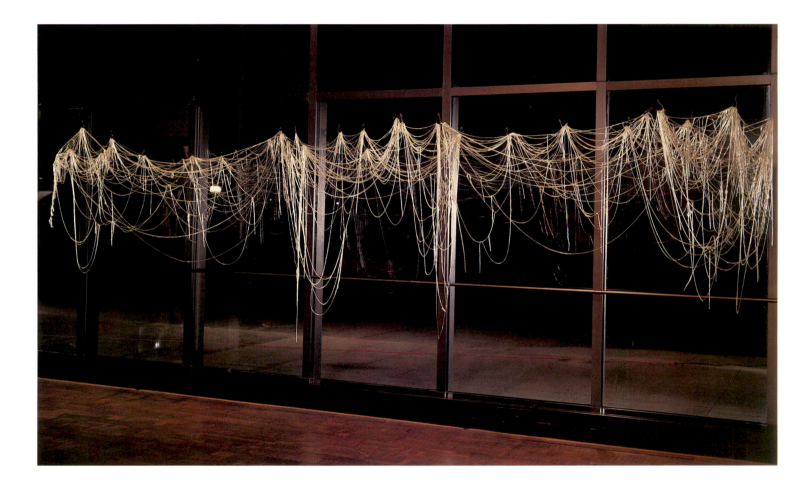

Right After, completed July or August 1969
Casting resin over fiberglass cord and wire
hooks
60 x 216 x 48 in. (152.4 x 548.6 x 121.9 cm),
dimensions variable
Milwaukee Art Museum, Gift of Friends of Art
Plate III

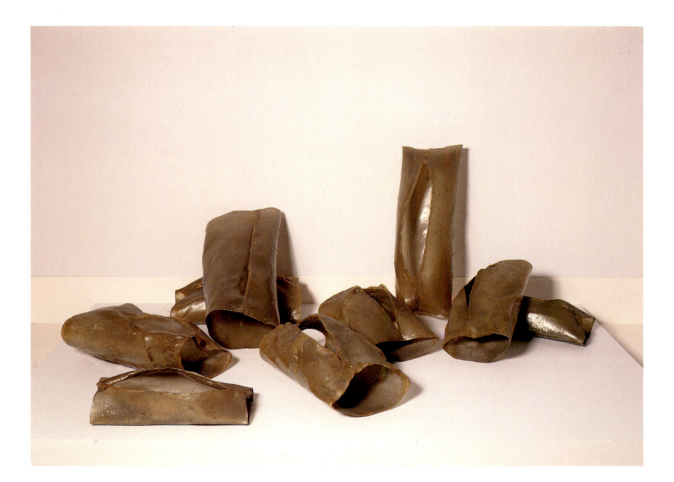

Tori, August 1969
Fiberglass and polyester resin over wire mesh
Each of nine units, 30–47 x 12½–17 x 11¼–15 in.
(76.2–119.4 x 31.7–43.2 x 28.6–38.1 cm)
Philadelphia Museum of Art, purchased
with funds contributed by Mr. and Mrs.
Leonard Korman, Mr. and Mrs. Keith Sachs,
Marion Boulton Stroud, Mr. and Mrs.
Bayard T. Storey and various funds
Plate 112

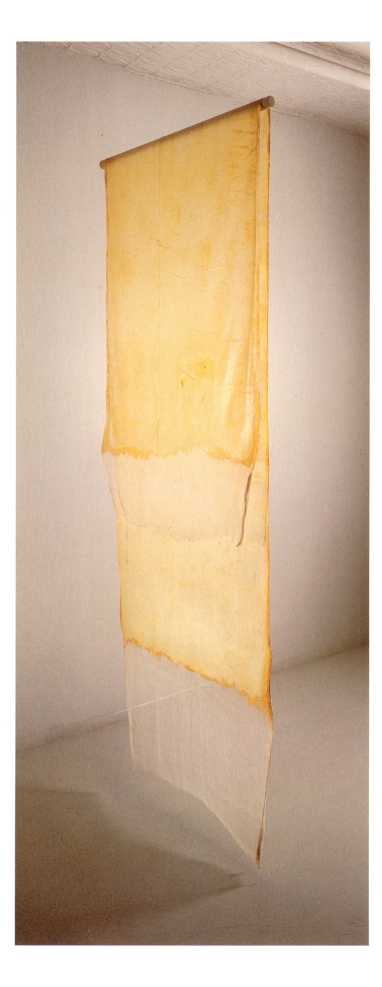

Test Piece for "Contingent", 1969
Latex over cheesecloth
144 x 44 in. (365.8 x 111.8 cm)
Collection of Naomi Spector and Stephen
Antonakos
Plate 113

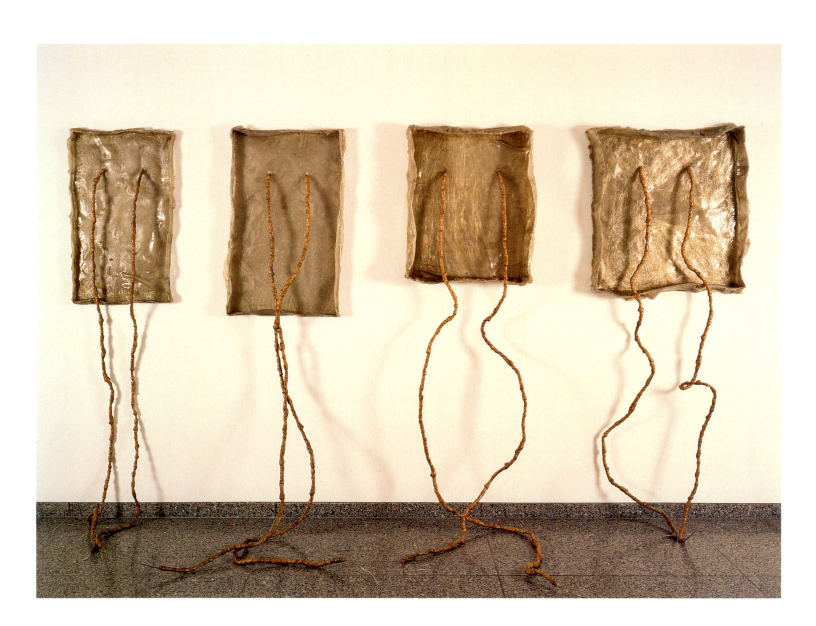

Untitled, 1970
Fiberglass and polyester resin over wire mesh
and polyethylene, and latex over cheesecloth
over wire
Each of four units, 34–42¾ x 23–34 x 2–6 in.
(86.4–108.6 x 58.4–86.4 x 5.1–15.2 cm)
Des Moines Art Center, Purchased with
funds from the Coffin Fine Arts Trust,
Nathan Emory Coffin Collection
Plate 114

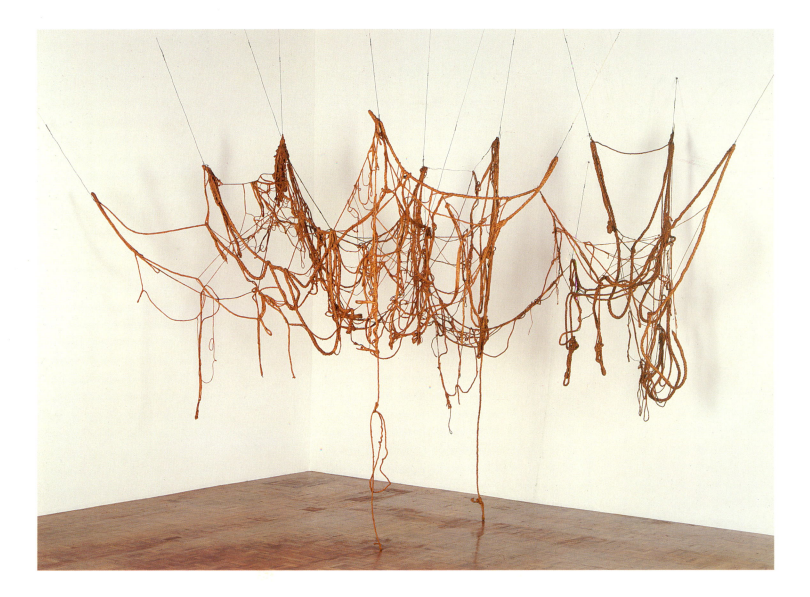

Untitled, completed March 1970
Latex over rope, string and wire
H. each of three units, 144, 126, and 90 in.
(365.8, 320, and 228.6 cm); width varies
with installation
Whitney Museum of American Art, New
York; Purchase, with funds from Eli and
Edythe L. Broad, the Mrs. Percy Uris
Purchase Fund and the Painting and
Sculpture Committee
Plate 115

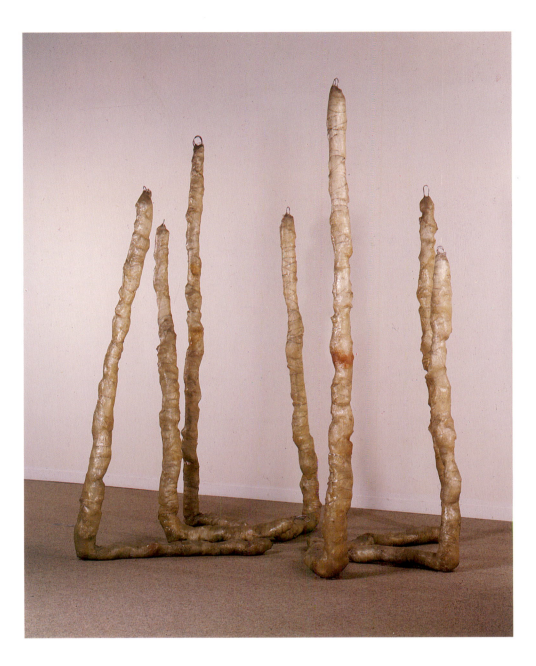

Untitled, completed May 1970
Fiberglass and polyester resin over
polyethylene over aluminum wire
H. each of seven units, 74–111 in.
(188–281.9 cm); circumference each unit,
10–16 in. (25.4–40.6 cm)
Centre Georges Pompidou, Musée National
d'Art Moderne, Paris
Plate 116 · not in exhibition

INDEX

PHOTOGRAPHY CREDITS

Photographs have for the most part been supplied by the owners of the works reproduced. Exceptions and additional credits are listed below by plate and figure numbers.

Michael Agee: pls. 26, 47, 55, 60, 77, 100, 106
Bill Aller: pl. 5
Rudolph Burckhardt: figs. 47, 48, 51, 53, 62, 82
Geoffrey Clements, Inc.: pl. 115; fig. 73
Sheldon Comfort Collins: fig. 113
D. James Dee: fig. 57
Hein Engleskirchen: fig. 40
Allan Finkelman: pls. 81, 83, 84; figs. 8, 77
Lynton Gardiner, courtesy of Timken Publishers: pl. 98
Hans Haacke: fig. 44
Akira Hagihara: fig. 2
David M. Heald: pl. 76
Bill Jacobson: fig. 59
Bernd Kirtz [Duisburg]: pl. 78; fig. 45

Gretchen Lambert: fig. 13
H. Landshoff: fig. 31
Peter Moore, N.Y.: figs. 64, 81, 83, 85
Douglas M. Parker: pls. 24, 53, 56, 66, 74
Beth Phillips: pls. 59, 75
Nathan Rabin: fig. 58
Walter Scholz-Ruhs: pl. 96
Phillips/Schwab, N.Y.: pls. 12, 14, 51
Lee Stalsworth: pl. 94
Statens Konstmuseer: pl. 89
Jim Strong: pl. 73
Joseph Szaszfai: fig. 49
Mark Tade, courtesy University of Iowa Museum of Art: pl. 99
Jerry L. Thompson: fig. 84
Michael Tropea: pl. 97
Günther Uecker: fig. 42
Ellen Page Wilson: pls. 95, 109
Zindman/Fremont: pls. 1, 2, 4, 6, 7, 13, 15, 18, 19, 20, 23, 27, 28, 29, 30, 32, 44, 46, 48, 49, 50, 80, 86; figs. 4, 6, 10, 23, 39

Design and typography · Catherine Waters

Text composition · Highwood Typographic Services

Duotone negatives · Robert Hennessey

Color supervision · The Colman Press

Printing and color separations · Eastern Press, Incorporated

Press supervision · Nan Jernigan and Susan Medlicott

Printing of covers and jackets · Wild Carrot Letterpress

Softbound binding · Mueller Trade Bindery

Casebound binding · Acme Bookbinding Company, Inc.